REFRACTED VISIONS

OBJECTS/HISTORIES

Critical Perspectives on Art, Material Culture, and Representation

A series edited by Nicholas Thomas

PUBLISHED WITH THE ASSISTANCE OF THE GETTY FOUNDATION

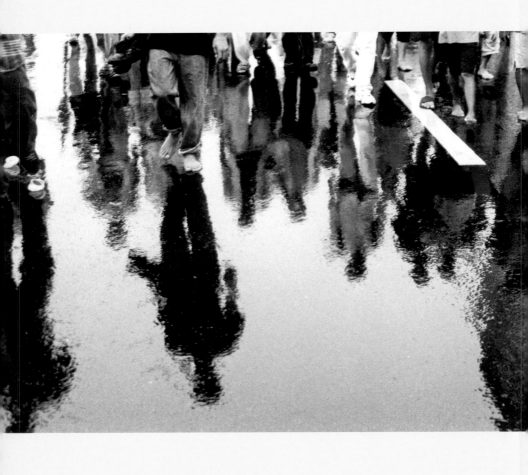

KAREN STRASSLER

Refracted Visions

POPULAR PHOTOGRAPHY AND

NATIONAL MODERNITY

IN JAVA

DUKE UNIVERSITY PRESS DURHAM AND LONDON 2010

© 2010 Duke University Press
All rights reserved
Printed in the United States of
America on acid-free paper ∞
Designed by C. H. Westmoreland
Typeset in Carter & Cone Galliard
with Quadraat Sans display by
Tseng Information Systems, Inc.
Library of Congress Cataloging-in-
Publication Data appear on the last
printed page of this book.

frontispiece photograph: Students
march to the People's Consultative
Assembly building, Jakarta, November 12,
1998. Photo by Agus Muliawan.

CONTENTS

ILLUSTRATIONS

"You are fortunate indeed, my students," he
said, "to be able to witness the beginning of the
modern era here in the Indies."

Modern! How quickly that word had surged
forward and multiplied itself like a bacteria
throughout the world. (At least, that is what
people were saying.) So allow me also to use
this word, though I still don't fully understand
its meaning.

In short, in this modern era tens of thou-
sands of copies of a photo could be reproduced
each day. PRAMOEDYA ANANTA TOER,
This Earth of Mankind

THESE ARE THE MUSINGS OF MINKE, the young Javanese protago-
nist of Pramoedya Ananta Toer's novel of the Indonesian nationalist
awakening, *This Earth of Mankind*, set in early-twentieth-century Java.
To Minke's naive eyes, as he soaks up the novelties of his Dutch colo-
nial education, photographic technology emblematizes the marvels
of modernity itself. Photography represents an opening to the world
("Now I could see for myself everything from all over the world upon
these printed sheets of paper"), and a transcending of spatial and so-
cial barriers ("It was as if the world no longer knew distance").[1] Pho-
tography not only brings the far away close at hand, Minke asserts,
it also offers an advance in representational technique over block and
lithograph printing, which by comparison with photography's perfect
mimesis offer "very poor representations of reality" (17). But, empha-

sizing that Minke's exuberant embrace of modernity represents received knowledge, the governing ideology of his day, Pramoedya nevertheless has Minke follow his praise with the more hesitant "at least that is what people were saying" (18). Minke's uncertainty signals the anxiety that surrounds a term like "modern," a word that implies its own self-evidence yet has no clear referent or definition, a word that gains discursive power as it proliferates like bacteria—or photographs.

Also in this passage, Minke credits his colonial education with his penchant for documenting his own observations and experiences: "And that's how it was that I, a Javanese, liked to make notes—because of my European training. One day the notes would be of use to me, as they are now" (17). For Minke, this impulse to document the past for the benefit of the future distinguishes him from an earlier, "deprived" Javanese generation that left no mark in the world beyond "the accumulation of its own footsteps in the lanes of its villages" (17). Pramoedya suggests that the act of documentation is part of inhabiting a new self-consciously modern temporality. In linking photography and writing, Pramoedya locates photography within the broader technological configuration of print culture and mechanical reproduction, and within a modern archival historicity in which paper traces are authorized to record a past that recedes irrevocably as time moves relentlessly forward.

In the course of the novel, Minke develops a far more critical stance toward European ideologies of modern progress, technology, and realist representation.[2] Shedding his naiveté, he moves from fawning adulation to a sophisticated deployment of modernity's discourses and practices in the service of nationalism. Photography again figures prominently in this transformation. In the early pages of the novel, Minke becomes infatuated with the beautiful Dutch Queen Wilhelmina via her mass-produced portrait. Rather than cultivate sentiments of political allegiance—its intended effect—possession of the queen's portrait inspires Minke to imagine her as a peer and a lover. Minke's misrecognition of the queen arises from the fact that photographic images operate in different registers, circulating in the public sphere as political symbols while also mediating an intimate realm of personal affiliations, memories, and sentiments. When Minke falls in love with the Dutch queen via her portrait, he falls victim to the mystification of modern technology. But there is radical potential in his mistaken sense of intimate proximity to the queen.

Minke becomes disillusioned as he finds that the portrait offers a false promise; even wondrous modern technologies cannot transcend the social, political, and legal structures of colonialism. When his beloved Annelies—the illegitimate child of a Dutch colonialist and his Javanese *nyai* (concubine)—falls victim to colonial oppression, a more savvy Minke uses photography to transform personal tragedy into nationalist cause. Whereas Minke had transposed the queen's image from the realm of public symbology into the sphere of intimate affections, now he reverses this movement, circulating Annelies' portrait via that quintessential vehicle of national consciousness, the newspaper.[3] Minke shrewdly recognizes that mechanical reproduction can transform his lover's portrait into a nationalist icon capable of galvanizing anticolonial sentiment.

At the novel's end, Minke has realized himself as neither the Javanese aristocrat he was born to be nor the Dutch "mimic man" he was educated to be, but as a new kind of subject: an Indonesian nationalist.[4] Pramoedya's meditation on photography in the dawning years of Indonesian nationalism sets the stage for this book's exploration of photography's formative role in the first half century of Indonesian postcoloniality. It foreshadows several key themes explored in the pages of this book: the centrality of photography in the making of modern, national subjects; the participation of photography in generating new spatial and temporal orientations; and the way that popular photographs entangle intimate and idiosyncratic projects of love, selfhood, and memory with more public, collective imaginings and yearnings. But to begin our exploration of these themes we need to leave behind the dawn of "the modern era" in the Indies and, leaping ahead a hundred years, locate ourselves in a Javanese city at the turn of the twenty-first century.

ACKNOWLEDGMENTS

Mere words of thanks cannot redeem the many debts acquired in the writing of this book. Like photographs that may evoke but can never capture the fullness of experience, these words, I hope, at least gesture to my profound gratitude.

My greatest thanks go to the people in Indonesia who shared their time, memories, knowledge, insights, and, of course, photographs, with me. The photography community of Yogyakarta—amateur photographers, studio photographers, journalists, students, artists—warmly took me into their world. I owe special gratitude to Jack Andu, Ali Budiman, Heri Gunawan, Johnny Hendarta, Pak Herman, Risman Marah, Moelyono, S. Setiawan, Soeprapto Soedjono, Danu Kusworo, Fatchul Mu'in, Patmawitana, R. A. B. Widjanarko, Rabernir, Kelik Supriyanto, and Agus Muliawan. Thanks also to Aris Liem, Rama Surya, Yudhi Soeryoatmodjo, R. M. Soelarko, and many other professional and amateur photographers from Bandung, Jakarta, Semarang, Solo, and Surabaya who also greatly enriched my study. I am especially indebted to Agus Leonardus for his generous help in many aspects of the project.

Nita Kariani Purwanti's competence, knowledge, and energy infuse this book. Vevi Ananingsih, Endang Mulyaningsih, and Azwar Hamid participated actively in the research and were the people I turned to for things great and small. Other friends provided listening ears and insightful comments: Clarissa Adamson, Setiti Andayani, Merda and Bondan Hermaniselamat, Very Kamil, Linda Kaun, Laurel Maclaren, Ni Made Ayu Marthini, Goenawan Mohamad, Dias Pradadimara, Gambit Raharjo, Dewi Trisnawati Santoso, Laura Sedlock, and Supriyono. Ibu Soekati and Ibu Soekilah were beloved grandmothers to me. The children, volunteers, and staff of Kuncung Bawuk sustained

me with their friendship and humor. Ibu Moekiman, Mbak Etik, and family opened up their home to me and helped me be at home. Wiwied Trisnadi and Kirik Ertanto kept me in dialogue with Indonesian anthropology and always opened my eyes to facets I had not seen. Didi Kwartanada was more than generous with his family's extraordinary collection of photographs and his extensive knowledge of Chinese Indonesian history. I am grateful to P. M. Laksono for welcoming me to the anthropology community at Gadjah Mada University and to Romo Budi Susanto of Sanata Dharma University, my sponsor, for his support and intellectual exchange. Astuti Koesnadi was a diligent transcriber. If it were not for my cousin Sara Newmann, a fellow traveler in so much of my life, I might never have gone to Java.

The University of Michigan, where this project began, was as collegial and intellectually rich an environment as I can imagine. In Ann Stoler I found a mentor and friend. Along with her astute insights and generous guidance, she has taught me above all the importance of bringing passion to my work. Brinkley Messick gave me many of the tools with which to explore the social practice of documentation. Rudolf Mrázek offered an inspired model of scholarship on technology and modern Indonesian history. Webb Keane challenged me to think rigorously about the sociality of material objects and the materiality of signs. Nancy Florida's observations demonstrate a subtle, incisive intelligence that I can only aspire to emulate. Her reading of a final draft of the book manuscript in its entirety gave me courage to put it out into the world. Many readers of this book will also recognize the profound influence of several scholars who were not directly involved in my training. I want especially to acknowledge Christopher Pinney, whose ethnographic work on photography—and images more generally—has provided both inspiration and dialogue.

I gratefully acknowledge support received from the Fulbright-Hayes Program (administered expertly by the American Indonesian Exchange Foundation in Jakarta) and the University of Michigan Rackham Graduate School. My position as Hrdy Postdoctoral Fellow in Visual Anthropology at Harvard University's Peabody Museum provided me with a stimulating environment within which to begin preparing the manuscript. I thank Mary Steedly and Ruby Watson for bringing me there and I am grateful to the staff of the Peabody Museum and the staff, faculty, and students of the Anthropology Department for making my stay so rewarding. Since 2005, my colleagues at Queens

College have been extremely supportive as I have juggled the demands of teaching, writing, and motherhood. I thank them for providing a nurturing community. I am also grateful to Angela Zito and Faye Ginsburg for offering me a Visiting Scholar position at NYU's Center for Religion and Media during a leave in 2007 as I completed the manuscript. Ken Wissoker, Mandy Earley, and Tim Elfenbein at Duke University Press enthusiastically and patiently stewarded this book to publication. I thank Lynn Walterick for her meticulous editing, and Jan Williams for her expert indexing. The Getty Foundation generously provided support for the images in this book.

Earlier versions of parts of this book have appeared elsewhere. Portions of chapters two and three appeared in "Cosmopolitan Visions: Ethnic Chinese and the Photographic Envisioning of Indonesia in the 1950s," *Journal of Asian Studies* 67, no. 2 (2008): 395–432. Part of chapter two appeared in "Photography's Asian Circuits," in an issue of the *International Institute of Asian Studies Newsletter* (Summer 2007) on Asian photographies, edited by David Odo. Parts of chapter five appeared in "Material Witnesses: Photographs and the Making of Reformasi Memory," in *Beginning to Remember: The Past in Indonesia's Present*, edited by Mary Zurbuchen (Seattle: University of Washington Press, 2005), and in "Witness of History: Student Photography and Reformasi Politics in Indonesia," in *Visual Sense: A Cultural Reader*, edited by Elizabeth Edwards and Kaushik Bhaumik (Oxford: Berg, 2008). Finally, a small portion of chapter six appeared in "Documents as Material Resources of the Historical Imagination in Post-Suharto Indonesia," in *Timely Assets: Resources and Their Temporalities*, edited by Elizabeth Ferry and Mandana Limbert (Santa Fe, N.M.: SAR Press, 2008). I thank the editors of and reviewers for these publications for helping me sharpen my arguments.

More colleagues and friends have made their imprint on this book than I can mention. The book would never have taken shape without the contributions of the writing group who for two years met weekly around my grandmother's dining room table: Ilana Feldman, Pamila Gupta, Rachel Heiman, Brian Mooney, and Mandana Limbert. For their insightful and challenging readings of parts of the book at various stages in its realization, I thank Ilisa Barbash, Jennifer Cole, Ayala Fader, Tejaswini Ganti, Didi Kwartanada, Smita Lahiri, Ann Marie Leshkowich, Johan Lindquist, Janet McIntosh, Rosalind Morris, Patricia Spyer, Mary Steedly, Ajantha Subramanian, Lucien Taylor, Steven

Wachlin, and Christine Walley. Even at a greater distance than I would have liked, Penelope Papailias has remained a most valued interlocutor. Rachel Heiman and Julie Subrin always urged me on when I needed it most. I am especially grateful to Mandana Limbert and Laura Kunreuther, who read and reread versions of the manuscript to the point where I often do not know where their insights end and mine begin. For more than two decades, I have relied on Rachel Sherman's hard questions, wise counsel, and steady encouragement.

I thank my mother for teaching me to look at images, my father for conveying the pleasures of writing, and my brother for his probing curiosity and enthusiastic support. I am nourished each day by David Herbstman's humor, generosity, and kindness and by Leo and Caleb, who see with new eyes.

NOTE ON ORTHOGRAPHY AND PSEUDONYMS

In spelling Indonesian words, I have generally followed the orthographic system officially adopted in 1972. However, in a few cases (especially with personal names), following common usage or the preference of the individual involved, I use the old orthographic system. Generally, for example, I have spelled the first Indonesian president's name Sukarno. However, in the illustrations to chapter six, readers will note that Noorman, on whom that chapter focuses, chooses to spell Sukarno's name by the old spelling, thus rendering it Soekarno.

Throughout the book, I follow common anthropological usage by using pseudonyms, with several important exceptions. When writing of a photographer whose images appear in the book, I always refer to that person in the text by his or her actual name. This is to avoid confusion and to make sure that photographers are properly acknowledged for their work as well as their thoughts about their work. Second, for those aspects of the research that constitute oral histories, I also provide the actual name of the person interviewed, in order to make that history as useful as possible to other scholars and interested parties.

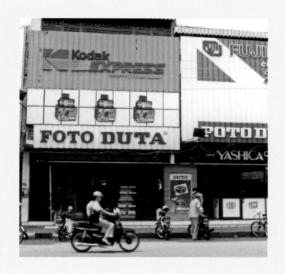

Popular Photography and
Indonesian National
Modernity

ON DAYS WHEN THE HEAT became overwhelming, I often went to visit Ibu Soekilah. In the narrow alleys of her *kampung*, a dense urban neighborhood perched above the river that cuts a deep gash through the center of Yogyakarta, it was easy to forget that Indonesia was in the midst of a turbulent transition. President Suharto had stepped down just a few months earlier, bringing to a close his thirty-two-year authoritarian regime, the New Order. Students were still demonstrating—as they had been all year in a movement known as *reformasi* (reformation)—to bring about a new, less corrupt, and more democratic Indonesia. Insulated from the roar of the main city streets—periodically clogged by protestors and convoys of political party supporters on motorcycles—life here seemed to pulse to a gentler rhythm. Men in sarongs with prayer blankets over their shoulders walked in small groups to the nearby mosque, boys standing on tin rooftops launched their homing pigeons into the air, women watered parched potted plants outside their homes, chickens wandered aimlessly.

Escaping the white-hot glare of the midday sun, I would step inside Ibu Soekilah's door. It always took my eyes a minute to adjust to the dark, but even before I could see her, I could already picture her sitting in the wooden chair just to my right, a heavy-set old woman in a faded housedress with a creased face and poorly dyed long black hair. There was just enough space in the tiny room for me to sit facing her, next to a small corner cabinet. The old television on top of the cabinet was broken; for company, Ibu Soekilah kept a small radio propped on the arm of her chair. A framed black and white portrait of her only son, whose death several years earlier had left her—already a widow—bereft, stared out blankly from the wall above us.

Ibu Soekilah liked to talk about the past. As she did, she would reach into the cabinet to pull out photographs that she kept, along with a few old letters and important papers, in various containers: a tattered, felt-lined jewelry box, a worn black purse, an old photo album, and several

of the plastic-sleeved albums that photofinishers give out for free. The black and white pictures from the 1950s affixed to the album's crumbling pages were very small, just slightly larger than a postage stamp, because, she explained, "We were poor. Only rich people could afford big photos." But in them people posed proudly, in their best clothes, sometimes against elaborate tropical backdrops. Other images were simple frontal portraits, the kind used for identification documents, of friends with whom Ibu Soekilah had long since lost touch. Faded snapshots, taken by a friend who had owned a *tustel* (Dutch: camera), captured outings to waterfalls and beaches; a group of men posed by a car; neighbors and relatives gathered for a wedding. In one photograph of a group of neighbors at a circumcision ceremony, Ibu Soekilah pointed out a young man who had disappeared during the anticommunist purges of the mid-1960s because, she whispered, he had "smelled of the Communist Party" (*bau PKI*). Some of her photographs were eaten through with worms, and many of the newer, garishly colored images "protected" by plastic sheaths were moldy and rotting with trapped moisture. Ravaged as the pictures were, they recalled a densely populated life, enriched by celebrations and shadowed by loss, a life that she told me was now—but for these fragile paper traces—"all gone, like a dream."

What insights might such intimate artifacts offer the study of Indonesia at this critical juncture in its history? Ibu Soekilah's photographs, like Ibu Soekilah herself, seemed marginal to the eventful national history so vividly taking place on the thoroughfares of the nation's cities. Yet it is the central argument of this book that, albeit in more oblique ways than the violent images smeared across the front pages of newspapers, photographs like Ibu Soekilah's have profoundly shaped how people imagine that troubled collectivity known as "Indonesia" and their own place within it. Whether in the recycling of an identity photograph as a memento to a past friendship, a portrait posed against an iconically Indonesian landscape, or the haunting reminder of a young man who disappeared during the communist purges of 1965–1967, Ibu Soekilah's photographs and others like them speak to the role that everyday practices of image making play in forming political subjectivities. As photography becomes more widespread as both a personal and a public form of representational practice, images become increasingly central to the ways individuals and collectivities imagine and recognize themselves. In training people to see in particular ways,

and in working to entwine personal experiences with larger historical trajectories, photographic practices bind people to broader collectivities and social imaginaries. Devoted to the personal concerns of friends and family, outings and ritual events, births and deaths, popular photographs nevertheless register the imprint of Indonesia's experiment in national modernity on individual lives.

It is through the reflexive production and circulation of images that "imagined" social entities like nations become visible and graspable, that they come to seem to exist prior to and independent of those images. National iconographies project ideal models of citizenship and construct both national "culture" and "nature" as objects of value. Visual symbols become recognizable condensations of national mythologies and rallying points for mass movements. Images of national history offer vivid mnemonic and pedagogic tools for training would-be national subjects. Whether marshaled as proof of the past or projected as shimmering visions of the future, photographs give national appearances tangible presence, durability, and reach, helping to produce the effects they appear merely to record.

Beyond giving visual form to national imaginings, photography's political significance lies in the technology's traversal of intimate and public domains. Images that circulate via mass media like television, film, and commercial print-images penetrate into the rhythms and intimate spaces of everyday life, providing imaginative resources with which people fashion their identities.[1] But what distinguishes photography from these other visual media is its openness to popular *practice* and its explicit use as a medium of personal affiliation, identity, and memory. For it is not only as consumers of images but as producers and subjects of them that people become participants in the envisioning of the nation.[2]

Through popular photographic practices the nation is not only "materialized" but also *personalized*.[3] Photographic practices help mediate "the personal" as a distinct realm of experience saturated with intimate sentiment. At the same time, popular photographs entangle the work of forging selves, social relationships, and personal memories with broader projects of collective imagining. Popular photography thus offers a lens onto affective dimensions of national belonging that have remained elusive to scholarship—not (or not only) the strident emotions of nationalist fervor and patriotism but the more subtle and often

ambivalent sentiments that attach to the nation as people live their lives within its frame and against its backdrop.

Mediating between broad currents of discourse and more particular concerns and sentiments, popular photographs record and produce the longings of Indonesian national modernity: nostalgia for rural idylls and "tradition," desire for the trappings of modernity and affluence, dreams of historical agency, and hopes for political authenticity. Participation in the shared visual idioms and practices in which these longings find form constitutes a crucial means by which people come to belong to the community that calls itself—however tenuously and uneasily—Indonesia. In posing for—and with—the camera, people place themselves (and are placed) within the visual landscapes, temporal logics, and affective and ideological structures of Indonesia's national modernity. Popular photographic practices thus register how people pose as "Indonesians" and the ways that "Indonesia" itself has been posed: as a problem, a proposition, a possibility, and a position from which to occupy the world.

Indonesia through the Lens

One day I asked Ibu Soekilah if she recalled the first time she had ever been photographed. She did, vividly. The year was 1940, and the city of Yogyakarta was celebrating the coronation of a new sultan, Hamengkubuwono IX. Because—and only because—it was such a special day, Ibu Soekilah's mother had allowed her to go out unchaperoned with her boyfriend, to watch the sultan's procession through the streets. On their way home, they had stopped at a portrait studio, where a Chinese photographer took their picture, a small one, of course, for thirty cents. She hid the portrait from her mother.

Serving simultaneously as a souvenir of a public event and a memento of a personal relationship, Ibu Soekilah's first portrait augured the dawn of a new era in more ways than one. It commemorated the ascent of a progressive, Western-educated sultan—himself an avid amateur photographer—who would, just a few years later, become a nationalist hero. At the same time, her trip to the studio performed a ritual of a distinctly modern kind of intimate relationship. As James T. Siegel has argued, the bonds of romance—ties forged between individuals outside of the traditional structures of the family—were inte-

gral to the realignments of social relations and authority entailed in the emergence of nationalist consciousness.[4] Small wonder that photography, itself an emblematic modern technology, would be called upon to mark the progress of Ibu Soekilah's romance.

Although at the time of Ibu Soekilah's first portrait photography was still a rare luxury for most inhabitants of the Indies, a full century had elapsed since the technology first arrived in the Dutch colony, then known as the Netherlands East Indies. There had been only the barest of lags between metropole and colony; the ministry of colonies ordered the first photographic commission in the Indies in 1840—just one year after the announcement of photography's invention—to test the new technology in tropical conditions; the second was commissioned in 1841 to "collect photographic representations of the principle viewes, etc. and also of plants and other natural objects."[5] In the colonial period, photography was deployed as an instrument of rule to survey landscapes, to catalogue the diverse peoples and archaeological treasures of the Indies, and to present an ideal image of ordered colonial modernity in photographs of bridges, railroads, factories, and neat rows of "native" schoolchildren.[6]

Alongside state-sponsored photographic practices, an ever-growing number of commercial photographers enabled Dutch colonists to picture themselves as bourgeois Europeans enjoying a life of colonial ease. Elite Javanese commissioned elegant portraits of themselves as refined and enlightened aristocrats. Commercial photographers also provided exotic images—"views" and "types"—of the colony's land and peoples for sojourners and travelers to send to those back home. By the late 1800s, as simpler equipment became available, more of the colony's elite took up amateur photography, transforming the colony into an object of aesthetic contemplation and consumption. Yet even as it became increasingly part of domestic and leisure practices, photography remained, for the most part, a technology to which only the upper echelons of colonial society—Europeans, wealthy ethnic Chinese, and native aristocrats—had access.

Just two years after Ibu Soekilah's first portrait was taken, the colonial order into which she had been born collapsed. The Japanese occupation of 1942–1945, for all the severe suffering it caused, also brought the promise of nationhood within tantalizing reach. Shortly after the Japanese surrender, on August 17, 1945, the nationalist leader Sukarno declared Indonesia's independence. The long and painful revolutionary

war that followed as the Dutch attempted to reclaim their colony ended at the close of 1949. During the revolution, the progressive sultan whose coronation had occasioned Ibu Soekilah's first photograph lent his palace as the seat of the Indonesian Republic's government. Breaking with his past as a traditional Javanese ruler, the sultan gave his support to a new kind of political community.

In the years following independence, people sharing little more than the common experience of colonial rule and the desire for nationhood struggled to forge a national community out of hundreds of ethnic groups spread across thousands of islands in a vast archipelago. They spoke hundreds of distinct languages and practiced diverse religions (Islam, today the professed religion of 90 percent of the population, is itself hardly uniform in Indonesia). President Sukarno led a struggling democracy rent by regional rebellion and dissent about the political structure and ideological basis of the new nation. As economic and political crisis deepened, Sukarno became increasingly dictatorial, initiating the period known as Guided Democracy in 1958. Tensions grew in the ensuing years between the country's two major power blocs, the army and the Communist Party, finally culminating in 1965 with an alleged coup attempt that left six top generals dead.[7]

In the aftermath of this event, later known as "G30S/PKI" or the "Thirtieth of September Movement/Indonesian Communist Party," General Suharto seized power. His New Order regime began with a campaign of extraordinary violence and terror; in the period 1965–1967, an estimated half million or more alleged communists were killed and hundreds of thousands more were imprisoned, mostly without trial. The new regime promised stability and order, and Sukarno's fiery anticolonial nationalism gave way to Suharto's foreign-investment-friendly commitment to economic "development." Development brought improved education and a raised standard of living—helping to create the middle class whose college-going children would push for Suharto's ouster in 1998. But neoliberal economic policies and corruption disproportionately benefited Suharto's own family and cronies, a select group of military generals, and the ethnic Chinese business elite in Jakarta.

During the revolution and afterward, Indonesia's first photojournalists represented the nation to itself, not only capturing on film key historical moments—such as the proclamation of independence—but also scenes of the everyday life of the *rakyat* (the people).[8] In the years following independence, photography served as an important medium

enabling people to try on and imagine new "modern" Indonesian appearances. But it was Suharto's economic policies, coupled with technological innovations like automatic processing, color film, and small snapshot cameras, that fully transformed photography into a mass phenomenon in urban Java. By the mid-1990s, when I first came to know Yogyakarta, a provincial capital in the densely populated region of central Java, photography seemed to have penetrated into every corner of urban life.

The extended period of prosperity enjoyed during the 1990s came to an abrupt halt with the economic crisis that hit Southeast Asia in 1997. In Indonesia, the crisis lingered and deepened, exposing the corrosive effects of the corruption that permeated the economy at all levels. Spurred by economic collapse and by Suharto's increasingly clumsy efforts to neutralize political opposition, students took to the streets to protest against rising prices and "corruption, collusion, and nepotism." As their appeals for reform gained momentum and repression of their protests became more violent, students demanded genuine democracy and an end to the New Order regime. Images of their demonstrations—some taken by students themselves—circulated throughout the nation and the world, bypassing government censorship and generating widespread outrage.

On May 13, 1998, in Jakarta, soldiers shot at protestors, killing four demonstrating students. The ensuing riots in the capital left large swaths of the city burned and more than a thousand people, mostly looters, trapped inside burning malls, dead. In a familiar pattern, much of the rioting was directed against Chinese Indonesian businesses and communities. Other cities erupted in violence as well. Students, with massive popular support, occupied the People's Consultative Assembly building. In Yogyakarta, on May 20, 1998, the reigning sultan, Hamengkubuwono X, followed in his father's footsteps with his own nationalist gesture. Addressing the hundreds of thousands of student activists and citizens who had peacefully marched through the streets of Yogyakarta to his palace, Hamengkubuwono X issued a formal proclamation in support of reformasi. Finally caving in to pressure, Suharto stepped down the next day.

Coinciding with my fieldwork (from November 1998 to May 2000), the immediate post-Suharto period presented Indonesians and ethnographers alike with the simultaneous exhilaration and discomfort of no longer being in any recognizable "order." Scholars had painted a largely

coherent and convincing picture of Suharto's New Order regime with its use of terror to stifle dissent and its cultural discourse celebrating authentic "tradition" as a means of containing difference.[9] For all the excitement that greeted Suharto's resignation, the New Order did not simply come to an end on May 21, 1998. B. J. Habibie, Suharto's protégé and vice president, took over the presidency, and Suharto's ruling party, Golkar, remained intact and strong. The military, although on the defensive, was still the most powerful institution in the country. On a quotidian level, the bureaucratic structures, educational institutions, and ideological habits that had characterized the New Order persisted. When Abdurrahman Wahid, an intellectual and religious leader with a commitment to democracy and tolerance, took power in October 1999 it seemed there might be significant change. Yet his rule proved unstable and ineffectual. Elite political leaders squabbled and stalemated in the face of Wahid's aggressive attempts at reform, eroding public faith in prospects for economic recovery and genuine change.

Nevertheless, there was often an electric excitement in the air, a sense that the nation's future hung in the balance. In the course of my fieldwork, new freedoms of the press unleashed lively debates about the nation's past and future; Indonesia held its first free general elections since 1955; East Timor voted for independence and separatist movements in West Papua and Aceh gained strength; calls for "regional autonomy" challenged the centralization of power and wealth in Jakarta (and, more generally, the "Javacentrism" of previous regimes); ethnic and religious conflict turned to full-scale war in Maluku and escalated elsewhere.[10] Longstanding grievances and tensions suppressed during the New Order erupted, often violently. Once silenced voices—of radical Islamists, former political prisoners, Chinese Indonesians—staked claims to inclusion within the emerging political landscape. Fears of instability, strife, and "national disintegration" coexisted with a palpable sense of new possibilities: for questioning enshrined historical narratives, for political expression and agency. Even as the very project of the Indonesian nation was profoundly in question, its promise— the "hopes for justice and modernity" it had once embodied—seemed open again for a more meaningful fulfillment.[11]

Yogyakarta, a bustling city of more than half a million people, provided a base from which to experience the unfolding dramas of the immediate post-Suharto period. Amid a constant feeling of anxiety, the impetus of daily life—the need to cook, shop, earn money, care for

children, cope with illness—carried people along in the busy-ness of the everyday. Yogyakartans were proud of the absence of destructive violence that had accompanied reformasi in other major cities. They attributed the city's relative peace to its historical uniqueness as both a center of Javanese "traditional culture" and as representative of the best that the modern community of Indonesia had to offer. People often claimed that the presence of the sultan, whose traditional authority "still" commanded respect, deterred potential troublemakers. At the same time, they credited Yogyakarta's prominence in education and the arts—earning it the nicknames "city of students" and "city of culture"—for its atmosphere of cultural vitality, cosmopolitanism, and tolerance.

Indeed, the sultan's palace, or *Keraton*, and the university are the two poles around which Yogyakarta's urban life revolves. The *Keraton* is still home to the current sultan, but much of it is open to the public; in the vast courtyard, regular gamelan and classical Javanese dance performances entertain both domestic and international tourists, and portions of the palace complex serve as a museum of Java's traditional rulers. One corner of the museum is devoted to Sultan Hamengkubuwono IX, celebrating his contributions to national history. Prominently on display are his cameras, English and Dutch-language photography books, and photo albums, visible evidence of his modern cosmopolitanism. Encapsulated within the museumized *Keraton*, then, are two distinct pasts, that of "cultural tradition" and that of the modern, "national struggle," both of which are central to Yogyakarta's place in the national imaginary.

Gadjah Mada University, a thriving center of intellectual, cultural, artistic, and political activity oriented to the nation's future, provides a counterpoint to the *Keraton*. The university owes its existence to the forward-thinking Sultan Hamengkubuwono IX, who, in 1946, offered his palace's grounds to house the first Indonesian university. It now occupies a sprawling campus in the more suburban areas to the north of the city. Like the many other institutions of higher learning located in Yogyakarta, Gadjah Mada attracts thousands of young people from all over the archipelago who, in enrolling in college, also enroll themselves into the middle class. It was on this campus that some of the first reformasi demonstrations took place in 1998. Like other universities and colleges, it is also a center of photographic activity: it has had a popular photography club since 1991 and a degree program in jour-

nalistic photography since 1994. Despite its significance as a center of Javanese culture, then, Yogyakarta's community is religiously and ethnically diverse, open to currents of thought beyond its own borders, and oriented to national concerns. Confident of their relevance to the national psyche, Yogyakartans like to refer to their city as the "barometer" of Indonesian politics.

My pursuit of photography's various habitats led me on many paths through this vibrant city, from intimate spaces such as Ibu Soekilah's home to public galleries, museums, and street protests, from crowded wedding reception halls to the offices of government bureaucrats, from the theatrically darkened chambers of photography studios to the amiable evening gatherings of Yogyakarta's amateur photography club. Some photographic practices I investigated clearly participated in the questioning of national narratives, dreams of transparency, and nostalgia for authenticity that were the order of the day, while others seemed to register the tumult of the present moment subtly if at all. Yet each genre revealed the participation of popular photographic practices in the making of "Indonesia" and "Indonesians" in postcolonial Java.

Translocal Circulations, Chinese Indonesians, and the Dilemmas of Indonesia's National Modernity

Not far from Ibu Soekilah's house, rows of photo studios line commercial streets crowded with buses, cars, motorbikes, pedicabs, and bicycles. Many of the studios' names evoke the glitter of modernity in terms that resonate with the imagery and rhetoric of Indonesian nationalism: "Cerah" (Bright), "Sinar" (Ray of Light), "Matahari" (Sun), "Cahaya Baru" (New Radiance), "Maju" (Progress), "Modern."[12] At the same time, indicating photography's entanglement with global capitalism, the studio storefronts bear large green, yellow, and blue signs announcing their allegiance to the multinational corporations Fuji, Kodak, and Konica. Their glass windows are plastered with glossy portraits of wedding couples in "traditional" Javanese dress, of young women in pin-up poses and trendy Western-style clothes, of families dressed in markedly Islamic attire, of children posed with sunglasses and bright hats like the "little stars" (*artis cilik*) endlessly singing on television. Like department store display cases showing off their array of wares, the images behind glass seem to hold out promise to each passer-by.

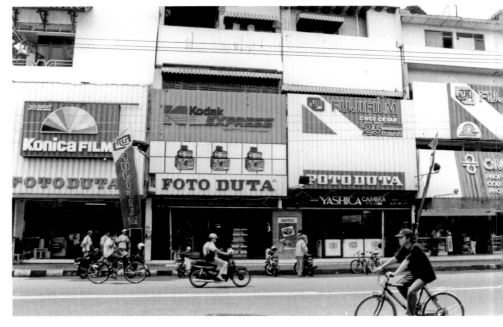

1. Photo studio, street view, Yogyakarta, 1999. *Photo by the author.*

2. Photo studio window display, Yogyakarta, 1998. *Photo by the author.*

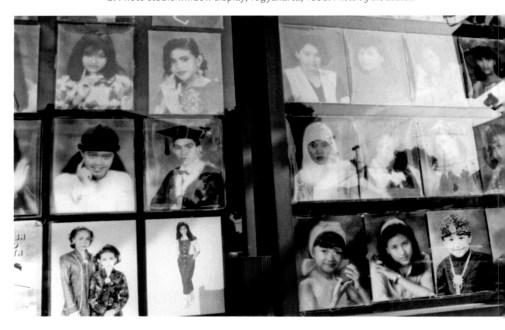

As the names of the studios suggest, to turn one's gaze to photography in Java is to examine the entangled concepts of "nation" and "modernity."[13] Scholars of Indonesian history have noted that these two concepts were "almost indistinguishable" in the late colonial period, and technologies—emblems of modernity and mediators of the new kinds of social relations and imaginaries that gave rise to national communities—played a key role in their entanglement.[14] But however foundational to the formation of Indonesia, the entwining of "modernity" and "nation" is also fraught with tension. People in the Indies, James T. Siegel suggests, experienced the desire to "feel the currents of world communication"—to be part of the modern world—*before* their yearnings were domesticated into the narrowed project of creating a particular national community.[15] Modernity, in this sense, has always been "at large," exceeding the boundaries of the nation, even as the desire to participate in global modernity was itself a force animating the formation of the Indonesian national community.[16]

Photographic technology embodies this tension between the globalized scope of modernity and the more narrow, territorialized ambitions of nationhood. In the late colonial Indies, Siegel argues, photography emblematized the pervasive fantasy of a lingua franca that would offer perfect translatability and open transmission, a medium ideally suited for a new orientation to the globalized world of modernity and away from the closed boundaries, rigid hierarchies, and fixed identities of "traditional" and colonial society.[17] Just as the lingua franca of Malay was converted into "Indonesian"—a national language tied to a specific national identity—so photographic mediations played a formative role in the consolidation of the imagined community of the nation by giving visual and tangible form to national subjects, spaces, and narratives. Yet even as photography has been harnessed (both overtly and in more subtle ways) to the project of nation making, it resists full domestication into the structures of national authority. A global technology introduced under colonial conditions and tied to transnational flows of people, capital, industry, and media, photography continues to bring people into contact with imaginings and circuits that necessarily transcend and often undermine a strictly national frame.

In Indonesia, the association of photography with the ethnic Chinese—quintessential "outsiders within"—further reinforces photography's structural ambivalence as both formative of the nation and dangerously threatening to it. In the postcolonial period, the primary

practitioners of photography have been Chinese Indonesians, members of an ethnic minority ambiguously placed within the nation.[18] As a transnational community that often maintained cultural, economic, and linguistic ties to Chinese in other parts of Asia and especially in Hong Kong and Singapore, ethnic Chinese in the late colonial Indies often served as cosmopolitan brokers of the global capitalist modernity—its ideas, practices, and products—that had taken hold more firmly in these pan-Chinese centers.[19] Alongside the more familiar story of ethnic Chinese participation in the emergence of a monetized, capitalist economy, some scholars have emphasized the contributions of ethnic Chinese to the Indonesian national project through their key roles in the late colonial development of Malay literature and the Malay press and in the dissemination of nationalist ideas.[20] The history of photography reveals the contributions of ethnic Chinese to the formation of Indonesia's national modernity, not only in the early period of nationalist awakening but well into the postcolonial period. An argument of this book is that any understanding of postcolonial Indonesian national modernity must include ethnic Chinese within its frame.[21]

It was no coincidence that Ibu Soekilah's first photograph was taken in a studio owned by a Chinese photographer. By the beginning of the twentieth century, immigrant Cantonese photographers were opening studios throughout Java and other parts of the archipelago that often served a less affluent clientele than frequented European studios. A more elite group of ethnic Chinese, meanwhile, became practitioners of amateur photography in the late colonial period. Following the Japanese occupation (1942–1945) and the revolution (1945–1949), it was primarily ethnic Chinese photographers who carried this technology into the postcolonial period, translating colonial iconographies and practices into national idioms. Even as photography has become more widely practiced among Javanese and other indigenous populations, the Indonesian photography industry, from small studios to large equipment companies, remains dominated by Chinese Indonesians.

Ethnic Chinese also provided the templates for a range of photographic practices that would spread to a broader Indonesian population. As a problematically mobile minority with ambiguous political allegiances, the ethnic Chinese in the Indies were among the earliest targets of the colonial state's surveillance tactics, including identity photography, which in the New Order would come to be required

of the population as a whole. Because ethnic Chinese tended to be urban, cosmopolitan, and more integrated into capitalist economies than Javanese and other "native" communities, they adopted many of the practices of global modernity—including the use of photography as a technology of domestic life and leisure—more quickly. In numerous respects, then, ethnic Chinese have been pioneers of popular photography.

The historical relationship between the ethnic Chinese minority and photography reinforces a certain structural parallel: both ethnic Chinese and photographic technology signal the circulation of the foreign within the nation.[22] Chinese Indonesians were in some ways uniquely positioned to forge "Indonesia," imagined as a new, self-consciously modern community that would transcend the narrow limits of regional, cultural, and, although this was far more contested, religious identities. To become "Indonesian" was to occupy a subject position oriented to the wider world, unfettered by traditional ties, and free to move along with the tide of "progress." Many ethnic Chinese spoke Malay—the region's lingua franca that was to become the national language—as their first language. Unmoored to Indonesia's primordial communities and tapped into translocal currents, the ethnic Chinese were in many ways poised to become brokers of a specifically Indonesian modernity.

Yet the ethnic Chinese also represented the threat that the desire to participate in global modernity might undermine the nation. Indeed, the colonial and later the Indonesian state's pattern of discrimination against those of Chinese descent registers an alternative, primordialist imagining of Indonesia that counters the more expansive vision embodied in the ideal of the lingua franca.[23] In this competing imagining, Indonesia is conceived as a bounded collection of "*asli*" (authentic, indigenous) groups joined together under the umbrella of the nation-state. When the nation is conceived as a territorialized community with "natural" members, Chinese Indonesians can only be inauthentic Indonesians.[24] Chinese Indonesians—and modern, global technologies like photography—remain "imports," signs of a foreignness that refuses to be fully assimilated.

The history of photographic technology as mediated by the ethnic Chinese thus brings into view a central tension within Indonesian nationhood. As a project of participating in global, capitalist modernity, the nation emerged as a formation both tied to and threatened by a modernity that exceeds national boundaries. Even as the nation

proposed itself as the means by which to achieve modernity, the risk remained that the urge to participate in global modernity might bypass affiliation to the nation altogether. Chinese Indonesian photographers helped give visual form to national imaginings; at the same time, both photography and Chinese Indonesians signaled the nation's failure to provide a fully domesticating container for modern impulses and global circulations.

Photography and the "Culture of Documentation"

When I would tell people that I was doing research on photography, their response was typically one of surprise, or even mild pity, that I had chosen my research topic so poorly. Many asked, "Why study photography here, when it is so much more advanced in your own country?" Bemused by my apparent disinterest in the more familiar and validated anthropological subjects of "ritual" or "traditional arts," they often patiently explained to me that photography was not really important in Java because no one "yet" understood the value of documentation. There was "not yet a culture of documentation" (*belum ada budaya dokumentasi*), they told me. There was "still" very little "documentation awareness" (*kesadaran dokumentasi*).

Such protestations sat uneasily with the obvious enthusiasm for photography I saw all around me, and with the language that people themselves used to describe their photographic practices. Most people said that they used a camera for *kenang-kenangan* (souvenir/memories), *dokumentasi keluarga* (family documentation), or *dokumentasi sejarah* (historical documentation). Some spoke of creating *arsip pribadi* (personal archives). Like many people I knew, Ibu Soekilah stored her photographs along with other important documents, such as an official letter entitling her to her husband's pension and personal letters. In practice as well as in discourse, then, people treated photographs as valuable records. In the public sphere, meanwhile, the climate of reformasi seemed to have unleashed a widespread obsession with documentation as the means to bring about a more democratic future, manifested in the proliferation of photography exhibitions and books chronicling the reformasi movement, debates about the need to locate "authentic" documents in order to "straighten out" the New Order's distorted histories, and a rise in professional and amateur documentary

film production. Yet this "boom" in documentation was also accompanied by lamentations about the "weakness" of public awareness about the value of documents.[25]

Why this simultaneous embrace and disavowal? What might the ambivalence surrounding documentation tell us about the place of photography in contemporary urban Java? First, in associating photography with *dokumentasi*, people located it within a broader class of technologies of record making that wield authority through their association with modernity.[26] On the one hand, *dokumentasi* invokes the bureaucratic and surveillance apparatuses of modern states. A Dutch loanword, the very term reverberates with the sound of bureaucratic officialdom and foreign power. On the other hand, *dokumentasi* was also linked, in reformasi's postauthoritarian moment, to the utopian possibility of a modern polity epitomized by transparency and popular participation. Evocative of both authoritarian control and democratic emancipation, *dokumentasi* was a profoundly ambivalent keyword in the imagining of Indonesia's national modernity.

Second, people's bemused responses to my project signaled that they identified photography as part of a modernity they viewed as essentially alien to the Javanese traditions they expected anthropologists to study.[27] They also registered a certain anxiety about their own relation to and participation in that modernity. Implicit in the idea of the "not yet" was an evolutionary logic, an internalization of those discourses of modernity that situate the non-Western world as temporally behind and spatially marginal to the Euro-American center.[28] Photography was clearly aligned in this narrative with a modernity imagined as a not-quite-reached state. Being "aware" of the value of documentation marked a modern historicity distinguished from a Javanese or "traditional" way of being. Indeed, the very language of "awareness" echoed the discourses of Indonesian nationalist "awakening," in which the achievement of modernity depended on a break with the past and the production of a new kind of (national) subject and community.[29]

In using the phrase "culture of documentation" to describe what they believed they still lacked, people echoed official New Order state discourses that sought to instill desirable modern traits in the population through engineered culture (the noun for culture was often used in state discourses as a verb, *budayakan*: "to make [something] culture"). Thus, for example, throughout the mid- to late 1990s government billboards promoting the "National Discipline Movement" urged people

to adopt a "culture of order, culture of cleanliness, culture of work" (*budaya tertib*, *budaya bersih*, *budaya kerja*). Other signs and banners promoted a "culture of queues" (*budaya antri*) and "culture of being-on-time" (*budaya tepat waktu*). For people to use the phrase "culture of documentation" was implicitly to invoke the top-down development policies of the New Order state, as well as, more broadly, the self-conscious pursuit of modernity that has been integral to the project of Indonesian nationhood.[30]

Yet I also found people's use of the term "culture of documentation" evocative for its more conventional anthropological sense. The notion of a "culture" of documentation aptly drew attention to the subtle cultivation of sensibilities and habits that occurs through everyday practices.[31] Identified with an alien and yet-to-be-achieved modernity, photographic and more broadly documentary practices have nevertheless insinuated themselves into domestic landscapes and intimate realms of personal vision and memory, generating new conceptions of time, truth, authority, and authenticity. In speaking of a "culture" of documentation, people acknowledged that technologies like photography involve what Benjamin described as a "complex training" of the "human sensorium" that yields new ways of seeing and being in the world.[32]

Genres as "Ways of Seeing"

How does this technological training of the senses take place? We know little about the camera until we view it in practice; just as there is no transhistorical, precultural "human" subject, so there is no photography outside of its specific historical and cultural determinations. I address this question, then, by looking at the ways photographic genres cultivate distinctive "visualities," or "ways of seeing."[33] Photographic genres are sets of social practices, aesthetic conventions, and "semiotic ideologies" that condition how people make and make sense of photographic images.[34] The six genres explored in this book—amateur photography, studio portraiture, identity photographs, family ritual photography, student photographs of demonstrations, and photographs of charismatic political figures—guide people to see themselves and others in particular ways. Each genre casts a selective frame and focus on the world, yielding characteristic blindnesses and visibilities.

"Organs of memory," genres are historically accreted ways of seeing that both enable and constrain new possibilities for vision.[35] As people communicate within a photographic genre's forms, they are recruited into its way of seeing. Yet they may transform that way of seeing in turn as they exploit the genre's accumulated resources to address new situations, concerns, and aims.

An approach to photography via genre allows us to steer between the ossified stances of "technological essentialists"—those who would identify a singular, transcultural "essence" of photography—and "social constructionists," who refuse altogether the notion of photography as a "medium," arguing instead that, as John Tagg memorably phrased it, photography's "history has no unity, it is a flickering across a field of institutional spaces."[36] These opposed approaches tend either to treat photography as an immutable apparatus that yields singular, universal, and predetermined effects, or to dissolve it entirely into its myriad social, institutional, and ideological contexts. What becomes clear from the analysis of genres is how each form of photographic practice organizes and molds the more or less stable material properties of the technology to different ends.[37] The analytic of genre, then, allows us to keep in view *both* photography's material and historical coherence as a medium *and* its profound malleability as it is put into the service of different kinds of projects and social actors.

This doubled vision has become particularly crucial as anthropologists attempt to "provincialize" Euro-American histories and theories of photography.[38] Anthropological studies of photography emphasize the often quite different semiotic ideologies and aesthetic sensibilities informing photographic practice in various non-Euro-American contexts.[39] Yet these photographic histories are never entirely "other"; they are not external to Euro-American histories but entangled with them in complicated webs of colonial history, global capitalist flows, and transnational media circuits. Rather than a "global" or "Western" technology encountering—and either overwhelming or being absorbed into—a self-contained and discretely "local" or "indigenous" set of cultural practices, photography's genres are emergent forms fed by the confluence of numerous currents, both present and past, near and far. All the genres under consideration in this book participate in "visual economies" that extend beyond the geographical and temporal limits of "Indonesia."[40] Yet they are also profoundly shaped by concerns and histories specific to the location of Java in the postcolonial period. It is

this specificity, as well as the ways they have helped generate popular envisionings of "Indonesia," that make them "Indonesian" genres.

The photographic genres examined in this book generate multiple and at times contradictory visions of and relationships to Indonesian national modernity, each saturated with particular temporal and affective sensibilities. Since the late colonial period, amateur photographers (the subject of chapter one) have produced a remarkably consistent iconography of idyllic tropical landscapes and picturesque "traditional" peoples. Amateurs—the majority of them self-consciously cosmopolitan Chinese Indonesians—embraced photography as a means of belonging to a wider, modern world. Their images, transforming the peoples and places of Indonesia into pictorial art, served as a kind of currency enabling exchange with a global community of peers in Europe and other parts of Asia. During the New Order, as the state harnessed amateur practice to the project of promoting national tourism and cultural heritage, amateur images began circulating beyond the elite club milieu, coming to play an important role within domestic imageries of the nation. In the process, Chinese Indonesian amateurs ironically became producers of a visual discourse of "authentic [*asli*] Indonesia" that excludes them from full membership in the nation.

The nostalgic vision of amateur photography stands in marked contrast to the expectant temporality of the "not yet" that pervades studio photography (the subject of chapter two). Since the late colonial period, the portrait studio has enabled people to "put themselves into the picture" of an anticipated national modernity and make contact with various desired "elsewheres" culled from global media images. In this genre, too, cosmopolitan Chinese Indonesian photographers played a key role as cultural mediators, translating globally circulating imageries into "Indonesian" idioms. Studio photographers provided a space for their customers to realize their own cosmopolitan longings and transcend the limits of the here and now. Combining theatrical fantasy with personal record, studio portraits reject stabilized identities in favor of a nonessentialist, outward- and future-oriented sense of the "as if."

Like studio and amateur photography, identity photography (the subject of chapter three) is a global genre that nevertheless has accumulated resonances and nuances specific to Indonesia. In stark contrast to studio portraiture's eclectic and theatrical sensibility, identity photography is rooted in the state's faith in the camera's powers of

indexical transcription and its own ability to map appearances reliably onto "identity." During the New Order, the identity photograph became a widespread visual idiom for legitimate belonging within the state-authorized national community, but the state's fetishization of "proof" of identity also gave rise to doubt and irreverence about documentary truths. Moreover, when appropriated for popular use—circulated among friends, incorporated into personal albums, or reframed as memorial images—identity photographs enter into spheres of social relations and identifications that challenge the state's claim to be the sole agent of recognition within the nation.

Ideologies and practices of documentation tied to state bureaucratic knowledge production also reverberate within the intimate realm of personal and familial memory in the photographic documentation of family rituals (the subject of chapter four). Whereas the identity photograph fixes the individual in the form of an atemporal, decontextualized, singular index, the documentation of family rituals generates an iconic mapping of ritual process, enhancing and extending ritual's formal conventionality and replicability. The concern with recording the "complete" temporal progress of a ritual within the *dokumentasi* series correlates to a new value placed on the creation of "family histories" (*sejarah keluarga*) embodied in photograph albums providing complete documentary records of personal trajectories. This self-consciously modern, archival historicity coexists in tension with other practices of family memory popularly associated with "Javanese" ways of being.

Photographs of reformasi demonstrations by students (the subject of chapter five) register the growing political significance of practices of personal documentation. Students recognized themselves as "witnesses" of national history through their production and consumption of reformasi images. They simultaneously hailed these photographs—also called "witnesses"—as signs of a new era of transparency and openness and valued them as sentimental tokens of their own personal pasts. The blurring of two regimes of value within this photographic genre promoted a deeply personal stake in national history that had both empowering and containing effects. Even as students realized themselves as historical agents through acts of witnessing, they failed to acknowledge the use of photographs—including images of and by students—to support the New Order regime during its early years and the extent to which their own images might be co-opted into dominant historical narratives.

If photographic "witnesses" of history embody the morally charged act of seeing violence, the photographs considered in the final chapter mediate a different order of contact with history. The chapter focuses on one man's alternative version of Indonesian history fashioned out of collaged images and texts attached to the walls of his home. Noorman's counterhistory simultaneously emulates state historiography's fetishization of documentary truth and deploys an alternative, messianic historical epistemology in which the truth of history is revealed not in documentary records but in potent indexical signs. Photographs of former President Sukarno and other auratic images of charismatic figures counter, via appeals to indexical presence, the evidentiary regimes and linear temporalities underlying official national histories, promising recovery and return. Although idiosyncratic, Noorman's counterhistory brings into relief widespread concerns about mechanical reproduction, documentary authority, and political authenticity. It reveals the presence of messianic visions within popular strains of nationalism.

Together, these genres participate in a kaleidoscopic visual field within which people in urban Java constitute themselves and are constituted as Indonesian subjects. For all the distinctiveness of their ways of seeing, genres never operate as discrete, independent units; rather, they "mutually delimit and mutually complement each other," thereby structuring a larger field of practice.[41] They may compete for primacy or interpenetrate each other, yielding hybrid forms. Although separated out in the chapters of this book, in everyday life different types of images jostle against each other, and people move fluidly among genres, activating different ways of seeing as they do so. Some of the same students whose photographs of demonstrations pictured a nation in crisis, for example, were members of campus photography clubs modeled on amateur clubs. Most people have sat for both identity photographs and studio portraits, often in the same studio. As people participate in each genre's distinctive visuality, they place themselves—and are placed—within the nation in different ways. Popular photographic genres thus challenge any simple notion of a national "imagined community," both revealing and giving rise to the complexities, contradictions, and tensions of postcolonial national belonging.

In seeking to understand the ways that photography has shaped the envisioning of "Indonesia" and "Indonesians" in postcolonial Java, we have moved from a discussion of "photography"—its identification with "alien" modernity, translocal circulations, and documentary practices and authority—to a more specified consideration of the multiple visualities that arise from different genres of photographic practice. We must now sharpen our focus further if we are to understand the ways that photographs mediate people in urban Java's participation in Indonesian national modernity. In a process I call "refraction," everyday encounters with photographs entangle widely shared visions with affectively charged personal narratives and memories.

In his analysis of novelistic prose, Bakhtin suggests that an author's intentions are necessarily "refracted" as they enter the medium of a thoroughly historical and social discourse: "The prose writer makes use of words that are already populated with the social intentions of others and compels them to serve his own new intentions, to serve a second master."[42] Photography, like language, is a mode of communication permeated with "alien" intentions that people nevertheless seek to mold to their own projects and purposes. People's idiosyncratic, intimate concerns are necessarily refracted through shared genre conventions and visual repertoires. At the same time, as people draw on widely circulating imageries (often tied to the state, the mass media, and other powerful and public institutions) to fashion their personal statements, they redirect them into a more intimate register. Diverting public visions to purposes of self-fashioning, popular practices also distort, fragment, and transform those visions and their attendant ideologies and narratives. The metaphor of "refraction" thus clarifies an important sense in which I consider the photographs discussed in this book to be "popular." Rather than *opposed* to (outside of or in resistance to) the "official" or the "elite," these photographs are popular because of the way they mediate between widely shared representational forms and visual logics and more intimate concerns.

One day, Ibu Soekilah asked me to take her picture. She wanted to send it to her brother in Jakarta, she told me, in order to show him "that I am already old" and "live like this." Without changing out of her faded *duster* (housedress, an item not worn in public), powdering her face, or combing her hair, she posed matter-of-factly in front of her

doorway. Seeing my camera, Ibu Soekilah's elderly neighbor asked if I would also take her picture. Her response to this opportunity was far more typical of those who requested my services as photographer: she disappeared for a few minutes, returning with her hair combed and pulled into a neat bun, her ripped men's button down shirt and old *kain* (wrapped cloth) exchanged for the standard costume of formal Indonesian dress: a brand new batik *kain* and a flowered *kebaya* (long blouse). Drawing me into the house where she lived with her adult children and grandchildren, she arranged herself on a rattan chair and pulled her granddaughter's brand new bicycle—a luxury item that contrasted with the otherwise sparse surroundings—into the frame. "It's good to have a picture," she said, "so that when you die, there's a memory."

Although Ibu Soekilah chose to be pictured in a less embellished way, her self-image was no less crafted to have particular effects. Ibu Soekilah rejected the more typical impulse to prettify her portrait, designing an image that might compel her brother's recognition of her poverty. She knew that the photograph, resonating with media images of urban poverty and narratives about those who have been *ketinggalan* ("left behind") on the path to development and prosperity, would be immediately legible as a picture of one who is deserving of pity (and, perhaps, aid). Ibu Hardjo, by contrast, put a better face on poverty because her intentions for her portrait were different: anticipating her death, she hoped to leave a dignified trace of herself behind. In staging her portrait, she borrowed from the conventions of studio portraiture, with that genre's rendering of future aspirations in the material form of commodities signaling modernity and affluence (discussed in chapter two). Drawing the bicycle into the frame may have been a way to connect herself to her granddaughter, the imagined recipient of the photograph; but the bicycle may also simply have been part of what, to her mind, made a "good" portrait.

Ibu Soekilah's and Ibu Hardjo's personal and particular interests are refracted, in these portraits, through the shared conventions of photographic genres and widely circulating visual repertoires. Both the disenchantment of Ibu Soekilah's stark self-portrayal and the enhancements of Ibu Hardjo's portrait speak implicitly to the "expectations of modernity" that are central to the nation as a temporal and affective formation.[43] Although intended for circulation within an intimate sphere, both images involve a certain positioning, whether with dis-

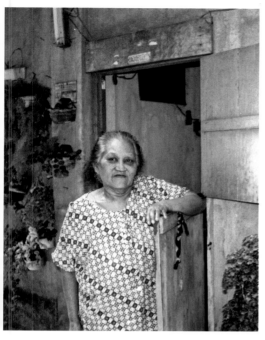

3. Ibu Soekilah posing outside
her home, Yogyakarta, 1997.
Photo by the author.

4. Ibu Hardjo's self-composed
portrait, Yogyakarta, 1997.
Photo by the author.

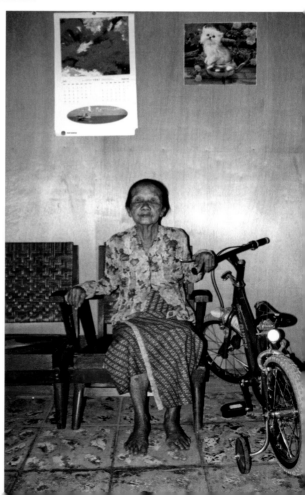

appointment or pride, within Indonesian national modernity. Both photographs point to the way that encounters with the camera entail a heightened awareness of what Kaja Silverman has called the subject's "emplacement within the field of vision."[44] In adopting a pose, people conform themselves (both consciously and unconsciously, willingly and unwillingly) to a set of available models of appearance. This bodily molding anticipates being seen by others and is a bid to be recognized in a particular way.[45] As subjects of photographs, people both appropriate available image-repertoires to stake claims to particular identities and social positions and, at the same time, are subjected to ideologies and narratives attached to these visual appearances that are never entirely of their own making.[46]

The term "refraction" also illuminates the processes of redirection and transformation that occur as ways of seeing, modes of interpretation, and habits of practice attached to one photographic genre or representational form refract within another. On another day, Ibu Soekilah found the negative for an identity photograph of her husband taken more than forty years earlier. Handing it to me, she asked if I would have an 8 by 10 inch print made and placed in a frame. She wished to hang the photograph on the wall as a memorial image, next to the portrait of her deceased son.

Echoing identity photographs all over the world, the photograph pictures a young man against a plain drapery backdrop, with only his head and upper torso included within the frame. Yet, if we look closely, we see that this particular state subject has proven recalcitrant (or the photographer has been a bit lax in enforcing the standard conventions of identity photography). The young man has turned his head slightly, obscuring one of his ears and looking askance at the camera, thus violating the anthropometric rules that govern identity photographs. This small action introduces a disturbance into the process of visual interpellation, transforming an official sign of identity into a portrait that might serve purposes beyond those envisioned by the state.

Slightly visible in the upper right hand corner of the image I had printed from the negative is the trace of a fingerprint, a reminder that photographs (and negatives) are not only visual representations to be seen but material artifacts to be handled, touched, and manipulated.[47] Embodied in the material form of a photograph, ways of seeing acquire durability, affective value, and, in some cases, self-evident facticity. Yet as objects that can be held in one's hand, displayed on a wall, placed

5. Ibu Soekilah's husband's identity photo, 1950s.
Collection Ibu Soekilah.

in an album, exchanged with friends, preserved, defaced, or discarded, photographs can change contexts and, in the course of their often complex social "biographies," accumulate new meanings and social functions.[48]

Ibu Soekilah's manipulation of the photograph, altering its scale and mode of display, allowed her to transpose it from one realm of significance to another. In transforming her husband's identity photograph into a memorial image by enlarging and framing it, Ibu Soekilah further redirected the photograph from the realm of state surveillance into a more intimate sphere of personal sentiment and memory. But even as the state's identifying aims are refracted and bent to more personal purposes, they continue to some degree to adhere to the image, helping lend it legitimacy and authority as a formal memorial portrait.

Through popular photographic practices, narratives of development and national history, icons of tradition and of modern affluence, ideologies and practices of citizenship, mass-mediated images and discourses of cultural identity, religion, and family enter—in material, tangible

ways—the everyday, close-at-hand, affect-laden landscape of personal vision and memory. Grafting personal sentiments and memories onto public iconographies, popular photographic practices bind individual people to the broader historical trajectories and narratives of national modernity. It is these processes of refraction that make photography such an important technology in the mediation of national imaginaries and the formation of national subjects.

In 2004, when I returned to Yogyakarta, I was saddened, though not surprised, to learn that Ibu Soekilah had recently died. A distant relative who was now living in Soekilah's house had cleared out her meager belongings. When I asked about Soekilah's photographs, she simply shrugged. The dispersal of her collection, mere waste matter in the absence of someone to lend it coherence and value, reminds us that, detached from the people who animate them with sentiment and story, photographs remain incomplete objects.

Popular photographs yield both a history *of* vision and a history *through* vision. They reveal the larger currents of Indonesian history as they are refracted through the prism of the intimate and the everyday. At the same time, they show the visual to be a domain crucial to the very making of history itself. History, after all, encompasses not only the main events and central plots but also people's barely registered efforts to orient themselves to new narratives and possibilities, to assimilate alien ideas and practices, to see and be seen in new ways.

Amateur Visions

A SMALL SEPIA PHOTOGRAPH taken around 1910 shows Tan Gwat Bing, a Chinese-Indonesian amateur photographer, with two companions on an excursion to Parangtritis, a dramatic stretch of beach to the south of Yogyakarta.[1] They ride bicycles and wear white suits and jaunty caps. Their cameras are strapped over their shoulders. They are at the end of a railway track, as if they have reached the outer limit of civilization. An angular wooden structure, perhaps part of a bridge, encloses two of the riders like a viewfinder. A second photograph from the same excursion shows the photographers relaxing in the shade of a ramshackle hut as local inhabitants look on; their immaculate white clothing brings them into sharp relief against the muted tones of their surround. One stands with a foot resting on a bench in a conventionally colonialist pose of mastery; his hand rests casually on the thermos slung across his chest. Another lounges, one leg stretched in front of him, his back leaning against a bamboo pole of the hut. A third, Tan Gwat Bing himself, rests his "box" camera on his knee. Villagers, children, and adults stand watching; one, a barefoot man in rags with a farming tool resting on his shoulder, appears also to be posing for the unseen photographer.

Nearly a century later, I accompanied amateur photographers on another "hunting" expedition to a village not far from where Tan Gwat Bing and his friends had cycled.[2] At daybreak, Jack, his teenage son Budi, and Edy picked me up in Jack's old van. We drove through the awakening streets of Yogyakarta, heading south out of the city, soon entering the flat river plain of Bantul with its lush rice fields and forests of sugar cane. After a long stretch on the main road, which we shared with buses and trucks, cars, motorcycles, bicycles, and *becak* (pedicabs), we turned off onto a road that led east toward the river. On either side were brilliantly green rice fields in which farmers bent over their seedlings. Yogyakarta had disappeared from view, and one could easily forget that it sat—with its urban bustle and suffocating pollution—

6. Tan Gwat Bing and companions, "hunting" expedition, Parangtritis, ca. 1910.
Collection Didi Kwartanada and family.

7. Tan Gwat Bing and companions relaxing in a village, ca. 1910.
Collection Didi Kwartanada and family.

between these peacefully tended fields and the ancient volcano looming over the scene, a gentle wisp of smoke rising from its perfect cone. Mist caught in the trees along the edges of the paddy. As we traveled down the rough and narrowing road, women heading in the opposite direction for the local market, carrying their produce on their backs or precariously balanced on their bicycles, slowed our progress.

Along the way I chatted in the back with Edy. He explained that today we would be "hunting" with a purpose: to take pictures for entry into a photo contest with the theme of "Happiness in Old Age," sponsored by the Asia/Pacific Cultural Center for UNESCO (ACCU). Jack and Edy were both members of Yogyakarta's amateur photography club, HISFA (Himpunan Seni Foto Amatir, Association for Amateur Art Photography, founded 1954), and both often submitted photographs to local, national, and international photography competitions. Though they often went hunting together, they seemed an unlikely pair—Jack was a Chinese Indonesian in his early fifties who wore thick glasses, belted out rock songs at gatherings, played poker, and never tired of joking, while Edy was a soft-spoken Christian Javanese, perhaps in his early forties, who maintained a low profile at HISFA events. Jack joined HISFA in 1975; Edy had been a member since 1991. Both had gradually made photography their profession, Jack by opening a studio in his home and photographing weddings and funerals, and Edy by photographing graduations and other events.

The little road ended abruptly at the foot of a bamboo bridge that spanned the wide, slow-moving river. The bridge, and the heavily burdened people walking across it, glowed golden in the morning light. Jack told me that the bridge frequently washes away during the rainy season as heavy downpours turn the green shallow waters into a torrent of mud. While the sand from the riverbed is used for construction projects in the city, there is no infusion of money here to build a sturdier bridge. So the picturesque but fragile bamboo bridge is rebuilt each time. This spot had been a favorite HISFA hunting destination for years. All of Bantul, Edy told me, with its quiet villages, open vistas, volcano views, and stretches of beach had long been the favored "terrain" of Yogyakarta's amateurs.

At first, Jack and Edy set up their tripods on an embankment to take photographs of the market women as they made their way across the bridge. Soon, though, we decided to cross it ourselves—a tricky enterprise as we were going against traffic. On the other side, instead of

walking into the village, we followed a narrow path along the riverbank and down to the exposed gravel of the riverbed. There, a small group of people was at work shoveling and two large yellow dump trucks sat waiting for their daily fill of sand.

Jack and Edy moved comfortably through the scene, politely greeting people as we passed and offering brief, socially lubricating explanations like, "We're going for a walk" (Javanese: *mlampah-mlampah*) or "We're exercising" (Indonesian: *olah-raga*). They knew what they were looking for; they spoke to each other of "good camera face," "good color," and "good light." As we moved from spot to spot, Jack's son was enlisted to help carry the various lenses and equipment, and occasionally he received his father's instruction on how to photograph. But mostly he stood to the side, conspicuously holding his cell phone and looking bored.

Jack and Edy soon found their "objects" (*obyek*)—an old man waist deep in water shoveling sand out of the river and an old woman in a faded pink *kebaya* (blouse) gathering small rocks into a basket. When it was filled, she would carry it on her head up the bank of the river into the village where someone would crush the rocks with a hammer to form dark piles of volcanic sand. Jack and Edy worked in tandem, one training his camera while the other engaged the "object" in light banter, asking friendly questions, hoping to elicit a laugh or an animated expression. They never asked permission to photograph, but their style of interaction was ingratiating—lighthearted and informal, but respectful. The old woman seemed highly amused by the whole scene and provided satisfyingly exuberant laughs in response to their joking questions. The old man willingly obliged as they choreographed his movements: "Move forward, look at me, now take the sand up slowly, now throw, smile." Neither seemed particularly surprised by the encounter. Other people, who paused occasionally from their work to watch the scene, seemed to find it comical. When I asked Edy later how people typically respond to being photographed, he said simply (echoing the consensus of most amateurs), "Usually, they like it." Neither Edy nor Jack seemed perturbed by the idea that what they were depicting as "happiness in old age" were two elderly people engaged in heavy physical labor.

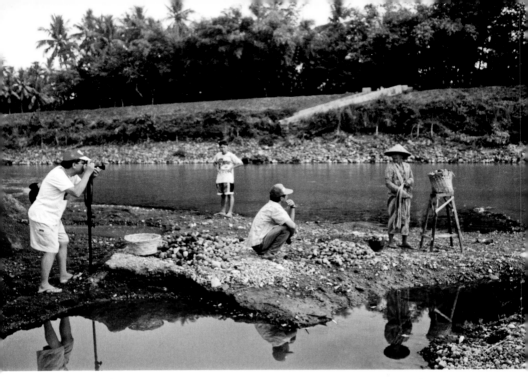

8. Jack photographs while Edy engages their "object" in conversation, Bantul, June 1999. *Photo by the author.*

9. Proof for "Happiness in Old Age" with markings for adjusting color and cropping, June 1999. *Photo by Jack Andu.*

Amatir Visions and Asli Indonesia

For every person who has a camera and more or less already possesses the basic knowledge of how to make photographs, there is no greater happiness than to gather socially in an environment where all talk is the language of photography and where one can weave the threads of brotherhood, a brotherhood formed of the enthusiasts of photography.

— Introduction, Semarang Photo Club catalogue,
May 1953

In the late colonial period and early years of independence the word *amatir* (an Indonesianization of the Dutch and English "amateur") had a particular meaning, one laced with the feel of modern technology and the privilege of leisure.[3] *Amatir* were members of an elite group of photographers who defined their practice against, on the one hand, the humble *tukang potret* (studio photographer) who worked for pay and to satisfy his customers, and on the other hand, the family "snapshooter," whose goal was mere documentation and who knew nothing of how to craft an aesthetically pleasing image. The prosaic demands of neither work nor family life constrained the amateur photographer, who left such cares behind when he came to the club.[4] He was motivated by the distinctly personal pleasures of discovery, dedicated self-improvement, and sociality. The universally legible "language of photography" provided a medium, a lingua franca, for a new community of likeminded people. This "brotherhood" comprised not only the face-to-face gathering of (mostly) men who together mined the landscape of Indonesia for its beauty and transformed its peoples into objects of aesthetic appreciation. Being an amateur also meant becoming joined as if by an invisible technological tether to a global community of photographers throughout the modern world.

Today, Indonesian amateurs more often use the English word "hobby" to describe what they do, but they still go hunting, have meetings, and participate in contests—the main activities of amateur photography clubs since the late colonial period.[5] Also enduring is the vision generated by amateur photographers of an authentic (*asli*) Indonesia preserved in "traditional" villages and court enclaves, located temporally and spatially at a remove from the urban elites who would portray it. It is perhaps no surprise that it would be self-consciously cosmo-

politan and modern urban elites who would envision a romanticized, authentic Indonesia. Yet the ambiguous position of Chinese Indonesians within the nation lends a particular poignancy to this otherwise familiar story of elite nostalgia and modernist constructions of the traditional.

Throughout the postcolonial period, the majority of amateur practitioners have been upper-middle-class, urban Chinese Indonesians.[6] When I began my inquiries into the history of photography I often met with startled reactions when I would observe that many photographers seemed to be ethnic Chinese and many photographic practices seemed to have roots in the Chinese community. Chinese Indonesian amateurs would often hastily protest that they felt themselves to be thoroughly Indonesian; they spoke no Chinese and felt no connection to China. Presenting the club as an ideal microcosm of the national community, they would emphasize the harmony and lack of concern for ethnic labels among its diverse members. Only when I made clear that my aim was not to identify photography as "Chinese" *in opposition to* "Indonesian" but rather to trace the contribution that people of Chinese descent had made to the envisioning of the nation did this initial defensiveness ease.

These discomforted reactions signaled the charged ambiguity of Chinese Indonesians' participation in the fraternal bonds of the nation, a sense of ambivalent belonging that refracts through Chinese Indonesian amateurs' light-hearted photographic interactions with the rural poor in peaceful village settings. That people were willing to talk about these matters as openly as they were was probably due to the more open climate of reformasi in which my research took place. Yet as I got to know them better, many spoke of painful experiences of being marked as different and of feeling that they could never prove that they were "really" Indonesian. The devastating anti-Chinese riots that had accompanied reformasi in Jakarta and Solo in 1998 were just the most recent, potent reminder of the prevalent anti-Chinese sentiment they experienced daily as a submerged form of threat. Despite inclusive gestures toward the Chinese community following Suharto's resignation, the rise of radical Islam and religiously inflected violence—many ethnic Chinese are Christians[7]—and the ongoing political and economic crisis that also marked this period meant continued vigilance and fear among Indonesia's ethnic Chinese minority. Although informed by global pictorialist aesthetics and shared by other colonial

and postcolonial elites, Chinese Indonesians' investment in a romanticized and depoliticized encounter with racial and class others can also be understood as a response to tensions they faced in their everyday lives in urban Java.

Participation in a self-consciously global practice allowed postcolonial Chinese Indonesian photographers to transcend their fraught location within the nation by sustaining transnational affiliations. Yet their cosmopolitan orientations were not necessarily opposed to their aspirations toward national belonging; rather, Chinese Indonesian amateurs sought to define themselves as exemplary modern national citizens through their technological mastery and their promotion of Indonesia to the global community. They sought to produce a distinctively Indonesian photographic repertoire—a kind of national currency marketable in an international exchange of photographic images produced by their "salonist" peers in Europe, the United States, Japan, Singapore, Hong Kong, and elsewhere.

During the New Order, the state began enlisting amateurs to document the cultural riches of an Indonesia increasingly devoted economically to cultural tourism and culturally to a discourse of tradition and authenticity (*keaslian*). Forced by New Order prohibitions on the public display of Chinese cultural affiliation to abandon overt signs of their own Chineseness, Chinese Indonesian photographers devoted themselves to documenting the cultural displays of others, thereby helping to produce a visual iconography of the *asli* nation. As amateur practice was increasingly channeled toward state-sponsored goals, amateur images began to travel beyond the narrow circuit of clubs.[8] Images drawn from the amateur archive—of young children taking shelter from the rain under massive banana leaves and farmers guiding their water buffalo on a dusty path, of women drawing intricate designs in wax on batik cloth and bustling "traditional" markets, of dancers in elaborate costumes and volcanoes towering over vivid green rice fields—appeared in tourist brochures, postcards, and glossy picture books.

While promoting Indonesia to an international tourism market, these images also began to appear domestically in state-sponsored books and billboards, in advertisements for a wide range of consumer products, and in political campaign imagery. This secondary life of amateur images, moving out of the more narrow and elite circuits of club members and into the realm of a public, national visual culture,

helped produce an ideally imagined authentic Indonesia: an idyll of peaceful villagers, pristine nature, and colorfully vibrant "tradition." Ironically, the images Chinese Indonesian amateurs produced have ultimately reinforced indigenist ideologies of national belonging that exclude them from full belonging in the nation.

The Double Gaze of Colonial Amateur Photography

The practice of amateur photography helped forge a late colonial society made up of Dutch, Chinese Indonesian, and Javanese elites brought together by bonds of sociality, a common technological expertise, and a shared aestheticizing gaze toward lower-class "natives." Amateurs used cameras to transform the people and topography of the Indies into objects of aesthetic contemplation and value. Even before 1870 some commercial photographers were selling equipment and offering lessons to amateurs.[9] By the close of the nineteenth century, the new availability of portable cameras, film negatives, and easier developing techniques helped spur widespread enthusiasm for photography as a hobby. Amateur photography gained popularity in tandem with the popularization of anthropological discourses and the development of tourism in the Indies. By the first decades of the twentieth century cameras were frequent companions on picnics, hunts, and other excursions.

"Salon photography," a movement that aimed to elevate photography to the status of an art, provided a global context for Indies amateur practice. In London, in 1893, a group known as the Linked Ring broke with the more science-oriented Royal Photographic Society and held the first "salon" exhibition. The "salon" movement they founded would expand, in subsequent decades, into an international network of amateur photography clubs.[10] Salonists sought to develop photography as an "independent art" wrested "from the bondage of that which was purely scientific or technical."[11] Club-sponsored competitive salon exhibitions, as well as popular magazines for amateurs, became the principal vehicles for the dissemination of the pictorialist aesthetics they embraced. Pictorialism "stressed the depiction of subjective states of being over objective facts" and celebrated the pre-industrial value of craft and the elevating function of art.[12] Belief in the

edifying effects of the contemplation of natural beauty led to a prefer-
ence for landscape photographs. Eschewing positivist uses of photog-
raphy, pictorial photography was to represent "the ideal": "This could
not be done when imagery was too specific, too clearly documenting
an identifiable person, time or place."[13] As one critic wrote in 1898,
"The aim of pictorial art is not to copy nature, but to appeal to the
imagination."[14]

Although photographers in the Indies may have followed the inter-
national salon movement informally from an earlier time, formal clubs
first emerged there in the 1920s. After the First World War, large photo-
graphic equipment firms began to sponsor competitions to stimulate
interest in amateur photography, and magazines devoted to life in
the Indies, such as *De Orient* and *Het Indisch Leven*, began regularly
to publish photographs that celebrated the "Beautiful Indies."[15] The
First Dutch Indies Amateur Photographers Association was formed in
1923 in Weltevreden, Batavia; that same year, in an explicit assertion of
colonial cosmopolitanism, Indies amateurs organized an international
photo salon. The aim of the salon was to "[promote] the development
of photography, [and] to show the current state of the art of making
images with light both in the Dutch Indies as well as in the Netherlands
and other countries."[16] In 1925, the Preangar Amateur Photographers
Club and the Bandung Art Club (founded in 1924) held a second inter-
national salon.[17]

In the tropical outposts of European colonialism, salon photog-
raphy's pictorialist aesthetics merged with exoticizing discourses of
"Oriental" beauty. In the Indies, amateur photography was closely
allied with a painting genre known as *Mooi Indië* (Beautiful Indies),
which celebrated untainted, pre-industrial tropical landscapes fea-
turing peaceful, terraced fields, palm trees, and volcanic grandeur.
Commercial photographers (both European and Chinese) had long
sold picturesque views, cultural scenes, and "types" as postcards that
Dutch colonials collected in albums and sent home to their families
in the Netherlands.[18] But the pictorial images produced by salonist
amateurs tended to differ in subject and style from those produced
by commercial photographers. Commercial photographers often pic-
tured "views" of modern infrastructure (bridges, factories, railroads),
whereas, in keeping with the nostalgic sensibilities of pictorialism,
scenes of modernity were largely excluded from salon photographers'
visual vocabulary.

10. Pictorial landscape by Tan Gwat Bing, ca. 1930s.
Collection Didi Kwartanada and family.

As "art," not documentary records, moreover, pictorial photographs emphasized aesthetic experience. Unlike postcard landscapes taken in full daylight to reveal the precise topographical contours of a "view," pictorial landscapes were often taken at sunset or sunrise, when features of the landscape were bathed in interesting light or swathed in a picturesque mist. Photographers also experimented with developing techniques to achieve varied atmospheric effects. Portrait images, unlike the stiff, frontal "types" popularized in postcards, more closely emulated bourgeois portraiture conventions, using close-up framing,

asymmetrical or three-quarter poses, and dramatic chiaroscuro lighting. Scenes depicting "customs" and everyday life were not merely illustrative but often cast in universalizing idioms as allegorical images of, for example, "youth," "craft," or "family."

A nonofficial and explicitly leisure activity, amateur photography helped tutor a particular kind of colonial imagining of the Indies as a space of aesthetic pleasure. In the context of emerging nationalist challenges to colonial rule, Dutch amateurs produced and disseminated a reassuringly serene and idyllic vision of the colony and its peoples. This aesthetic performance cultivated fantasies of the "Beautiful Indies" as a peaceful, timeless idyll and cultural preserve even as the Indonesian "age in motion" rendered this dream increasingly fragile.[19]

But Dutch colonialists were not the only ones to invest in this romance. For "enlightened" Javanese aristocrats, the practice of amateur photography emblematized their position as brokers between the realm of "tradition" and the "light" of modernity. In 1903, the young aristocrat Kartini, whose impassioned letters to Dutch friends embracing women's education and other "modern" forms of "progress" would make her a nationalist icon, wrote, "I wish so often that I had a photographic apparatus and could make a permanent record of some of the curious things that I see among our people. There is so much which we should like to preserve, so that we could give to outsiders a true picture of us Javanese."[20] Elsewhere she wrote, "It is a pity that photography is such a luxury, for we should be glad to take some peeps, for the benefit of our friends, into typical Javanese customs."[21] Peeping into the traditional world of the Javanese, looking out toward the modern world of Holland, Kartini exemplified the double gaze of elite "native" photographers in the late colonial era.

For ethnic Chinese amateurs photography also opened a channel of communication in two directions, toward the "natives" of the Indies and the "modern" world beyond the archipelago. Most Chinese Indonesian amateurs in the pre-independence period were wealthy *peranakan* (members of a distinctive mestizo culture) professionals who spoke Dutch and moved relatively easily in a European milieu. Tan Gwat Bing, the young amateur who bicycled with his friends on a hunting expedition and with whom this chapter opened, exemplifies such *peranakan* Chinese. Born in 1884 in Yogyakarta, Tan Gwat Bing was well educated, worldly, and able to read Javanese, Chinese, Dutch, Arabic, and some English. A writer of poetry on "universal themes"

11. Album page, pictorial portraits, by Tan Gwat Bing, late 1930s.
Collection Didi Kwartanada and family.

and a "modernist" in politics, he was strongly influenced by the Chinese nationalist movement and was one of the first in Yogyakarta to cut off his queue, the long braid signaling Chinese tradition that was mandated in colonial sumptuary laws. Alongside his pursuit of amateur photography, in the 1920s Tan Gwat Bing owned a business printing greeting and calling cards, broadsides, and commercial postcards.

The many albums that gather dust in Tan Gwat Bing's family home today attest to a wide-ranging fascination with the camera. Numerous formal studio portraits and informal family photos share space with Tan Gwat Bing's pictorial, salon-style photographs, several of which were published in the Indies magazine *De Orient*. Some of the latter images show landscapes typical of the *Mooi Indië* genre: scenes of the

beach, of palm trees and rice fields, tranquil and, if populated, only by silhouetted or ill-defined figures who serve as picturesque features of the landscape. Other pages from the album show Tan Gwat Bing's experimentation with figure studies and still-life compositions. Still others display Tan Gwat Bing's portraits of comely young women and wizened elderly men and women in traditional dress. For Tan Gwat Bing, as for others like him, photography was an enduring pastime; his albums show the fruits of frequent photographic excursions and experimentations throughout the first decades of the twentieth century. One photograph taken in the late 1930s, for example, shows Tan Gwat Bing—older and more portly than the slim young man who rode a bicycle to the end of the world—training a camera perched on a tripod at one of the Hindu-Buddhist temples in the Central Java region, a favorite subject of colonial amateurs that remains popular among amateurs today.

Postcolonial Moderns: 1950–1965

An association of AMATEURS has the goal of perfecting PHOTOGRAPHY as an instrument of ART, and in this way also works to push forward and develop PHOTOGRAPHY . . . as an INSTRUMENT that is very useful in modern society.
—R. M. Soelarko, "Introduction to GAPERFI News, no. 1,"
Kamera, February 1956

Following independence, Javanese and Chinese Indonesian amateurs translated this colonial practice into a new national context. Hobbyists continued to cultivate an elite, urban, and self-consciously modern way of seeing rural landscapes and their inhabitants as objects of aesthetic pleasure located in a timeless present-as-past. At the same time, photography continued to offer a bridge to the "modern" world of technological progress located ideally in the more advanced "West." Reframing their practice in a nationalist idiom, postcolonial amateurs imagined they were launching Indonesia toward modernity while promoting their nation as an equal among global peers.

Amateur clubs proliferated in major cities in the 1950s with memberships that were predominantly Chinese, especially in cities with large ethnic Chinese populations like Jakarta, Bandung, Semarang, and Surabaya. During the revolution, in 1948, the first all-Chinese

photography club, Sin Ming Hui, had been founded in Jakarta (in the late 1950s, in response to growing anti-Chinese sentiment, the club adopted an Indonesian name: Lembaga Fotografi Candra Naya). The Semarang Camera Club, founded in 1952, had an almost exclusively Chinese Indonesian membership.[22] In cities with sizable Javanese aristocratic and merchant communities, like Yogyakarta and Solo, membership was more mixed.[23]

It would be a lasting pattern in postcolonial clubs that even when membership was heavily Chinese, the president would be *pribumi* (native). In 1954, the formerly Dutch club of Bandung, Preanger Amateur Fotografen Vereniging (founded in 1924), changed its name to Perhimpunan Amatir Fotografie (PAF).[24] Although the club continued to have some Dutch and many Chinese members, leadership was taken over by R. M. Soelarko, a Javanese of aristocratic background with a "modern" education.[25] In the same year, Yogyakarta's Association for Amateur Art Photography (HISFA) was founded by an aristocratic Javanese (R. Soemardi) and two Chinese Indonesians (Sim Gwan Jauw and Tjan Gwan Bie); R. Soemardi became president.[26]

As the Netherlands ceased to be the primary locus of modernity for Indonesians, photographers looked elsewhere for the latest trends. English was replacing Dutch as the preferred marker of modern cosmopolitanism among the postcolonial elite, and club members were increasingly learning about photography by reading English publications and following club events in America and other parts of Europe. This shift is evident in club publications from the 1950s. In a list of images exhibited by the Semarang Photo Club in 1953, for example, just over half of the eighty-two works were titled in English; most of the remainder were titled in Indonesian, with only a handful in Dutch. Likewise, advertisements in the catalogue of the First International Salon in Bandung in 1956, mostly from ethnic-Chinese-owned stores, were printed primarily in English and Indonesian. What they advertised also pointed to photography's association with technological modernity and modern leisure: car tires, hotels, radio service, Garuda Airlines, electrical and x-ray equipment, and a kind of candy called *lokomotif*.

The predominance of Chinese Indonesian members meant that Indonesian clubs also oriented themselves to the more close-at-hand pan-Chinese cultural centers of Singapore and Hong Kong. The popularity of photography clubs in Indonesia was not an isolated phenomenon;

12. "Homeward," 1956 Gaperfi First International Photo Salon
of Indonesia catalogue. *Photo by R. Soemardi.*

there was a notable flowering of amateur activity all over Asia in the
1950s and 1960s.[27] Ethnic Chinese were particularly active in Southeast
Asian clubs. Regional photography associations, such as the Society of
World Ethnic Chinese Photographers (SWECP, 1958, Hong Kong), the
Photographic Salon Exhibiters Association (1963, Hong Kong), and
the Federation of Asian Photographic Art (1966, Taipei), relied on and
fostered ties among ethnic Chinese photographers. Even if they were
unable to participate actively in these international associations, Indo-
nesian photographers followed their progress.[28] For some amateurs,
reading Chinese-language photography magazines and catalogues
published in Singapore and Hong Kong was as important as acquiring
treasured copies of the American magazine *Popular Photography* or the
British Journal of Photography.

Anxious optimism about securing Indonesia's place as a newcomer
to modernity also animated postcolonial amateurs' participation in the
global amateur community. As R. M. Soelarko wrote in February 1956,
photography was a language that Indonesia needed to master in order
to join the ranks of modern nations:

Photography in a modern society has a great function, in keeping with the function of technical machines in the life of modern man. The airplane, the train and automotive transportation machines, machines that generate energy and industry, and along with that the gramophone and the photographic instrument as *recording-machines*, can no longer be separated from life today.

The use of the photographic instrument as a *recording machine*, within the field of science: topography, health, physics, biology, engineering, in documentation: the press and publicity, and in art and applied art: commercial photography and advertising, these are aspects that are still spreading and growing.

In all fields, photography in our society is still in an early stage, and is still far behind compared with other modern societies. In order to overcome this distance of being left behind in an efficient way there is only one path: ORGANIZATION.[29]

For Soelarko and others, forming a national organization of Indonesia's dispersed photography clubs was a crucial step toward overcoming postcolonial provincialism and the temporal gap of underdevelopment. In 1953, Indonesia's first national federation of amateur clubs, Gaperfi (Gabungan Perhimpunan Foto Indonesia, or Federation of Photography Associations), was founded with thirteen original member clubs based mostly in the major cities of Java (with several in Sumatra, Kalimantan, and Sulawesi).[30] In 1956, Gaperfi published an edition of a national magazine called *Kamera* and sponsored the First Indonesian International Salon in Bandung.[31]

But hopes for a national organization outreached feasibility. Gaperfi's first salon was its last, as was its single edition of *Kamera*. Harsh economic conditions—inflation and the scarcity of imported equipment and supplies, the difficulty of extracting dues from members to support a national organization, and the lack of corporate sponsorship or external funding for club activities—doomed its survival. A climate of rising anti-Sinicism in the late 1950s, in which many ethnic Chinese left the country, and the violent political transition of the mid-1960s also undoubtedly had dampening effects on amateur club activities. While Gaperfi embodied club members' aspirations to transcend locality and achieve parity *as a nation* with other international amateur communities, the socioeconomic and political conditions that could nourish such an organization would not emerge until the early 1970s.

If amateurs imagined photography as a vehicle by which Indonesia might assert its place among modern nations, club membership also offered more mundane and intimate pleasures. The sole edition of *Kamera* printed this exhortation to readers: "Become a member of the photo club closest to you! Benefits: get photography lessons for free, go on excursions, photograph together, buy photographic materials collectively more cheaply, and many other benefits." Typical club activities included hunting excursions and monthly meetings with lectures on technical matters and internal contests. A list of the activities of PAF (the Bandung club) in January 1956, for example, includes a "group photography event with the subject: 'peaceful nature with flowers' [*alam tenang dengan bunga2*]" and an excursion "to photograph rushing water [*stroomversnellingen*]" at Batujajar. A planned excursion to photograph at a Chinese temple the following month is announced. Also listed are the winners of a club contest, divided into junior and senior members.[32]

Such routine club activities secured the durability of salonist habits of vision. Amateur images tended to look alike not only because on hunting excursions club members typically pursued a given theme or subject but also because they followed the same conventions of "correct" photography. From internal monthly contests at club meetings to the international salon competitions, a culture of contests dominated club activity. Contests were the means by which members participated in the broader salon community, gained recognition and status, and marked the progress of their work. They also reinforced and helped transmit pictorial aesthetics. Senior members critiqued the work of those more junior and images tended to be judged according to narrow criteria of technical accomplishment. As one member put it, "This was the heritage of the old generation: photos that are beautiful, perfect in terms of lighting, technique. The idea [behind the image] was not really developed. And all photos were almost the same."

Pictorialist aesthetics drew on European painting traditions, and photographers studied "classic" rules of composition, lighting, and pose. A photographer described the dominant taste when he joined PAF in 1954: "People learned from the Dutch. So we followed their taste, the salon taste. A European taste . . . The lighting had to be right. It was too artificial, too composed." But the influences on amateur photog-

13. "Faithful Friend" (*Kawan Setia*), ca. 1973. *Photo by Ircham.*

14. "Misty Morning," 1973 Salon Foto catalogue. *Photo by Ong Tjhoeng Pauw.*

raphy in the 1950s were not just European; contact with the clubs and publications of Hong Kong, Singapore, and other parts of Asia also shaped Indonesian amateur aesthetics. In response to questions about why pictorialism had remained popular in Southeast Asia long after it had gone out of fashion among European and American amateurs, some club members speculated about an affinity between pictorialism and Chinese art traditions. It was the preference for natural scenery and contemplative imagery, they suggested, as well as a certain formalism, that made pictorial photography so enduringly popular in the ethnically Chinese dominated clubs of Southeast Asia.[33]

As in the colonial period, amateur photographers eschewed prosaic documentary photography. They subsumed the indexical, denotative specificity of the photographic image within what Barthes called the "mythic" language of connotation, transforming the raw material of particular landscapes and peoples into visual symbols and conceptual expressions that were to have a transcendent and timeless value.[34] Titles—such as "Old Master," "Misty Morning," "Moonlight at Sea," "Hidden Beauty," "Artist's Hands," "Woman's Pride," "Reflection," "Portrait of an Old Man"—helped elevate the image to a more allegorical register.[35] Such titles (often in English) translated images of "Indonesia" and "Indonesians" into the universalizing aesthetic language with which Indonesian photographers could speak (or imagine themselves speaking) with their pictorialist peers in other nations.

Harnessing Amateur Practice

Our country is full of photographic objects that are interesting and beautiful. Because of this, we agree when it is said that: "through photography mutual understanding among society and the peoples of the world will be encouraged." And this forms an honored mission for our photographic artists, to make known all of the beauty of Indonesia to the peoples of the world, through their photographic art works. We are of the opinion that the Salon Photo Exhibition, in addition to being a receptacle for the desires of the enthusiasts of art photography, is also one of the media for the promotion of National Tourism.

—Ali Sadikin, "Address of the Governor of Jakarta," December 10, 1973

Echoes of Kartini: a desire to communicate the beauty of Indonesia to others, now expressed in an idiom of national tourism and "mutual

15. "Ceramic Craftswoman" [Perajin Kerabah], 1974.
Photo by Ircham.

understanding." In the colonial period and during the first decades of independence, amateur photographs circulated within an exclusive, if global, community. The high cost of photographic equipment and supplies, as well as the amount of leisure time and skilled knowledge required, made the hobby accessible only to a very privileged few, and their images moved within a narrow circuit of salon clubs.

Amateurs' romantic images of beautiful landscapes and noble, hard-

working, picturesque peoples would be taken up more explicitly for the task of national imagining beginning in the 1970s. The 1970s saw dramatic transformations in the practice of amateur photography and the circulation of its images, as political stability, economic growth, and technological advances began to make photography more accessible than ever before. Foreign goods and investment flooded Indonesia. The development of automatic color printing and the entry of less expensive, easier to use, and more automated Japanese cameras significantly lessened the financial and technical barriers to becoming a hobbyist. By 1971 Fuji had gained a presence in Indonesia through its Indonesian partner company, Modern Photo; Sakura (later Konica) and Kodak had similar arrangements. Fuji and other multinational photographic equipment and supply firms began to cultivate the amateur market, sponsoring club activities, contests, and other events.[36]

Members of PAF in Bandung began publication of a national photography magazine, *Foto Indonesia*, in 1969.[37] They also initiated efforts to replace the now-defunct Gaperfi with a new national association of amateur clubs. In 1971, the Indonesian Photography Society (Persatuan Fotografi Indonesia, later renamed the Indonesian Federation of Art Photography Groups, or Federasi Perkumpulan Senifoto Indonesia, FPSI) officially became a member of the international umbrella organization for salon clubs, FIAP (Federation International d'Art Photographique, which operates under the auspices of UNESCO).[38] Two years later, sixteen clubs joined together for the first national amateur photography meeting since the mid-1950s and held the second national photo salon in the history of Indonesia.[39] Between 1973 and 2000, FPSI would sponsor more than twenty Indonesian photo salons as well as numerous other national and international-scale amateur photography events.

Within the political and cultural climate of the New Order, amateur photography began to flourish in an increasingly symbiotic relation to state-sponsored development projects, particularly the promotion of tourism.[40] By the mid-1970s amateur photographers' work began to be supported and made use of by national and provincial departments of tourism and other government agencies. State agencies frequently commissioned individual amateur photographers for specific photographic projects. More widespread was the use of amateur photography contests (*lomba foto*) as an inexpensive way for the state to tap into a pool of skilled practitioners and acquire high-quality images;

the photos submitted to contests could be displayed at exhibitions and reprinted in brochures, books, and other promotional materials.

The longstanding amateur culture of contests laid the groundwork for the success of these competitions in enlisting photographers' participation in state-initiated projects. But contests were also a more generally deployed weapon in the arsenal of New Order strategies for popular mobilization and public education. Essay contests for youth and adults on the value of "development" and tourism, musical, dance, and painting contests, "clean village," "family planning," and even "*kampung* security" contests all sought to elicit popular participation in development initiatives. As one official at the Culture Office (Dinas Kebudayaan) in Yogyakarta explained to me, such contests ensured "that those who have a hobby can be channeled [*disalurkan*]."

Beyond the narrow instrumental goal of acquiring images to lure foreign tourists, photo contests had a broader educative function: training new "ways of seeing." On the occasion of the second annual "Tourism Photography Contest" (*Lomba Foto Wisata*) sponsored by the National Tourism Department in 1975, R. M. Soelarko wrote an article in *Foto Indonesia* in which he explained—it still required explaining at that point—that the contest was sponsored in order "to gather . . . quality photographs for the use of promoting/marketing Tourism in Indonesia." A second goal, he wrote, was "*to stimulate the desire to photograph tourist objects* and in that way to improve the quality of tourism photos among the experts of photography in Indonesia."[41] This pedagogy of desire was part of a broader national campaign of "Tourism Awareness" (*Sadar Wisata*). Targeted groups such as craftspeople, hotel, restaurant, and transportation workers, and people living near tourist sites were to be taught the appropriate dispositions and attitudes to facilitate tourism (friendliness, cleanliness, appreciation and knowledge of tourist sites and museums). In addition to workshops with target groups, the *Sadar Wisata* program relied on photography contests and exhibitions (as well as poster, painting, and essay contests) to promote general public awareness of the value of tourism.

Photography clubs actively sought to align themselves with these state projects, which gave amateurs a sense of purpose and offered them greater opportunity for public recognition and financial reward. Clubs sponsored their own tourism-related contests, such as the Semarang Photography Club's "The Year of Tourism Awareness 1989" contest, timed to coincide with a "Tourism Awareness" campaign. The minister

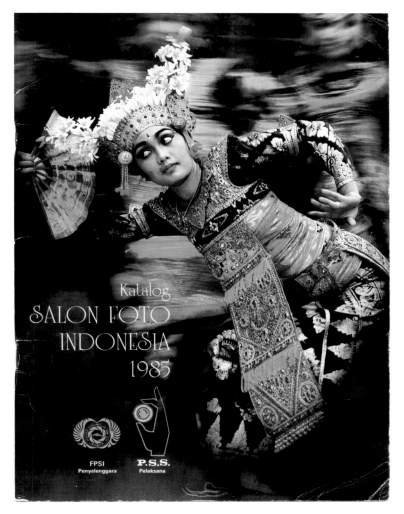

16. "Balinese Dancer," Salon Foto Indonesia 1985 catalogue cover.
Photo by Santoso Alimin.

of tourism gave the opening address at the exhibition. The Indonesian Photo Salon also on several occasions offered a special prize for "Best Tourism Photograph."[42]

In the repressive political environment of the New Order, more-over, collective activities were safer if aligned with national goals; all organized group events required explicit (if nominal) state approval. Salon catalogues from the 1970s on were routinely introduced with

letters from government officials. Foreign Minister Adam Malik, for example, who had been named "protector" (*pelindung*) of the national photography federation at the 1973 FPSI national meeting, endorsed amateur photography in that year's Salon Foto Indonesia catalogue by noting that it would help preserve "the purity of culture" as Indonesia entered the "technical and mechanical culture of mankind."[43] When PAF members rewrote their charter in 1970, they explicitly linked club activity to the project of national development, using the stilted and formulaic language of New Order officialdom: "The members of the Association of Amateur Photography have the conviction that with this New Spirit, the Association of Amateur Photography will better connect its service to the process of Nation-building and State Development."[44]

Beyond the promotion of tourism, a new focus on documenting traditional arts and customs dovetailed with broader New Order cultural logics. John Pemberton has described the New Order's obsessive appeals to the authority of tradition and depoliticized reduction of cultural and regional difference to the diversity of formally equivalent "customs."[45] Not surprisingly, Taman Mini Indonesia Indah (Beautiful Indonesia Mini Park), the cultural theme park opened in 1975 that for Pemberton epitomizes this cultural logic, frequently sponsored photography competitions devoted to the documentation of cultural arts and traditions.

Pemberton's analysis of New Order appeals to "traditional" cultural authority emphasizes their colonial genealogies and their underpinning of repressive politics. But New Order cultural politics must also be placed in the context of international discourses of cultural heritage closely linked to global development initiatives. International agencies such as the United Nations and ASEAN (Association of Southeast Asian Nations) also helped disseminate a depoliticized, multiculturalist rhetoric of diversity and tradition through their own sponsorship of photography contests. It was, in fact, these international contests that provided the template for the New Order's state-sponsored competitions as well as the themes of "mutual understanding" and "cultural riches" they so often articulated.[46] In the service of "good will" among nations, the exchange of formally equivalent images of local traditions and "culture" would lubricate global economic and political exchange.

The Asia/Pacific Cultural Center for UNESCO (ACCU) began spon-

soring yearly contests for its member countries in 1974; ASEAN has sponsored competitions and exhibitions since 1978. These international competitions were rooted in liberal ideologies of universal humanism for which photography—conceived as a universally transparent language—was imagined to be the ideal medium. Edward Steichen's famous "Family of Man" exhibition of 1955 at the Museum of Modern Art in New York formed a model for this kind of photographic universalism.[47] With themes such as "Living in Harmony" (2000); "Our Elders—Happiness in Old Age" (1999); "Nature and Daily Life" (1998); "Traditional Arts and People" (1997); "Children at Play" (1996); "Living Together" (1995); "People at Work (1994); and "Family" (1993), the contests articulated a vision of diversity rendered benign by appeals to a reassuringly common humanity. A description of the contest on the ACCU website exemplifies this discourse: "This contest is organized in the hope that people living in different countries in Asia and the Pacific will develop mutual understanding through photographs by finding what they have in common and gaining insights into the lives and cultures of people in countries other than their own. Winning photographs form a traveling exhibition that 'tours the participating countries . . . bringing messages of peace and mutual understanding.'"[48]

These international agency-sponsored competitions contributed to a shift within Indonesian amateur practice, beginning in the 1970s and gaining ground in the 1980s, away from the aesthetic of pictorialism toward a different universalizing visual discourse, described by amateurs as "human interest."[49] To compete on an international scale, photographers needed to "market" the specific cultural wealth of Indonesia within a globally legible visual idiom. Characterized by more dynamic images that "told a story" and pictured "everyday life," human interest photographs tended to highlight culturally specific arts and traditions: the colorful "interest" overlaid onto an assumed common humanity.[50] In pictorial images, pictured subjects often figured primarily as elements in an overall visual composition that lacked a singular focal point. In human interest photographs, human subjects were usually the focus and often smiled and looked directly at the camera, engaging the viewer in what MacDougall calls "transcultural" recognition.[51] Even as they appealed to universal humanism, as one photographer noted, showing me his prize-winning photograph of a woman hanging a batik cloth out to dry, the photographs that won in international

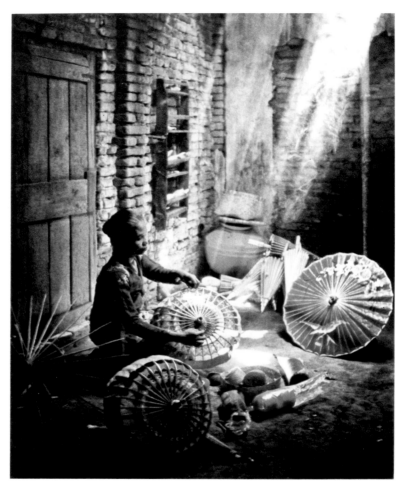

17. "Parasol Fantasy," in the Faces of Indonesia exhibition sponsored
by Fuji Film, 1984. *Photo by S. Setiawan.*

contests had to picture something "uniquely Indonesian" (*khas Indonesia*). Not coincidentally, some amateurs found that the images they submitted to such contests could be profitably repackaged as postcards sold to foreign tourists.

To some extent this turn to human interest also marked a generational shift among amateur photographers. Many younger photographers who joined clubs in the 1970s and 1980s drew inspiration from American documentary photography, as exemplified in magazines like

National Geographic and *Life*, with its emphasis on "captured moments" and visual storytelling rather than the studied compositions and crafted pictorial effects favored in the salon tradition.[52] Even within a genre oriented to the production of photographic "art," the growing global prestige of photojournalism in the era of the Vietnam War may also have contributed to an aesthetic shift away from pictorialist beauty toward documentary reportage. Technological factors—especially the rise of color film—also affected shifting amateur tastes. Black-and-white film had encouraged attention to the play of light and composition as well as darkroom technique; now black and white seemed old fashioned next to the glossy surfaces and eye-catching vividness of color images.[53] Despite these shifts in the aesthetics of amateur photography, the stock repertoire of iconic images developed since the late colonial period and their mood of sentimental nostalgia remained remarkably durable.

Increasingly in the 1980s and 1990s, national and multinational corporations also jumped on the photo contest bandwagon, using competitions for their own promotional purposes. Canon, Nikon, and other large photographic equipment companies have long held international photography competitions. But multinational film and camera equipment companies began to sponsor specifically national

18. "Flower Market," ca. 1990s. *Photo by Jack Andu.*

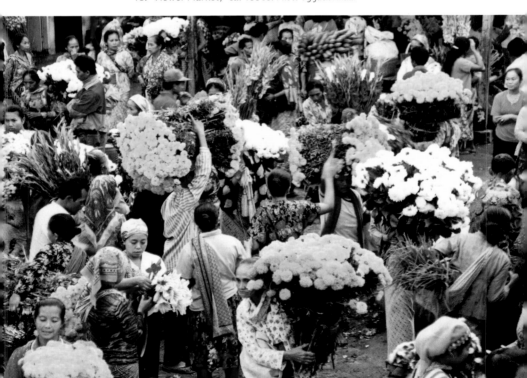

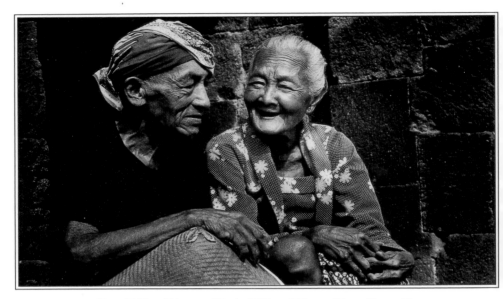

INDONESIA

Happy Old Javanese Couple

19. "Happy Old Javanese Couple" (postcard), ca. 1990s. Printed in sepia.
Photo by Johnny Hendarta.

competitions aimed at cultivating their share of the rapidly growing Indonesian market, in some cases collaborating with domestic companies and state agencies. These corporate competitions cloaked their promotional aims in appeals to nationalist sentiment and official state discourses. In 1984, for example, Fuji sponsored a contest and exhibition titled "Faces of Indonesia" (*Wajah Indonesia*); the next year, the same contest was titled "My Motherland" (*Tanah Airku*), and in 1996, "I Love Indonesia" (*Aku Cinta Indonesia*). In 1995, Konica Film and the private television station Indosiar sponsored a contest titled "I'm Proud of Indonesia" (*Aku Bangga Indonesia*) and in 1999 Fuji and the private television station RCTI teamed up to sponsor a competition titled "Building the Nation Together" (*Bersama Bangun Bangsa*). The same year, Fuji and its Indonesian partner Modern Photo sponsored "Tourism in the Islands" (*Wisata Nusantara*).

An important feature of these commercial competitions was the large

financial rewards they offered, which blurred the old definition of amateur practice as a leisure activity removed from the pursuit of money. Meanwhile, anxious to lure participants, state-sponsored competitions increasingly teamed with private corporations so that they too could offer prize money. Salon contests and most state and internationally sponsored competitions had rewarded the photographer with prestige alone. But as photography competitions were increasingly seen (especially by younger members of clubs) as a means to make money, many amateurs became reluctant to submit their photographs to international salons, which were expensive to enter (the cost of shipping alone was often prohibitive) and offered no promise of remuneration. For many, gaining points in the intricate awards system of the international salon societies paled in desirability next to the immediate gratification of hard cash. While some amateurs claimed that the rise of competitions was an important stimulant to the development of amateur photography, others bemoaned their increasing commercialization. They argued that, as photographers tailored their images to win particular contests, they had forgone the pleasures of individual creativity and the disinterested pursuit of beauty that amateur photography should ideally provide.

20. Children performing traditional dance, ca. 1990s. *Photo by Jack Andu.*

Despite the sociopolitical, economic, aesthetic, and technological shifts that occurred in the late 1970s, amateur photographers continued to generate a nostalgic, romanticizing iconography of *asli* Indonesia. On our way to the village with the bamboo bridge, as we looked out at the verdant scenery, Edy described to me how his neighborhood in Yogyakarta had changed over the years. Once quiet and dotted with rice fields and trees, it had become so crowded that the houses leaned against each other and no one had a yard anymore. After he and Jack finished photographing the old woman, we left the riverbank and began walking through the village, searching for more people to photograph. Even though he and Jack complained that many of the town's picturesque bamboo-weave houses had been replaced with "modern" concrete and brick structures, diminishing the opportunities for "good" photographs, Edy commented approvingly to me as we walked: "This is still an authentic [*asli*] village."

On another excursion, Edy asked me, "In America, in the countryside, is it still . . . still?" I waited, hoping he would define his question. Finally, he finished lamely, "Are people still close to their neighbors?" By referencing neighborly intimacy, Edy invoked a key feature of conventional understandings of Javanese "traditional" village life: the ethics of "harmony" (*rukun*) and "mutual obligations" (*gotong royong*).[54] On yet another occasion, while photographing an annual ritual at the tombs of the Javanese kings at Imogiri (south of Yogyakarta), Edy turned to me and asked, "In America are there still events like this, that are still . . . ?" As he trailed off, I pressed him, asking, "Still what?" but the only answer he came up with was "Still . . . still . . . yeah, still like this."

Perhaps Edy was particularly inarticulate, but this never-specified idea of "still" (*masih*) came up often in conversation with amateur photographers. This ill-defined "still" seemed to suggest the inherent vagueness of a romantic and ahistorical notion of tradition that photographers and others projected onto the Java they thought of as authentic. Another amateur commented that, as an anthropologist, I too must "like to see the villages, to see the ways of life that are still . . . simple." In their photographs of poor villagers made picturesque and of ritual ceremonies or traditional arts, photographers gave material form to this vague, nostalgic idea of a "still" that existed only in the stillness of the photograph.

21. "Heading Home," ca. 1990s. *Photo by Jack Andu.*

Photographers were deeply invested in an idea of rural life as a reservoir of tranquility and simplicity lacking in their own daily lives and urban surround. They often described their trips to the villages as ways of "relieving *stress*." Setiawan, an active member of HISFA since the early seventies, told me in language peppered with English, "We *enjoy*, it's a kind of *refreshing* . . . if we are hunting we are free of the busyness of the everyday, free of everyday life. We can be relaxed [*santai*], *relax*." He felt happiest when he found people he considered "authentic Javanese." Like many other photographers, he spoke of the kindness with which these "simple" villagers took him into their homes and the pleasure of "sharing experiences" with them. Another photographer, showing me a photograph of a woman bathing in a river, told me, "Even though this photograph is bad, I still like it. Because I remember the atmosphere . . . When I am taking pictures, I'm not so much thinking about the photography as the atmosphere, the experience . . . which you can't get here," and he gestured to the roaring traffic outside his home on a busy street in Yogyakarta. Another remarked, as we

returned from an overnight hunting trip, "Yesterday, there were many pretty people, a dream world. Now we return to the real world."

As is common to the nostalgic search for authentic origins, travel, however limited, was essential to this experience of a "dream world" apart from everyday life.[55] I once asked Jack if there weren't interesting photographic subjects in his own urban backyard, to which he responded, "Actually, [locations] immediately around us are also interesting." But, he said, those sites were "too familiar" (*terlalu biasa*), his eyes could no longer see them. Moreover, he said, the pleasure of hunting was to break out of the familiar routines of everyday life, to go somewhere that felt far away from daily concerns and responsibilities. While many amateurs spoke of their desire to travel to distant and exotic places in Indonesia—and some did—for most, the demands of family and work dictated that their hobby took place in brief moments of leisure within a relatively small radius around the urban centers where they lived. A rich lore passed down within the club identified numerous nearby places rich with possibilities for hunting.[56] While geographically close, these places were invested with a strong sense of temporal and social distance.

Hunting excursions were also social events that involved more than photography. Photographers prided themselves on their knowledge of out-of-the-way places; one day I went with several photographers to an obscure hillside village not only because it was scenic but because the area's famous *salak* fruit were in season. We returned home with crates of the delicious fruit. These trips always involved a stop at a favorite restaurant, and conversations were full of stories about mishaps, practical jokes, and memorable moments on previous excursions. Occasional events like club-sponsored "model shoots" and a more general atmosphere of jocular teasing and male bonding (including jokes about leaving the wife at home) cemented social ties of a "brotherhood" that was as gendered as it was classed.

For some, the social pleasures of club membership were paramount. Saying it made pursuit of the hobby "more lively," one exclaimed, "If you go hunting by yourself, and look at [the results] by yourself, and select them by yourself, it gives you a headache! But if there are people you can invite to discuss . . . it's good . . . so if there were a life membership I'd enroll myself [in HISFA] as a life member, for my whole life!" Another club member, ambivalently shifting between first- and third-person pronouns, expressed a more critical attitude toward club

sociality: "They photograph for recreation, they photograph for so-
ciality. So we get together with friends. We all bring our camera, we
photograph the same thing. And ultimately they all *enjoy* together. So
the goal is actually not photography."

It would be easy to dismiss amateur photographers as simply project-
ing an urban, middle-class fantasy of rural life onto their anonymous
subjects. Between their stereotyped ideas of "tradition" and "simple"
rural life and their pursuit of preconceived contest themes, amateurs'
process of "discovery" often seemed severely limited. Yet many photog-
raphers, when asked what they liked most about hunting, emphasized
precisely the opportunity to explore and interact with people differ-
ent from themselves. Amateur photographers may have had romantic
and patronizing attitudes toward those they photographed, but they
rarely derided them (as did other middle-class urbanites) as "dirty" and
"backward." Many prided themselves on the mastery of cultural knowl-
edge and etiquette that allowed them to take good human interest pic-
tures not only in rural Javanese villages but all over the archipelago.
One photographer, who described his travels in various remote parts
of Indonesia, noted the importance of understanding "their customs
[*adat-istiadat*]" and learning some of the local language: "We have to
understand them a little bit and if we can learn their language just a
bit, that's really good for becoming close to them." Amateur anthro-
pologists of a sort, they often explicitly distinguished themselves from
tourists, emphasizing their willingness to "really go down to the vil-
lage" (*terjun ke desa*), explore off-the-beaten-track locations, and spend
time with their subjects. For all its apparent superficiality, amateur pho-
tography did satisfy desires for contact across class and other lines that
middle-class life in urban Java rarely encourages.

Urban Anxieties and Ethnic Tensions

For Chinese Indonesian amateurs, these desires seemed also to stem
from the charged racial politics they experienced in their urban neigh-
borhoods. The depoliticizing discourses of tradition and authentic cul-
ture so prevalent in the New Order may have had particular resonance
for those who felt daily the tensions of difference that those discourses
worked to contain. Similarly, the relative paucity in the salonist canon
of photographs showing Muslim religious practice may have regis-

tered a legacy of colonial-era Dutch visions of "authentic" Java that edited out Islam, but it surely also had to do with the anxiety ethnically Chinese and Christian photographers felt about the identification of Indonesia with Islam.[57] Notably, salon photographs depicting Muslim religious practice often pictured women or young children praying or engaged in individual or family-based religious study; pleasing images that depoliticized Islam by emphasizing gendered piety, family values, and tradition.

The ethnically Chinese wife of a photographer seemed to sum it up when she told me that she enjoyed going hunting to the villages with her husband because "the people [there] are happy. They're poor, but they're happy." If the poor in rural settings seemed unthreatening— even welcoming—they were definitely not so in the urban neighborhoods where photographers lived. The violence unleashed against Chinese Indonesians during the May 1998 riots in Jakarta and nearby Solo was still fresh in people's minds. Although Yogyakarta had been spared, the threat of rioting had been palpably felt. One photographer, for example, told of how during the reformasi demonstrations in Yogyakarta in May 1998, he and his wife set up a stand offering free tea to protesters as they went by their house in the hopes that the angry crowds would not turn on them. Many told of the precautions they took daily to ensure good relations with their Javanese neighbors—such as contributing financially to neighborhood improvement projects and even helping pay for the education of poorer neighborhood children.

A telling conversation with Tomy, a thirty-one-year-old amateur photographer, began one night in August 1999 on a bus as we made our way out of Jakarta back to Yogyakarta after a two-day excursion to a wildlife park and a national amateur event sponsored by Fuji Film. As our white, air-conditioned luxury bus with the word "Tourism" (*Pariwisata*) written on the side slowed in heavy traffic, we pulled alongside a city bus crammed with clearly hot and uncomfortable people headed home from work. Just several feet apart, we looked at them and they at us across the divide of glass windows. Tomy turned to me and said, "A big contrast, isn't it? I don't like this . . . They see us, they feel jealous. And then they don't like Chinese people." Holding his cell phone idly in his hand as he talked, he went on to say that "they" would blame "us" rather than the government, "which has never wanted to help them."

Tomy was from Solo, but he frequently joined HISFA events. More so than many other club members I knew, Tomy was outspoken about

his ethnic Chinese identity and his experiences with racism. Unlike most of the Chinese Indonesian amateurs in Yogyakarta, he was a first-generation immigrant (his father was born in Canton). While most amateurs used Indonesian rather than Chinese names in accord with New Order "assimilation" policies, he always used his Chinese name when submitting photographs to contests, so that when he won awards, "people know a Chinese person did this." (For business and official purposes, however, he used an Indonesian name as a precaution against discrimination.) During the May 1998 riots in Solo, in which many Chinese homes and shops were burned, he and his wife had locked up their sewing supplies shop and barricaded themselves into their home behind the storefront. A house just ten meters away was burnt to the ground. Visiting his home months after the riots, I was struck by its fortifications: one had to go through several heavily bolted metal doors to enter the living areas behind the store. As we later drove through the streets of Solo, Tomy pointed out the gutted remains of burned-out buildings, joking that perhaps in Solo they could market "riot tourism."

At times, Tomy self-consciously asserted his nationalism: "My nationalism is no less than anyone else's." But at other times he seemed doubtful, asking me, "In your opinion, do you think nationalism is important? . . . If you feel you are not protected, not accepted, how is it possible to love this country?" Tomy also spoke of a desire to leave Indonesia and of wanting to secure a better future for his son: "I want my child to be a citizen of the world, not just an Indonesian citizen, but a citizen of the world." Such ambivalent sentiments suggest the line that many Chinese Indonesian photographers walk: on the one hand viewing their practice as an expression of their love for the nation; on the other embracing a cosmopolitan desire to transcend national limits and become "a citizen of the world" though participation in the global amateur community.

The anxiety about uncertain belonging in the nation that lay below the surface of Chinese Indonesian amateurs' easy ways was further brought home when I learned that many Chinese Indonesian amateurs had declined invitations to become members of the Hong Kong–based Society of World Ethnic Chinese Photographers (SWECP). One photographer said that, heeding "the lesson of G30S" (the alleged communist coup of 1965) in which artists had been jailed for joining communist-affiliated arts organizations like LEKRA (Lembaga Kesenian Rakyat),

he feared that joining the society could be misconstrued as a political gesture. His friend, an older Chinese Indonesian amateur, reminded me that many members of Baperki, an important Chinese cultural organization, had been imprisoned in the aftermath of the alleged coup for supposed communist sympathies. Any assertion of Chinese identity, they noted, was a dangerous political statement in the New Order. On another occasion, a Chinese Indonesian amateur explained the absence of politically sensitive topics in amateur photography not only as a function of the legacies of "pictorialism" and the pursuit of "leisure" but also as a result of what he called a "political allergy" among its primary practitioners: "Most Chinese in Indonesia—I am also influenced by it—don't really like politics. Maybe because there was trauma [in 1965], and it's had an influence . . . there is a feeling of fear, it's better not to have any business with politics."

But in the mid-1990s Tomy had decided to join SWECP. Comparing himself with others who had not, he said, "Maybe they are more nationalist than I am, or maybe they are afraid." But his description of going to a meeting in Hong Kong was poignant for the sense of exclusion he experienced there as well. By far the youngest of the delegation of about twenty Indonesian members, he was the only one who spoke no Mandarin (being of the generation that had received no Chinese-language education because it was forbidden during the New Order). He found himself unable to communicate, "like a deaf-mute," "silent" and "unable to do anything." Not allowed to be fully Indonesian, his ability to participate meaningfully in a transnational "Chinese" community was limited to the "language of photography."

Chinese Indonesian amateurs were aware that their own images participated in generating a discourse of the *asli* that worked to exclude them as "authentic" participants in the nation. I once asked Tomy how he felt about contributing photos to contests with themes like "I love my country." Acknowledging that he himself was barred from the categories of *asli* and *tradisionil* that were implicitly invoked by such contests, he commented, "Clearly, what [juries] want is the local [*lokal*]. And Chinese people, we are never local." Another member of HISFA told me, "Look for yourself. After I studied it for a number of years, [I found that] no matter how good the photograph, if it has a Chinese face, it won't win a contest." He went on, "But you know I understand, I accept it, because I have to know my place. I am a minority here. How could a Chinese face represent Indonesia? Because the numbers of

Chinese are small." Yet minority status, he agreed, was not explanation enough: photographs of people from West Papua, who look quite different from most Indonesians, often won contests. But unlike modern, urban, transnationally oriented Chinese Indonesians, West Papuans fit the profile of exotic, nonmodern "local" or *asli* difference sought in such contests.

The class and ethnic criteria smuggled into the supposedly universal category of "human interest" also became evident in discussions among photographers during the celebration of Waisak (a Buddhist holiday) at the great Hindu-Buddhist temple of Borobudur. A photography contest timed to coincide with the celebration, sponsored by the amateur club of the nearby city of Magelang, drew large numbers of photographers from Yogyakarta. I went there by car with several young Javanese Muslim and Chinese Indonesian HISFA members. On the way to the temple, they complained that Waisak was no longer as it used to be. The ritual used to involve mostly poor peasant farmers from the immediate area around Borobudur who observed this major Buddhist holiday despite the fact that they were nominally Muslims. But in more recent years, they told me, organized groups of Buddhists, most of whom were middle class, urban Chinese Indonesians, had turned Waisak into a pilgrimage, arriving in large tour buses wearing matching outfits. There were fewer "people from the lower class" (*masyarakat dari kalangan bawah*), they told me, and therefore "the opportunities for human interest are fewer . . . there aren't as many indigenous/authentic people [*orang asli*]."

Nevertheless, things did seem to be changing in the reformasi period. As one of his first acts in office in late 1999, President Abdurrahman Wahid symbolically ushered in a new era in the relationship of the Chinese-descended minority to the nation by revoking the ban, imposed in 1967, on all public expressions of Chinese culture.[58] For the first time in thirty-two years, Chinese Indonesians could openly celebrate Imlek, the Chinese New Year, and perform the Chinese Barongsai and Liong dances. This new openness quickly reverberated in the amateur photography world. In Yogyakarta, several groups affiliated with the Indonesian Democratic Party of Struggle (which used the Barongsai dance in its campaign events as both a popular entertainment and an invitation to the economically powerful Chinese community) started teaching the dance to youngsters of both Chinese and Javanese background. One late afternoon I went with Jack to photograph a les-

22. "Through Rain under Banana Leaf" (postcard), Sumba, ca. 1990s.

Photo by Agus Leonardus.

son taking place in the large dirt yard of an old school. In the 1950s, before it was shut down and turned into a state school, this had been a Chinese school; Jack had been educated there as a boy.

As it turned out, it was with a photograph of an elderly man performing the Barongsai dance during a rally for the Indonesian Democratic Party of Struggle—and not an old woman gathering rocks—that Jack won a prize from the ACCU "Our Elders: Happiness in Old Age" contest. Another of Jack's Barongsai dance images earned him an honorable mention in a "Cultural Arts Photo Contest" sponsored by the Yogyakarta Department of Tourism in February 2000. At the exhibition of winning photos, Jack's photograph of the Barongsai dance hung alongside images of *wayang kulit* (shadow puppet), *jatilan* (a popular Javanese trance dance), *wayang wong* (a Javanese dance theater), and the *Gerebeg* (an annual court ritual), indicating that the Barongsai was now being incorporated into the Indonesian pantheon of *asli* cultural arts.

While Jack's winning image of the Barongsai dancer marked a shift in the cultural politics of ethnicity in Indonesia, this "inclusion" of Chinese culture was predicated on the same multiculturalist domestication of difference that the New Order had used to neutralize other forms of ethnic and regional difference in Indonesia, a depoliticized celebration of diversity as (marketable) cultural wealth. Echoing this discourse, President Abdurrahman Wahid noted, "Hopefully now . . . we can continually enjoy this [Chinese] cultural wealth . . . the differences among us have to be enjoyed."[59] Despite its limitations, many Chinese Indonesians were greatly moved by the new visibility of their cultural traditions. In photographing the Barongsai dance, something he had not witnessed since his youth, Jack documented, perhaps, his *own* "happiness in old age."

Envisioning Indonesia

The practice of amateur photography embodies a tension between two concurrent but contradictory formulations of Indonesian belonging. By defining themselves as cosmopolitan practitioners of a quintessentially modern technology, postcolonial amateurs aligned themselves with a vision of national citizenship in which to be Indonesian was to participate in global modernity. For Chinese Indonesian amateurs in particular, this vision offered an appealing way to participate in the nation as elite "local cosmopolitans."[60] But the iconography amateurs

23. "Still Going Strong," from the 1999 ACCU Our Elders:
Happiness in Old Age catalogue. *Photo by Jack Andu.*

produced—nostalgic, romanticized images of "traditional" people and culture—contributed to the visualization of an alternative ideology of national belonging. This ideology of the *asli* ultimately works to exclude Chinese Indonesians from authentic belonging in the nation.

Like any selective vision, the picturing of Indonesia that has emerged out of amateur photography produces the unseen along with the seen. The sentimental and pleasing images that appeal to a touristic fantasy of the picturesque stand in for unseen threats: urban congestion and rural poverty; religious, class, and ethnic tensions; environmental devastation; political upheaval. They also screen out history; pleasing images of timeless "tradition" and rural tranquility lull away more jarring historical memories of the corpse-filled rivers of rural Java and Bali in 1965–1967, the anti-Chinese riots of 1998, and other traumatic and violent contests to define the nation and its boundaries.

As the iconographies forged by amateurs were taken up in advertising images and public media campaigns and published in newspapers and popular magazines, they gave shape to an envisioning of the nation with wide currency and appeal. At the close of the twentieth century, images of towering volcanoes and tranquil rice fields, of smiling children in traditional costumes, of bustling and picturesque markets, competed with scenes of violence, demonstrations, and desperate poverty in a bid to represent Indonesia. During the turbulence of reformasi, various political parties and nonprofit agencies called upon images of *asli* rural and traditional Indonesia in their campaigns for political power and for solidarity against the threat of "national disintegration." In an antiviolence public service announcement made by the filmmaker Garin Nugroho in 1999, for example, a young girl in a simple rural home sings about peace as a television beside her broadcasts images of violence, demonstrations, and students occupying the parliament building in Jakarta. Juxtaposed with shots of her singing are scenes of people working and cooking in traditional rural settings—images that might have been taken directly from amateur salon catalogues. The public service advertisement portrays an ideally peaceful rural childhood upon which urban violence, through the medium of television, intrudes. These two kinds of images—the one depicting an idyllic vision of an authentic Indonesia and the other documenting a nation in crisis—emerge out of different visual genres. Both are part of the wider repertoire of images that claims to represent Indonesia, and both are resources with which Indonesians imagine themselves, their past, and their future.

Landscapes of the Imagination

IN MARCH 2000, a temporary photo studio called "Rona Studio: Hello Hong Kong Mania" opened in Yogyakarta's main mall, featuring three vibrantly painted "Chinese" backdrops (a pagoda with fireworks, a dragon [*naga mas*], and a seashore scene complete with pier and Chinese boats). Props included a red-painted structure made out of foam that appeared to represent a temple or old building, carved chairs, a bamboo pole and fishing net, a red lantern, a sword, a stringed instrument, a scroll and ink brush, a fan, a porcelain vase, and a parasol. Customers could choose from a wide range of brightly colored embroidered costumes in different sizes (for male and female, adult and child) and a number of elaborate headpieces.

The studio's opening coincided with the first public celebrations of Imlek, the Chinese New Year, following President Abdurrahman Wahid's revocation of New Order laws restricting public expressions of Chinese cultural affiliation. The studio's owner, Hendra Kusuma, a Chinese Indonesian engineer from Semarang who became a professional photographer after many years as a serious amateur, explicitly linked his decision to open the studio to the new climate of openness: "I made this [studio] because I want there to be reform. In the era of Gus Dur [President Abdurrahman Wahid] mixing [*pembauran*] is possible. Before, between Chinese and native [*pribumi*] the gap was too big." An article in a Yogyakarta newspaper notes that "at the beginning, Hendra was hesitant. Could these photos with their nuance of mixing [*pembauran*] be accepted? 'But,' Hendra observes, 'turns out the response has been extraordinary.'"[1]

If, in the previous chapter, Jack's photograph of the Barongsai dance was accepted as an instance of a "cultural tradition" equivalent to "Javanese," in this case it was as imported exotica that signs of "Chinese" culture became desirable fashion for Javanese subjects. In the 1920s and 1930s, some ethnic Chinese-owned studios had offered their customers the opportunity to pose against backdrops depicting Chinese settings

24. Posing for a Hong Kong Mania portrait, Rona Studio, Yogyakarta, March 2000. *Photo by the author.*

and landscapes. Such renderings of Chinese space disappeared from the portrait studio as, in the postcolonial era, Chinese Indonesian studio photographers developed a distinctively Indonesian backdrop iconography of volcanoes, rice fields, beaches, and modern buildings. In the time of "Indonesia," references to China seemed out of place, and they became explicitly so when the New Order outlawed visible signs of Chinese cultural affiliation in 1967. Yet though excluded from official discourses and imageries of nation and "authentic" culture, signs of "Chineseness" could slip back in as "fashion" imported through the popular culture of film, television, and music.

Indeed, it was not so much reformasi as the extraordinary popularity of Hong Kong–produced martial arts television dramas located in a mythic Chinese past that made Hendra Kusuma's "Hello Hong Kong Mania" such a success.[2] At the time that Rona Studio opened

its doors, a particularly popular series (especially among teenage girls) called *White Snake Legend* was airing on a private television station two evenings a week. Several months before, an equally popular series called *Sacred Monkey* (*Kera Sakti*) had riveted audiences. In interviews with customers of the studio and in newspapers reporting on the "Hong Kong Mania" phenomenon, people repeatedly spoke of their enjoyment of these shows and of wanting to possess a picture of themselves looking "like a Chinese princess." One twenty-two-year-old woman who worked as a saleswoman at the mall in Semarang where the studio was first located was quoted saying that she wanted to be photographed "a la Chinese" because she liked Mandarin films: "I want to hang this photo in my front room [*ruang tamu*]."[3] A nine-year-old boy explained, "I want to be like the martial arts star in the film Sacred Monkey. I want to be photographed like a fierce warrior!"[4]

Among the many people I met at the studio were two young women who came in wearing *jilbab* (headscarves). Although the issue of removing these markers of Muslim identity for photographs has been a contentious one when it comes to the requirements of state identity photographs (discussed in the next chapter), these young women were perfectly comfortable taking them off and replacing them with

25. Young women show off their portraits in "Chinese" fashion, Yogyakarta, March 2000. *Photo by the author.*

the costumes and headdresses of a mythic Chinese princess. Was the headscarf not a mark of an essential identity but a costume appropriate for particular settings, such as school, perhaps, or the street? Was it the obvious artifice of the studio genre and the exotic setting of the image that made it possible to shed these signs of Islamic identity?[5] Certainly it is characteristic of the genre that, within the studio space, signs of identity lose their indexical certainty, becoming detached from origins and available for play. Far from signs of an interior essence, studio portraits exploit the illusionistic potential of photography to bring into material, tangible proximity a fantasy portrayed "as if" it were real. In contrast to the image-repertoire of the *asli* produced by amateurs, studio portraiture has promoted a vision of national belonging characterized by an eclectic aesthetic, openness to global currents, and an indeterminate relation between appearances and identities.

Into the Picture: Photography and Imaginative Extension

A portrait taken about a century earlier also projects its subjects into a novel, imagined scene. Here, rather than Javanese virtually traveling to "China," we see two ethnic Chinese men in front of an iconic "Dutch" landscape, complete with a windmill. Whereas in the Rona studio portraits people adopt a consistent (if mythic) "Chinese" appearance drawn directly from filmic images, here the subjects present themselves via a more eclectic assemblage of signs culled from different sources. Both are smartly dressed in white Chinese-style jackets with batik pants and slippers. Both wear watch fobs and Western-style hats, which partially conceal their hairstyles, still in the mandated "queue" (a long "Manchu" braid required of Chinese by the sumptuary laws of the Indies).[6] One of the young men, Tan Gwat Bing (the avid amateur we met in the previous chapter), poses awkwardly on a bicycle.

However much the Rona Studio portraits reflect their time—both the period of reformasi and a global moment of transnational media flows—they also participate in a genre whose visuality has a much deeper genealogy.[7] Since the late nineteenth century, photo studios in Java have been both embedded into the fabric of urban life and marked as sites of alterity and translocal communications. The portrait offers a form of virtual travel beyond the horizons of the everyday even as it commemorates intensely local events—engagements, birthdays, new

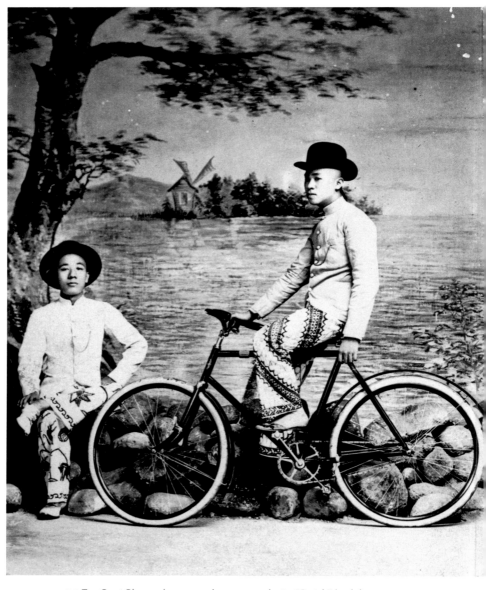

26. Tan Gwat Bing and a companion pose against a "Dutch" backdrop, ca. 1900.
Collection Didi Kwartanada and family.

jobs—and circulates among friends and family. Allowing people to project themselves "into the picture" of scenes drawn from national and global media, studio portraits bridge the gap between distant and as yet unrealized "elsewheres" and intimate spheres of personal memory and self-representation. Miniaturized and materialized within the portrait, imagined landscapes can be brought home as personal souvenirs.

Recent scholarship on photography in non-Western, postcolonial contexts has challenged assumptions implicit in many Euro-American writings on portrait photography.[8] Rooted in Euro-American ideologies that treat photographs as privileged records of the real and in a history of portraiture as a sentimental, bourgeois genre, these Euro-American writings assume that the purpose of a portrait is to picture the "real" person, to reflect interiority and preserve the person's "essence" for posterity.[9] These accounts tend to treat the conventionalized, material aspects of the photographic portrait such as pose, costume, and backdrop as superficial supplements secondary to its authentic value as a trace of the remembered person.[10] By contrast, in late colonial and postcolonial Java, these aspects of the portrait are not supplementary but central to its work. Through pose, costume, and backdrop, widely circulating iconographies are drawn into the intimate frame of self-presentation. As in vernacular Indian photography, studio portraiture in postcolonial Java operates primarily in a "world creating" rather than a "world duplicating" mode.[11] Rather than a window onto reality, the portrait offers a carefully staged theater-space for the projection of possible selves.

Yet despite the playful, highly artificed, and theatrical modality of the studio genre, the portrait's status as an indexical trace of a particular person is not immaterial to its efficacy. Rather, the significance of the studio portrait lies in its conjoining of fantasy and record, of projection and commemoration. Studio portraits in Java exploit photography's indexicality to serve imaginative ends, working to expand the horizons of the actual. The studio portrait's charge emerges from its marriage of the possible ("this might be") to the actual ("this has been").[12] Documents of the "as if" and the "not yet," studio photographs materialize desires, aspirations, and experimental fantasies of becoming "other."

This chapter traces the shifting fashions of studio backdrops, arguing that these have been integral to the making of national subjects who project themselves into the picture of national modernity.[13] Other scholars have noted the importance of fashion in the formulation of

"Indonesian" appearances in the late colonial and postcolonial periods.[14] Like clothes and accessories worn on the body, the studio backdrop serves as a kind of adornment of the pictured body, a fashion that fashions the subject within. In tracing a late colonial and postcolonial history of these fashions, we can sketch the sensibilities and tastes tutored within the studio.

A major theme running through postcolonial backdrops—particularly in the first decades following independence—was the delineation of a distinctively national space. In contrast to the nostalgic landscapes produced by amateurs discussed in the previous chapter, however, these often conjoined iconic scenes of tropical beauty with modern architecture. An equally important strand in the history of studio portraiture has been the placing of subjects within a global modernity emblematized by consumer commodities like bicycles, radios, and cars. Drawing inspiration from film and other media, these portraits materialized desires for a more affluent and technologically advanced future that have been as central to what it means to be Indonesian as pride in national landscapes.

The previous chapter noted the irony that Chinese Indonesians helped to produce a vision of "authentic" Indonesia from which they themselves were excluded. The history of studio portraiture, by contrast, reveals the crucial role of a different group of ethnic Chinese photographers in forging an alternative vision of Indonesian belonging, one characterized by cosmopolitan yearnings and aspirations for upward mobility. Ethnic Chinese studio photographers acted as cultural brokers and taste-makers, translating colonial and global iconographies into national idioms. They developed and selected the backdrops from which their customers chose. On the walls of their studios, "example" (*contoh*) images (usually with the photographer's own family serving as models) advertised the photographer's skill and illustrated for customers the appearances they might assume.[15] Inside the studio, they adjusted their customers' clothes and stance, and, later, touched up their photographs to enhance their effects. Ethnic Chinese studio photographers thus played an integral role in the process by which people in postcolonial urban Java came to see themselves as "Indonesians" situated within the national and global landscapes of modernity.

Ethnic Chinese have long predominated in the practice of studio photography in Indonesia. In 1999, two-thirds of Yogyakarta's approximately 125 studios and color processing labs were Chinese Indonesian owned.[16] Nevertheless, the story of Cantonese immigrant photographers remains an underappreciated strand in the history of photography in Indonesia.[17] Most accounts of colonial photography in Indonesia have focused on the works of better-known European photographers, as well as the "first" native photographer, Kassian Cephas, who opened his studio in Yogyakarta in 1871 and became the sultan's official photographer.[18] Europeans owned the earliest and most illustrious studios in the Indies, to be sure (the first opened in 1857). Many of these early photographers, in addition to owning commercial portrait studios, were involved in various photographic expeditions and archaeological inventory projects commissioned by the Dutch colonial state.

Yet by the final decades of Dutch rule, Cantonese immigrants had already established a strong presence throughout Java and in other parts of the Dutch colony. These photographers were more likely than Europeans to found studios in smaller cities and towns. Portrait studios mirrored the hierarchy of colonial society, with Dutch-owned studios tending to be reserved for the Dutch community and a tiny group of elite Indonesians and Chinese.[19] The rest of the population who could afford photographs—or who needed them for official purposes—went to the more modestly appointed and affordable Chinese *tukang potret*.[20]

Cantonese immigrants were known in Java as *tukang* (craftsmen) of various sorts, and were especially recognized for their expertise in making furniture and their technical know-how.[21] The term *tukang potret* (literally "portrait-maker") indicates that photography, too, was considered a craft—a form of skilled labor, but labor nonetheless. Indeed, the self-consciously modern and elite amateur photographers discussed in the previous chapter often distinguished themselves from the *kuno* (old-fashioned) *tukang potret* who understood neither the optical principles underlying photography nor the aesthetic theories that might elevate photography to an art form.

The humble nature of their craft may explain in part why the history of Chinese Indonesian photographers is so thinly documented. With

the exception of a few individuals, most second- and third-generation photographers I interviewed could recall few details about their parents' and grandparents' lives. Lost, too, to the ravages of humidity, insects, impoverishment, war, social upheaval, and neglect were many of the material remains of the history of early studio photographers. A number of photographers still used the old wooden cameras of their parents' day, but in most cases the old "examples" and painted canvas backdrops had long since been thrown away or destroyed. They were, after all, ephemeral fashions, not meant to last. Studio photographers in Java also always gave customers their negatives along with their prints; theirs was a dispersed archive.

The stories second- and third-generation photographers told me were fragmentary and often sketchy, but a general pattern was clear: the vast majority of ethnic Chinese photographers operating in late colonial Indies emigrated from Canton (*Kwangtung*) after the turn of the century, often via Singapore or Hong Kong.[22] These studio photographers' primary point of reference was not Dutch colonial society, to which they had few ties, but a pan-Chinese cultural milieu to which they remained connected through bonds of family, ethnicity, and language.[23] The Indies pattern of Cantonese immigrants establishing successful small-scale enterprises, nodes within expanding familial (and village-based) networks of studios, appears to have been part of a broader Southeast Asian phenomenon.[24]

Chinese studios in the Indies operated as family businesses, and photographers tended to learn the trade by apprenticing in the studios of other ethnic Chinese photographers, usually family members or people from the same place in Canton. Starting work at a young age, they received shelter and food instead of payment. When ready, often with money borrowed from former employers and handed-down equipment, they opened their own studios. Since it was expensive to buy cameras, photographers often deployed their woodworking skills to construct their own cameras, buying only the imported German lenses.

Wives, children, and other relatives, sometimes themselves recent immigrants from Canton who would later open their own studios, helped run the shop. Studio photography required a rare form of knowledge that was carefully guarded from outsiders. As one photographer told me, "Photography in those days was still a secret. You didn't tell outsiders how you did it. Now everything's out in the open, but in the

past it was kept strictly within the family." Photography was also a profession that *turun-temurun* (passed down from parent to child); while many second- and third-generation photographers were gifted practitioners who enjoyed their work, most came to the job out of family obligation or expedience rather than passion.

Many of the studios operating in Yogyakarta at the time of my research could be traced back through familial ties to two colonial era studios, Sinar and Hwa Sin, founded (in 1925 and 1928 respectively) by Cantonese immigrants.[25] Hwa Sin's history illustrates the larger pattern. Its founder, Oei Pak Ho, was born in Canton around the turn of the century. He came to Java as a young boy, settling in Yogyakarta with his father, a carpenter, who apprenticed him to a local, probably Chinese-owned, studio. In 1928, Oei Pak Ho founded his own studio and was now ready to start a family (his father had made arrangements for his marriage to a woman from their village in Canton). When his wife arrived in Java, Oei Pak Ho trained her to develop and print the photographs; he did the photographing. In addition to maintaining his studio, he also worked as a *tukang foto keliling* (traveling photographer) bicycling to outlying villages and taking photographs of wealthy land-owning families and village weddings. Around 1930, Oei Pak Ho's sister and her husband, Tjen Hauw, arrived from Canton. After a period of apprenticeship at Hwa Sin, Tjen Hauw opened his own studio, Liek Kong (1933). A distant relative, Y. Untung Sutanto, also came to work at Hwa Sin while still a youth in the late 1930s. He married Oei Pak Ho's daughter, Yanti Indartini, and in 1950 they opened their own studio in Yogyakarta, Tik Sun (after the New Order prohibition on Chinese names, it was renamed Indah Foto; Hwa Sin's name was changed to Mekar Jaya). In ensuing years, these studios would spawn additional studios linked by ties of family and apprenticeship.

The Japanese occupation brought the colonial world of studio photography to an end. Most Chinese-owned photo studios in Java closed during the occupation, by some accounts because of a lack of supplies and by others due to being forcibly shut down by the Japanese. The Japanese seem to have left at least one studio in each city open to serve the occupation army's administrative needs; in Yogyakarta the studio chosen for this purpose was Tjen Hauw's Liek Kong, which went on to be the city's largest studio in the 1950s.[26] Some late colonial studios never reopened their doors after the Japanese occupation, but those that survived found an even better climate for business after indepen-

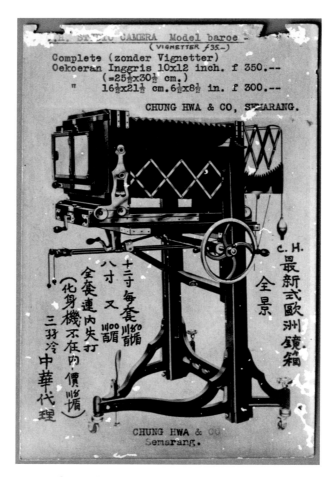

27. Page from a photography equipment catalogue, in Chinese and
Malay, Chung Hwa Company of Semarang, ca. 1935.
Collection Didi Kwartanada and family.

dence, when the exodus of Dutch and other foreign photographers
brought new opportunities. Whereas native-owned studios remained
a decided minority,[27] in the 1950s and 1960s the numbers of Chinese
Indonesian–owned studios, most tied by direct descent or appren-
ticeship to those that had operated before independence, continued
to increase dramatically.[28] It was these Chinese Indonesian photogra-
phers, then, who brought photography into the postcolonial period
and helped fashion the appearances of modern Indonesians.

"Every age re-accentuates in its own way the works of its most immediate past," observed Bakhtin.[29] So too, in the postindependence period, studio photographers recast colonial templates to fit the emerging tastes of a new nation. In the late colonial period, as if to erase the geographic and cultural distance between Europeans in colony and metropole, most backdrops in Indies studios emulated those found in Europe. Favoring interior scenes and domesticated landscapes (parks, gardens, etc.), they evoked a cultivated "European" milieu coded in references to classical architecture (pedestals, columns) and details such as curtains and domesticated flora. Colonial portraits typically placed the subject within an enclosed, man-made or artificed space that signified (European) "culture" rather than (native) "nature."[30] But the same European backdrops that offered Dutch colonials a space to perform their European (and often newly bourgeois) identities could offer wealthy non-Europeans and aristocratic Javanese an opportunity for performative play with new "modern" appearances. For elite Javanese and Chinese, the "European"-style portrait was one more accoutrement of an affluent, modern persona like the European furniture, chandeliers, and paintings native aristocrats collected in their homes.[31]

In some Chinese-owned studios, late colonial backgrounds gestured to the Far East as well as the West. In the 1930s, Chung Hwa (a Chinese-owned equipment distributor based in Semarang) began importing backdrops from Shanghai and selling them to studios throughout Java and beyond. Some of these backdrops are notable for their references to an idealized classical Chinese "great tradition" not unlike that pictured at Rona Studio. One, still hanging at Chung Hwa's studio, shows a distinctively Chinese structure in the foreground, as if the subject were standing on the terrace of a large pavilion with carved pillars looking out onto other buildings. The color is monotone sepia brown and the painting soft-edged, designed to create a subtle effect and fade into the background. Another backdrop from the same era hanging in Jawa Studio, also in Semarang, shows a garden and a lake with rock formations that evoke classical Chinese landscape painting. Like Europeans posing before European interiors, these images of elegant Chinese pavilions and poetic landscapes called to mind an imagined China that was both a nostalgically recalled "home" and a projected fantasy of wealth and elite status.[32] Although Chinese-owned studios more often

28. Detail of "Chinese" backdrop still hanging in Chung Hwa Studio, Semarang, imported by Chung Hwa from Shanghai, ca. 1938. *Photo by Agus Leonardus.*

29. Studio portrait with volcano backdrop, ca. 1960. *Collection Didi Kwartanada and family.*

pictured "European" scenes, they frequently did so in overtly theatrical ways, as in the "Dutch" landscape backdrop in the portrait of Tan Gwat Bing and his friend. This tendency toward fully rendered scenes rather than the more subtle suggestions of space typical of European studio portraits would be adapted in the conventions of postcolonial Indonesian-made backdrops.

Starting in the 1950s, Chinese Indonesian photographers began working in collaboration with Javanese backdrop painters and their customers to forge a distinctively "Indonesian" backdrop style. Many of these new backdrops strove to place subjects in distinctively Indonesian spaces. The production of postcolonial backdrops was centered in the village of Sokaraja, outside of Purwokerto, a small provincial city in Central Java. In this village, a craft industry of landscape paintings had flourished since the 1920s.[33] These paintings imitated (in a cheap, popularized form) the Dutch *Mooi Indië* (Beautiful Indies) style.[34] During the final decades of the colony, Sokaraja painters would set up shop on streets near hotels in colonial resorts, selling their paintings of Indies landscapes to Dutch colonials on vacation. They also painted theater sets for *kethoprak* performances (a popular theater form).

By 1950, Sokaraja landscape painters had begun to paint backdrops, and by 1954 their backdrops were being distributed to points in Indonesia as far east as Makassar by Photo Asia, a photo equipment company located in the East Javanese port city of Surabaya. More often, however, Sokaraja backdrop painters peddled their backdrops themselves, as they had their landscape paintings, traveling not only throughout Java but also to the major cities of Sumatra, Kalimantan, and Sulawesi with their wares on their backs.[35]

Gesang, a spry and lively seventy-eight-year-old backdrop painter, still recalled clearly the collaborative process by which he and Chinese Indonesian studio photographers had produced these new backdrops of the 1950s. He remembered, for example, a Chinese *tukang foto* in Medan showing him backdrops from Europe and China and examples in books and magazines. But Gesang (who went by the name A. Ngarobi in those days) also drew on his own experience traveling around Indonesia:

> A *tukang foto* would say, for example, "I need a backdrop showing an interior room, with a radio . . ." So I would draw a basic sketch and if he liked it, I'd go ahead. Or for example, "I'd like one with the sea, the beach, a sail boat," for example. Well, I was used to traveling, I'd

seen the sea a lot, so I would just think about it and then paint it. Then I'd get criticisms from him: "This is not quite right, this is not good yet." So then I'd fix it. Sometimes a photographer wouldn't trust that I could do it, so I would paint [the backdrop] without pay and leave it with him a few days, telling him that he could pay me if the customers liked it, or I would take it back. Within three days he would come to where I was staying and ask me to paint more!

Stylistically, these Indonesian backdrops soon departed from their European and, to a lesser extent, Chinese predecessors. Whereas European backdrops' evocations of space were suggestive more than descriptive, leaving large parts of the screen virtually empty, the entire surface of these backdrops tended to be filled in. Backdrop scenes tended to be detailed, in focus, and clearly delineated with strong forms and lines, as if claiming equal status with the photographed subject. Initially Chinese Indonesian photographers admonished Sokaraja painters that backdrops should be more subtle. But they soon found that their customers preferred the more "busy" (*ramai*) and "complete" (*lengkap*) or fully realized backdrops that Sokaraja painters made. A key word of popular Javanese taste, *ramai* means lively, busy, colorful, and full of life. It can describe visual appearances but may also refer to the appealing bustle of busy streets, festive parties, and noisy crowds.[36] The owner of Jawa Studio in Semarang contemptuously described these Indonesian-made backdrops as catering to "*selera desa*" (village taste): "Actually, this kind of backdrop doesn't support photography at all. The background should be soft and allow the person in the foreground to stand out. But if the people want it *ramai*, well, we have to give them *ramai*."

Another manifestation of the aesthetic of *ramai* was the introduction of color. Originally, the backdrops Gesang and the other Sokaraja painters made were monochrome (painted in shades of black, sepia, or blue) like those imported from Europe and China in the colonial era. But, according to Gesang's account, sometime around 1956 or 1957, a Chinese Indonesian studio photographer in Semarang suggested he paint a backdrop in color, like the smaller landscape paintings he also peddled.[37] Again, studio photographers' preference for "soft," noncontrasting colors soon gave way to the bright colors typical of Sokaraja landscape paintings. That color backdrops were popular in the 1950s despite the fact that only black-and-white film was available gives us some sense of how customers viewed the *experience* of being photo-

30. Contemporary version of a *Mooi Indië* landscape in a Sokaraja shop, 1999.
Photo by the author.

graphed. Backdrops were clearly attractions in themselves, and the more elaborate and vibrant the better.

A fairly stable visual repertoire emerged in the 1950s and 1960s: landscapes of volcanoes, rivers, and rice paddies; beach scenes with full moon and palm trees; interiors of rooms; and exterior architectural or garden scenes. Landscapes showing palm trees and volcanoes, beaches and sunsets refashioned exotic European "tropical" imageries typical of many parts of the colonial world, as well as the specific tropical paradise iconography of the *Mooi Indië* painting genre. In the colonial period these tropical paradise images had been reserved for the exoticized depiction of "traditional" natives set in idyllic rural landscapes apparently untouched by European colonialism and development. Now people posed as modern Indonesians, wearing modern fashions of the day: khaki pants and a button-down shirt for one young man posed proudly against a beach backdrop; for a young mother, a pretty *kebaya* (blouse) and elegant batik *kain* (wrapped cloth), the modern costume of the "traditional" Indonesian woman.[38] Despite their obvious ties to colonial iconographies, backdrop painters recalled the imagery of postcolonial backdrops in an idiom of nationalist sentiment. As Gesang put it, "I love Indonesia, so I only wanted to paint Indonesian landscapes."[39]

The optimism of a nation-building era seems tangibly evident in backdrops such as one painted in the 1950s that hangs (though now

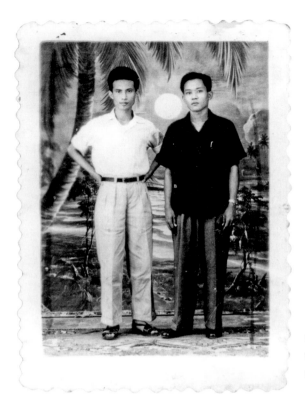

31. Two young men posed
with beach backdrop, 1955.
Collection Ibu Soekilah.

32. Family portrait with
tropical backdrop, ca. 1950s.
Collection Ibu Soekilah.

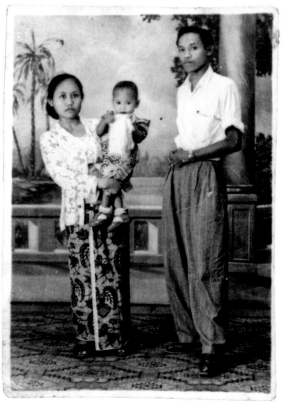

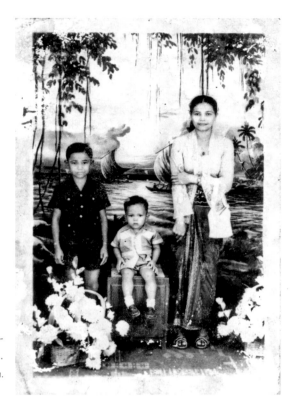

33. Young woman and children with tropical ocean backdrop, Jakarta, ca. mid-1950s. *Collection Ibu Soekilah.*

34. Interior and exterior backdrop, Lie Studio, Yogyakarta, ca. 1950s. *Collection Liem Goen Hok.*

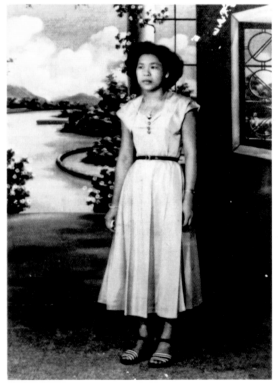

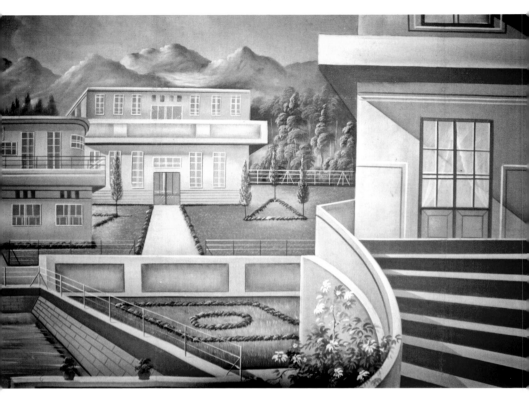

35. Detail of a backdrop with volcano landscape and modern
architecture painted by A. Ngarobi of Sokaraja, City Photo Studio,
Yogyakarta, late 1950s. *Photo by the author.*

dusty and unused) at City Studio in Yogyakarta, depicting a dramatic
volcanic landscape and, in the foreground of the painting, a number
of almost fantastically modern buildings: two-storied, with pools,
walkways, staircases, and other elaborate architectural details. Colo-
nial Dutch visual conventions in a range of media had carefully segre-
gated the "modern" colonial world of roads, trains, factories, modern
buildings, and Dutch sociality from the colonized premodern preserve
of "tradition" and "nature."[40] But postindependence backdrops in-
sisted that modern architecture and natural tropical beauty—as well
as modern, Indonesian subjects—could meet within the same visual
space. By situating modern, urban-looking masonry buildings within
a rural landscape, Sokaraja backdrops departed from the conventions of

the *Mooi Indië* paintings that continued to be produced in that village. Rather than nostalgically conjuring a pristine, preindustrial rural idyll, they sought to merge the beauty of Indonesian landscapes with signs of modernity and affluence.

In a photograph the size of a postage stamp from the 1950s, a woman dressed neatly in *kain* and *kebaya* stands before a backdrop depicting rice fields on either side of a paved road that stretches into the distance behind her. This backdrop brings together the road, a sign of modernity and development, with the rice field, sign of Java's "traditional" agrarian way of life. The paved road stretching to the horizon behind her suggests the possibility of movement. Located within rural space, she is not confined to it.

Virtual Travel within the Nation

Many backdrops of the 1950s evoked an unspecified, iconically Indonesian space through a visual vocabulary of volcanoes, rice fields, and beaches. In the 1960s and increasingly in the 1970s, themes of movement through national space were further suggested in backdrops portraying particular national and cultural landmarks. In a Chinese-owned studio in a small village in the mountains of Central Java near the Dieng Plateau, for example, a backdrop from the 1960s shows Sukarno's pride: the ultramodern international-style Hotel Indonesia, built in 1962 in Jakarta.[41] Behind it one can see the parliament building, and in front, a monumental statue, icons of the modern capital city. Commenting on the significance of Jakarta to the national imaginary, the author Pramoedya Ananta Toer noted the feeling among many who lived outside the capital that "people aren't 100 percent citizens before they've seen Jakarta with their own eyes."[42] Such backdrops allowed people who may never have visited Jakarta to nevertheless incorporate these national symbols into their self-representations, testaments to their belonging in the nation.

Indonesian mosques were also popular subjects for backdrops, especially around the holiday of Lebaran (the celebration following the end of Ramadan), when families to this day often memorialize their gatherings with a trip to the studio. These backdrops depicted particular mosques that were as much symbols of locality as they were signs of religious identity. Common backdrop subjects in the area of Central

36. Woman posed against backdrop with rice fields and road, ca. 1950s. The original is blurry, size 1″ by 1.5.″ *Collection Ibu Soekilah.*

37. Backdrop showing Hotel Indonesia (built 1962), (badly water-stained), Samiaji Studio, Wonosobo, Central Java, ca. 1960s. *Photo by the author.*

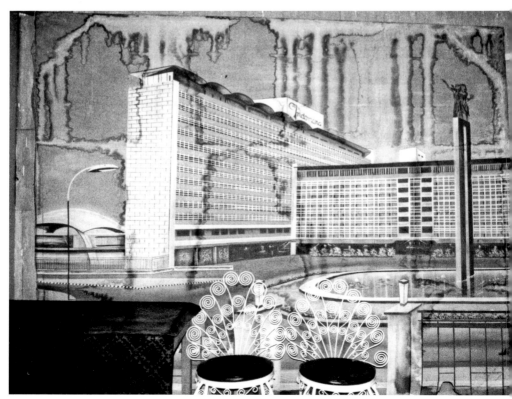

Java, for example, were Yogyakarta's large Syuhada Mosque as well as the Kauman mosque (Masjid Kauman or Masjid Gedhe) in front of the sultan's palace. Also popular were backdrops showing the great mosques of Aceh and Medan, enabling a kind of virtual pilgrimage of the nation organized around an imagined *Indonesian* Islamic community. These backdrops seem largely to have disappeared since the 1980s in favor of more generic mosque backdrops. A backdrop at Oscar Studio in Yogyakarta, for example, depicts an unspecified mosque with architecture more typical of South Asia or the Middle East than Indonesia, suggesting the growing importance in late New Order Indonesia of identification with a transnational Islamic community.

As practices of tourism increasingly provided new idioms and regimes of value shaping people's relationships to Indonesian space in the 1970s, "virtual travel" within the nation increasingly conformed to a narrowed route of recognizable (state-promoted) icons rather than more generalized evocations of national space. Some backdrops depicted sites of cultural "heritage" packaged for touristic consumption: Tanah Lot Temple in Bali, Prambanan Temple near Yogyakarta, even the Taman Mini Theme Park outside of Jakarta, a park containing simulacra of "traditional" homes from all over Indonesia.[43] Portraits made against such backdrops mimicked the vacation snapshot for those with no camera and no leisure to travel. This virtual tourism theme persists in a vivid Sokaraja background painted in the 1990s, hanging in a small studio in Kota Gede (on the outskirts of Yogyakarta); it shows a modern hotel and swimming pool.

Developed in the 1950s by Chinese Indonesian studio photographers and Javanese painters as a backdrop for "modern" Indonesians, by the late 1990s the Sokaraja backdrop style was considered "old fashioned" by sophisticated urban dwellers and photographers. These elaborate, brightly colored backdrops, however, continued to be found in smaller studios catering to lower-class customers, often recent migrants from rural villages. A particularly flamboyant example hung at Iboe Photo, a small studio in Yogyakarta owned (quite atypically) by a Javanese woman. In its brilliant color and busy detail, it is the epitome of the popular aesthetic of *ramai* that dominated postcolonial backdrops. But iconographically it is a return to the colonial *Mooi Indië*. No modern building interrupts its scene of river, rice fields, and volcano; the road is dirt, the huts are thatched with palm. Its mood is not eager anticipation of modernity but nostalgia for an agrarian past.

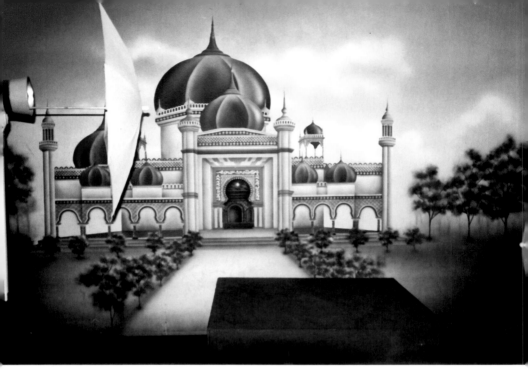

38. Mosque backdrop, Oscar Studio, Yogyakarta, ca. 1990s. *Photo by the author.*

39. "Hotel Agung" backdrop, Panorama Studio, Kota Gede, Yogyakarta, ca. 1997. *Photo by the author.*

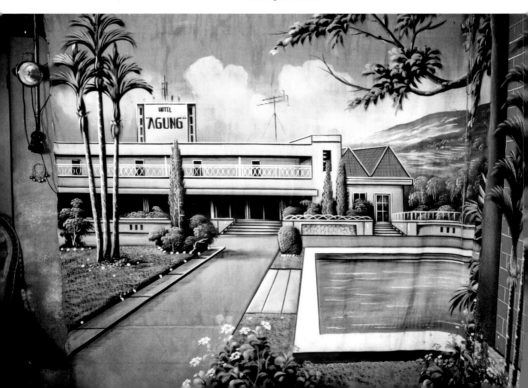

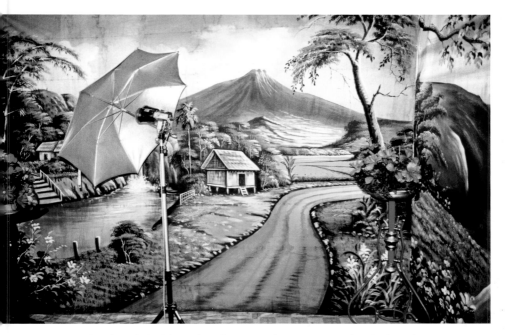

40. Sokaraja-style backdrop, Iboe Photo, Yogyakarta, ca. 1995. *Photo by the author.*

Images of Longing: Material Culture of Modernity

Simply going to a photography studio could feel like a form of exotic travel beyond the horizon of the here and now. One man who had owned a studio in the late 1950s recalled the intimidated awkwardness and excitement of those for whom entering the studio space was like visiting "a foreign world." Most studios offered their customers several choices of backdrop. Alongside those picturing national space were others that provided imagined access to an eagerly anticipated modernity pictured in luxurious interiors, icons of affluence, and fantasies of mobility. Ibu Soekilah recounted the thrill of going to Liek Kong Studio in the 1950s to have her portrait taken. The employees would unfurl screen after colorful screen, each one more magnificent than the first, all available for the choosing. It was, she recalled, just "like the movies."

Ibu Soekilah's association of the photo studio with a world of luxury brought tantalizingly near by film recalls an observation made by Indonesia's first president, Sukarno:

The motion picture industry has provided a window on the world, and the colonized nations have looked through that window and have seen

the things of which they have been deprived. It is perhaps not generally realized that a refrigerator can be a revolutionary symbol—to a people who have no refrigerators. A motor car owned by a worker in one country can be a symbol of revolt to a people deprived of even the necessities of life . . . [Hollywood] helped to build up the sense of deprivation of man's birthright, and that sense of deprivation has played a large part in the national revolutions of postwar Asia.[44]

Sukarno's insights about the revolutionary significance of a refrigerator glimpsed through the "window" of film foreground the power of visual images to stir longings and of material objects to embody aspirations.[45] In speaking of the "colonized" and not just Indonesians, Sukarno evokes the global dimensions of the allure of mass-mediated modernity; indeed, studio portraits from Africa and other parts of Asia show a similar fascination with filmic images and modern technological icons.[46] Writing of Ugandan photo-collages, Behrend argues: "By producing images of what poverty and social exclusion render impossible and even more desirable, the photographers implicitly criticized the status quo, and, through the juxtapositions of various sceneries and landscapes with modern media, the photographers and their customers entered spaces from which they were normally excluded."[47]

Unlike films that could be consumed only in the moment of watching, studio photographs allowed one physically to enter the space of these fantasies and bring them home as tangible *kenang-kenangan* (memories/souvenirs). Icons of modernity such as radios and cars pictured in films and studio portraits evoke what Benjamin called the "commodity-on-display," characterized not by exchange or use value but by "representational value." Consumed visually, such objects (epitomized by the items displayed in the windows of stores) were spectacles that "held the crowd enthralled even when personal possession was beyond their reach."[48] The studio portrait transformed this "representational value" from public spectacle into virtual private property, allowing the desired object to be brought home in image form as a personal accoutrement.

Postcolonial backdrops put people into the picture of filmic images of luxury, often evoking mobility in strikingly literal terms. Even in colonial studios, the appeal of some backdrops, such as an image of an airplane from a Chinese-owned studio, had seemed to lie in what Pinney calls "release from chronotopic imprisonment."[49] In the 1950s, this tendency toward transcendence of the limits of time, space, and so-

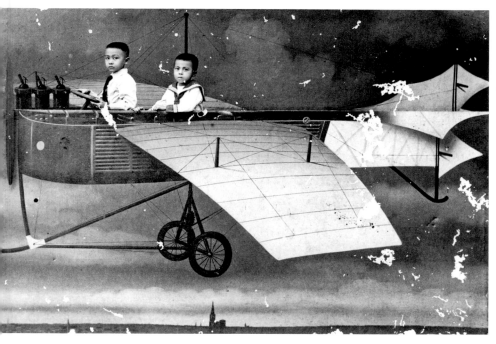

41. Airplane backdrop, Che Lan Studio, Yogyakarta, ca. 1916.
Collection Didi Kwartanada and family.

42. Convertible backdrop, Madiun, mid-1950s. *Collection Agus Leonardus.*

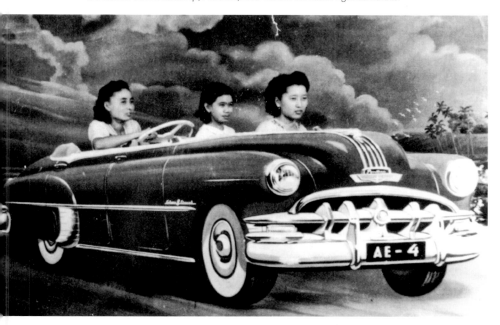

cial location became particularly pronounced. Backdrop painter Imam recalled the popularity of freestanding, two-dimensional convertible cars, boats, and airplanes as part of elaborate studio sets. The daughter of a photographer active in the 1950s remembered a backdrop of an ocean scene featuring a wooden motorboat placed in such a way that the person being photographed would appear to be sitting in it. Similarly, an image from a studio in the East Javanese city of Madiun shows three young Chinese Indonesian women driving a convertible. While the airplane of circa 1915 floats over what appears to be a European landscape dominated by a church, the convertible of the 1950s roars past a tropical landscape with palm trees.

Other images offered economic mobility in the form of luxurious domestic settings realized in carefully rendered detail. Many postcolonial backdrops depicted homes built of brick or concrete, which (implicitly contrasted with bamboo-weave dwellings) were potent signs of modernity and wealth.[50] Interior scenes prominently featured modern, deluxe architectural details such as glass windows, staircases, and swimming pools.[51] A backdrop painted by Gesang in the 1950s with strong lines and colors and complex but awkward perspective, for example,

43. Interior backdrop with radio, painted by A. Ngarobi, City Photo Studio, Yogyakarta, late 1950s. *Photo by the author.*

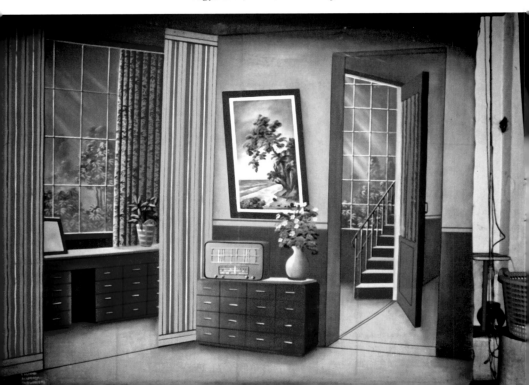

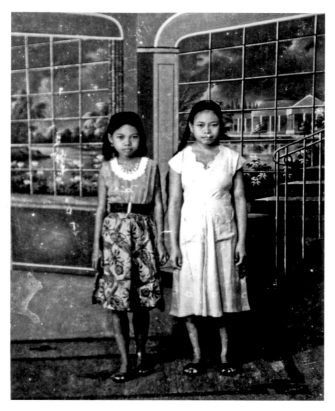

44. Interior backdrop with staircase and glass windows, late 1950s.
Collection Didi Kwartanada and family.

depicts an elaborate interior scene complete with glass windows, door-
ways to other rooms, staircase, and a radio. (The painting hanging on
the wall is an example of the kind of *Mooi Indië* landscape that had
provided the template for Sokaraja's postcolonial beach backdrops.)
For those who went to studios to have their photographs taken, such
settings were distant from real life, glimpsed mainly through films and
other media images, and possessed imaginatively through the studio
space.

The staircase—an almost too literal sign of upward mobility—
continued to be an important icon in backdrop paintings and studio
sets well into the 1980s.[52] A young Javanese woman who grew up in
a village in Central Java recalled her envy when, in the early 1980s, a

classmate went to a studio in the nearest small provincial city and had her photograph taken against a staircase backdrop. Longing for such a picture, she begged her mother to take her to the city to get her portrait made there. She recalled that in those days houses with two stories were extremely rare, so people always associated staircases with rich people. Her memory of the photograph that was never taken points to the materiality of desire, as particular visual elements come to be coded as signs of wealth and become fetishized objects of longing in themselves.[53]

"At Home" with Photography

Studio portraits often performed as a virtual substitute for domestic and leisure snapshot photography, while at the same time domestic photography often took its cues from conventions learned at the studio. From the colonial period on, studios allowed people to pose "as if" at home with such icons of affluence and modernity as bicycles, books, and watches. In the 1970s, as affordable cameras imported from Japan entered the market and snapshot photography became more widespread among the growing middle class, this interpenetration of home and studio genres deepened. Just as studio portraits began simulating tourist snapshots, so studios increasingly allowed customers to mimic the *practice* of domestic photography.[54]

Studio portraiture began noticeably to imitate snapshot conventions with settings that looked more "real," like actual gardens in the back of studios ("garden" [*taman*] studios, meant to look like the yard of a middle-class home) or "three dimensional" settings within the studio (actual stage sets rather than simply painted backdrops). Studios featured props such as actual Vespa motor scooters, false but three-dimensional televisions, actual staircases and furniture. Rejecting the conventional formality of studio portraits for the affectation of "candid" realism, people assumed more relaxed and active poses, designed to suggest that the picture was an informal, layperson's snapshot taken at home.

A comparison of two strikingly similar sets of photographs taken in the early 1970s is instructive. The first is a series of family photographs taken at home by a middle-class Chinese Indonesian man with a small manual camera. The second is a series of photographs of a Javanese

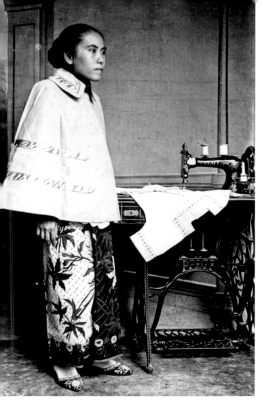

45. Tan Gwat Bing's wife posed with sewing machine (possibly taken by Tan Gwat Bing in his own studio), Yogyakarta, ca. 1915. *Collection Didi Kwartanada and family.*

46. Tan Gwat Bing posed with bicycle, Yogyakarta, ca. 1900. *Collection Didi Kwartanada and family.*

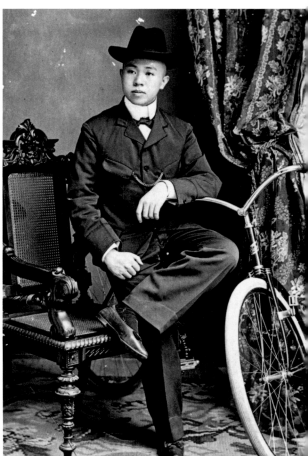

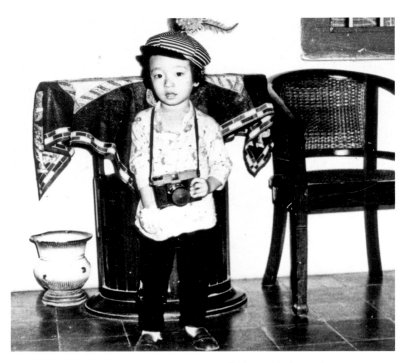

47. Child with camera, Solo, ca. 1972. *Collection Dewi Trisnawati Santoso.*

48. Page from a photo album, children with toys, Solo, ca. 1972.
Collection Dewi Trisnawati Santoso.

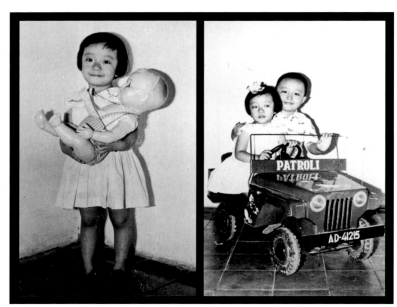

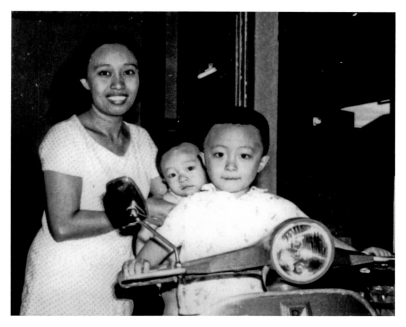

49. Posing with Vespa, Solo, ca. 1972. *Collection Dewi Trisnawati Santoso.*

50. Posing with television, Solo, ca. 1974. *Collection Dewi Trisnawati Santoso.*

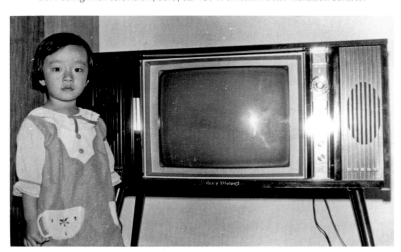

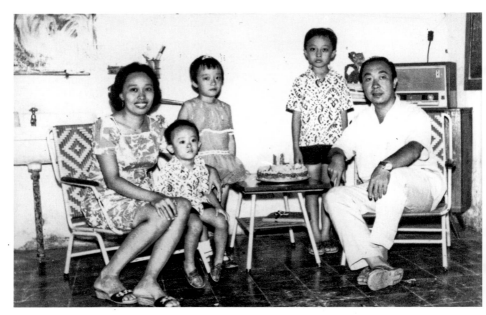

51. Birthday photograph with cake
and radio, Solo, ca. 1974. *Collection
Dewi Trisnawati Santoso.*

52. "At home" with Vespa, Tugu
Studio, Yogyakarta, ca. 1972. *Collection
Endang Mulyaningsih.*

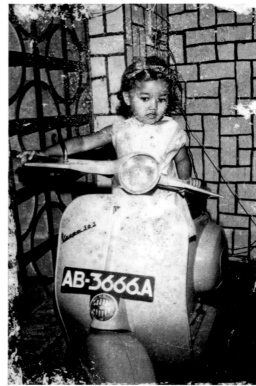

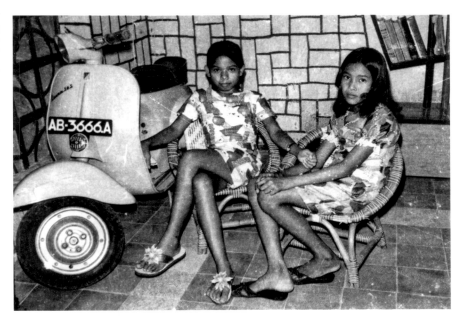

53. "At home" on terrace with Vespa, Tugu Studio, Yogyakarta, ca. 1972. *Collection Endang Mulyaningsih.*

54. "At home" with bicycle, Tugu Studio, Yogyakarta, ca. 1972. *Collection Endang Mulyaningsih.*

55. "At home" with fake TV, Yogyakarta, ca. 1972.
Collection Endang Mulyaningsih.

family taken at Tugu Studio in Yogyakarta by a Chinese Indonesian photographer using a large format camera. The "home" photographs depict children next to televisions, bicycles, dolls, and other large, expensive toys. One picture shows a child with a camera around her neck, underlining the family's (doubled) possession of a camera. The "studio" series reconstructs a similar middle-class domestic environment. But the "television" is made of cardboard, the Vespa and the bicycle are real but only played with for the moment of the photography session. Though the picture is taken by a professional photographer, the informal poses and casual domestic setting effect the untrained and candid style of home photography. Taken "as if" at home, these portraits are saturated with the temporality of the "not yet."

By implying camera ownership, these candid-style studio portraits implicitly picture the camera alongside the televisions and Vespas that appear prominently within the frame. As David Morley has argued, the emphasis on television as a medium often fails to take into account its quality as a physical object endowed with symbolic significance and capable of organizing the "micro-geography" of the home.[55] This observation can be extended to photography as well. Imitating the conventions of snapshot photography, such portraits provide a metacommentary on the value of photography as a *practice* integral to a desired modern, middle-class domesticity. One young woman told me how as children in the early 1980s she and her friends had "played photo" (*main foto*), a game in which one child would pretend to hold a snapshot camera and make clicking noises as the imaginary shutter closed, while the other would adopt a pose. Like this childhood game, studio portraiture gave imaginative access to a practice that was visible but, for many, just out of reach.

From Craft to Machine

The emulation of snapshot photography within the studio indexed a larger shift in the industry as a whole. Technological changes along with the New Order's realignment of economic priorities combined to dramatically transform the photography industry in the mid-1970s. Foreign investment–friendly policies allowed companies like Fuji (which opened Indonesian operations through its Indonesian partner, Modern Photo, in 1971) to begin developing their share of the Indonesian market. In the early 1970s, color printing became available in Jakarta and Bandung; Yogyakarta's first color lab opened in 1974.[56] With the increased presence of mechanized color processing and multinational photography equipment companies eager to provide credit, soon anyone who could buy or lease a machine or set up an "agent" relationship with a color photo lab could open a studio. The expansion of the photography industry in the last quarter of the century is reflected in the fact that 83 percent of the 125 studios I surveyed in 1999 had been founded since 1975.

Meanwhile, the improvement of economic conditions and the new availability of inexpensive, automatic cameras imported from Japan meant that more people were able to purchase cameras for personal use. Although studio portraiture remained in demand for identifica-

tion photographs and for portraits on special occasions, by the early 1980s *cuci-cetak*, or automatic developing and printing, was becoming a larger segment of the photography industry. Wedding and other forms of "documentation" (*dokumentasi*) photography that relied on small cameras and inexpensive film processing (the subject of chapter four) also became more prevalent.

In Yogyakarta in the late 1990s, the shiny glass storefronts of newer studios invited people in with their cool, white formica counters and tiled floors, large, efficiently whirring machines, and uniformed salespeople. By contrast, older studios, with their cracked and faded signs and dark interiors, seemed almost to shrink from view.[57] At City Photo, Herman halfheartedly maintained the studio his father, son of a Cantonese immigrant, had founded in 1949. A few loyal old customers and chance passersby occasionally entered the dank and dusty studio to pose for their identity photographs, not knowing perhaps that rolled up behind the plain red backdrop were two brilliantly painted landscape backdrops from the late 1950s, vestiges of a different era.

Like Herman, many older-style *tukang potret* found themselves increasingly marginalized. Indeed, on either side of City were more successful, "modern" studios. Matahari, although founded in 1946, had kept up with the times: it had opened an automatic color processing lab alongside its studio in 1978. Also sharing the street with City was Studio Kencana (founded in 1981), whose Chinese Indonesian owners were newcomers to the business. Herman's own niece, on her birthday, went down the street to Kencana's more up-to-date studio, where she posed beside a huge pink birthday cake construction, one hand coyly cupping her chin in a saccharine pose that Herman mockingly called "the toothache."

Half a century since the founding of his father's studio, Herman had almost abandoned photography (or photography, it seemed, had abandoned him); he and his wife were busy running their more lucrative "Travel" (intercity minivan) business. Like a number of other second- and third-generation photographers, Herman recalled his parents' era nostalgically. Photography then was "truly a craft, something that required expertise and skill." His father, like others of his generation, did everything from start to finish—he knew how to photograph, develop, retouch negatives, print, and color prints by hand. "Today it just takes machines and business sense," Herman told me dismissively. "Anyone can do it. You used to really have to be an expert."

As descendents of Java's pioneer photographers have confronted a changed economic and commercial climate, a marked split has emerged between those who, like Herman, follow the craft model of their parents, and those who have reinvented their parents' businesses in accord with the emerging demands and possibilities of a new market. Two sons of Tjen Hauw, founder of Liek Kong Studio, epitomize the transformation from the old *tukang* studio into modern capitalist firms. In 1975, Tun Yulianto opened Duta Photo, which during my fieldwork was the largest studio, color processing lab, and photography equipment supplier in Yogyakarta. His younger brother, Sapto Handoyo, in 1979 opened Artha Photo, the second-largest photography business in Yogyakarta. Both sons rejected the conservative business practices of their father's era. As Tun Yulianto recalled, his father had taught him two things about business: "Always be honest, so that people will trust you, and never borrow money from a bank." Tjen Hauw had always paid for everything up front and barely advertised. But Tun Yulianto believed that the key to his business success lay in his willingness to speculate, borrow, and use promotional marketing and advertising aggressively. The studio is now just a small component of a larger, diversified business, which includes wholesale and retail color processing and equipment supply and services for photographing and videotaping events. When I met with him in his office above the main branch of Duta Photo, Tun Yulianto was busy and all business; no nostalgic stories here.

By the mid-1980s, snapshot photography had ceased to be a novelty, and naturalistic studio depictions of domestic scenes had, like the elaborately painted Sokaraja backdrops before them, succumbed to the obsolescence of the modern. Increasingly in the 1980s and 1990s—though certainly not uniformly—the elaborate studio set with backdrop and props gave way to more abstract, simple backdrops (usually monochromatic and slightly mottled for a soft effect).[58] Plain studio sets called attention to the rarified, formal space of the studio and provided a neutral stage available for the performance of different roles. This role playing is exemplified in the displays hung in photo studios, which show (often the same) models in a series of costumes and poses such as "traditional Javanese," "modern student," "devout Muslim," and "fashion model." But even if, in the time of late capitalism, the era of the *tukang* was over, at times photo studios could still be "chambers of dreams."[59]

In December 1999, a studio photographer named Heri Gunawan displayed a series of portraits of his daughter Laura in an exhibition titled *Dokumenku* ("My Documents") held at a small design school in Yogyakarta.[60] The exhibition's organizer, Rama Surya, a young Jakarta-based photographer, had seen these images one day while visiting Heri. Impressed by the "informal history" they recorded, he convinced Heri to exhibit them.[61] Heri's portraits of Laura, taken over a period of sixteen years, form an archaeology of Indonesian encounters with global media in the final decades of the New Order. Like the "Hello Hong Kong Mania" portraits with which this chapter began, these images are products of their historical moment but, in their eclectic sensibility and exuberant assimilation of the foreign, they are also continuous with the history of the studio genre traced in this chapter.

Heri's artfully staged portraits in many ways extend the craft tradition of the *tukang potret*, even as Heri himself is very much a product of the New Order era. The son of Chinese immigrants, he grew up in a remote rural town outside the West Javanese city of Bandung. Heri described coming of age at the opening of the New Order, just as "the wide world was entering Indonesia" in the form of music, film, popular culture, and consumer goods. His own interest in photography stemmed from a youthful ambition to transcend his humble surroundings. To the teenage Heri, the camera was an exotic emblem associated with the celebrities he saw in newspapers and on film, a symbol of "rich" people living the "good life." He longed to be able to hold a camera, so that he would look like "someone important." Heri's parents discouraged his infatuation with photography, but Heri idolized John Lennon, who had pursued music despite his family's disapproval. Pursuing his vocation, Heri found work in 1974 in Jakarta's Fuji Modern color lab—one of Indonesia's first—before moving to Yogyakarta in 1977, working in a color lab there, and ultimately opening his own studio in 1984.

Heri's portraits of Laura span both her life and his career; he opened his studio and had a child in the same year: "So it was studying as I went. I photographed my child to study studio portraiture." The portraits allowed Heri to practice his craft and experiment with new techniques, poses, and backdrops that he could then offer to his customers. Some he hung in his studio as "examples" (*contoh*) for his customers, alongside similar photographs of his wife, son, and the whole family

together, in various costumes and poses. But despite their use as promotional materials, Heri emphasized the personal value of these portraits as records of "every development of my child." He considered the Laura portraits a form of personal "documentation," differing from other parents' photographs of their children only in their self-conscious artfulness (*kesenian*). "This is documentation because I want there to be a memory [*memori*], 'Oh, my child was cute like this then.' So this is a kind of autobiography [*autobiografi*] of Laura."[62]

What, then, did Heri's photographs document? As he himself pointed out, they documented "my dreams, which are not necessarily Laura's dreams." Heri's dreaming for Laura began, perhaps, when he named her after Laura Ingalls in *Little House on the Prairie*. In the *Dokumenku* exhibition pamphlet he writes: "The Little House on the Prairie is a serialized family film that was popular on TVRI [state television] in the '70s. I really loved the story . . . the characters that were depicted gave meaning to my life, and acted as an example of a family that was whole and harmonious (*perfect*). I was inspired by the character of Laura in the film when my second child was born. I gave her the name Laura H.K. (Lala)."

In an interview, I asked Heri if it was not strange for a young girl from the nineteenth-century American frontier to provide a model for an urban Indonesian girl born toward the end of the twentieth century. His response suggests the availability of signs circulating via global media for appropriation and identification: "I never thought about her Americanness. I only thought about how Laura was, and her family . . . I saw a happy family. And they experienced many trials, but they could always stand again. That shows that the path of life isn't always, the Javanese say, 'straight' [*lurus*], it won't always be just what you want, but you will fall and you have to get up again. So I saw Laura Ingalls in that way." Like the fashions of the early twentieth century thought "to belong not to [the] Dutch but to the world in general," so these American cultural icons are unmoored from their historical specificity and available for use.[63]

Yet naming his daughter Laura was also an act of defiance against the New Order program of "Indonesianization" (*Indonesiasi*) that required Chinese Indonesians to adopt Indonesian names, part of the slew of "assimilation" policies meant to solve the "Chinese problem" in the years following the alleged communist coup of 1965. Like many other Chinese Indonesians, rather than give his children Indonesian names, Heri chose names "from outside" (*dari luar*).[64] Although Laura In-

galls's Americanness was not especially significant, her name was appealing precisely because it was part of what Heri and many others refer to as "international culture," rather than being marked as either Chinese or *pribumi* Indonesian.

The depiction in *Little House on the Prairie* of a lone family struggling to survive on a frontier may also have had particular appeal for an upwardly mobile Chinese Indonesian acutely conscious of his minority status. Heri told me that he especially liked Laura Ingalls because "she is smart, she is good, but also if someone corners her, she'll fight back. She isn't going to be silent." Heri's depiction of a little girl tough enough to hold her ground in a hostile world resonates with his account of his own attitude when several days of street fights between rival political factions in front of his studio and home threatened to turn into anti-Chinese rioting in May 1999. "I was ready. I locked all the doors, I closed them all. But I was already ready. I readied a sword, I sat behind the door. If they wanted to enter, I would have fought. I didn't want to overreact. I was behind the door. But I was ready. Yeah if I die, I die. That's nothing. But who wants to be killed just like that? If I die, he will also feel it."

Rejecting the racialized identity politics of contemporary Indonesia, Heri frequently questioned the possibility of drawing a clean line between "Chinese" and "Javanese." He described himself as a cultural mix: although Christian, he still enacted some Chinese "traditions," such as cleaning his parents' graves once a year, and he also participated in common Javanese rituals. "So whatever is good from each culture I try to take. What isn't good, I throw out . . . There's the influence of three cultures: Javanese culture, Chinese culture, and international culture. And you know, our children . . . they watch Chinese films, American television, American music, soccer, basketball, so there's an international culture."65

Explicitly countering discourses of cultural authenticity encapsulated in the notion of the *asli*, he pointed out, "As a matter of fact, in all of Java there is nothing that is original [*orisinil*]. What is the *asli* Java? There's Arabs, there's mixture with Chinese people . . . I ask, the original Java, what is it? There is none. Actually, there is none . . . Just look, a lot of the [traditional] customs are from China." In his own work, Heri also eschewed "originality" in favor of a cosmopolitan eclecticism: "I do not have any 'original' work. I have too many teachers . . . I look everywhere, I always look to the outside. For example, I

see in the work of Rembrandt . . . that the lighting is good, I remember, I try it in my studio. Whatever is good, I try to copy. So maybe [when] I photograph, the clothing is [traditional] Javanese. But the lighting is Rembrandt's, the pose is from the work of Darwis [a Javanese fashion photographer from Jakarta]."

Emphasizing the performative and transformative potential of portraiture, Heri spoke of his work in a theatrical idiom. He called himself a "director," and, in a typical nod to American film culture, he described being inspired by the actor Dustin Hoffman, with his ability to utterly transform himself into radically different characters. Heri tried to encourage his sitters to do the same: "I also say to my models, you have to play a role, you have to be able to pretend. This is a kind of acting . . . Actually all people can act." Heri's own manner was flamboyantly theatrical; he never simply told people how to pose, he would physically adopt the posture he intended them to assume or literally mold their bodies into form with his own hands.

Heri's portraits of Laura epitomize his eclectic and theatrical approach to portraiture. One portrait of a very young Laura imitates international advertising images, showing Laura in purple lipstick, grown-up dress, teased hair, and seductive pose, drinking Fanta out of a wine glass. Bottles of Fanta, Sprite, and Coca-Cola were common props in studio photographs of the late 1980s; such images indexed the influx of imported consumer goods newly available to the growing urban middle class in the 1980s, appropriating them as icons of modernity and affluence and incorporating them into people's personal portraits. At the time, Heri reminded me, "Fanta was still something for a special guest." As in the ads Heri emulates, desires for new consumer goods are overlaid and entwined with erotic desire; Heri once mentioned that he liked to photograph his wife and daughter in different costumes and poses in part as compensation for a dream he could not realize: to travel the world and take photographs of beautiful women in every country.

Another portrait shows Laura dressed up as a character in a Hong Kong martial arts film. Over her shorts and T-shirt, she wears a gauzy, glittery scarf, a large woven hat, and a gourd with Chinese-style painting on it. She holds a large "samurai" sword that she unsheathes as she looks seriously at the camera. Heri recalled, "That was when there was first private television . . . and children were being influenced by martial arts films, Chinese films. Laura was influenced, too. Often when she played she wore outfits like that." Like children's play, the studio por-

trait incorporates models provided by global media products directly into bodily performances. It thus reveals that "capacity for inventive reception based on mimetic improvisation" that Benjamin found so promising in the play of children.[66]

Heri labels a somewhat later portrait, in which Laura holds a gun and wears a Harley-Davidson cap, "Laura as an 'American gangster.'" After watching American films on television, Heri recounted, he bought the Harley-Davidson hat, the pistol, and other props such as a cowboy hat for use in his studio. (A self-portrait of Heri in a cowboy hat and jeans and a portrait of his son holding a pistol also hang in Heri's studio as "models" for customers and exemplars of Heri's skill.) Such props allowed customers to put themselves into the exotic pictures they watched on television. But sometimes the illusion of possession and pleasure of impersonation offered at the studio were not enough; the highly popular Harley-Davidson cap was eventually stolen from Heri's studio.

Other portraits of Laura draw resonance from their allusions to conventional photographic images. In a photograph marking her entry into high school, Laura wears glasses and an intent expression as she poses before a backdrop of encyclopedias on a bookshelf. Although this portrait of Laura differs from standard graduation photos—typically full-body portraits—the familiar backdrop automatically invokes the images of cap-and-gowned graduates holding diplomas against book-filled backdrops displayed in homes across Java. Exemplifying the college graduate's iconic status, in 1999, a painted billboard on a main street in Yogyakarta promoting unity among Indonesia's diverse populations depicted a young woman in cap and gown alongside representatives of *asli* ethnic groups in their "traditional" costumes. The graduation gown therefore appears as the authentic "costume" of the urban middle class. Read intertextually against these images, this portrait projects a middle-class future for Laura.

A portrait from 1997 of Laura as a teenager shows her looking up from reading *Femina* (a popular women's magazine modeled on *Vogue*). She appears as if in her own room, in front of a backdrop that looks like a wall plastered with cut-out magazine images and posters of actors and pop stars, mostly singers and actors from Hong Kong. As Heri describes it, "In this photo here . . . Laura is already becoming grown up, she reads women's magazines. The background is full of her idols." Heri made the backdrop for the teens that come into his studio, modeling it on Laura's actual bedroom. In discussing this portrait, Heri

56. Laura drinking Fanta, ca. 1988.
Photo by Heri Gunawan.

57. Laura playing dress-up, inspired by
Hong Kong martial arts films, ca. 1989.
Photo by Heri Gunawan.

58. Laura as an American gangster, ca. 1993.
Photo by Heri Gunawan.

59. Laura as a student with graduation backdrop, ca. 1996. *Photo by Heri Gunawan.*

60. Laura as a teenager reading *Femina* against teen idol backdrop, ca. 1997.

Photo by Heri Gunawan.

again critiques New Order attempts to erase the traces of Chinese culture in Java: "Then there were many Mandarin songs, translated into Indonesian. Indonesia wanted to cover up Chinese culture, but they can't. The culture of Indonesia is very influenced by the Chinese . . . you can see it from the food alone . . . tofu is from China, noodles have become Indonesian food, *bakso* [meatball soup] . . . before Islam came, the Chinese were already here."

The New Order suppression of Chinese culture was never complete, not only because—as Heri points out—so many aspects of Chinese culture have blended into Javanese life but also because, while the state focused on the threat within, Chinese culture snuck in through the "back door" of globalized popular media culture: television, film, and music. Another portrait shows Laura in a Chinese-style dress, a fashion trend of the late 1990s influenced by the popularity of Hong Kong films.

A final portrait of Laura depicts her as a student activist during the reformasi demonstrations of 1998. On her head is a red headband, with partially visible letters spelling "reformasi." She wears the typical dress of a college student—blue jeans—and her defiant look and clenched fist against a backdrop of a burning building evoke iconic images of the reform movement: "At the time it was the Indonesian reform movement. She didn't take part in the demonstrations, but this [portrait] was my idea . . . Laura as a person who wants to demonstrate . . . I wouldn't let her take part in the demos, only for the photograph. Actually she wanted to, but I forbid it because of the danger. In her spirit, she wanted to."

The history of this image is somewhat more sedimented, however. The backdrop showing the burning building was not initially made to evoke the banks and stores burned during reformasi riots but had been inspired by scenes from the film *Towering Inferno* (1974). Like many studio photographers before him, Heri often drew inspiration for his studio backdrops directly from film or television images. Such sets allowed Heri to possess and play with the flickering images on television and movie screens that seared his memory but left no material trace: "I have many leftover memories that I want to be able to see, to own." Ultimately, the *Towering Inferno* backdrop came in handy for the portrait of Laura as a reformasi activist because it fit with images of riots that Heri saw on television: "I imagined reformasi . . . Solo is burning, Jakarta is burning . . . and then I remembered . . . this background."

The reformasi portrait pictures Laura's "spirit," providing a material

61. Laura as a reformasi activist, 1998. *Photo by Heri Gunawan.*

memento of her *desire* to participate in the student movement (and Heri's desire to both restrict and realize it). Considering that most of the buildings burned during the riots were Chinese Indonesian businesses, there is a good deal of poignancy to this portrait of Laura impersonating the student activist, a quintessential national subject. Heri's portrait borrows from the iconography of heroic student activists (discussed in chapter five), bringing Laura's personal portrait into dialogue with a national image-repertoire. Like students' photographs of themselves as demonstrators, it materializes a longing to participate in national history and self-consciously realizes the intertwining of individual lives and broader collectivities. Unlike the student images, however, which rely on ideologies of photographic transparency and witnessing to stake a morally charged claim to "having been there," this portrait accumulates legible signs of reformasi to form an overtly theatrical image that presents Laura "as if" she were there. Picturing possibility rather than actuality, it materializes the otherwise intangible landscape of desire and sentiment.

Like Heri's photographs of Laura, the genre of studio portraiture records an "informal" history of Indonesia—a history refracted through personal memories and aspirations. Since the late colonial period, studio portraits have allowed people to experiment with new identities and make contact with distant and as yet unrealized "elsewheres." Drawing on global media images and translating international conventions into locally appealing forms, Chinese Indonesian studio photographers craft the pictures into which people project themselves in the theater-space of the studio. Studio portraiture cultivates an eclectic and performative sensibility, a "way of seeing" Indonesian subjects that challenges the fixities of identity and transcends the limits of the here and now.

This future- and outward-orientation was a vital part of the promise of becoming a subject of national modernity. Turning to identity photographs required by the state, the next chapter will look at a genre that, rather than embracing the indeterminate relation of appearance to identity, seeks to map one definitively onto the other. People go to the same photographers, in the same studios, to have their identity photographs made. Yet the "world duplicating" ideology underlying identity photography is radically different from the "world creating" modality of studio portraiture, as are the visions this genre produces of what it means to participate in Indonesian national modernity.[67]

Identifying Citizens

IN FEBRUARY 2000 a short story appeared in a weekly newspaper about a mundane ritual of contemporary Indonesian life: the taking of an identity photograph (*pasfoto*).[1] The story opens with an employee of a humble photography studio cleaning the glass of his display case on a typical day. Wandi wipes the glass, making it shine clearly and transparently. Suddenly two strangers, large men with short-cropped hair, approach him without the normal niceties of greeting. Their appearance suggests that of elite military figures; their dark glasses signal the threat of a penetrating vision that sees without being seen. The story lingers on these glasses, which, in obscuring their wearers' eyes, make Wandi feel terrifyingly exposed: "Their two pairs of eyes, which were concealed behind dark glasses, rather seemed to stare at Wandi sharply, as if consuming and exposing him completely, to the point that Wandi shuddered. All at once the hair on the back of his neck stood on end."

Although the abrupt appearance of power is frightening, the studio is a place of normalized routine. So, despite his apprehension, Wandi responds to them in the familiar tones he has used "who knew how many times" before, asking, "Yes, can I help you?" The men ask him if he can take an identity photograph, a question that Wandi finds irritating: "This was an insult to his professionalism, he complained in his heart. Thousands of times he had photographed, whether for *pasfoto*, or all-body photos, or family photos with various poses and styles. And now he gets such a very strange question from his strange visitors. Can you take a *pasfoto*? Jeez! What kind of question was that?"

The *pasfoto*, it turns out, is not for the two men, but for their boss who waits in a luxury car outside the studio. The car's tinted windows, which obscure him from view, signal (again) the presence of a concealed power that sees without being seen.[2] Things get stranger for Wandi as the men tell him that if he succeeds in taking a *pasfoto* of their boss he will be paid the extraordinary sum of ten million rupiah, but that if he fails, they will "hold you responsible"—a threat they empha-

size by revealing the pistols hidden under their long coats. After a moment of panicked indecision, Wandi convinces himself that he is up to the task. After all, "what was so hard about taking a picture? This was his routine work that he had already done over and over again for ten years."

When the boss enters the studio, Wandi is surprised to find that he is quite "regular" in appearance: "there was no sign of strangeness to him." Like his bodyguards, he too wears a long coat and sunglasses, but he has a fat, protruding belly. The man removes his coat and his sunglasses and sits on the stool facing Wandi's camera. But when Wandi looks through the camera lens he has a shock: "That very instant Wandi jumped back. Surprised beyond belief! He almost toppled backwards and a loud scream would have leapt out, if he hadn't immediately shut his mouth. It was as if he didn't believe what he was seeing with his own eyes. Through the lens of the camera, Wandi saw a face that was truly horrifying. It wasn't the face of a human! But . . . a jackal!!!!"

Shaking, he moves his head from behind the camera viewfinder and looks directly at the "original" (*asli*) face of the man in front of him. Seen without the aid of the camera lens, "the face of the important person was still just like that of a normal human!" Returning to the camera viewfinder, he again sees the face of the horrific jackal: "The camera lens still captured the face of a jackal and not the original face of this important person. Was there something wrong with the camera?" In terror, unable "to keep looking at the terrifying jackal's face dripping saliva," he shuts his eyes and pretends to focus the camera lens.

Aware of the threatening eyes of the bodyguards fixed on him, he presses the button. The flash flares, the picture is taken. Urged to hurry, he enters the darkroom, develops the print in terror, only to find with relief that the image that emerges on the photograph is that of "the original face of the man" rather than the jackal that became visible through the camera lens. But again he is in for a scare. For as he takes the photograph down from where he has hung it to dry, the face "suddenly came alive and looked like it wanted to speak!"

Congratulating him, the face in the photograph tells Wandi that he has succeeded where other photographers in the city have failed. It then explains the boss's terrifying appearance: he is a high official in the government who also has an unofficial business cutting down lumber in virgin forests, felling "giant trees that have never been touched by a hand in all this time" and depositing the massive profits into secret

bank accounts in Switzerland, Singapore, Hong Kong, and America. However, "because of my greed, I have been given a special hair that grows on my face. Hair that is special because not everyone can see it directly." Adopting a sad face, the *pasfoto* image says, "The more forbidden wood I cut down, the more also this special hair grows on my face. It will grow until it fills my whole face! And then suddenly, my face will change to become like a jackal with coarse hair dripping the saliva of my greed." The story concludes with Wandi's reaction to this revelation: "Wandi shuddered with horror when he imagined the frightful face of the jackal he had seen through his camera lens!"

Published during the post-Suharto reformasi era, when questioning of state abuse of power, corruption, and the excesses of bureaucratic surveillance was widespread, the story articulates a disenchantment with the dominant visuality of the New Order state. With its frequent references to clear and dark glass surfaces, the story generates themes of visibility, transparency, concealment, and power. Dark glasses are signs of the state's panoptic vision, of a power that sees all the more penetratingly for not being seen. At the same time, they signal a certain occult opacity to the workings of state power. The story imagines the possibility of a reversal of the state's gaze in which the state itself would be unmasked. To be photographed, the state official must step out of his tinted glass car and remove his glasses. Seen through the camera lens, he is further exposed. The magically mediated image of the jackal seen via the camera lens reveals the true identity of the state as a collection of supernaturally corrupt individuals.

But this is not simply a story of reversal in which the ordinary citizen, embodied in the figure of the humble photographer, turns the camera on the state. The story interrupts the logic of the identity photograph as transparent record, imagining instead the magic of a lens that might reveal a different order of truth not visible to the naked eye. Challenging the status of the photograph as a perfect copy of an "original" (*asli*) reality, the story suggests that appearance and identity are not the same. By locating revelation in the optical device of the camera rather than the photographic trace, and in magic rather than science, the story casts doubt on ideologies of transparent transcription and challenges the semiotic premises underpinning the history of photographic "proof" of identity.

62. Identity photo, 1954. *Collection Ibu Soekilah.*

Practices of Identification

Wandi's story uses the common experience of having a *pasfoto* taken to raise questions about the state's reliance on the camera as a fetish of its power to recognize identity. It is no coincidence that a critique of the New Order would be articulated in this way. Especially during the New Order, though beginning long before, the identity photograph was a routinized site where state power and individuals came into contact. The large numbers of *Afdruk Kilat* or "Express Printing" stalls in Yogyakarta and other cities attested to the ubiquity of the identity photograph. Along busy streets in urban centers, small, brightly painted wooden shacks on wheels with hand-painted signs interrupted the pavement, cropping up thickly near universities, schools, and government offices. At these printing stalls, black-and-white *pasfoto* could

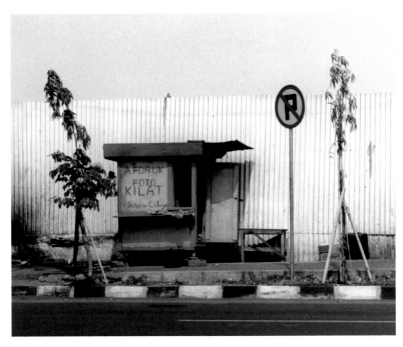

63. *Afdruk Kilat* stand, Yogyakarta, 1997. *Photo by the author.*

be developed "while you wait" using only a petromax light, chemicals, and photographic paper. The images quickly faded, due to poor quality chemicals, but they were cheap and fast and did the trick for myriad bureaucratic uses.

To print one's identity photograph at an *Afdruk Kilat*, one had first to possess a negative. That meant going to a photo studio like Wandi's to have a portrait taken against a flat screen of blue or red cloth. The vast majority of photo studios in Yogyakarta reported that their business was sustained by the constant public need for identity photographs;[3] this steady demand allowed studios to survive the seasonal lulls and economic downturns that made people less inclined to have portrait photographs taken or to have snapshot images developed. Composing oneself for a standard *pasfoto* was a ritual with which almost every Javanese was familiar, particularly those living in cities. For many, this was the first photograph ever taken of them, and for some, the only self-image they possessed.

But understanding the *pasfoto* simply as a fetish of state power does

not adequately encompass the rich social life of the identity photograph. This chapter traces how a state documentary practice ramifies and refracts, generating broad visual logics and accumulating new meanings and deployments. The identity photograph's history emerges, of course, within a larger history of state projects of surveillance and control. But as these projects were generalized and normalized, I argue, the identity photograph became a widespread idiomatic shorthand for citizenship or legitimate belonging in the state-authorized national community. As state-imposed models of identity and citizenship became more integrated into the spaces and habits of everyday life, they also rubbed up against competing local, familial, and religious forms of identity and sources of recognition. In the process, the transcriptive truths of the identity photograph were subject to popular doubt and irreverence. Moreover, exceeding its status as a state sign, the widely accessible *pasfoto* was put to use for a wide range of personal purposes, entering alternative circuits of recognition and serving ends quite distant from state aims.

State Gaze and the Boundaries of National Belonging

The history of the identity photograph is tied to the expanding reach of modern bureaucratic states and the global currency of a semiotic ideology in which the photograph serves as truthful legal and scientific "evidence."[4] Following Foucault's arguments about the disciplinary practices and regimes of visibility that characterized modern biopower, John Tagg argued that photography was central to the development of a new mode of rule that depended on "a proliferating system of documentation" producing "new forms of knowledge about state subjects." He vividly—if hyperbolically—described the quotidian representational violence of the identity photograph:

> A vast and repetitive archive of images is accumulated in which the smallest deviations may be noted, classified, and filed . . . The bodies—workers, vagrants, criminals, patients, the insane, the colonised races—are taken one by one: isolated in a shallow, contained space; turned full face and subjected to an unreturnable gaze; illuminated, focused, measured, numbered and named; forced to yield to the minutest scrutiny of gestures and features. Each device is the trace of a wordless power, replicated in countless images.[5]

The identity photograph, with its reduction of the individual to a rigidly conventionalized system of representation, enacts the fantasy that human subjects can be measured, known, archived, and thereby controlled by the state. Subjecting individuals to a "serializing" logic, it transforms each into "one digit in an aggregable series" of state subjects.[6]

Experimentation with photography as a technology of identification in both Europe and European colonies began little more than a decade after photography's invention. The colonies often provided "new testing grounds for new techniques of visual control."[7] The Dutch East Indies followed a pattern more broadly occurring in Europe and its colonies, adopting, at the turn of the century, a new mode of rule oriented to surveillance. Bertillon's system of anthropometric photography had been introduced to the Dutch East Indies in 1896 and was increasingly employed as a means of identifying criminals in the major cities of Java.[8] By 1917, the police in Batavia had begun using fingerprinting, which came to surpass photography as the preferred means of identification because of the fingerprint's immutability and clear distinction one from another.[9] Nevertheless, the practice of identity photography remained an important technology of rule not only because the technique required less training but, one imagines, because the photograph so effectively gave visual and material form to the state's simultaneously standardizing and individuating gaze.

Writing of the visuality of the late colonial period, Mrázek has linked the pervasive metaphor of modernity as the bringing of "light"—a discourse shared by Dutch colonials and nationalist elites—to the panopticism of the colonial state.[10] The colony, argues Mrázek, was increasingly imagined as if it were "under glass"—exposed to the Dutch gaze under the microscope, the camera lens, the telescope, or beyond the window of a train. As Barker notes, the Dutch "fetishization of the tools of surveillance was sometimes so extreme that simply exposing the world to light (and the 'natives' to enlightenment) was expected to bring order to the colony."[11] The expansion of identification documentation, Barker argues, occurred not only in the development of police surveillance intended to control criminality but in projects of hygiene meant to contain the spread of disease. The origins of the contemporary Indonesian identity card, he suggests, are to be found in the birth certificates administered in the 1930s in order to facilitate mass vaccination programs.[12] Another strand in the genealogy of identity documentation can be found in the colonial state's attempt to con-

trol flows of people, particularly ethnic Chinese. This effort to contain mobility was linked to concerns about origins, foreigners-within, and ultimately, the boundaries of citizenship and state authority.

Identifying the Non-*Asli*

Ethnic Chinese pioneered a particular notion of what it means to be a citizen (*warga*) in Indonesia by crystallizing concerns about inauthentic citizens who might respond to circuits of recognition other than those authorized by the state. The historically "documentary"—authorized, artifactual, and nonnatural—relation of the ethnic Chinese to the national community forms a prototype for the kind of belonging that would be institutionalized and generalized under the New Order, in which documents (especially the identity card) increasingly mediated who belonged and who was excluded from the realm of state recognition.

The distinction between *pribumi* (native/indigenous) or *asli* (original/authentic) inhabitants and those of "foreign" origins was a preoccupation of the colonial state that continued to have strong reverberations in the postcolonial period. The Dutch classified the population into "Native," "Foreign Oriental," and "European" classes with distinct legal rights. The ethnic Chinese, by far the largest group of "Foreign Orientals" in the Dutch Indies, were of particular concern for the colonial state because of their economic power and the ambiguity of their ties to China.[13] In an effort to control their economic activity, ethnic Chinese were required to live in restricted areas in urban centers (by the *wijkenstelsel* or residential zoning laws of 1866) and to carry travel passes (the *passenstelsel* system of 1863) whenever they moved through the country.[14] Although the onerous pass laws were finally revoked in 1918–1919 due to ongoing protests from the ethnic Chinese community, these Dutch policies began a "tradition" of placing ethnic Chinese at the vanguard of state policies of surveillance, control, and identification documentation.

Practices of identifying those with "foreign" origins intensified under the Japanese occupation.[15] In the Indies as in other parts of Japanese-occupied Asia, identity photographs were employed as part of the state's apparatus of rule. A law passed in 1942 required all citizens above the age of seventeen who were not of Indonesian origin to

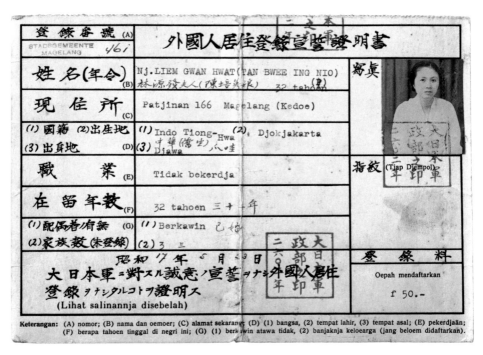

64. Japanese identity card for Indies Chinese. *Collection Didi Kwartanada and family.*

register with the authorities. Especially suspect of being anti-Japanese because they might harbor Chinese nationalist sentiments, those of Chinese descent were required to sign a statement of loyalty to the Japanese occupying government, which took the form of a card with an identity photograph.[16]

With the establishment of the Indonesian Republic, distinctions between Chinese Indonesians and the rest of the population remained marked. Many expressions of Indonesian nationalism had been predicated on the distinction between the *asli* and the non-*asli*.[17] A citizenship law of 1946 identified as "Citizens of Indonesia" (*Warga Negara Indonesia*) those who were *asli* and those non-*asli* who had lived in Indonesia for more than five years and wished to be naturalized.[18] In order for these latter to be registered as citizens they had to apply in writing to the Department of Justice and supply "proof" of their status within Indonesia. Should they satisfy the criteria for naturalization, they would offer an oath of loyalty to the state and receive a Proof

of Indonesian Citizenship Card (*Kartu Bukti Warga Negara Indonesia*). These proofs of citizenship, it was further outlined in a memorandum to a citizenship law of 1958, were required of all those whose citizenship was not natural but legal: the result of an "application" or "statement."[19] While apparently intended to eliminate doubt about citizenship, the accumulation of documentary proof served as both a sign of uncertainty and a discriminatory procedure in itself. The more they were asked to acquire documents, the more Chinese Indonesians were marked as non-*asli*, or "inauthentic" Indonesians.

New Order assimilationist policies exacerbated this tendency. The first two years of the New Order saw waves of anti-Chinese rioting across Indonesia, and Chinese Indonesians were targeted by the military for "indoctrination" sessions and were often required to make public show of their loyalty to the nation.[20] The links between "foreign teachings," "foreign descended citizens who tend toward exclusivism," and the "tragedy of G30S" (the alleged communist coup attempt of 1965) were explicitly made in early New Order discourse.[21] Laws passed in 1966 and 1967 urged the adoption of Indonesian names, shut down Chinese schools and newspapers, made it illegal to display signs or sell books with Chinese characters, and banned celebrations of Chinese rituals in public places.

New Order policies of forced assimilation, while promising to eliminate racial distinctions, actually intensified bureaucratic scrutiny of Chinese Indonesians. Once again, the logic was that the acquisition of ample "proof" of citizenship would provide a "solution" to the "Chinese problem" by eliminating lingering doubts about their membership in the nation. In addition to citizenship cards, all Chinese Indonesians, including those born in Indonesia, were to acquire a Proof of Citizenship Letter (*Surat Bukti Keterangan Kewarganegaraan*) and papers "relinquishing" the nationality of their parents (even if their parents were already naturalized). Chinese Indonesians also needed to acquire papers documenting their adoption of an Indonesian, rather than Chinese-sounding, name. While the prohibition against Chinese Indonesian names would appear to be aimed at erasing difference, the identity card always retained some mark alerting officials that a citizen was of Chinese descent.[22] These documentary "proofs" could be requested at any bureaucratic juncture, and, since requirements were rarely systematized and inconsistently implemented, they also provided ample room for bureaucrats to solicit bribes from Chinese Indonesians either

seeking to acquire such papers or seeking a service for which they could be demanded.

In everyday discourse throughout the New Order, to label someone WNI (*Warga Negara Indonesia* or Indonesian Citizen) was a euphemistic way to point to his or her Chinese ancestry. The "other" overtly evoked by WNI is WNA (*Warga Negara Asing* or Foreign Citizen), the term appearing on the identity cards of nonnaturalized Chinese and other foreign residents of Indonesia. "WNI" asserts official, legal belonging within the Indonesian national community. The term's implicit and more telling contrast is with those *asli* or *pribumi* members of the Indonesian community who are also technically WNI but who have less need for their belonging within the nation to be confirmed by official, paper signs. That the general term WNI is used specifically for Chinese Indonesians in everyday language points to their marked status within the national community and suggests how much the term *warga* (citizen) itself connotes bureaucratic regimes of belonging. *Warga* designates those whose belonging is authorized by state authority and dependent on documentary proof.

From the Dutch period into the New Order, the problem of the ethnic Chinese was a problem of ambiguous belonging, an ambiguity underlined more than appeased through the accumulation of documentary "proof." As in other parts of Southeast Asia, the overseas Chinese posed a threat to colonial and national states because of their transnational networks and their "wild," unregulated mobility.[23] Chinese Indonesians might escape the gaze of the colonial and postcolonial state, orienting themselves to other centers of power and other networks of recognition. They might falsify their identity and pass unnoticed as "authentic" members of the nation. The racialized discourse of *asli*/non-*asli* that opposed "native" citizens to those of foreign ancestry served to generalize all Chinese as equally suspect and cast questions of national belonging in racial terms. But while this pattern of discrimination continued during the New Order, anxieties about the authenticity and mobility of citizens also extended to the population as a whole, in a widening climate of surveillance and concern about *political* (rather than racial) inauthenticity and the possible presence of enemies within the body of the nation. Popular discourse pitted *warga* against the *asli*. But increasingly, from the state's perspective, *warga* were proper citizens defined against those who were *liar* (wild) or outside the state-authorized community.

During the Sukarno years, the most widespread form of official identity document was the *Kartu Keluarga* (Family Card), a form listing births and deaths within one household. The *Kartu Keluarga* did not need to be carried on one's person and contained no photographs. Shortly following the alleged communist coup of September 30, 1965, however, the state began requiring people in various parts of the country to carry identification cards (*Kartu Tanda Penduduk* or KTP) on their person at all times. As a journalist who had worked in an area under military control recounted, the identification card system began as a concomitant of military campaigns to purge communists: "Following the campaign against communists in the Klaten area of Central Java, the state initiated an 'operation KTP' requiring all citizens of the area to register at the *lurah* [village head] and acquire a KTP. This began from 1966–7, at which time the KTP became a requirement . . . The goal [of the KTP] was to differentiate between those who were PKI and those who were not . . . the PKI ones were given special marks because they had to report to the Kodim [Military Regional Command] every week. This was called '*apel*.'"[24] Special codes were inscribed on the KTP of those who had been imprisoned for political reasons (ET: *Ex-Tahanan Politik*) or had been members of outlawed organizations (OT: *Organisasi Terlarang*).[25] Those whose cards bore these marks had to report to military command whenever they needed to make a change to their KTP (for example, if they were moving, marrying, etc.) and faced discrimination at any point of contact with the state bureaucracy.[26]

These specific documentary initiatives were part of a broader visuality emerging in the early years of the New Order that posed the state as the sole agent capable of recognizing the presence of threats to the nation. Newspaper articles from 1965–1966 about the capture of and search for communist figures frequently rely on a trope of fugitives moving through the landscape in disguise.[27] A photograph on the front page of the Yogyakarta newspaper *Kedaulatan Rakyat*, for example, shows a captured communist leader from the town of Prambanan with his family under military guard; the communist leader is wearing a *peci*, a hat typically associated with nationalists and Muslims, not communists. In the caption, this oddity is explained away: "when he was captured he was wearing a peci [*pitji*] in order to disguise himself." Di-

rectly underneath this picture is a different article about attempts to capture the Communist Party head, Aidit, then still on the run. The headline reads: "Aidit has Disguised Himself as a 'Santri' [a devout Muslim]."[28]

Numerous newspaper articles attribute success in the fugitives' capture to military and other officials' keen ability to recognize true identity. Two similar articles from November 1965 describe how "suspicious movements" observed by various officials led to the capture of communist fugitives in disguise.[29] The articles do not elaborate on how, precisely, these movements were suspicious; simply being a communist causes one to emit signs that will trigger suspicion in the all-seeing eyes of the state.[30] An article in *Kedaulatan Rakyat* describes the capture of army Lieutenant Untung, leader of the September 30, 1965, coup attempt, as he tried to pass himself off as a humble "fruit seller."[31] The article notes, "His disguise inside the bus was uncovered thanks to the sharp eyes of two members of the army, who were also on the bus at the time." A large photograph on the same page shows General Suharto, then leading the search for communists, wearing dark sunglasses—as he often appears in images of the time. As in Wandi's story, the dark glasses code a penetrating vision attributed to the military state and embodied in the figure of Suharto.

A small blurb in the daily column "It Truly Happened" in a November 1965 edition of *Kedaulatan Rakyat* describes a woman who, upon being asked for her papers as she got on a bus, immediately burst into tears and revealed herself as a member of the outlawed communist women's group Gerwani.[32] It is as if simply by demanding papers, the state compels revelation of true identity. The discovery of fugitives on buses, moreover, emphasizes their potential to move through the landscape unnoticed by unsuspecting citizens. In these texts, the state's touted ability to discern "true" identity contrasts repeatedly with the inadequacy of ordinary citizens' own powers of recognition. The success of this rhetoric remains palpable in the way people who lived through that period frequently recall it as a time of terror precisely because "you didn't know who was your enemy and who was your friend."

In 1999, Sulami, a prominent figure in Gerwani who had been imprisoned by the New Order regime until 1984, published a memoir. In it, she described how during nearly two years of hiding before she was captured in 1967, she lived for a number of months in a friend's home in Jakarta. The friend provided her with a fake identity card that

identified her as a local resident: "In that way, my comings and goings could be orderly [*teratur*], and not *liar*."[33] *Liar*, a key word of New Order discourse, literally means wild or savage, but also carries strong connotations of the disordered, illicit, mobile, and unauthorized.[34]

Later in the text, we learn that Sulami used her own disguise to help others escape capture. During an interrogation soon after her arrest, her interrogator put four identity photographs in front of her on the table. "Do you know about this? Who are they? Look carefully!" he barks at her. She recognizes the images: they are the photos of four fugitive communists for whom she had attempted to acquire false KTP before she was captured.[35] In Sulami's memoir the KTP is a crucial instrument in the net of terror cast by the state; yet a false KTP can also, at least for a time, magically transform one from a *liar* fugitive into a legitimate *warga*.

A generation and political regime later, in August 2001, ex-president Suharto's famously corrupt son, Hutomo "Tommy" Mandala Putra, was in hiding. Tommy had disappeared following his conviction on corruption charges; the judge who had sentenced him was dead, murdered by hit men allegedly hired by Tommy. Megawati had just taken over the presidency and she vowed to bring him to justice. Newspapers reported that a police raid on the home of an acquaintance of Tommy had turned up a fake KTP and birth certificate.[36] On the identity card, "Tommy" had morphed into "Ibrahim" with long hair, beard, and moustache. Mimicking the communist fugitives his own father had hunted down, the slick playboy son of a dictator was attempting to pass himself off as a devout Muslim. That Tommy was imagined in these newspaper articles to need fake identification seemed a tribute to the durability of the regime of surveillance initiated by his father and pursued for more than three decades. But that Tommy was still on the run, eluding capture through false documents, gestured equally to the limits of state powers of recognition.

Warga versus *Liar*: Normalizing Paranoia in the New Order

Over time the emergency measures undertaken at the beginning of the New Order were normalized and incorporated into the everyday rituals of citizenship. By the end of the New Order, the KTP, which had to be carried on the body at all times, renewed every two years with a new

photograph, and changed whenever one moved residence, had become deeply entrenched as a sign of membership in the state-defined national community. The identity photograph became an idiomatic shorthand for the state's assertion of its power to authenticate who was a citizen and who fell outside the fold of state recognition and protection, or who was a *warga* and who was *liar*. In understanding the close relationship between the idea of the *warga* and the identity card, we should note that the identity card is technically a residence card and recall its origins in concerns about the mobility of the ethnic Chinese and political fugitives. The term *warga* not only connotes national citizenship (as in *Warga Negara Indonesia*) but can also signify membership in a particular localized community (as in *warga Yogyakarta*, or citizen(s) of Yogyakarta). To be a *warga* is to be located and locatable, matter in place.

Suharto's militarist regime initiated a vast expansion and penetration of the surveillance apparatus into the daily lives of Indonesians. Although the first national law to require the KTP was not passed until 1977, its intention was to standardize existing practices and local regulations begun well before that time.[37] These laws appealed to the need for "calm" and "national order" and referenced prior laws for registering foreign residents, making evident the genealogy of the KTP in efforts to track "foreigners within."[38] Now, all adults had to carry "proof of identity" (*bukti diri*).

For some, whose cards bore marks signifying their former status as political prisoners or members of the ethnic Chinese minority, the card identified them explicitly as threats under surveillance. More broadly, as a practice of state scrutiny the KTP helped establish a new basis for the relation between state and citizen formed within a paranoid visuality. As the identity card system was extended to include all citizens, all were served notice that they were regarded as potential threats. Routinizing the act of sitting for a photograph, of submitting one's image and information to the agencies of government, was perhaps the KTP system's most effective contribution to this new regime of visibility. The vast archive of identity photographs held jointly in individual wallets and in government offices, depicting individuated yet standardized citizens posed before an unseen but all-seeing state, offered an ideal representation of a society made up of docile *warga*.

The KTP was also both a product of and legitimated by "development": the spread of schools, health services, family planning, and

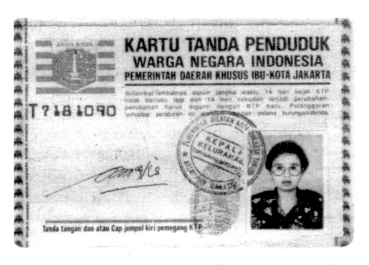

65. Identity card (KTP) reproduced as an illustration in a third-grade
social studies textbook. (In Muchtar, Rachman, and Sunoto,
Ilmu Pengetahuan Sosial, 38.)

other government-sponsored programs. Clearly, development policies
were closely linked to projects of state control. Paternalistic develop-
ment ideologies often provided the rationale for various intrusions of
the state apparatus into people's lives. Both "development" and the
elimination of the perceived security threat required identifying and
gathering knowledge about citizens, which was itself predicated on
their localization in particular places. But the successes of development
also meant a population increasingly on the move, spurred by improve-
ments in transportation and communications and by vast migrations to
the cities.

When I asked people about the institution of the KTP system, most
linked it to the early New Order period. But, echoing official logics,
rather than tie the KTP directly to the aftermath of the alleged commu-
nist coup, they often explained its necessity in terms of the increasing
social and physical mobility brought about by development. A man
in his mid-sixties cagily alluded to a climate of flux and uncertainty:
"It was the social condition that made it so there had to be a *pasfoto*.
There was a lot of falsification, of diplomas for example. People were
going here, going there. So in bringing about security [*keamanan*],
the residence [*domisili*] had to be clear, so there was the *Kartu Pendu-*

duk . . . because of the possibility of falsification, the photograph was required."[39]

In official accounts, the KTP came to emblematize the benefits of state paternalism. A social science textbook for third graders, for example, offers a brief explanation of the KTP, and the children's equivalent, the student identity card (also a KTP, *Kartu Tanda Pelajar*). A cartoon illustrates its value. On a class trip to a zoo, a young girl is separated from the group. Her KTP allows her to be identified by the authorities (a man and a woman) and safely returned to her teachers (also a man and a woman). Surrogate parents, the parallel gestures of the authorities and the teachers in the illustration underline the symmetry between state and familial forms of recognition. The text explains: "This card, it is hoped, will always be brought with you if you go to school or go anywhere . . . if something were to happen to the student, other people or officials will easily know [*mengenali*] him or her and will easily contact the parents or the school."[40] The KTP, as a sign of the legitimate *warga*, becomes a talisman against a vague fear: not to carry it is to render oneself vulnerable to an unnamed danger associated with being unknown.[41]

The formation of a boundary between the community of *warga* and those who are *liar* enacted through the identity card system often served to label as "outside" the national community precisely those who escaped or resisted the state's localizing logics: nonsedentary populations, guerrilla fighters, and homeless children. Indeed, if card-carrying lost children can be found, homeless children—children unmoored from the normative communities of family and neighborhood—pose a particular problem to a state order that requires "official" marks of identification. It should come as no surprise that homeless children are often referred to as "*anak liar*"—wild children. This relegation to a position outside of the state-sanctioned Indonesian community found ultimate expression in a case in Yogyakarta in which a murdered street child was refused proper burial because he lacked official identity papers that designated him a *warga* of a neighborhood. Despite his friends' attempts to identify and bury him properly, he remained officially an "unidentified corpse." Only a groundswell of popular protest organized by an activist group ultimately secured his burial in the neighborhood where he had been (unofficially) living.[42]

Here, a different potentiality of the term *warga* came to the fore. Unlike the charged collective terms *massa* (masses) or *rakyat* (the people),

which resonate with the revolutionary, leftist rhetoric of the Sukarno era, *warga* is usually a politically neutral term, one closely associated with official state discourse and bureaucratic practice.[43] Yet there is a tension between its official use as a singular noun, designating the atomized subject of state bureaucracy, and its everyday use as a *collective* noun to signify those belonging to a particular place (as in *warga Yogyakarta*, citizens of Yogyakarta, or *warga kampung*, people of the neighborhood). In its collective form, *warga* occasionally emerges as an assertion of local definitions of community. In this case, *warga* of the neighborhood in which the street child had lived claimed him as one of their own, forming, momentarily, a collective agent of recognition that opposed the state's documentary regime of identification.

Picturing Death: The *Pasfoto* and the Unidentified Corpse

It is in death that the boundaries between *warga* and *liar* become especially clear. Newspapers are, of course, powerful sites for the textual and visual representation of society, as well as important vehicles by which state discourses enter public debate and popular imagination. In the visual rhetoric of Indonesian newspapers, *warga* who die in violent incidents or accidents are pictured with an identity photograph, while gruesome images of "unknown corpses" form the spectral and spectacular image of those who are *liar*, who die beyond the bounds of state-defined community.[44] In April 2000 a Yogyakarta newspaper printed a photograph of the burial procession of a Javanese soldier killed in the troubled province of Aceh, with an inset of his identity photograph showing him in uniform.[45] The headline reads, "Son of Bantul [a region south of Yogyakarta], Killed by the Aceh Freedom Movement, Is Buried." The identity photograph establishes the dead as a recognized citizen, a "son" of a place to which he belongs, despite his death thousands of miles away at the hands of the Aceh Freedom Movement, a group that in the state's eyes epitomizes the *liar*.[46]

Similarly, in a March 2000 edition of *Kedaulatan Rakyat*, an accident in which a person was killed when his car was struck by a train is pictured in two nested images: a photograph of the smashed car and an inset of the driver's *pasfoto*.[47] In that same edition of the newspaper, a contrasting visual idiom of death appears. A photograph shows the bloodied corpse of a man who had attempted to assassinate a promi-

nent political leader. The would-be assassin was caught and beaten to death by a crowd as he fled the scene. The caption reads: "The suspect of the effort to murder Matori Abdul Djalil, who was beaten to death by the masses. The identity of the suspect is still being studied by the authorities." Those who die without identification are frequently portrayed in this way, with the phrases "corpse without identification" (*mayat tanpa identifikasi*) or "unknown corpse" (*mayat tidak dikenal*) used to describe their exposed bodies.

Ostensibly, the inclusion of such photographs would be intended to allow those who might "know" the corpse to identify it. But the photographs rarely show the corpse in a way that would facilitate identification; they seem rather to picture the state of not being identified. An article in a newspaper from August 1999, for example, carries the headline "Causing a Stir, a Tattooed Corpse in a Bag" and shows a photograph of villagers looking at a naked corpse, face-down and partially wrapped in a white cloth, lying on the ground in a field.[48] During the state's extrajudicial campaign of killings of thousands of gang leaders and petty criminals in 1982–1983, known as *Petrus (Penembakan Misterius* or Mysterious Shootings), the tattoo was read as a generic sign of criminality with lethal results.[49] One of the terms commonly used for the petty criminals and local toughs targeted by *Petrus* was *gali-gali*, an acronym for "group of wild children" (*gabungan anak-anak liar*).[50] While for the person who wears it, the tattoo is a marker of personal or group identity, for the state it becomes a sign that identifies the bearer as outside the community of "citizens" who would carry "proper" identification and who, presumably, would not be killed in such a manner. The tattoo is the anti-identity photo, a sign of being *liar*.

Those designated *liar* are thus vulnerable to state violence or at least unworthy of state protection; *liar* is the state's name for that which it excludes. Another article shows a large photograph of a corpse laid out on a table, with a plastic string still about its neck and a tongue protruding slightly from a bloated face.[51] The headline reads, "Corpse without Identification Found in the Progo River." The article's conclusion that "no citizen [*warga*] has yet reported the loss of their relative [*saudaranya*]" encapsulates the ideology embedded in images of unidentified corpses: the recognized dead are members of families, and these family members are citizens who follow proper procedure by making the death known to the authorities. As in the elementary

school textbook, state and familial structures of recognition are parallel and mutually reinforcing.

Doubting Identity and Documentary Suspicions

The cases of Tommy Suharto, Sulami, and the street child who was finally buried suggest that the New Order regime of identification was both durable and haunted by its own limitations. Stories of falsified identity cards form a vast urban lore of their own. But it is not only the possibility of inauthentic documents but the gap between the official identities recorded on the KTP and lived experience that shakes the foundations of this regime. Nowhere is this gap more deeply felt than when it comes to religious identity. The anthropometric requirement that a person be bareheaded for the *pasfoto* has met with frequent protests from devout Muslim women who regard this rule as evidence of the state's effort to impose a secularized face on its citizens. In a letter to the editor of *Kedaulatan Rakyat* in August 1999, for example, a young woman exultantly shares news of a rule allowing the wearing of headscarves for the driver's license photograph. She writes, "And thanks be to God . . . I was able to be photographed for my driver's license without having to take off my *jilbab*. To my Muslim sisters: we can get our license without having to violate the rules of God. Keep wearing your *jilbab*."[52]

Yet if for some the *pasfoto* seemed to impose a secular identity, the KTP was also one of the technologies by which the government promoted and enforced state-sanctioned religiosity. As Janet Hoskins argues, the New Order imposed new definitions of "cultural citizenship" in which "conversion to a world religion . . . [became] a prerequisite for participation in the wider world of government, schools, and trade."[53] The KTP law of 1977 required inclusion of religious affiliation on the card and a directive in 1978 listed the five officially accepted religions: Islam, (Protestant) Christianity, Catholicism, Hinduism, and Buddhism, noting that Confucianism was not a recognized religion.[54] Not to choose among these five—leaving the line on the KTP blank—implied atheism, which in the New Order was tantamount to communism. The insistence that citizens identify themselves religiously on the KTP formed part of a government crackdown on "wild" (*liar*) religions (such as animism, ancestor worship, and Confucianism) asso-

ciated with life-ways that the state was trying to eradicate in the name of development and anticommunism.[55]

Irreverence about the authenticity of "official identity" is an unintended outcome of state-imposed forms of identification. For many, the identity card became a code for an identity that was superficial or hypocritical rather than authentic. The idioms "Islam-KTP" ("identity card–Muslim") or "Kristen-KTP" ("identity card–Protestant") designate the merely nominal religious affiliation of people who are actually nonpracticing or who converted to a religion as a kind of political alibi. One man in his sixties, for example, told me that like many Javanese he had been raised a nonpracticing Muslim. Alienated by what he saw as an upsurge of Islamic "fanaticism" in the 1980s, he converted to Catholicism. But, he said, he remained a "Katolik-KTP," that is, a Catholic in name only. A Chinese Indonesian man told me that although he is identified as Catholic on his KTP he considers his true religion to be a mix of Catholic, Buddhist, and Confucian teachings. This same man asked me if I went to church. When I said no, he teased (assuming, as most Indonesians do, that Americans are Christian), "Ah, so you are an identity card-Christian [Kristen-KTP]."[56]

But if these idioms playfully reveal the gap between lived and bureaucratic identities, there were moments when the KTP's definitions of religious identity could—or at least were imagined to—have serious consequences. When religious conflict broke out in Ambon and, sporadically, in other parts of Indonesia in early 1999, rumors spread that gangs of Muslim militants were initiating "KTP raids" (*razia KTP*), stopping people and demanding to see their identity cards. If you were of the wrong religion, you might be killed. Mimicking the gestures of the police, who also periodically conduct KTP raids to ensure that people's papers are in order, these gangs appropriated the role of a recognizing agency authorized to read the "truth" of the identity card.[57]

Such rumors flooded Yogyakarta after a rally in January 2000 in support of Muslims in Ambon ended with youths riding in motorcycle convoys around the city and throwing rocks at local churches. Catholics and Protestants started leaving their KTP at home when they went out; their fear of this kind of raid far outweighed concern with being caught by the police. While to my knowledge these KTP raids never actually happened in Yogyakarta, the terror people felt was real. Such appropriations of the state's authority to conduct raids, like popular irreverence toward the KTP's truths, point to the limits of the state's arro-

gation for itself of the role of recognizing agency and to the unintended reverberations of state practices of identification in everyday life.

Popular Appropriations

Like all photographic genres, identity photography is neither discrete nor independent; it must be understood in its interrelations with other photographic genres that constitute a broader representational field. Writing of Europe in the late nineteenth century, Allan Sekula argued that all of society was engaged in a vast archival (and representational) project that extended from state identification photography to bourgeois portraiture. Collectively, the varied genres of photography produced a dispersed "shadow archive that encompass[ed] an entire social terrain while positioning individuals within that terrain." The "category of the individual" provided an overarching structure to this archive, but an implicit hierarchy was established through its two dominant portraiture genres, labeled by Sekula as the "repressive" and the "honorific." Criminals, mental patients and colonial others were subjected to the indignities of the "repressive" identity/anthropometric photograph and implicitly placed in relation to the bourgeois elite who avidly made, collected, and displayed their own elegant, "honorific" portraits.[58]

Yet in late-twentieth-century Indonesia, the lines between "honorific" and "repressive" portrait genres were not so clearly delineated. The New Order state's fetish of documentation made the identity photograph the most widespread form of photographic portrait. Inexpensive and readily accessible, *pasfoto* were put to a wide variety of personal, "honorific" purposes, from memorial portraits to tokens of friendship. The same photographs required for "official" purposes of identification, then, could be enlisted to display and sustain social ties and personal memory, tapping into different regimes of recognition. The social life of the Indonesian *pasfoto* demonstrates how state-bureaucratic and sentimental, "repressive" and "honorific," visual practices overlap and inform each other.

Nor, then, can we sustain a rigid opposition between official and popular visualities. Pinney draws a strong contrast between the visualities underpinning Indian state identity photographs and popular photographic practice.[59] In contrast to state practices of identity pho-

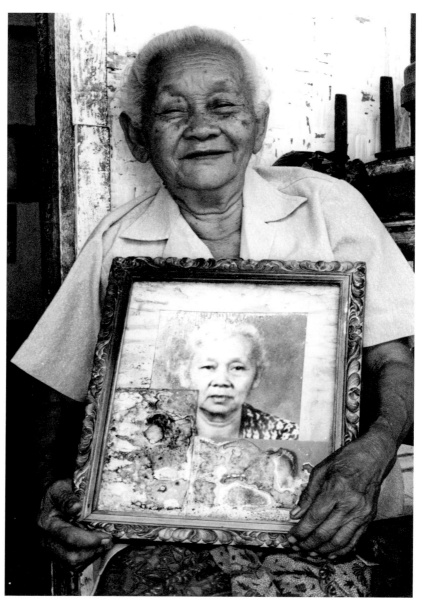

66. Ibu Gimo holds her framed identity photo, Yogyakarta, 2000.

Photo by the author.

tography, he argues, Indian popular photography treats the camera less as an instrument for pinning down the "real" than a means to generate imaginative worlds. Certainly, as we saw in the previous chapter, this is also the case with the genre of studio portraiture in Java. Yet popular appropriations of identity photographs as personal portraits demonstrate how the state's gaze is both extended and refigured as it seeps into popular "ways of seeing."

Just as words carry historical accretions of meaning beyond the immediate intentions of their users,[60] the identity photograph becomes available for new meanings as it moves into new contexts yet still bears the traces of its history within state regimes of photographic identification. Liam Buckley describes the popular use of identity photographs as personal portraits in Gambia as a "contra-modern" practice "in which the techniques of modernity animate behavior that falls beyond the spheres of rationalism, efficiency, and governmentality."[61] But these popular practices are not entirely "contra-modern," because, although they reach beyond the narrow purposes of governmentality, they refract the distinctly modern notion that individual "identity" can be represented through photographic signs. The imprint of the identifying function remains, refractory and not entirely assimilated, even as the *pasfoto* is drawn into alternative circuits of recognition and regimes of value.

But should we even assume the priority of the *pasfoto*'s identifying function? Moelyono, a photojournalist in his sixties, showed me his diplomas from junior high school (1957) and high school (1959), which feature his *pasfoto* overlaid with signatures, fingerprints, and official stamps. At first glance they perfectly perform the function of the identity photograph. Yet when examined closely, like Ibu Soekilah's husband's identity photograph discussed in the introduction, the images clearly diverge from the standard identity photo, picturing their sitter at a slight angle rather than in a frontal pose. Moelyono looks away from the camera rather than straight into it. Although evidently acceptable for the official purpose of a school diploma, these are obviously carefully composed images taken by a skilled photographer interested in flattering his subject as well as recording his likeness with perfect fidelity.

Until the mid-1970s, studio photographers routinely touched up *pasfoto* negatives in order to remove blemishes, shadows, and other unsightly marks (only a few studios still offer this painstaking and

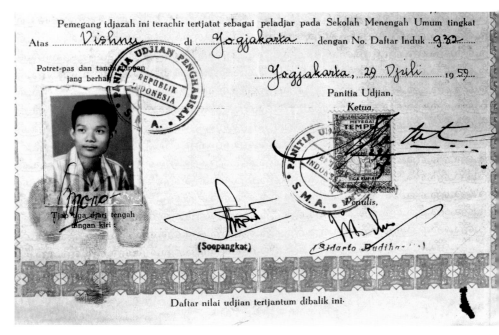

67. Moelyono's junior high school diploma, 1959.
Collection Moelyono.

skilled service). Such "identifying" idiosyncrasies as a birthmark or a scar might be erased in order to satisfy the vanity of the customer—to create a more perfect copy. Slightly improved and idealized portraits, *pasfoto* were always imagined to serve not only bureaucratic purposes but personal ones as well, their status as transcriptive records subverted by the photographer's hand and the customer's desire.

Memorial Images

The *pasfoto*'s coded message of legitimate death in the pages of Indonesian newspapers is an effect not only of the state's visual logics of citizenship but also of the popular use of identity photographs as memorial portraits. The *pasfoto* signals recognition-in-death not only by the state but also by the family. If Chinese Indonesians provided a template for state practices of identification, they also pioneered this common appropriation of the identity photograph.

68. Perfected identity photo,
1957. *Collection Ibu Soekilah.*

69. Chinese Indonesian funeral with memorial portrait affixed to coffin, ca. 1960.
Collection Liem Goen Hok.

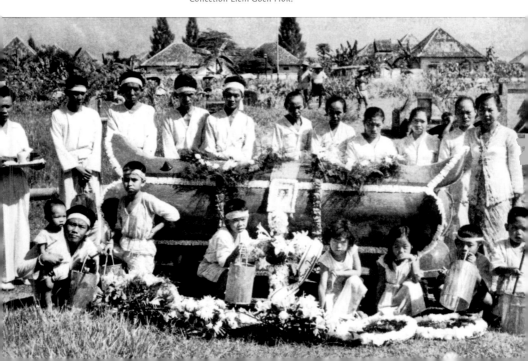

Darwo, a Chinese Indonesian photojournalist in his sixties, explained, "*Pribumi* [native] people back then didn't yet use photos, but now, you know, if the person is going to be buried they carry his [identity] photo. Before, it began with Chinese people." Typically, a standard identity photograph is enlarged and framed, displayed near the coffin throughout the funeral ceremony, and carried in the funeral procession. Thereafter it may be hung on a wall of the home, usually in a front room or, in Chinese Indonesian homes, above an altar at which incense is burned. "Those whose religion is Confucianism . . . hang the photo or put it on a table for prayer, and use incense [while praying to the person's spirit before the photograph] . . . and the ash from the incense can't be thrown away," explained Darwo, "We hang [the photo of the deceased] to remember." Describing the particular days on which Chinese families "give respect to the dead" by praying before their photographs, he continued, "So without the photo it's like it has no meaning." With the photo, "we feel as if we are facing the [deceased's] soul."

By at least the 1950s, the ethnic Chinese community had adopted the *pasfoto* for use in funeral and ancestor worship rituals. Beyond their ready availability, the formal qualities of identity photographs made them particularly adaptable to commemorative purposes. The extreme conventionality and reductiveness of the identity image—the stiff and uniform pose, the frontal gaze and vacant facial expression, the blank backdrop, the formal rigor of black and white[62]—all make for an image that eliminates what Benjamin called "the tiny spark of accident, the here and now," extracting the person from time and place.[63] It is the governing ideology of the identity photograph to treat the image as beyond history—like a fingerprint, the identity photograph is supposed to map consistently onto its referent—even though the failure to achieve this perfect ahistoricity is revealed in the requirement that the KTP photo be renewed every two years. The deracinated and timeless impression of the identity photograph is mobilized in its use as a commemorative image to signify the static, permanent, and radically decontextualized nature of death.

There are striking commonalities between the aesthetics of traditional Chinese portraits used for ancestor worship and the conventions of the identity photograph. In her study of early photographers of Hong Kong, Wue notes that in the late nineteenth century cheaper photographic images quickly became substitutes for the painted ancestor portraits previously used in commemorative family rituals.

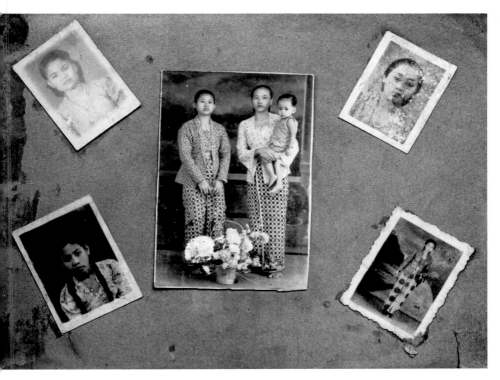

70. Page from Ibu Soekilah's photo album, combining studio portraits and identity photos (all ca. 1950s).

These photographs, imitating earlier painted portraits, used a "static and frontal seated pose," minimized shadows, emphasized a complete inventory of symmetrical features, and rejected facial expressions that might intimate interiority or action.[64] A major difference between the earlier ancestor portraits (both painted and photographic) and identity photographs, however, is that the ancestor portraits tended to be full body and to include objects that were signs of the status of the person. Nevertheless, by the second decade of the twentieth century it had become common in China for an image showing only torso and head to be used as an ancestral portrait instead of the full body image.

The use of identity photographs in funeral rituals seems to have spread from the Chinese Indonesian community to the Javanese Christian community and more recently to the Islamic majority; today the practice is fairly universal in urban Java.[65] Chinese funeral processions were often large public events before New Order prohibitions on pub-

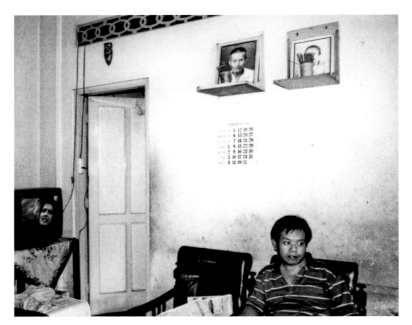

71. Ancestor portraits with incense, Chinese Indonesian home, Yogyakarta, 2000. *Photo by the author.*

72. Ancestor portraits and altar (and commercial image of Jesus), Chinese restaurant, Yogyakarta, 2000. *Photo by the author.*

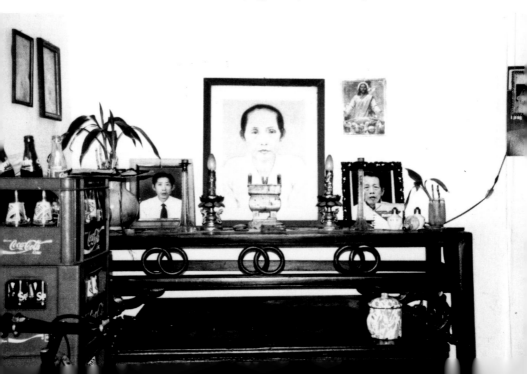

73. Framed identity photographs on the wall of a Javanese-owned restaurant, Yogyakarta, 2000. *Photo by the author.*

lic displays of "Chinese culture," and photographs of deceased family members are prominently displayed in Chinese Indonesian domestic and commercial spaces, often within clear sight of those entering the front room of a Chinese home, restaurant, or storefront. These highly visible practices may have provided object lessons for Javanese, who adopted them, albeit without their explicitly ritual and religious dimensions. One Javanese man in his sixties recalled his mother cautioning, in a comment that signaled anxiety about the blurring of cultural boundaries, "Don't make your house like a Chinese person's, with photographs all over the place!" Despite her warning, in many Javanese homes and restaurants today, one finds enlarged identification photographs of deceased elders on the wall.[66]

Although typically reserved for the dead, the blown-up identity photograph may also be used as a formal portrait for a living family member as well, or to unite the living and the dead. Ibu Sudirman's husband had died about eight years before I began living in her home, where I stayed for more than a year as I did research for this book. A copy of the identity photograph used in his funeral procession and

74. Composite portrait from two identity photos.
Collection Ibu Sudirman.

kept in a family album had been rephotographed with an enlarged copy
of Ibu Sudirman's identity photograph to form a single composite
image of husband and wife. This framed double portrait hung in the
front room of the house, high above a doorway. The only image of the
couple on display, it joined them together in a timeless, death-defying
union.[67]

The *pasfoto* has become so standard for memorial purposes that its
formal qualities are emulated even when an actual *pasfoto* is unavailable.
On one occasion, I went to visit Jack (the amateur photographer we
met in chapter one) but found that he was out. While waiting for him
to return I chatted with his wife, who began telling me of her elderly
mother's recent bouts of serious illness. Her mother had already pre-
pared her memorial portrait, she told me. Memorial portraits were on
Jack's wife's mind because a distant relative of the family had just died
and the bereaved family had called on Jack to help prepare a memorial
image for the funeral. When he returned a bit later, he told us that
the family had been unable to find a print or negative of an identity
photograph of the deceased woman. Eventually the family located a
full-body color snapshot of the old woman. To bring it formally closer

to the standard memorial image, Jack took a photo of the snapshot using black-and-white film. He would then enlarge and crop the image so that only her face and upper torso appeared. The resulting image approximated, as closely as possible, a *pasfoto*.

The same *pasfoto* that one accumulates for mundane bureaucratic purposes thus also inevitably signifies one's future death (and remembrance by one's loved ones). A thirty-year-old woman I knew expressed in a striking way her recognition that her identity photograph would become her funeral portrait. The death of a good friend eight years before had had a devastating impact: "I thought of death all the time," she told me. Obsessively imagining her own death, she prepared her memorial photograph, blowing up a *pasfoto* of herself, framing it, and hanging it on the wall of her bedroom. Although she was no longer consumed by thoughts of death, the image remained on the wall, a stark and eerily still portrait that contrasted with the animated images that filled her photograph albums. She had "updated" the memorial photograph several times since first hanging it, replacing it with more recent identity photographs.

Tanda Mata and New Circulations of Sentiment

In addition to memorial portraits of her son and husband hanging on her wall, Ibu Soekilah kept a felt-lined jewelry box filled with small, black-and-white identity photos of her friends and family from the 1950s and early 1960s. She called these images *tanda mata* — souvenirs or reminders, literally, "signs for the eye" — and explained that she and her friends had exchanged them as tokens of friendship. A few were portraits with painted backdrops like those discussed in the previous chapter. But most were identity photographs, because, she explained, one often needed to acquire them for official purposes. Once a negative had been made, *pasfoto* could be reproduced inexpensively and exchanged with friends.

For those of Ibu Soekilah's generation who lived through the transition from a colonial order to a national one, these "official" signs of identity were also tokens of the new opportunities and social relations made possible by independence and nationhood. Since the late colonial period, identity cards were associated with club memberships, professional associations, and other marks of privileged entry into the

modern world.[68] In the 1950s, one acquired *pasfoto* by participating in the rituals of "modern" national life, particularly education and employment in factories, bureaucratic agencies, and other professions that marked a break from an agrarian past.

As exchanged and circulating *tanda mata*, sentimental tokens of "modern" friendship and perhaps "love," these images also attested to new kinds of social bonds. One can imagine the appeal of the formal equivalency of these images, iconically representing the mutuality of social exchange among peers, in a social order proudly forming itself around notions of equality as Indonesian citizens, rather than the traditional hierarchies of Javanese social relations. The exchange of these images responded to the new physical as well as social mobility of the population. As Ibu Soekilah told me, *tanda mata* photos were most intensively exchanged at occasions of parting (*perpisahan*), as someone left to pursue a job or an education or married life in a different city.

The exchange of identity photographs as mementos of friendship among peers would become an integral part of youth culture as education became more widespread and the use of identity photos in schools more pervasive in the New Order. In the 1970s, schoolchildren of all ages were required to have identity photographs taken not only for their graduating diplomas but for their enrollment in school each year. Students often ended up with many extra copies of their own image; one woman told me that at one point in grade school in the early 1980s she had had over a hundred excess copies of her own *pasfoto*. These images were often pasted into *memori* books—small books in which each classmate could write a message to the owner—exchanged at the end of the school year. In addition to a proverb or personal message, each student inscribed her page with her *biodata*. Mimicking the style of a bureaucratic form, the pages usually included a standardized list arranged on the page like a prefabricated form: "name," "age," "address," "birth date," "religion," followed by more whimsical "data" such as "hobby," "goals," and "sign (zodiac)." At the bottom of the page, precisely where it would be on a typical government document, the *pasfoto* image would be glued in, next to or below the signature.

It is not surprising that the environment of school, a modern, bureaucratic, and quintessentially disciplinary institution, would produce forms of representation intimately tied to state technologies of identification. Nevertheless, as a memento of friendship, the *pasfoto* moves beyond a strictly bureaucratic frame and indexical function. In some

Data Pemilik Buku

Nama asli : Endang Mulyaningsih
nama bengokan : Endang / Donald / Fahie
lair : Yogya, 9 Februari 1986 ... eh 1969
ngalamat : Wik munut bapa biyung
warna favorit : biru, item, putih.
ageman : seragam sekolah, jeans
maeman favorit : apa aja asal gratis!

Diramalkan (oleh dukun anyaran) :
Kawin .. eh nikah : umur 23 th
Anak : dikit
Sugih : umur 30 th
Mati : umur 30 th ∠pas sugih z e⟩
Suami : lanang!

Tambahan data :
Hobbie : teater, maem, nggambar .. de el el
alergi : buah kelengkeng, kimia, guru
killer, cowok norak.
kendaraan : "si semut"

⟨Endang Mulyaningsih⟩

75. "Memory Book" page using old *pasfoto*, 1987.
Collection Endang Mulyaningsih.

memori books, *pasfoto* are used more playfully as signs of identity: one young woman graduating from high school in 1987 pasted in an old *pasfoto* from elementary school at the bottom of a message she had written to a friend. As if anticipating the nostalgia with which her friend would one day read the image, she underlines the passage of time that challenges the claims to immutability implicit in the identity photograph. In other *memori* books, identity photos are collaged with snapshots and images of rock and movie stars cut out of magazines, removing the *pasfoto* subject from her stark isolation and projecting her into the realm of mass-mediated fantasy. These more imaginative uses of the identity photograph subvert the governing ideology of the *pasfoto* while retaining traces of its identifying function.

Surrogate Biographies

The state's interest in generating photographic proof of identity preceded many people's ability to acquire "honorific" photographs of themselves; for many, the identity photograph served as their sole portrait. But as more and more Indonesians had access to cameras and disposable income to spend on photography, a new generation came to desire—and expect—documents of their pasts saturated with sentiment. Wiwik, a young woman in her mid-twenties, expressed intense regret that she had no photographs of herself as an infant or small child. Soon after she was born, her father married a second wife and quickly had two more children (in addition to the three he already had with her mother).[69] A taxi driver, he made enough money to put Wiwik and her siblings through high school, but there was little left to spare. Wiwik, however, attributed her lack of childhood photographs not so much to financial difficulties as to the emotional circumstances of her childhood.

For her, the absence of photographs was a painful sign of neglect. She told me she often asked her mother why she had no photographs, to which her mother responded, "I'm sorry Wiwik, at the time I just wasn't thinking of it." Then, to make her feel better, and so that she might have a "picture" (*gambaran*) of herself, her mother would describe how she looked as a child: "very little, with big cheeks, and reddish, very curly hair." "I try to imagine myself," Wiwik says, and then goes on,

I know that my mother didn't have any money and she was busy, what with thinking about the bad behavior of my father at that time . . . I always think, why don't I have even one photograph of when I was little? . . . My mother's sister, even though she can't read, has no education, doesn't have anything, yet her children all have pictures . . . and they are older than my older siblings and me . . . Even my grandfather has a photograph of himself. So I think truly it's because of the cruelty of my father, because my father never ever loved us, he never cared about my family. I think that my mother wanted to, that she felt proud, she wanted to have a picture, but she was too busy . . . I used to always be jealous of people who had pictures from when they were little.

What is striking in Wiwik's statement is her feeling that something rightfully hers has been denied. She refuses to see this lack as a sign of financial inadequacy or changing times, citing her aunt's children and her grandfather as counterexamples. Instead, Wiwik interprets the absence of childhood photographs as proof of a lack of love.

Wiwik told me, "I first got a picture [of myself] in junior high school. My friends and I would gather together enough money and go on a picnic and take pictures. One of my friends had a camera; I never did have a camera." As if to make up for the absence of childhood pictures that would have signified parental caring, Wiwik created her own condensed childhood album from her elementary and junior high school identity photographs. On a page of a family photo album containing images of herself and her siblings in later years, she lined up these *pas-foto* in a vertical row, forming a truncated version of the documentary biography that her parents had failed to provide.

A similar arrangement appears in one of Moelyono's family photo albums. A photojournalist and amateur photographer, Moelyono once told me that he enjoyed photographing his children more than any other kind of photography because their "expressions are still authentic" (*masih asli*) and they are natural comedians, perfect subjects for the camera. Moelyono's appreciation for his children as photographic subjects was clearly informed by his sensibility as a photographer, but it was also a means of expressing his love for his children. He prided himself on the extensive photographic "archives" (*arsip*) he had created for his family.

Moelyono's albums were also full of pictures of himself as an adult, after he became a photographer. But his life prior to adulthood was

76. Album page with Moelyono's identity photo "biography."

Collection Moelyono.

compressed into part of a single page in one of these albums, sharing space with photographs he had taken of his daughter. Like Wiwik, Moelyono composed a skeletal visual narrative of his childhood from the only images he had of himself prior to adulthood. While two of these show him with other children (and appear to be photographs taken on the occasion of his circumcision, a ritual that often warranted a trip to the studio), the rest are identity photographs—the same ones that appeared on his diplomas.

Both Wiwik and Moelyono overcame a perceived lack by putting identity photographs to use as records of personal history. Incorporated into and recontextualized within a family album, they exceed their function as state signs. While the *pasfoto* used for memorial purposes and as *tanda mata* exchanged among friends exploit the singularity of the identity photograph as a proxy for the individual, the compilation of multiple identity photographs to form a series, a surrogate biography, works against this singularity to generate a sense of chronological progress, temporality, and transformation.

Appropriating State Signs

In the spring of 2000, the Indonesian postal service (in collaboration with an Australian company) launched a new kind of postage stamp.[70] Using digital photography and scanning technologies, one's own face could appear on a bona fide stamp. As one article about the customized stamps noted, these state-issued and authorized signs could now be "very special, unique, and personal."[71] The new product was called "prisma," an abbreviation for Your Own Identity Stamp (*Perangko Identitas Milik Anda*). The verb *milik* ("to possess") conveys the idea that identity is a possession that can be materialized and symbolized in the photograph—a notion that gained currency in part through such bureaucratic practices as identity photography.

The prisma stamp playfully inverts the logic of the state's imposition of documentary forms of identity by turning signs of formal bureaucracy and state power into material for personal expression, sentiment, and memory. The stamp is an "interesting product because, aside from being used to send letters, it can become a souvenir, a collection, a memory of an event (like a graduation or a marriage)," says one promoter in a newspaper article.[72] Another promotional article suggests

using the prisma stamp as "a decoration or something to hang [on a wall]."[73] Enmeshing notions of individual identity with the market economy, commodified state signs become available for popular consumption.

The story about Wandi and the magical identity photograph described at the opening of this chapter articulates a prevailing mood of suspicion toward state visuality during the reformasi period; the prisma stamp, meanwhile, embodies an attitude of playful irreverance toward state signs of power that equally characterized this transitional moment. It may have been coincidence that the Australian product reached the Indonesian market during reformasi. Nevertheless, the idea that "you" could put yourself in the place traditionally occupied by state leaders and other important personages fit well with the general sense that the icons of state power were available, in new ways, for popular engagement.[74] In the days immediately following Suharto's resignation, enterprising photographers and performance artists had enlarged stamps, money, and official posters bearing Suharto's image, cut out his face, and sold people the opportunity to make souvenir photographs that put themselves in his place under the title "Next President of Indonesia." One article explicitly drew a connection between the postal service "reforming itself" and the use of more popular images on stamps: "While before the stamps that were distributed only had the image of the president, now there is a wealth of things that can be made into stamps."[75]

From the KTP to the prisma stamp, this chapter has traced how a mere "paltry paper sign" has come to be a token of individual identity overlaid with the stamp of state approval and the foreknowledge of death.[76] Scholars have noted a homology between personal acts of documenting identity and the archival practices of modern states.[77] Beyond homology, an Indonesian history of the threads linking the state's insistence on documentary *bukti diri* (proof of identity) to personal practices of documentation reveals identity photography to be a practice that ramifies beyond state projects, helping to produce the very idea of identity as a possession that can be represented in photographic form.

The identity photograph has become a material site where state definitions of citizenship and popular forms of recognition overlap and compete. However pervasive, the state's insistence on the identity document as the locus of "true" identity was always subject to doubt.

In arrogating for itself the power to see through disguises—presenting itself as the sole agent of recognition—the state stimulated anxiety about the mutability of identity and the uncertainty of documentary evidence. But doubt also arose because, as documentary forms of identity became more deeply entrenched in everyday life, dissonances between people's lived experiences and the narrow confines of state-defined identities became more palpably felt. Meanwhile, put to popular use, identity photographs move beyond the meanings assigned by the state, entering new circuits and responding to other sources of authority and recognition, even as they retain the traces of their identifying function.

Popular practices embed identity photographs in networks of social relations, structures of recognition, and personal trajectories that exceed the *pasfoto*'s state-assigned function as proof of identity and mark of citizenship. The next chapter will examine a different way that photographic "documentation" has become integrated into the intimate practices by which families and individuals constitute, recognize, and remember themselves. If the *pasfoto* became an icon of Indonesian citizenship, "documentation" photographs of family rituals work to enframe religious, ethnic, and other familial rituals within the temporal logics of Indonesian national modernity.

Family Documentation

IN 1978, AS SMALL AUTOMATIC CAMERAS were newly making their way into the homes of the Indonesian middle class, an ad for Sakura film showed a picture of Widyawati, a popular Indonesian singer, and featured this quote from her: "Like me, you need documentation photographs to immortalize [*mengabadikan*] your life. To remember things that have happened that will never be repeated again." Linking photography to memory and familial sentiment, the advertising copy read, "Widyawati greatly loves herself and her family. Her love is always immortalized with Sakura Super Postcard in her albums."[1]

Just over twenty years later, as the economic crisis that began in 1997 threatened to devastate an industry that had flourished during the previous two decades, one of Yogyakarta's prominent studios and wedding photography services attempted to shore up business by promoting itself with an article in the local newspaper.[2] The article, bearing the headline "The Party Can Be Simple, the Photos Must Be Special," quotes Kencana Studio owner Kirana Yulianto saying that wedding photographs need to be good because "this is, of course, an historic occasion that will be remembered for as long as you live." Economic hard times may have caused people to cut back on the scale of their ritual ceremonies, she goes on, but, "as for documentation, that's still considered important. It may even be the main point [*point utama*], because documentation photos can create a chain [*rangkaian*] of beautiful memories all the way to [your] grandchildren."[3]

In the interim between these two promotions, economic development—a rising standard of living, a growing consumerist middle class, openness to foreign investment under Suharto's economically liberal regime—greatly intensified photography's use as an instrument of family memory in urban Java. By the mid-1970s, the introduction of smaller, inexpensive cameras, color film, and automatic processing began radically to expand photography's accessibility. We have seen that, since the 1950s if not before, people in Java had been commemo-

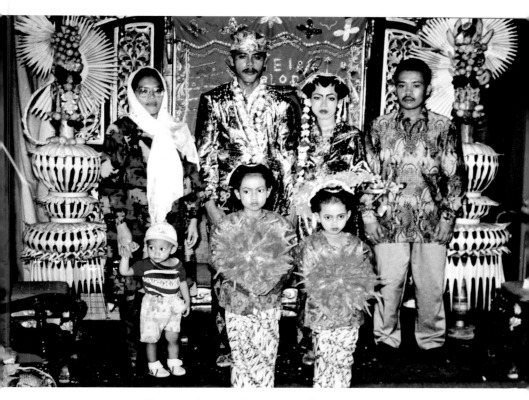

77. Wedding reception, Yogyakarta, 1996. *Collection Minarni.*

rating key life passages, family gatherings and holidays, and other spe-
cial occasions with trips to the studio. Now, more and more personal
photography took place outside the studio. This *in situ* photography
was performed both by laypeople of their own families and by profes-
sional or quasi-professional photographers performing a service known
as *panggilan* ("called [upon]").[4] In *kampung* (closely knit, lower-class
urban communities), owning a camera often meant one would be ex-
pected to serve as the photographer at neighbors' funerals, weddings,
and other ritual events.

In response to my inquiries, most people would tell me that they had
purchased their cameras for "family documentation" (*dokumentasi ke-
luarga*); in Java as in many other parts of the world, the camera has been
taken up in service of what Bourdieu called "the family function," "sol-
emnizing and immortalizing the high points of family life, in short . . .

reinforcing the integration of the family group by reasserting the sense that it has both of itself and its unity."[5] Barry King describes a global ideology of "photo-consumerism," which construes the act of photographing as "an act of visual caring."[6] In the Sakura ad and in similar promotional materials, the deployment of such "photo-consumerist" discourses of "capturing" unrepeatable moments in order to show family "love" indicates confidence on the part of multinational film companies in their easy transmission and relevance to Indonesian contexts. Such marketing strategies naturalize and universalize the need for photographs as family memory objects even as, through their very investment in advertising, film companies and photo studios implicitly acknowledge that these "needs" must be cultivated.

Many people I spoke with also emphasized that these new idioms for expressing familial sentiment required the development of new kinds of "awareness." Observing that "the culture of photography is new," an artist explained that Java is fundamentally an "oral culture" without a "tradition of documentation." Another person noted that Java had gone in a generation from being "weak in documentation" to "crazy with documentation." One man in his early thirties expressed regret about having accidentally ruined his only photograph from his childhood: "I regret it so much," he told me, "It was the only one I had." I asked why he had so few photographs, suggesting that perhaps it was because of the economic conditions of his rural childhood. "Maybe . . ." he answered doubtfully, in a polite form of disagreement. Then he added, articulating a common theme, "Maybe because there wasn't yet awareness of documentation [*kesadaran dokumentasi belum ada*]." A young writer similarly told me, "Unfortunately, Javanese people are not yet aware of documentation." When again I specifically raised the question of economics, he replied, "Even rich people, if you look, their collections aren't complete [*lengkap*], not from a baby up to a youth up to being married. Maybe only those [events] that are most important." Such comments suggested widespread recognition that, far from a neutral technology that satisfies preexisting desires, photography involves the reorganization and production of desires and needs themselves.[7]

Class did, of course, shape the social distribution of these emerging habits. In one conversation I initiated on the subject, two photographers debated to what extent photography remained a middle-class phenomenon or had become integrated into family life across class.

One explained, "Before, people just had *pasfoto*, but now people need family history" (*sejarah keluarga*). The other countered, "It's only a need for the middle class. There are others who up until they are dead never have any documentation." Although certainly more established and elaborate a practice among the urban middle class, the documentation of major family rituals—and at the very least the desire for such documentation—seemed from my observations to be a cross-class phenomenon in urban Java.

Yet the economic crisis that swept through Southeast Asia in 1997 and lingered in Indonesia throughout my fieldwork, accompanied by skyrocketing prices on all imports, almost overnight threatened to render photography inaccessible even to the middle class.[8] People frequently lamented that photography was now once again a "luxury item" (*barang mewah*), even though it had already become a "necessity" (*kebutuhan*) they could not do without. Many told me that whereas they used to take out the camera for all kinds of occasions, family outings, and visits with relatives, now they reserved its use for truly "important" ritual events like weddings. The owner of a photo-finishing shop explained that she now required her customers to pay almost the full price of developing in advance because so many people were bringing in their film and then never picking up their developed pictures. That people would take pictures even when they could not afford to pay for the resulting photographs suggests the importance of photography as a *practice* integral to the enactment of familial events.

The Logic of *Dokumentasi*

Family photographs, Marianne Hirsch has argued, operate at the intersection between what she terms the "familial gaze"—normative, hegemonic ideologies of family composition, comportment, and affect that are embodied in and taught through conventions of family photography—and family life as it is actually experienced, narrated, and remembered.[9] The "familial gaze," she points out, is not a transhistorical universal but varies across time and space. Yet photography advertising and other globally circulating media give widespread currency and authority to certain visions of family life. When people spoke of their new awareness of the need for "family documentation," they to some degree registered the effects of the Euro-American ideology of photo-

consumerism, which equates taking and consuming photographs with expressions of family love. Nevertheless, family photography in Java does not conform to the idea of "capturing" unique moments, spontaneous facial expressions, and authentic emotion promoted in global photography advertising such as the Sakura ad. The "familial gaze" embodied in postcolonial Javanese family ritual photography has its own specificity.

This specificity can be found in the practice of *dokumentasi*, a genre of photographic practice that cultivates a particular "way of seeing" and remembering the family. The key to *dokumentasi* photography is the creation of an iconic series that recapitulates ritual process; the value of these images is located not in the authenticity of the unique, captured moment but in the authenticity of perfect repetition.[10] *Dokumentasi* photographs aim to produce a highly conventionalized and ideally complete replica of ritual process. Of course, ritual itself is highly formalized behavior, characterized by heightened conventionality, a predictable, sequential structure, and authority that derives from the recognition that participants are engaged in actions that have been done in the same way countless times before.[11] Photographic documentation reinforces—through a technological redoubling—the authority and efficacy of ritual (re)enactment. As simultaneous inscription, photography visibly marks the repetitiveness of ritual while writing out the inevitable slippages between ideal ritual performance and contingent practice. It is not that Javanese images are more conventionalized than Euro-American family photos, of which Bourdieu writes, "few activities are so stereotyped and less abandoned to the anarchy of individual intentions."[12] Rather, in Javanese *dokumentasi* photographs formal conventionality is explicitly sought and elaborated, not disavowed.

In February 2000, the photography magazine *Fotomedia* ran an article titled "*Foto Dokumentasi.*"[13] Oriented to hip young photographers interested in commercial, documentary, and art photography, *Fotomedia* rarely devoted ink to the ordinary images that populate family albums. Only occasionally, recognizing that many of its readers earned a living by photographing ritual events, did the magazine address these prosaic familial genres. The article may be read as both a "positive" and a "negative" reflection on the genre of *dokumentasi*. It articulates many of the genre's usually implicit assumptions and doxic rules. Yet, addressed to its more sophisticated audience, the article also assumes

a knowing tone as it comments negatively on these prevailing practices of family documentation. Outlining how to take successful ritual photographs, the article offers its readers a way to perform *dokumentasi* that will distinguish their practice from the mainstream.

The authors introduce *dokumentasi* as a "need" and an integral part of everyday life: "The making of documentation photos is always needed time after time. Every day there is a party or an event that takes place in which photography plays an important role as an instrument of documentation." Memory—photographs that "will be remembered forever"—is *dokumentasi*'s primary purpose. The authors enumerate the types of photographs that fall under the category of *dokumentasi*, a list that includes birthday parties, weddings, graduations, as well as "a special event at a company."

That this genre includes both familial photographs and photographs of corporate and institutional events is not surprising if we follow Pemberton's argument that "ritual" became an overarching rubric in the final two decades of the New Order. Associated with the New Order quest for order and its appeals to the authority of "tradition," ritual—and the codified behaviors and predictable outcomes associated with it—extended beyond domestic events to "community and institutional observances" and "nationwide, colossal performances" such as the regime's carefully staged political elections.[14] Formal events at universities, businesses, and government agencies inevitably had a *seksi dokumentasi* (documentation section) in charge of recording their proceedings. A pervasive bureaucratic sensibility formally joined public ceremonies of "modern" nationhood with the "traditional" ritual practices of domestic life.

The article's definition of the word *dokumentasi* further emphasizes the genre's ties to an extrafamilial realm. *Dokumentasi* photographs are "proofs" (*bukti-bukti*) and "explanations" or "clarifications" (*keterangan-keterangan*). The article then moves on quickly, as if these definitions were self-explanatory. But we might linger here to consider that both the word *dokumentasi* and those used to define it have strong associations with the legal and bureaucratic apparatus of the state. If the *pasfoto* is *bukti diri* (proof of identity), *keterangan* is what one must supply to police when one is suspected of a crime (one must also submit "letters of explanation" [*surat keterangan*] to bureaucratic agencies, when, for example, moving residence or acquiring a new passport). Such semantic resonances with the state apparatus suggest the refrac-

tions, within this domestic practice of photography, of evidentiary ideologies underlying bureaucratic and legal practices.

Dokumentasi is also characterized in this definition by its plural character. Its authority and efficacy lie not in the impact of a singular index (as in the identity photograph) but in the narrative structure of the photographic series. The article likens *dokumentasi* to a "photo essay": "within the many photographs strung together [*dirangkaikan*] we can find the substance of a story [*cerita*]." A quote from a photographer reminds the reader to photograph as if for someone not present, "so that he can see or know the event" via the pictures. Photographers I spoke with frequently echoed *Fotomedia*'s advice, emphasizing the need to follow the event's "story" and record its chronology in "complete" detail.

Underlying this idea of the "story" is an assumption that the ritual event has defined boundaries and an obvious and predictable progression: "'So when the event is taking place, the photographer has to follow it with precision [*cermat*],' says Dom Sanjaya, a photographer from Bogor. To achieve this, the photographer has to get complete information about various things before photographing, for example the ordering [*susunan*] of the event, [and] what is the climax of the event or which are the most important parts, and [who are] the important people who will come." Another photographer quoted in the article urges the photographer to "prepare himself as well as possible" by anticipating "the sequence" (*rangkaian*) of events.

If the governing rules of *dokumentasi* dictate careful adherence to the scripted and formal event, the camera also serves to mark the ritual event's temporal, spatial, and social boundaries. Although it is common to take pictures of the planning committee (*panitia*) of a wedding, for example, the actual assembling and disassembling of the event is not photographed. As one photographer told me, reflecting prevailing wisdom, one does not take pictures of the preparations or the aftermath, "because that's not interesting, there's no action." The *Fotomedia* article urges its readers to violate precisely these conventions by recording moments "before and after the event" and, in addition to important guests, "the people who support or prepare the event." Elsewhere, the article suggests photographing not only the formal but also the "spontaneous" moments "outside of the scenario [*skenario*]." One photographer quoted in the article states his preference for photographing informal moments, such as guests with "their mouths stuffed" with

food. By contrast, a photographer I spoke with pointed to such images as examples of what not to do: to photograph people eating food or otherwise deviating from formal appearances "wouldn't be polite. People don't like it."

In another negative commentary on *dokumentasi* practice, the *Fotomedia* article reminds readers that photographs need not be "monotone or boring" and deplores the common view that it is simply the fact of documenting that matters, not the aesthetic quality of the images: "What's boring is if we photograph what is . . . just typical, the same as other people," comments a photographer quoted in the article. The authors of the article suggest using varied compositions and lenses to make the series "more dynamic and to give an impression of intimacy [*akrab*]." Otherwise the images will be "stiff." Not only should the images capture the unique "nuance" of the event, the authors emphasize, they should also express the photographer's own individuality and creativity: "The photos that come from the heart [*diniatkan dari hati*] will have far different results than those that are done in a merely routine way." Introducing an aesthetic element into the documentation relies on the "feeling/intuition" (*rasa*) of the photographer.

But "stiff" frontally posed images, with "a face that looks [directly] into the camera [are] still better liked, especially for consumers in the regions," acknowledges a Jakarta-based photographer, underlining the difference in taste between himself and customers further removed from the centers of fashion and power. At a wedding I attended (which I discuss in more detail below) the photographer confided that because the bride lived in Jakarta and worked in advertising, he was taking a few shots in which he played with angle and shutter speed. When he took several photographs of the decorations, his assistant remarked that "old people" view such "artistic" photographs as a waste of film.

In standard practice, the photographer strives not for individual expression (either of the photographer or of the photographed) but for ideally conventionalized images. The *dokumentasi* image is what Barthes called "unary": an image utterly devoid of contingency, in which "no detail interrupts" the intended message.[15] A photograph album from a fiftieth wedding anniversary party of an affluent Chinese Indonesian couple exemplified this ideally unary nature. The album contained over a hundred nearly identical photographs of guests greeting the honored couple. For each encounter between host and guest there were two photographs showing a bow of respect and then a handshake. The pho-

tographer had clearly worked hard to achieve an effect of sameness and repetition, capturing the same moment and pose in each shot. The accumulation of these formally equivalent images—the currency of social respectability—registered both the import and the success of the formal event and thereby displayed the social status of its hosts. In *dokumentasi* photography, the camera helps produce the ritual's spectatorial structure, facilitates its deconstruction into a series of discrete, defined elements, and visibly displays its formality and predictability. Like formal ritual speech that "works to assure that what might be but a momentary happening is in fact a repeatable instance of a general kind of act," photographic documentation highlights an event's repeatability and proper formality.[16]

Another way to approach the logic of *dokumentasi* is to think of it as a kind of writing (the term *dokumentasi*, after all, affirms the link between photography and other technologies of inscription). In New Order Java, James Siegel argues, "It is through writing that matters become 'official.'" He suggests that writing functions in Java much like *kromo* (high Javanese): "Writing seems to the Javanese to carry out the potential of speech levels, being placed in replicable form and standing opposed to unique and spontaneous thoughts."[17] Like high Javanese, formalized bureaucratic speech and written documents achieve their value through the deferral of "what might have been said"; "writing takes on the role of an empty form whose function it is to be played off against possible content."[18] Extending these observations about formality to the performance of village ceremonies and rituals, Siegel argues that it is "the replicability of the ceremonial events" that renders them "official."[19]

Of course, *dokumentasi* photographs are not reducible to writing or formal speech. The indexical and iconic properties of photographic images and their materiality as objects that can be collected and arranged into a series are crucial to their efficacy. The *dokumentasi* series creates a semblance of a whole composed of discrete parts.[20] *Dokumentasi* emphasizes chronological structure, registering a concern with recapitulating a ritual's temporal unfolding as an ordered "chain" of events. The entire string of ritually significant moments must be included for the photographic record to be satisfactory; the greatest compliment typically given to a photographic representation of a ritual event is that it is *lengkap* (complete). The work of family ritual *dokumentasi* is thus to record the ritual as if complete, yet edited of spontaneity, contingency,

and unscripted emotional display. We will keep in mind these defining elements of *dokumentasi* as we move into a discussion of three family rituals—weddings (and other "traditional" rituals), funerals, and birthday parties—where *dokumentasi* works to different effects.

Weddings and "Javanese" Rituals: Reenacting Tradition

Photography has become thoroughly integrated into the authentic enactment of "tradition" in urban Java. Echoing Kencana Studio's self-promoting insistence that photographs are the "main point" because from them will be formed the memory of the event and the lasting "proof" of a successful ritual performance, Suzanne Brenner observes:

> The photographs, which preserved the memory as a series of images that would remain fixed over time, were almost as important as the events themselves. The photographic depiction of the wedding was more than just a recording of the event. It was, one might say, the key to establishing the authenticity of the event, while the actual wedding served almost as a backdrop for the photographs . . . The ritual life of the photographs would be nearly as significant as the ritual event that they documented: they would be framed or preserved in albums, passed around, and shown to visitors for years to come as proof of a culturally authentic (and personally and socially significant) moment, the wedding.[21]

For Brenner, wedding photographs exemplify a phenomenon she calls "the mask of appearances," the relentless effort to keep up a show of status despite often troubled realities. But rather than view them as dissimulating images, we might emphasize the *productive* nature of these photographic "masks." *Dokumentasi* photographs *produce* the generic, ideal Javanese wedding by transmuting the indexical specificity of a particular event into iconic perfection, conforming to "a vision of cultural order as people felt it *should* be";[22] hence the similarity of wedding albums from one family to the next, even across class and religion. Indeed, people in Java frequently bemoan the obligatory tedium of attending these numbingly similar events and of leafing through near identical albums of wedding photographs. As John Pemberton observes, New Order wedding rituals are "utterly predictable" and "dra-

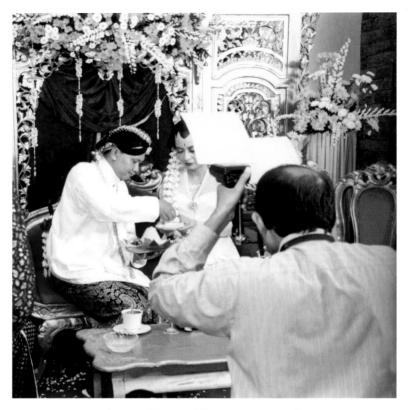

78. Photographing a wedding ceremony, Yogyakarta,
September 1999. *Photo by the author.*

matically flat."[23] It is precisely this idealized sameness that *dokumentasi*
photography helps to generate.

During the New Order, the wedding ceremony took on new sig-
nificance as an auto-ethnographic display of cultural authenticity and
"tradition." The idea of a return to tradition after the turmoil of poli-
tics in the 1950s and 1960s was a hallmark of the New Order cultural
ideology that both enframed and found its fullest expression in the
wedding ceremony: "No scene of 'tradition' in contemporary Java ex-
hibits the New Order compulsion of cultural recovery more obviously
than the *upacara manten*: a proper wedding ritual."[24] The aristocratic
style of Javanese "traditional" wedding costume became popularized
and couples of all classes began performing their ceremonies before a

(rented) *krobongan*, an interior backdrop with a stage-set reference to courtly tradition. Described by many of Pemberton's informants as evidence of a "renaissance" of "awareness" of tradition (but dismissed by some as "bad acting"), these elaborate, pseudo-aristocratic weddings signaled, in part, the pretensions of an emerging middle class. But they were also a product of New Order cultural politics, which cultivated the authority of "authentic Javanese tradition" and elevated "ritual stability" to a social and political ideal. The photographic documentation of this quintessential New Order ritual recalled the late colonial use of the camera as an instrument of cultural exhibitionism to document (and preserve in albums) the rituals of the Javanese courts.[25]

When Clifford Geertz did fieldwork in East Java in the late 1950s, he found the wedding to be one of the most important ritual occasions in Javanese family life, but only aristocrats (*priyayi*) wore traditional costumes. Brides of the peasant majority (*abangan*) tended to wear Western dresses or a nicer version of their typical clothing (*kain* and *kebaya*), although they might bear some sign of "tradition" in their distinctive black makeup forming a stylized hairline. Grooms typically "appear[ed] in a Western jacket, a sarong, and the small black overseas cap, the pitji [*peci*], that has become the prime symbol of nationalism so far as dress is concerned."[26] As in studio portraits of this period, wedding backdrops of the 1950s and early 1960s often alluded to fantasies of mobility and modernity.[27]

Geertz emphasized the neighborly obligations and the ethic of "harmony" (*rukun*) that accompanied the collaborative production of ritual events. By contrast, Pemberton noted a bureaucratic language of "efficiency" (*efisien*) and "consistency" (*konsekwen*) used by those performing wedding ceremonies during his fieldwork in the early 1980s, revealing a "structure of authority" modeled on "the ritualized *sukses* of a working bureaucracy."[28] Recalling the highly formalized rituals of the late colonial–era courts of Java, New Order weddings, he notes, followed "a schedule of events performed with near perfect predictability."[29] This "attention to ritual detail" and "highly cultivated sense of repetition," refracting both ethnological discourses of cultural authenticity and bureaucratic procedures, found further reiteration in written narrations of weddings in the news media[30]—and, I suggest here, in photographic *dokumentasi*.

In early September 1999, I attended a wedding with the photographers hired to document it. It was an elaborate event, though not un-

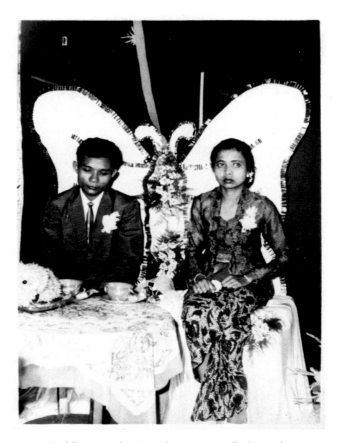

79. Wedding reception, Yogyakarta, 1962. *Collection Moelyono.*

usually so for Yogyakarta's professional upper middle class. In addition
to the two photographers, a team of four videographers was on hand
to cover each step in the ritual proceedings. The bride was the family's
only daughter, and thus her marriage offered the sole opportunity for
the family to host a wedding, always a display of status and wealth.
The just-built house in which the parents lived and where many of the
events took place had been designed by one of their sons, an architect.
The finishing touches were still being applied. A grand, high-ceilinged
entranceway led into a large empty space that would serve as a living
room; the living room opened onto a "modern" kitchen. The latter
seemed to be for show only; at the back of the house—out of view—
was a more typical Javanese kitchen.

On our arrival, several hours before the first event in a series that would take place over four days, we were handed a printed schedule that listed the different ceremonial events (*Selamatan*, *Pengajian*, *Munggah Tarub*, *Siraman*, *Srah-srahan*, *Midodareni*, *Akad Nikah*, *Panggih*, and *Resepsi*) and the times and places of their occurrence.[31] The photographers and videographers diligently followed these proceedings, meticulously documenting each ritual twist and turn. In between "events," they would rest, smoke, and eat in the back where the food was being prepared.

A middle-aged woman, a relative of the bride's mother, played the role of *protokol* (master of ceremonies).[32] Using a microphone to carry her voice over the din, she tirelessly narrated the unfolding events in a florid combination of high Javanese and formal Indonesian. She needed no rehearsal or script because the events followed prescribed patterns; they were already, in effect, prerehearsed. She had learned to be a *protokol* from reading books on the subject. Her technologically mediated narration echoed, in an aural mode, the step-by-step *dokumentasi* undertaken by the photographers—a simultaneous "writing" and reproduction of the ceremony. Both visual and verbal narrations provided a metacommentary on the predictability and replicability of the unfolding events.

The culmination of the wedding was the evening *resepsi* (reception) at a large public hall. It is not uncommon at upper-middle-class weddings to invite anywhere from three hundred to a thousand guests to the *resepsi*, the most public part of the wedding ritual. The bride and groom—dressed in even more elaborate courtly clothing than they had worn for the wedding ceremony at their home earlier in the day—and their family sat stiffly on a flower bedecked stage looking out over the large room. They gazed out vacantly as guests streamed in, ushered along by heavily made-up female "committee" members dressed in matching *kain* and *kebaya*. The photographers took photos as the arriving guests signed the guest book, dropped their "gift" envelopes into a box, and took their seats. Elaborate speeches in high Javanese and performances by "traditional" dancers provided entertainment for the seated guests, who paid little attention. Guests were invited to take plates of food from various stations set up around the room (at less trendy weddings, guests were served food as they sat in their seats). The bridal couple continued to sit, still as statues. When the eating began to wind down, a long line formed as people made their way to the stage to

congratulate the family and the bride and groom. The photographers set up their tripods and bright lights at the foot of the stage and took photographs of honored guests and family members as they passed to "center stage." The entire line would be stopped as some guests were invited to arrange themselves around the bride and groom for a formal portrait. In this way, as at numerous other weddings I attended, the photography served as a conspicuous display of the bride and groom's affiliations and affections, highlighting which of the guests were significant enough to be photographed.

At the end of the evening, as the guests dispersed and the staff of the reception hall began clearing away the chairs and tables, I helped the photographers pack up their lights and equipment. The bride and groom finally came down from the stage, had a few bites of leftover food, and said goodbye to her parents. At this point the mother started to cry, and the father embraced his daughter, formally at first. Then, holding her close, he kissed her cheek repeatedly. When he finally pulled away, his wife gently wiped the tears from his cheek with her handkerchief.

80. Wedding reception, Yogyakarta, September 1999. The photograph was taken from a position several yards to the right of the official photographer. *Photo by the author.*

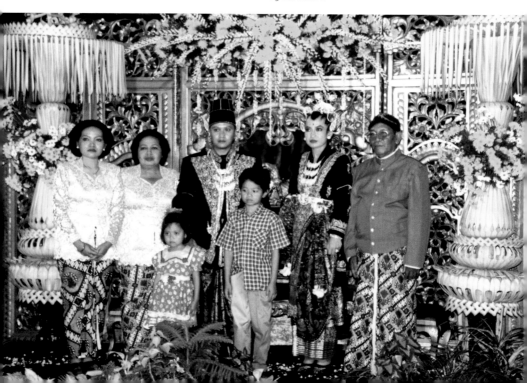

This intimate moment occurred after the event was "over"; it was clearly off-camera. The videographers were already out in the parking lot and the photographers were busy wiping their lenses and coiling their electric cords. This nonceremonial, spontaneous expression of sentiment marked a striking contrast to the formalized moment of emotional display within the ceremony, the *sungkeman*, in which the bride and groom bow down before both sets of parents to ask for their blessings. Although tears are often shed at this point, it remains a licensed and highly conventionalized display of emotion.[33] This ritual moment has become a virtual icon of familial devotion—a popular poster of former president Sukarno, for example, shows him on his knees, bowing his head into his mother's lap.[34] As if in recognition of its iconic and eminently photogenic status, in a photograph of the *sungkeman* from another wedding, the father looks not down at his daughter but directly at the camera.

The orientation to an ideal "audience" embodied in the camera is evident in the choreography of many ritual events. In the *siraman*, a ritual bath that takes place in almost every life cycle ceremony marked as "traditional," the person undergoing the ritual is bathed by a ritual specialist and by family members. In almost every ritual I observed, the person being bathed faces the spectators; a basin of water with flower petals sits to his or her side. The ritual specialist and family members stand behind the person as they dip a ladle into the water, and pour it gently over his or her head.

The significance of this choreography became clear to me at a pregnancy ritual (*mitoni*) for Ibu Sudirman's daughter in a village outside of Yogyakarta. The simple ceremony took place in a small cement courtyard of the father-to-be's parents' home. An elderly village midwife (*dukun bayi*) performed the role of ritual specialist. Instead of a professional photographer, one of Ibu Sudirman's sons and I were enlisted to document the event. When the time came for the *siraman*, in which the ritual specialist and female family members bathe the father- and mother-to-be, the couple sat *facing* the ritual specialist and female family members; the "audience" thus saw bather and bathed in profile. As I realized when I tried to photograph the scene, it was impossible to take a picture that showed frontal views of both bather and bathed and difficult to encompass all the participants in the same frame without also including the heads and shoulders of spectators.

Returning to the city, Ibu Sudirman commented to two of her

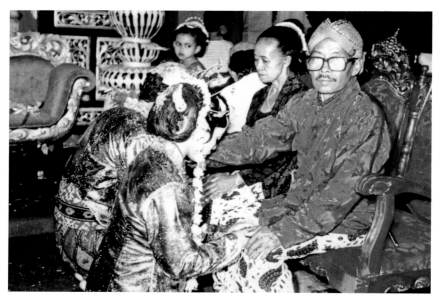

81. *Sungkeman*, wedding photograph, Yogyakarta, 1996. *Collection Minarni.*

82. Ibu Sudirman ritually bathing her daughter and son-in-law,
Prambanan, 1999. *Photo by the author.*

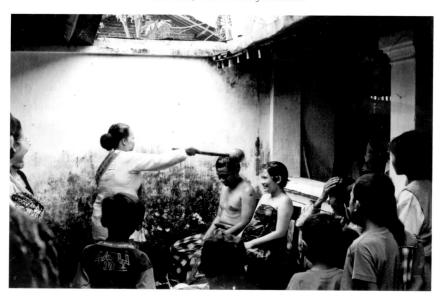

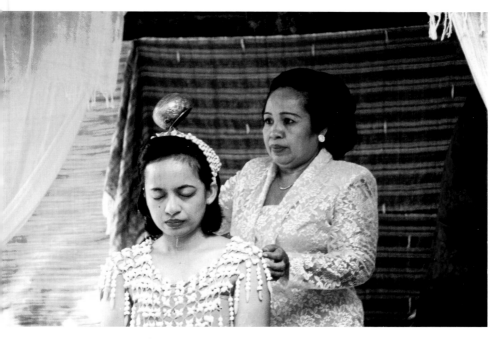

83. Photogenic *siraman* (mother bathing her daughter), wedding ceremony, Yogyakarta, September 1999. *Photo by the author.*

daughters that the ceremony had been much less *rinci* (detailed) than the *mitoni* rituals she had hosted for them.[35] She attributed this difference to the fact that this ritual specialist was a *dukun bayi* rather than a *perias manten* (a wedding ritual specialist), and to the difference between the "village" and the "city."[36] While the village is often figured in popular imaginings as a reservoir of tradition, where ritual practices and neighborly obligations remain potent forces in everyday life, in Ibu Sudirman's rendition, the village was an inadequate site of tradition because villagers were not as knowledgeable as their more sophisticated urban counterparts (who, living in Yogyakarta, are also closer to the courtly center of traditional Javanese authority). Offering an example of the superiority of "city" ceremonies, she noted that the *perias manten* always makes it "easy to be photographed" during the *siraman* by placing those who do the bathing *behind* the ones being bathed, instead of facing them.

The ideal enactment of this symbolic gesture of cleansing was thus

not as a face-to-face encounter, as it appeared in the less camera-savvy village ritual, but as a display oriented to the camera. At the wedding described earlier, the *siraman* of the bride-to-be was performed on a decorated platform before a professional photographer, videographers, and spectators (many with their own snapshot cameras). During a quiet moment between events, I asked the bride's mother to describe her own wedding in 1970. She told me that all the same stages of the wedding had been performed, but that it had not been nearly as *canggih* (fancy). A neighbor had acted as photographer, she noted, and the *siraman* had taken place in the bathroom with no one watching except the intimate circle of family members who were bathing her.

The reverent attention to ritual detail and proper procedure evident in "traditional" ritual performance and its photographic documentation can be described as a highly self-conscious form of auto-ethnographic "textualization."[37] In their commentary during ritual performances and in narrations of *dokumentasi* photographs, people proudly emphasized the "richness of symbolic meaning" (*kekayaan makna simbolis*) within the ceremony and took pleasure in enumerating the names of each step of the ritual process. Yet this attention to authenticity was tinged with anxiety; Pemberton describes wedding hosts' fears of failing the demands of tradition, as if "tradition" were an authentic original just out of reach, demanding a replication nevertheless doomed to failure as an imperfect copy.[38]

It is this attention to ritual detail that aligns family *dokumentasi* with practices of ethnological documentation. In an article on the photographic practices surrounding a "traditional" coming-of-age ritual in Japan, Eyal Ben-Ari distinguishes between photographs taken by family members and those taken by academics "documenting" the event.[39] While family members' photography focuses on the individuals involved in the ritual, the ethnological images, underpinned by an ideology of photographic objectivity and motivated by a salvage impulse, "reveal a constant stress on obtaining as detailed as possible a coverage of the ceremony."[40] In Java, the familial genre of *dokumentasi* encompasses this ethnological mode of "coverage." Professional *panggilan* photographers—many of them Chinese Indonesian—continually emphasized that their task required a detailed knowledge of Javanese ritual; many displayed their mastery of this knowledge by reciting in sequence the stages of various rituals and what kinds of clothing and pose are appropriate at each step. Like the *perias manten*

(the wedding ritual specialist), photographers are ritual experts who guarantee the appearance of traditional authenticity; a friend once returned from a wedding laughing about how the photographer would not let him and his friends "break the rules" of proper pose. Epitomizing the presence of "ethnological" ways of seeing within family ritual *dokumentasi*, the videographers hired to record the wedding I attended in September 1999 worked for the for-profit wing of a cultural organization dedicated to documenting and archiving "traditional Javanese culture."

A difference in the conventions of ethnological documentation and family *dokumentasi*, however, lies in the visibility of the camera itself. Ethnological documentation (like other forms of documentary photography) typically maintains the fiction that events unfold untouched by the intervention of the camera. But in wedding and other rituals in Java, no effort is made to conceal the camera's presence and influence on the course of events. Ritual moments may be repeated if the photographer requests it. Photography is such a highly marked part of the ceremony that in a *Fotomedia* article on wedding photography, a photographer suggests dressing "neatly to respect and not embarrass the host. Because besides the bride and groom, the photographer also becomes a center of attention [*menjadi pusat perhatian*]."[41] At the wedding described above, I noticed at one point that the videographer was recording from behind the professional photographer in such a way that the photographer was surely included within the frame. When I asked the videographer why he included the professional photographer and other guests photographing the ceremony, he told me, "We see that as an addition, an addition to the art [*tambahan seni*] [of the video]."

In wedding and other "Javanese" rituals, the camera visibly enframes the ritual, indicating that the *enactment* of tradition is just that, a successful performance. It is precisely this technological enframing that marks the ritual as not only "Javanese" but Indonesian, a performance of tradition taking place within modernity. Indeed, the practice of *dokumentasi* extends to rituals that are not marked as "traditional," suggesting that its logic cannot be explained exclusively in terms of New Order preoccupations with cultural authenticity and auto-ethnographic practices. The photographic documentation of funerals suggests a different dimension of *dokumentasi*'s recapitulation of formal ritual process, rooted in social prohibitions on open displays of sentiment.

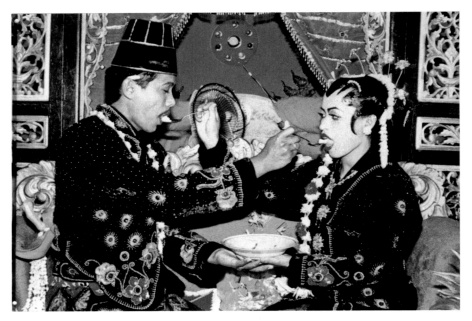

84. Ritual details, wedding album, Yogyakarta, 1996. *Collection Minarni.*

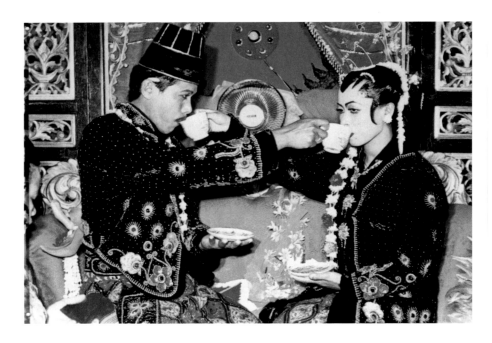

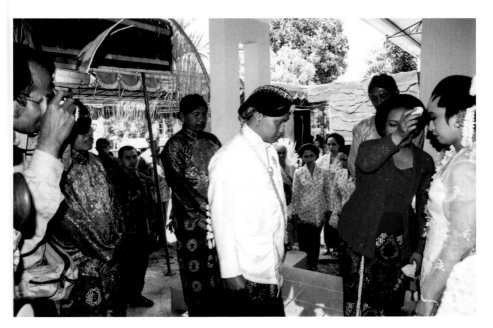

85. Documenting ritual detail, wedding ceremony, Yogyakarta, September 1999. *Photo by the author.*

Funeral Photography: Narration and Deferred Sentiment

One evening, a few days after I had moved in, I came home to find Ibu Sudirman looking at a photo album with her four-year-old grandson. The album contained pictures of her children's graduations, weddings, and outings with friends. When I joined them, Ibu Sudirman abruptly got up and went to the cabinet where the family albums were kept. She pulled out another large album and placed it on my lap, saying, "This is when *Bapak* [father] died."

The opening page of the album held an enlarged black-and-white *pasfoto* of her husband. The photograph had been used in his funeral procession; a copy of it hung framed in the front room, joined with Ibu Sudirman's identity photograph in a composite portrait. The next pictures in the album took us into the hospital, where Pak Sudirman had languished for more than a month after an operation for liver cancer. The photographs showed him sitting up and lying in bed and being visited by family members. They documented his decline as well as the

presence of people around him. Subsequent pictures showed his dead body in the hospital bed, his body being prepared at home, placed in the coffin, people standing around the open coffin, the gathering of neighbors, friends, and relations, the formal ceremony, the procession to the cemetery, the burial, putting flowers on the grave, and then more ceremony, Koranic recitations, and food at the house.[42]

As I looked at these images, Ibu Sudirman kept up a steady narration. Like others speaking of severe illness or accident, she calmly and in graphic detail recounted the course of his disease, recalling each symptom and its diagnosis, each course of remedy and its failure, each increment of suffering leading finally to his death. Then she went through the various stages of the funerary ritual, describing what had happened and who had attended. Ibu Sudirman's narration followed closely the contours of the photographs, redundantly describing the events documented in the album. Both her litany and the detailed photographs reduced death to a series of discrete, sequential facts.

But the precise, elaborated enumeration of concrete details in her recounting of an event that had taken place almost a decade earlier alluded to an intensity of emotion that belied her affectless telling. I have suggested that *dokumentasi* photography partakes of a specifically Javanese logic of writing, following Siegel's argument that writing in Java works like *kromo* (high Javanese) to suppress spontaneous expression "in favor of 'official' form."[43] While *kromo* articulates the hierarchically located, social persona, *ngoko* (low Javanese) is said to express the more base and intimate self. Siegel argues that the use of *kromo* entails a process of translation from *ngoko* that defers intention.[44] So too, the obvious formality of the photographically inscribed ritual event can subtly gesture to sentiments that remain not so much hidden as formally deferred. Although systematically screened out, sentiment hovers in the negative space around the photographs of *dokumentasi* series. The conspicuous absence of visible sentiment can point to its presence "elsewhere" while displaying the grieving person's socially valued mastery of her emotions.

Funeral albums such as Ibu Sudirman's, while not quite as mandatory and never as much on display as wedding albums, are common.[45] Unlike weddings, funerals are not subjects of auto-ethnographic discourses of cultural authenticity, yet funeral photography follows the same basic *dokumentasi* pattern: a reiteration of ritual process that clings to the formulaic and the formal. Like many other rituals, funerals in

Java often appear utterly devoid of emotion. Yet while their atmosphere can feel almost casual, they are socially significant and obligatory community events. Even (or especially) in funerals for young people who have died sudden deaths, there is an effort to maintain the calm and reassuring predictability of ritual procedure. Surviving loved ones are not supposed to show emotion because extreme sentiment is considered dangerous to the individual and because, it is believed, the grief of those left behind will encumber the spirit of the dead as it leaves the world.[46] To ease the deceased's spirit on its way, one must be *ikhlas* in the face of death: one must achieve (or at least present) an ideal state of detachment.

To this end, Geertz observes, the Javanese rituals surrounding death cultivate flatness of affect: "The detailed busy-work of the funeral, the politely formal social intercourse with the neighbors pressing in from all sides, the series of *slametan* stretched out at intervals for almost three years—the whole momentum of the Javanese ritual system—are supposed to carry one through the grief process evenly and without severe emotional disturbance."[47] In Geertz's description of a funeral gone awry, it is the interruption of conventional ritual procedure that causes people to be unable to contain their emotional distress.[48]

Elaborating on Geertz's arguments, Siegel sees in Javanese funeral photography evidence of the absence of "mourning," in the strict Freudian sense, in Javanese encounters with death. Siegel notes the prevalence of albums showing funeral proceedings but quickly fixates on the photograph of the corpse typically included in such albums:

> Many families have albums of photographs of relatives' funerals, which include pictures not merely of the crowd and the speakers at the ceremony, but also of the corpse and of the coffin after it had been lowered into the grave. Ordinary photographs of people we know stimulate recall: being taken at a particular moment in time, they seem to capture the person as he was when the picture was taken . . . A photograph of a corpse has a different effect. A body devoid of life remains as it is. Rather than being unique to the moment in which the picture was taken, the same condition of the body continues after the picture was taken. There seems to be nothing outside the picture, nothing more to the corpse than what is visible.[49]

Siegel argues that the corpse image allows the person to be imagined as "dead"—fixed and stable, a sign. This, he suggests, is not mourning

in the sense of a process of returning to one's memories and cathecting them with the knowledge of death, eventually leading to a withdrawal of investment in the deceased. "Javanese do not mourn. That is, they do not create a notion of loss through a transformation of memory. In place of the work of mourning there is an accession to High Javanese, seen in funerals to be a form of identification with the idealized 'dead.' This is an identification that depends on imagery, particularly, today, photographs, to indicate the presence elsewhere of spirits. This 'elsewhere' marks 'loss' in its Javanese sense, one that does not depend on memory."[50]

Echoing Geertz's argument that Javanese do not fear death in part because death exemplifies "that emptiness of emotional and intellectual content, that inner restraint of will, that they value so highly," Siegel argues that the corpse "fulfills a Javanese ideal" because it represents the person finally released from the dangers of disruptive emotion and improper speech.[51] Its face fully a mask, the corpse symbolizes the ultimate achievement of the suppression of one's own interiority and willful impulses.[52] This idealization of the corpse, Siegel suggests, explains why Javanese often adopt an eerily corpselike, slack, vacant expression when they themselves are photographed.

But Siegel does not address the significance of the corpse image's placement within a series of images. The corpse image is never, to my knowledge, separated out and treated independently. Rather, as suggested in the previous chapter, it is the identity photograph as memorial image, displayed with the coffin, carried to the grave, and finally hung on a wall in the home, that fulfills the function of a singular, fixed sign of the person radically divorced from time and place, an ideal sign of death. Embedded as it is in a series, the corpse image is situated firmly and reassuringly within the social sanction and temporal grounding of ritual process—quite in contrast to the images of unidentified corpses also discussed in the previous chapter.

Images of funeral process provide future memory with a contained and structured form, harnessing recollection itself to the temporality of ritual process. Just as the funeral ritual mobilizes a sense of predictability and formality to contain emotional disruption, the photographic recapitulation of ritual process extends this containing gesture into the future and to those not present. (Relatives who cannot attend funerals are also frequently sent *dokumentasi* albums.) Thus the *series* of images and the conventionally anchored narratives they support are

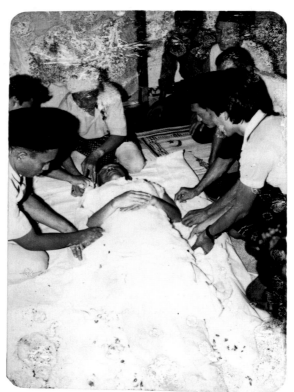

86 and 87. Preparation of the body for burial, from funeral album, Yogyakarta, 1984. *Collection Ibu Soekilah.*

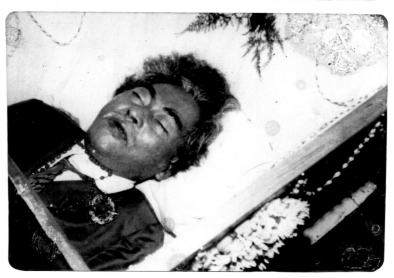

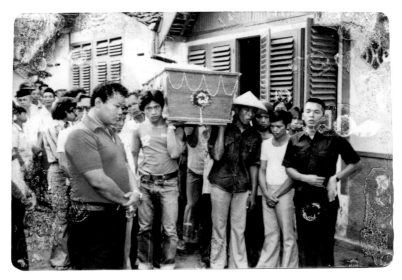

88. Carrying the coffin to the cemetery, from funeral album,
Yogyakarta, 1984. *Collection Ibu Soekilah.*

crucial to the work of funeral *dokumentasi*. The photographic memory of the ritual may help displace or defer disturbing memories and emotions, while supporting a socially acceptable way of recounting an experience of loss.

Recall Brenner's statement that photographs of weddings support a "mask of appearances." In using the image of the mask, Brenner invokes one of the most pervasive tropes in scholarship on Java, one worth revisiting briefly here. The image of the mask has been central to scholarly interpretations of Javanese preoccupations with formality and proper public behavior. Geertz's classic analysis of Javanese subjectivity and cultural order was based on the opposition between exterior surfaces (*lahir*) and walled-off interiors (*batin*).[53] He portrayed the public persona as a mask that conceals and protects an inner self but whose smoothness alludes to and ideally mirrors a tranquil inner state.[54] He thus located Javanese interest in surface appearances in a concern with social etiquette, emotional equilibrium, and the achievement of ultimate *rasa*—the unity of interior and exterior. Writing of Javanese political culture, Benedict Anderson also regarded Javanese public behavior as "a mask" that reflected "the dualism in the Javanese mind" between the "private" realm of the "heart" and external, pub-

lic appearances.[55] But, in arguing that the Javanese face is a "built-in mask," Anderson emphasized that the relationship between exterior and interior was "obscure and intricate" rather than a simple one of false appearances versus inner truth.[56] For Siegel, the masks of formality and self-conscious artifice so evident in many arenas of Javanese social life do not so much conceal "true" interiors or hidden meanings as they construct conventional absences which signify presence elsewhere; *kromo*, he suggests, works as a mask in this sense of deferral.[57] As Nancy Florida has suggested of Javanese literature, visible surfaces are conceived less as concealing masks than as allusive screens.[58]

Ibu Sudirman's narrative fixated on the details of death and ritual process that were materially present in the images themselves. Her redundant narration mostly sustained the "unary" surface of the photographs, only occasionally allowing a "punctum" (a prick, or wound) of memory to disrupt the self-evident facticity and smooth chronology encoded in the images.[59] Even as Ibu Sudirman strayed briefly from the images to tell me, for example, how one of her daughters had arrived minutes too late at her father's deathbed, or how another had fainted from sheer grief, the photographs were always there to return to, moorings for dangerously wandering memories. The more comprehensive the *dokumentasi*, the more the event itself expanded in narratability. In this expansion of narrative time, emotional weight accumulates even as it is held in check. The absence of overt expression of emotion signals both its presence elsewhere and its successful deferral by formal means.

Javanese concerns about formality and emotional display inflect the practice of *dokumentasi*, yet funeral photography serves as a further reminder that self-contained analyses of "Javanese" culture are insufficient to explain photographic practices in Java, which are always formed from broader historical and cultural dialogues. From discussions with photographers, it seems probable that, like the practice of using identity photographs as memorial portraits, the practice of photographing funerals originated in the ethnic Chinese community and only later spread to the Javanese community. Chinese Indonesians also document each step in the funeral ritual, including photographing the corpse. Chinese Indonesian funerals, especially those of the *totok* (full-blooded and/or more culturally identified) Chinese, are often elaborate events compared to the quiet Muslim rituals practiced by most Javanese. In a strikingly concrete imagining of an afterlife, the dead were (and some-

times still are) "sent off" with fake money, clothes, and even model houses and cars to "take with them." Photographing the corpse in the coffin, one photographer explained, was intended less to show the dead body itself than to document the coins and other objects prepared for the corpse's journey. Chinese Indonesian funeral photography thus emphasizes the idea of "proof" embedded in *dokumentasi*: the photographs provide a lasting trace that will remain after the actual objects are consumed by flames.

Itself a conspicuous expenditure, the photographing of Chinese Indonesian funerals documents the respect and care lavished on the dead, who will return the favor by bestowing blessings on the living. Javanese funeral *dokumentasi* similarly provides material proof of the successful performance of the funeral ritual. Ibu Sudirman took evident satisfaction in the documentation of her successful fulfillment of ritual obligations befitting a respected member of the community. Overtly, the emphasis on ritual procedure in her photographs located death socially. But beyond social respectability, these images also offered a sanctioned platform for Ibu Sudirman to recall and subtly convey profoundly felt sentiments of loss.

Birthdays and Biographies

Photographs of the living also serve as visible proof of caring. As we saw in the previous chapter, especially in Wiwik's resentment about her lack of photographs, possessing a material record of one's childhood is increasingly viewed as a sign of parental love. Birthdays have become key moments for the production of this sentimental proof. Unlike weddings and funerals, birthday parties have no deep genealogy in Java. Far from "authentic" rituals, birthday parties are associated in some imaginings with the deleterious effects of an alien modernity and consumerist materialism. A high school anthropology textbook, for example, cites "celebrating the birthdays of every member of the family one by one with a fancy, festive party" as exemplary of imitative "Westernized" (*kebarat-baratan*, which carries a mocking sense of imitation or pretense, "playing at being Western") behavior. Other telltale signs of Westernization are wearing clothes in Western style and calling one's father "pappie" or "daddy."[60]

The increasingly common annual birthday celebration registers

89. Birthday party, Yogyakarta, ca. 1975. *Collection Endang Mulyaningsih.*

the growing influence of globally circulating media representations of family life modeled on a Western nuclear family ideal. Yet as is so often the case in Java, Chinese Indonesians mediated the appearance of this "Western" practice. As early as the 1950s, Chinese Indonesian studio photographers displayed sample photographs of children posed singly or with their nuclear families next to birthday cakes in the studio, suggesting to potential customers that a birthday was an appropriate family photo opportunity. In one studio photograph taken in the early 1960s to commemorate a little girl's birthday, the Chinese Indonesian photographer has arranged a Chinese Indonesian family in a balanced, pyramidal composition around a cake. Their faces illuminated by the candlelight, their bodies turned toward the glowing cake, their solemn, reverential expressions, all give the photograph a quasi-religious feeling, as if the cake were an altar, an object of worship. As with other examples (*contoh*) displayed in portrait studios, these may have facilitated the spread of photographic practices associated with modernity from the more self-consciously cosmopolitan Chinese Indonesian community to the majority Javanese.

Children's birthday parties share with weddings and funerals an aesthetic that favors formal, predictable, and spectatorial behavior. As

90. Birthday studio portrait (Chinese Indonesian family),
Yogyakarta, ca. late 1950s. *Collection Liem Goen Hok.*

with other family rituals in Java, the children's birthday party is highly
structured and conventionalized. Fully integrated into the ritual enact-
ment, photographic *dokumentasi* reinscribes ritual process and visibly
marks its replicability, while also serving as a form of conspicuous con-
sumption.

One party—typical of others I attended—celebrated a girl's fourth
birthday. Dressed up in a frilly dress, the little girl was fat, cute, spoiled,
and doted on by her older siblings and her parents. The party was held
in their modest home, a sparsely furnished concrete structure decorated
with various signs of their strong affiliations with modernist Islam (a
tapestry of Mecca, decorative Arabic calligraphy, and a calendar with
pictures of the Great Mosque hung on the walls). The girl's mother was
the principal of a Muhammadiyah kindergarten.[61] Also on display were
studio portraits showing family members dressed in Muslim costume:
peci and *sarong* for the men and boys, *kerudung* (loose head shawl) for
the women and *jilbab* (veil) for the girls.

When I arrived, family members and neighborhood women were
sitting on the floor in the kitchen putting together packets of food that
would later be given out at the party. There would be enough food for
all the children in the immediate neighborhood; about sixty little paper
trays were filled with coconut rice, a quarter of an egg, vegetables, and

a kind of spring roll. The distribution of food within the neighborhood marked the presence within the "modern" birthday party of some elements of the *selamatan*, the ceremonial core of most Javanese ritual events. But the formalized enactment of the birthday ritual conformed more closely to Indonesian *acara* (planned events) that take place in neighborhood associations, institutions, and government agencies.

The front room was decorated with balloons. Its few pieces of furniture had been pushed to one end of the room to create a stage: a couch faced out into the room, a small table was placed in front of it with two chairs on either side. Carpets covered the empty expanse of floor that would eventually be filled with neighborhood children. A large bakery-bought cake covered with fluffy white frosting and a candle in the shape of a four sat on the table, a cell phone placed conspicuously next to it. In front of the table, on the floor, large baskets held bags of candy and piles of fruit that would be distributed to the children. Gradually, children arrived in small groups and sat docilely along the edges of the wall, a contrast with their normally ebullient and mischievous demeanor (usually tolerated indulgently by adults).

As the little girl took her place on the couch, a camera flash marked the start of the ritual event. Although he lacked training and used a simple automatic camera, the photographer told me he was often asked by his neighbors to document their family events. For this party, he was to take one roll of twenty-four exposures. Everyone sang "Happy Birthday" to the little girl. Then she was photographed blowing out her candles and sitting, both alone and with various family members, with the cake and cell phone before her. The gathered children watched all of this quietly, not talking to each other. Each time the camera flashed, everyone in the room applauded politely. Then the photographer placed the little girl on the floor, so she could be photographed with the other children. After these photos had been taken, the children were invited to come up and take the packets of food that were waiting for them. As if released from a spell, they burst out of their stuporlike formality and became a clamoring mass of pushing and grasping hands, as the adults laughingly reassured them, "There's enough for everyone."[62] Shortly thereafter, the children dispersed, packets in hand.

At children's birthday parties, it often seemed that rather than the event being photographed, the event *was* the photographing. At another party, children were encouraged to come "on stage" to sing songs with the inducement "If you sing, you can be photographed, too." At a

birthday party for a boy turning thirteen at which I was the designated photographer, one guest made him stand up as she formally presented him with a gift that she and other friends had bought. After a brief formal speech, she shook his hand, and then looked over at me, in a clear signal that I should photograph this moment, a mimicry of the "official" handshake among government officials that appears repeatedly in the newspapers. Here, too, once the picture was taken, everyone clapped and cheered. Similarly, in a photograph from a birthday party in the 1970s, the birthday boy and his guests formally shake hands.

Such "official" handshake-photos suggest resonances between birthday parties and bureaucratic and official events. At a celebration of Indonesian Independence Day in the *kampung* where I lived, the centrality of the camera to such quasi-official community rituals became clear in its absence. The physical arrangement of the space in the small courtyard where the ceremony took place echoed, on a larger scale, that of the birthday party described above. The head of the neighborhood unit and the *protokol* (who controlled the microphone and the amplified music playing from a cassette player and large speakers) sat in chairs at a small table facing the empty yard lined, along its edges, with people sitting on mats. After the head of the neighborhood unit read various speeches from local government officials and led a group prayer, a *tum-*

91. Birthday party, Yogyakarta, 1999. *Photo by the author.*

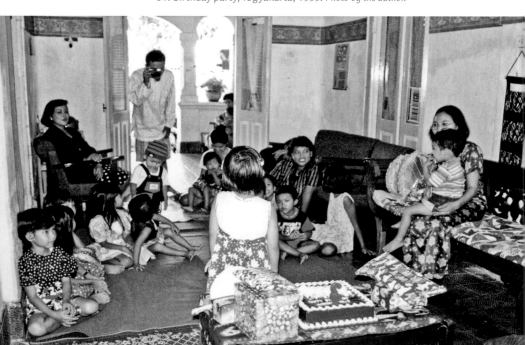

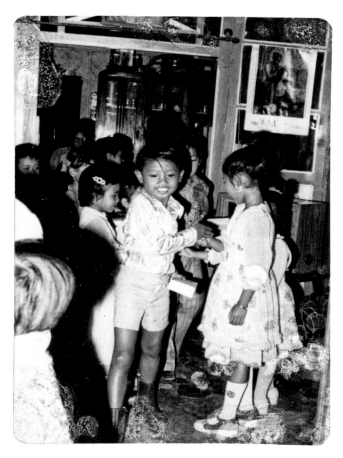

92. Formal handshakes, birthday party, Yogyakarta, mid-1970s.
Collection Ibu Soekilah.

peng (a cone-shaped pile of yellow rice typically served on ritual occasions) was brought out. An Australian man who had recently married a young woman from the community was offered the honor of cutting the top off the cone (an act similar to making the first slice of cake). At this point a photograph clearly should have been taken, because Ibu Sudirman leaned over to a young Chinese Indonesian neighbor and asked him where his *tustel* (Dutch: camera) was. Once the Australian had cut the top off the *tumpeng*, the *protokol* asked the audience to clap their hands "given that there is no camera," as if the clapping was to substitute for the punctuation normally provided by the camera.

Birthday parties register and help produce new sensibilities about time, personhood, and memory. Weddings and funerals, socially significant rites that occur once in a lifetime, correspond to a generic "Javanese" lifecycle.[63] But birthdays are celebrated with annual regularity. Their significance lies within the frame of an individual life trajectory marked by linear movement through abstract, homogenous time. The value of birthday *dokumentasi* lies not only in each ritual series but in their yearly incorporation into an ever-expanding photograph album.[64] A series of series, the photographs in albums accumulate to form a "biography" or personal history. The birthday party is thus closely tied to a more general individualizing and self-historicizing impulse embodied in the making of personal albums.

Although the annually marked birthday has become more widely celebrated, some still mark their children's Javanese birthdays, calculated according to the confluence of the Javanese five- and seven-day calendars. Rather than an event that occurs once a year, the Javanese birthday recurs every thirty-five days. As Geertz noted, Javanese calendrical time is "pulsative" in contrast to the more linear, abstract, and spatialized conceptualization of time associated with the modern West.[65] The Javanese birth date is not an historical accident but a cosmologically determined event (future wedding partners might be chosen or rejected according to the compatibility of their birth dates). Commemorations of Javanese birthdays often involve the preparation of ritual foods by the child's mother (or grandmother) as offerings meant to ensure the safety and health of the child. A mother might make a special kind of *bubur* (rice porridge) on a sickly child's birthday, while doing nothing to mark the birthday of another, healthier child, less needy of her protection. Unlike the visual display of the birthday cake, the efficacy of these ritual foods lies in the indexical transmission from mother to child implied in the intimate preparation and consumption of food.

With its spectatorial structure and its production of a paper trail that becomes the child's possession, the birthday party privileges vision over taste and conveys parental love through artifact rather than ingestion. At the birthday party of the four-year-old girl described earlier, the Western-style cake remained a prop, like the cardboard cakes at studios, necessary for the proper appearance of the birthday party. Nobody ate it, consuming instead the rice, spicy vegetables, and other foods typically served at Javanese ritual events. Birthday photographs documenting parties, cakes, and cell phones are similar to photographs

of children placed strategically next to televisions, bicycles, and other signs of material wealth (described in chapter two). They serve as doubled signs of parental investment in their children: the affluence attested to *within* the frame is reiterated by the expenditure on the photograph itself.

More generally, the popular culture oriented to children and child-rearing treats photography as an index of parental care and an integral part of the ideal (middle-class) Indonesian childhood. Popular mothering magazines include features where people send in photographs of their children along various themes such as "smiles," "talking on the phone," or "wearing hats." Some sponsor nationwide photo contests with titles like "Loving Mother & Child."66

Also providing potent new, mass-mediated models for Indonesian childhood are the extraordinarily popular *artis cilik* (little stars), who sing children's songs and whose music videos play constantly on television.67 A book titled *Album Artis Cilik* (Album of Little Stars), containing photographs, interviews, biographical sketches, and fold-out posters of several major child stars, takes the form of a photo album.68 A sophisticated marketing device, the book cultivates a sense of intimacy between children and these TV personalities and provides an object lesson in the value of photographic documentation. The book explains itself thus: "Why an album? We all like to look at our pictures in an album, while remembering when the picture was made." Images in the book appear with white borders and a slight drop-shadow suggesting objects that rest on the surface of the page. Captions in a font imitating handwriting appear below the images, which include photographs of birthday parties, formal portraits, and informal snapshots of the stars. The first page has written across it, in the same font: "This album belongs to": with spaces marked out for the owner of the book to write in his or her name and paste in a photograph. The introductory page describes the images in the album as "a kind of souvenir/memory [*kenangan*], or also a form of record [*catatan*; implying written notes]," to be read "page by page." We can, it teaches, "save these memories and records in our heart. And when we are missing [our friends], the album helps us."

A similar book, titled *My Name is Joshua: A Biography of the Little Star Joshua Suherman*, also has an albumlike appearance, with photographs appearing as if pasted in.69 In it, Joshua boasts, "I am considered the smallest star in the world who possesses a biography." He writes, "It's

Album ini milik :

Foto

93. Frontispiece page, with room for photo, from *Album Artis Cilik*.

not by chance that for a long time my father has often photographed me. He says [it's] so as to see my development over time. And, turns out, I really like to be photographed." The first page reads across the top, "This book, 'My Name is Joshua' truly belongs to me" and leaves blanks for the owner to fill in his or her name, address, hobby, and other "biodata." In a gesture that combines promotion with an ideology of private property, Joshua advises his fans, "What's important is to buy the book! Don't photocopy it! Don't take turns [borrowing it] constantly! Really . . ." Mimicking the form of the photo album, such books bring these celebrities into intimate proximity, while teaching more generally the value of albums, photos, and biographies as possessions of the individual.

As a series, *dokumentasi* images generate a conventionalized diagram of the event, harnessing memory to the temporality of ritual process; this logic of iconic mapping also informs an emerging value placed on the documentation of individual life trajectories in the form of albums. Just as the photographic recording of an event should replicate ritual process in complete but idealized form, so one should have documentation that hews closely to the path of one's life but marks only its "high points."[70] This self-historicizing becomes a kind of imperative: as Kencana Photo Studio put it (in another promotional article): "A person always wants to immortalize the most beautiful moments in his life. Birth, growing to be a teenager, marrying, and having children form moments that must not be forgotten [*yang tidak boleh terlupakan*] for as long as one lives."[71]

Dokumentasi as a Genre of Family Memory

Dokumentasi photography represents a mode of memory distinct from other forms of remembering practiced in Javanese family life. One young man told me, "Every family, if they can afford it, definitely has their album. There are photos of grandmother, of grandfather, so if there are guests they can look at the album. Or children can look at it." Albums, on the one hand, provide a sense of "continuity" (*urutan-urutan*) between past and present, but they also allow a kind of time travel: "Looking at photographs is like returning to the past, 'here is grandmother back then. Look how funny her clothes are.' 'Here is you when you were small.' 'Here is an old car.'" Summing up, he said, "It turns out that photos express once again the genealogy [*silsilah*], they can be for telling the story to the new generation."

The *silsilah* he invoked are genealogical maps of generational descent restricted to those who trace their ancestry back to the sultans and the prophets who brought Islam to Indonesia.[72] But *silsilah* record lines of descent without narrative elaboration or visual detail (one would have no sense of what grandmother wore from a *silsilah*). More often than invoking *silsilah*, people speak of "family history" (*sejarah keluarga*) when articulating the value of photography. The word *sejarah* derives from the Arabic word for genealogy. Since its modern translation into Indonesian as "history," the word *sejarah* has become associated with history with a capital H: the narrative, archival, written history taught in schools and displayed in museums. Genealogical understandings of

history remain smuggled into this "official" modern history—perhaps most significantly in the New Order paranoia about the latent threat of a resurgent communism borne by the children and grandchildren of communists purged in the 1960s. Nevertheless, the implicit analogy when people speak of photographs as *sejarah keluarga* is less to the old Javanese family genealogies than to printed histories of the nation illustrated with photographs of its heroes.

Aligned with *sejarah*, *dokumentasi* may be contrasted with *kenangan*, another word often invoked to characterize the value of photographs as memory objects. *Kenangan* (or *kenang-kenangan*) can mean both "memory" and a material object that evokes memory, a "souvenir."[73] In the *Album Artis Cilik*, we saw that *kenangan* (souvenir/memory) and *catatan* (written notes or records) were used almost—but not quite—as synonyms. In everyday discourse, *kenangan* is sometimes associated with oral recollection conceived as spontaneous and incomplete, while *sejarah* is linked to writing, linearity, chronology, authority, and completeness. Writing one's "autobiography," one woman suggested to me, demands fidelity to the complete unfolding of events "from A to Z"; she preferred to tell her children stories about her past rather than commit them to writing, so that she could jump around in time and leave gaps as she pleased. Anderson notes that the early nationalist Dr. Soetomo's memoir, titled *Kenang-Kenangan*, departs from the expectations of "modern Western-style biography and autobiography" in that rather than unfolding chronologically, it is constructed out of "fragmented, episodic and unanchored" memories.[74]

Kenangan often refers to objects that serve as metonymic reminders of an event or person.[75] Such objects—typically given by women, especially mothers to daughters—are congealed embodiments of past experience imbued with the presence of their absent owners. Many people told me of clothing, jewelry, even kitchen utensils (like a favored mortar and pestle) given to a distant loved one as *tanda cinta* (signs of love). People give and save batik cloth and clothing to commemorate events, especially weddings or funerals, or as reminders of the person who made or wore them.[76] Many women carefully stored the *kain* (batik cloth) they wore on significant occasions like their engagement or their marriage, never wearing them again. Often, a woman will have *kain* that her mother and even grandmother wore at their own weddings. A friend once listed for me the cloths she kept: the batik laid over her mother's corpse before she was placed in the coffin, the batik

her mother had worn at her wedding, and a batik that her grandmother had made for her in anticipation of her wedding. As one woman said as she showed me the batik cloths handed down from her mother and grandmother, "each one has a story." Another told me that when she wanted to remember her deceased mother, she would wear a shirt that had belonged to her. She had given her mother's jewelry and batik to one of her daughters, in acknowledgment of a special connection between grandmother and granddaughter: "My mother often visits her in her dreams." When I was leaving Indonesia, Ibu Soekilah gave me an embroidered cloth, saying, "If you see this, remember me, this is something I made."

As a modality of memory, *dokumentasi* coexists, at times uneasily, alongside *kenangan*. When Ibu Soekilah showed me the photo album of her husband's funeral, she noted that she kept the dress she had worn that day: "I still have that dress, I still save it." Photographs can also move between these complementary modes of memory. Like a shirt or a mortar and pestle, a photograph of a loved one may serve as a *kenangan*, an indexical proxy invested with sentiment. Rather than a characteristic internal to the image, it is placement within a series that distinguishes *dokumentasi* from *kenangan*.

Wedding photographs, for example, may circulate as *kenangan* to family members and friends. But once placed in the album as part of a *dokumentasi* series, the photograph loses its autonomy. Reflecting *dokumentasi*'s emphasis on "complete" recapitulation, guests are expected to look through an entire wedding album, however perfunctorily.

In one instance, the desire to preserve a complete record of a wedding conflicted with the expectation that images should circulate as *kenangan* among the extended family. Several blank spaces where pictures had been removed interrupted the three carefully composed albums from Ibu Sudirman's daughter's wedding. These marked spots where relatives had extracted photographs from the album to bring home as *kenangan*. A college graduate with a degree in anthropology, Ibu Sudirman's daughter provided a sociological explanation: "They are still from the *desa* [village]," and, lacking a sense of private property, "They still follow the idea that what's yours is mine." As with the *artis cilik* book-albums, she drew a connection between *dokumentasi* albums, individualism, awareness of private property, and modernity.

The genre of *dokumentasi* photography harnesses memory to the iconic mapping of temporal progress and homogenizes different kinds

of family rituals within a single representational logic. Yet this representational logic cannot be said to have uniform effects: in wedding photographs the emphasis is on the compulsive reenactment of tradition; funeral *dokumentasi* photography extends the work of ritual to contain sentiments of loss and grief; the *dokumentasi* of birthday parties provides proof of parental love. The nuances of *dokumentasi* depend on the position of different rituals in the social, historical, and ideological landscape of contemporary urban Java. Refracting within the intimate familial genre of *dokumentasi* are diverse discourses and practices: colonial and New Order preoccupations with cultural authenticity, ethnological and bureaucratic logics, Javanese concerns with proper comportment and affect, ethnic Chinese practices of ancestor worship, and globally circulating ideologies of photo-consumerism. For all its internal heterogeneity, the practice of *dokumentasi* corresponds to a growing value placed on the creation of a paper trail that recapitulates one's personal trajectory. The next chapter examines how in students' production and consumption of photographs of reformasi demonstrations, the "regime of value" that constitutes photographs as sentimentally charged, personal memory objects intersects with the impulse to bear witness to national history-in-the-making.[77]

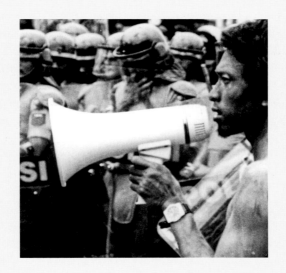

Witnessing History

ON OCTOBER 10, 1999, the writer and editor Goenawan Mohamad's weekly column in *Tempo* magazine recounted the story of a young soldier in the Indonesian revolutionary army who bore witness to Dutch atrocities.[1] Titled "Nationalism," the essay begins with the Dutch army shooting down an airplane bringing humanitarian aid from India to Indonesia on July 29, 1949. Mohamad relates, "A young man, seventeen years of age, comes to that site of death. He wants to immortalize [*mengabadikan*] what has happened. He is not a photographer. He is a painter, and he makes a sketch of the wreckage, with the hope that he will become a witness."

Srihadi Sudarsono, writes Mohamad, made "priceless recordings of events throughout the revolution" in the form of sketches. Srihadi's recordings "show that even in its war of independence, Indonesia was an open book. The outside world came, saw, and Indonesia, though thin, was standing strong." Unlike today's army, he suggests, the revolutionary army felt no need to be *malu* (ashamed): "They wanted to record the events, even if only with paintings, before cameras were owned. They did not want to erase the traces. They were not thieves. They were in the process of making a meaningful history."

The essay appeared during a tense period following the overwhelming vote by East Timor for independence from Indonesia in August 1999. The response of "pro-integration" militias and their Indonesian military backers to this defeat was a scorched earth policy that destroyed homes and infrastructure, killed up to a thousand people, and forced tens of thousands to flee and become refugees on the border of Indonesia and East Timor. Shortly afterward, the United Nations sent in troops to restore peace and disarm the militias. Stoked by a defensive military and an inflammatory news media, some members of an outraged public railed against unfair international "intervention" in Indonesian affairs. Mohamad's essay observes a sad contrast between the present mood and a less hostile nationalist moment, when a young Indonesia looked

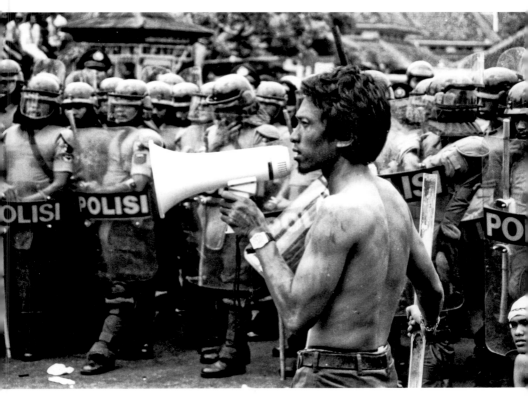

94. Student orator, Gadjah Mada University, Yogyakarta,
April 2, 1998. *Photo by Patmawitana.*

to the outside world for support in its idealistic struggle, when Indonesia was not the oppressor but the oppressed.

In the essay, the camera is present as an absent ideal, the privileged vehicle of "witnessing." That Srihadi Sudarsono's desire to bear witness overcame his technological lack enhances his nostalgic appeal. Like the sharpened bamboo sticks with which Indonesian guerillas fought against superior Dutch guns, the sketches that record despite the absence of a camera signal a youthful, indomitable will.

This chapter explores a similar impulse to document history-in-the-making. Like Srihadi, Indonesia's student activists of 1998–1999 were young, idealistic, and committed to exposing brutality to the world. Unlike Srihadi, these students faced their own army, one all too eager

"to erase the traces" of its violence. Also unlike Srihadi, many did have cameras with which to "record the events" and recognize themselves as makers of a "meaningful history."

In the popular language surrounding photographs of reformasi demonstrations, the images themselves as well as their makers were often called "witnesses of history" (*saksi sejarah*). The trope of the "witness of history" both defines a particular kind of historical agency and articulates a popular theory of photographic efficacy. As witnesses of history, photographers and photographs lay claim to an authority that rests not only in the camera's transcriptive powers of mechanical mimesis but also in the morally charged, highly personal, embodied act of seeing, or bearing witness. The photograph acts as an extension of the photographer's eye, a trace of his agency and vision.

In Indonesian historical discourses, the idiom "witness of history" implies physical presence on the scene of history-in-the-making. Exemplifying the meaning of the term, in the introduction to his autobiography, *Witness of History*, President Sukarno's personal physician writes, "All men have their own individual history, but the man who is aware that his life is at the center of the society around him automatically becomes part of the history of his people."[2] To be a witness is to be "aware" (*sadar*) of oneself as a certain kind of historical subject; it is to stand self-consciously at the juncture between individual and national history. Acts of bearing witness give history its credibility, he writes: "History is only judged legitimate if it has a witness. And, aware that I am a witness of the history of my people, I thus feel myself to have the right and to be absolutely legitimate in recording [this history]."[3] One realizes oneself as a witness of history by creating a testimonial document authenticated and legitimated by the sheer fact of having been there.

Although it predated the reformasi period, the term "witness of history" gained new currency in that moment as official historical narratives of the New Order increasingly became subject to public contestation. Participants in historical events began coming forward to offer personal accounts that were often at odds with official versions. As witnesses of history, they called upon the authority of eyewitnessing to attest to the truth of their claims. The idea of the witness of history came to have a faint tinge of opposition, of truths kept from public view and erased from official histories that had nonetheless been preserved in personal memory.

The treatment of photographs as "witnesses" that authenticate history also predated reformasi. An article in *Fotomedia* in 1996 about Indonesia's first independent professional photojournalists, for example, refers to both the photographers and their photographs as "witnesses of history."[4] History museum texts also described photographs and other material objects as "witnesses" and "authentic proof" that offered visitors a more "direct" experience of the past.[5] While there is nothing specific to Indonesia about according photographs the status of self-authenticating evidence, the idea of the photographic witness places emphasis on a different aspect of photographic indexicality than is usually highlighted in accounts of photography's evidentiary status.[6] Rather than the indexical connection between the image and its extra-photographic referent, what is foregrounded is the indexical connection the photograph establishes between an original, embodied act of witnessing and future acts of witnessing via the image. The photograph, in this understanding, preserves and transmits the subjective act and moral force of *seeing*. It enables an act of seeing, located in a particular time and place, to be extended and collectivized: the camera "functions as a space-time machine capable of instantiating a potentially infinite chain of eye-witnesses."[7]

Modern society, Barthes claimed, has made "the (mortal) photograph into the general and somehow natural witness of 'what has been,'" replacing the monument as the ideal commemorator of the past.[8] Unlike the "immortal" historical monument that establishes itself as a transcendent sign of the past, the photograph's miniaturized scale, mobility, and fragility, its fluid movement between public and private spheres, and its interpellation of the viewer as witness all work to establish an intimate relation to the historical past. The photograph embodies the modern idea that anyone can be a witness of history and that history needs everybody to be its witnesses.

Celebrated by students as signs of a new era of transparency and openness and, at the same time, valued as sentimentally charged tokens of their own pasts, images of reformasi demonstrations mediated students' memories of reformasi and their sense of their own personal stake in national history. This chapter journeys with the photographs along a circuit of witnessing: from the students who took photographs at demonstrations, to popular consumption of reformasi images in the immediate post-Suharto period, to a forgotten past of student witnessing at the opening of the New Order, to the absorption of reformasi

images into a mythic narrative of "student struggle" in state museums, tracing the visual constitution of the student as ideal witness of Indonesian history.

Making History

"To witness is to act!"
—Nazca, comment at the My Witnessing photo exhibition

The year 1998 opened amid economic collapse and growing discontent with Suharto's rule. Students on campuses in Yogyakarta and other major cities in Indonesia began demonstrating against price increases, corruption, and the suppression of democratic freedoms. These demonstrations formed the vanguard for a more generalized push for political reform that ultimately led to Suharto's resignation on May 21, 1998. As campus demonstrations increased in size and frequency—and in the brutality of their repression—students carrying cameras became highly visible on the scene. With substandard equipment, minimal training, no funding, few outlets for their images, and at considerable risk to themselves, student photographers began documenting the student movement. As Danu Kusworo, a twenty-two-year-old accounting student and member of the Sanata Dharma University Lens Club put it, "I had this tool. So how could I let history pass me by?"

Unlike Srihadi, whose sketches approximated an imagined but inaccessible ideal form of record, the student photographers of the reformasi movement were of a generation for whom the camera was an integral part of everyday life. When the reform movement began, for the first time in Indonesian history a large proportion of the student body was familiar with using cameras for leisure and personal documentation. By the late 1990s, photography had become particularly identified with youth culture in Indonesia; of all social milieus perhaps none was as pervaded by photography as campus life.[9] Photography was so popular on student campuses that one student joked, "It's like if you aren't carrying a camera, then you're not really a student."

Many photofinishers in Yogyakarta reported that among their biggest customers were students developing snapshots of friends and school-sponsored trips and events. But in addition to such casual snapshooting, photography had also become both a popular hobby and a

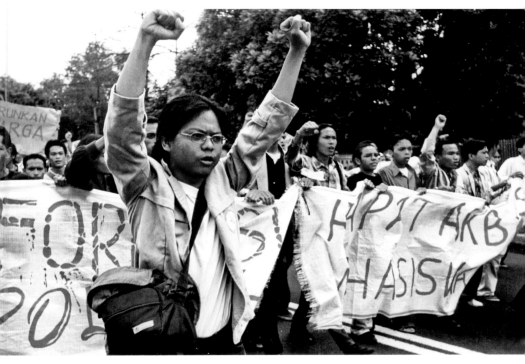

95. Student protest, Gadjah Mada University, Yogyakarta, March 1998. *Photo by R. A. B. Widjanarko.*

subject of study. In 1994, the two major public universities in Yogyakarta (Gadjah Mada University and the Indonesian Institute of Art) instituted photography degree programs, one emphasizing journalistic and the other art photography. A number of other city campuses offered photography courses and programs of study. Perhaps most significantly, the mid-1990s saw a mushrooming of photography clubs on campuses throughout Yogyakarta and other parts of Indonesia.[10] Many of these campus photography clubs were based on the model of amateur salon clubs, and members of amateur clubs often provided initial training, advice, and support.[11] Campus clubs frequently sponsored photographic exhibitions, contests, and seminars.

Given the pervasiveness of photography on campus, it is little surprise that many students were drawn to make and consume images of the dramatic events taking place as reformasi gained momentum around them. Some students took photographs of demonstrations as

an extension of their personal photographic practices. They used cameras to create "souvenirs" (*kenang-kenangan*), personal proof that they had witnessed the historic events giving rise to a new era. At one campus action in February 1999 called "A Million Signatures for Peace," students and political opposition leaders gave speeches and signed a long white cloth banner as a protest against violence. There I met two sisters, college students, whose white cotton *jilbab* glared in the hot midday sun. One carried an old manual SLR camera and the other a clunky video camera. They had been bringing these cameras, borrowed from their father and uncle, to actions and events since the demonstrations had begun in Yogyakarta more than a year earlier. Each sister took turns signing the white cloth banner while the other photographed and videotaped her "in action." Tri, the older sister, contrasted their images with journalistic photographs. Noting that they always pictured themselves in the images, she explained, "We take these pictures for ourselves, not for anyone else, it's like a hobby." Conceiving the pictures as future memory objects within a projected family history, she said they would place them in albums and use them "to tell stories to our children later."

Ani's and Tri's practice was largely consistent with the camera's use as an instrument of personal memory. If studio portraits often incorporated the nation as backdrop to personal images, these photographs refract national history in the domestic idiom of family documentation. Their photographs are materials for "popular memory," defined by Annette Kuhn as a way of remembering that "typically involves the rememberer, the subject, placing herself—what she did or where she was at the time of the big event—at the centre of the scene; as it were grounding the remembered event in her everyday world, domesticating it."[12]

Even students who took images that visually conformed to the conventions of journalistic photographs emphasized their value as personal records. Although Kelik (a member of HISFA as well as a student photographer) took photographs for the student press, for example, he asserted that his primary motivation was personal, continuous with his urge to document all his experiences: "I document mainly for myself, privately. So I have a stock of all the events that I have experienced. I don't think about whether the pictures will be used or not . . . my instinct just tells me to document all the events." Many student photographers spoke with satisfaction of their extensive "private collections"

96. Ani photographing Tri, Gadjah Mada University campus action "A Million Signatures for Peace," Yogyakarta, February 1999. *Photo by the author.*

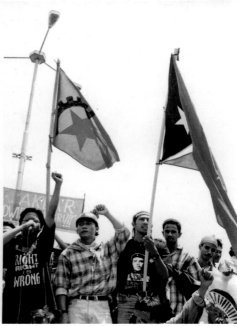

97. Idul Fitri holiday card combining photograph of the Koran with a photograph of protestors (note the Che Guevara T-shirt and the flag of the [then] leftist East Timorese opposition party, Fretelin), made by Bambang Pamungkas, 1998. *Collection of the author.*

of images. Some sold their images to other students who wanted them as souvenirs, and students who saw themselves pictured in another student's photograph would often ask for a copy of the image.[13] Several enterprising students even made holiday greeting cards from reformasi demonstration photographs that they sold to their peers on campus. As greeting cards, journalistic demonstration images acquired currency as a medium of personal exchange and commemoration. As we will see, this dual valence as both historical documentation and personal memory object was also strongly evident in student consumption of photographs at reformasi photo exhibitions.

While many students—male and female alike—took and collected souvenir pictures of demonstrations, those who photographed the more violent mass demonstrations at the peak of the reformasi movement were mostly young men who thrived on an intoxicating mix of

danger and political mission. Few had studied photography formally, but many had been members of campus photography clubs or had some kind of photographic experience before the movement. Fatchul Mu'in, a twenty-three-year-old electronics and computer science student at the Indonesian Islamic Institute, was typical. He started photographing in high school with a pocket camera when he was out hiking with his friends, "just fooling around." He began more seriously to teach himself photography when, at college, he became involved with the student press. Originally from Sumatra, he lived in a typical student boarding house with about twenty other male students. His small room was decorated with posters promoting various social causes and photographs he had taken of caving trips and other hiking expeditions with the "nature lovers" (*pecinta alam*) club on campus.[14] On a low shelf, he kept several albums of his photographs and an album of clippings from newspapers of journalistic photographs he especially admired. A small metal cabinet with a low-watt light bulb rigged inside protected his negatives from the moist tropical air.

Student photographers like Fatchul Mu'in tended to highlight the value of their photographs as historical evidence. They religiously attended marches, performances, rallies, exhibitions, and other reformasi "happenings" on campuses and in public arenas. I would receive a call from one of them telling me of an event and would arrive to see all the same familiar faces. They were clearly aware of looking "cool" with their heavy cameras slung around their necks, and, playing on the macho appeal of the camera, they might cockily train their lens on a pretty woman at an action until she noticed and giggled self-consciously (though they would rarely waste their film by taking the shot). Sometimes I met them on campus, at popular eating and gathering places. In these relaxed settings they were just like college students anywhere. They sat around smoking and laughing, flirted with women students walking by, and gossiped and teased each other.

But the conversation could quickly shift from casual joking to intense and impassioned debate when the subject turned to photography and politics. Motivated by their faith in the persuasive powers of photography to move people and shape opinion, they imagined that, in extending their vision to others, their photographs would generate support for the student cause and provide valuable evidence for a future history of the movement.[15] Before Suharto's resignation they had few public outlets for their images, but student photographs circulated in

underground student publications and from hand to hand. Following demonstrations, students would sometimes stage impromptu exhibitions by posting their photographs on campus bulletin boards. Fatchul recalled that the point of these campus exhibitions was to provoke a radicalization of students who had not witnessed the demonstrations, so that they would say, "Hey, that's my friend, why is my friend being beaten?" Other students described what they were doing as "shock therapy," using images to awaken their more complacent fellow students and "change their way of thinking."

Students also envisioned reaching out to the world outside Indonesia. Rabernir, a photography student at the Indonesian Institute of Art, told me, "I want to show that there are violations of human rights going on. So that other people know the situation . . . So that they can feel it, so they care about this movement." As the international community began to take notice of events in Indonesia, there were more opportunities to sell images to the media via the Internet; a few students became stringers for international news agencies like Reuters. Becoming a stringer meant little monetary gain (purchases of images were rare and compensation minimal) but did give these students the prized press card that offered some protection from security forces. Moreover, although the Internet served only minimally as a means of dissemination for student photographs, it provided an important, galvanizing *imagined* sense of possible connection to the outside world.

Students felt they were engaged in a heroic effort to challenge government attempts to discredit, downplay, or deny the student movement. Their images would counter the suspect reporting, distortions, and erasures of violence in the still-censored mainstream press. Photographs are necessary, said Fatchul, "because we have a principle: not all of the news that is written is true." Students sometimes explicitly compared the value of photographic "evidence" to written words, citing the unreliability of New Order news media and suggesting that photographs were more "objective," less vulnerable to manipulation.

An antidote to the Suharto regime's "thirty-two years of lies," student photographs would not only expose the regime's current abuses but would stave off future manipulations of history. Acutely aware of New Order distortions of the historical record, student photographers saw themselves participating in the making of a vast archive of "historical facts" (*fakta-fakta sejarah*) whose sheer density of accumulation would ensure that nothing remained "covered up" (*ditutupi*). Patmawitana,

a slight, long-haired law student and aspiring art photographer from Atmajaya University in Yogyakarta, compared student photographers with Indonesia's first photojournalists (IPPHOS), who provided many of the key images by which Indonesians collectively remember the revolution and the early Sukarno era. Citing iconic photographs like that of Sukarno reading the proclamation of independence, he stated, "They documented the history of the nation . . . if they hadn't, we wouldn't know that history." "We have to document," he continued. "That is the power of photography, it can become a historical file . . . If you see a photograph, you straight away know, 'the history was like that,' 'it was just like that, the event.'" When pushed, Patmawitana and other students acknowledged that the meaning of photographs could depend on context and interpretation. Nevertheless, they held fast to a notion of photographs as inherently factual and more reliable than words: "Of course photographs can be manipulated. But photographs will always be more like facts, [more able to] prove history: 'the event was really like that.'"

Student Authenticity

As a "witness of history," the photograph is imagined, in one sense, to be an autonomous, self-authenticating agent in its own right; yet, because the photographic "witness" preserves and extends a morally charged, subjective act of seeing, there is also a sense in which the photographer "adheres" to the image.[16] The moral authority accorded to student images of demonstrations had much to do with the ideological construction of the social category of "students" as ideal agents of Indonesian history. In leading the reform movement, students were fulfilling a role laid out for them in the official narrative of Indonesian nationalist history, which figures the *pemuda* (youth) as idealistic actors putting their lives at stake for the betterment of the nation. The narrative positions students at the vanguard of political transformation in Indonesia. But, as elaborated during the New Order, the narrative also contains student activism even as it celebrates it by defining students as the moral conscience of the nation untainted by the messy and corrupt world of *politik*. New Order efforts to depoliticize students following major student protests in 1978 (known as the "normalization" of campus) resulted in a "mainstream tradition of student dissent" emphasiz-

ing a "moral politics" and a "pure" stance located "outside and independent of a tainted power structure."[17]

These ideas about students as morally pure agents ideally detached from established structures of power played out in specific ways to shape the authority of student photographers as witnesses of history. Especially important was their status as amateurs rather than professionals. Students worked independent of—and often explicitly in opposition to—the mainstream media. Suspicious of the heavily censored and self-censoring news media, many students were motivated to photograph by a fear that their history might be distorted or go unrecorded unless they provided their own "facts" and "visual files," as they put it. Although some student photographers had aspirations of becoming professional photojournalists, in our conversations they continually underlined the difference between themselves and professional photographers, who, they pointed out, were motivated by a paycheck rather than idealism. A faculty member at the Indonesian Institute of Art in Yogyakarta echoed this notion of amateur authenticity: "That is what I always admire about the students [who photograph]. No one pays them. They are pure."

More accustomed to the camera's use as an instrument of power than an empowering instrument, many student activists viewed professional photographers with suspicion. They were well aware of the New Order state's reliance on photojournalists and intelligence agents posed as photographers to gather information on student activists. In an interview, a former photojournalist at a local newspaper told me that during student protests in 1974 and 1978 he had regularly turned over photographs of activists to the police.

> The police asked for documentation . . . you know, who are the protesters in front? Who are the ones running [the protest]? . . . They don't know that I am photographing for the police, helping the police, no. What they know is I'm a journalist . . . I take the photos, "snap, snap, snap," you know, and then I would process them, and then I'd give them to the police . . . and they'd pay for the cost you know, it was for documentation. "So this is the person, this is the person," then another time there'd be another demonstration, "Hey it's the same person," so they'd match it up.[18]

Intelligence agents posing as journalists were also present at reformasi demonstrations. In December 1998, for example, students appre-

hended an agent who was a bit too enthusiastically taking photographs of student activists.[19]

Even student photographers were not immune from suspicion. One student photographer recounted an incident in which a group of demonstrators demanded to see his student card and then suggested that it was false. An angry crowd of students formed around him and his attempts to reassure them were unconvincing. Fortunately, a student leader who knew him arrived on the scene and attested to his authenticity: "If he hadn't come, I would have been finished."

As unprofessional photographers, students also faced a number of practical challenges. For the most part, their equipment was unsophisticated: their often second-hand cameras lacked autofocus, telephoto lenses, and other staple features of contemporary photojournalism. Students had to run into the fray, carefully aim and focus their lenses, and get out again without being hit by a student rock or a police baton. Perhaps even more daunting was finding funding. The student movement took place at a moment of economic crisis. When a single roll of film could cost as much as food for a week, each photograph became a precious commodity for students who often lived on extremely limited budgets.[20] Asked how they managed to photograph under these conditions, one student shrugged and said, "Idealism." Another, asked the same question, replied, "Guerilla tactics."

Photographing demonstrations was dangerous work for photojournalists and students alike,[21] but most students carried no press badge to give them even the modicum of security provided by professional affiliation.[22] Students holding cameras at protests were often the targets of particularly vicious police and military violence; in September 1999, a female student, Saidatul Fitria, was beaten to death while photographing a demonstration at Lampung University.[23] In addition to bodily harm, students risked the destruction or confiscation of their cameras and film. They also faced intimidation from plainclothes intelligence officers who monitored campus actions and who sometimes lurked at photo finishers.

The lack of a press badge also directly affected the appearance of their images. Since students could not stand with journalists, protected behind police lines, they were not only more vulnerable to violence but their photographs often more literally represented the student perspective. As one student noted at a public discussion held at a reformasi photo exhibition, the photographs taken by journalists from behind

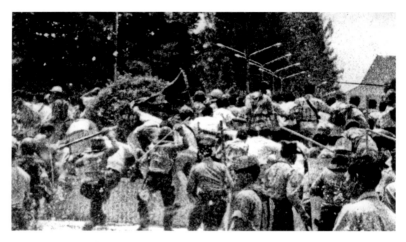

98. Student protestors run from police and water cannons, Gadjah
Mada University, Yogyakarta, April 2, 1998. *Photo by Rabernir.*

police lines looked like pictures of a "stage," while the student photo-
graphs brought the viewer right into the middle of the action. Stu-
dents' images also appeared more authentic to other students because
they often showed more violence than those taken by professional jour-
nalists who were positioned farther away and who were often more
politically cautious. Moreover, their amateur quality (the result of both
inexperience and poor equipment) sometimes more effectively evoked
the chaotic atmosphere of the demonstrations.

This visual alignment with the student experience points to perhaps
the most important source of the authenticity of student photogra-
phers as witnesses: their sense of personal stake in the events recorded
by their cameras and their identification with the student movement.
Versed in notions of journalistic objectivity, some students experienced
conflict between their identification with the student cause and their
role as documentarians. Rabernir commented, "I'm confused about
where to position myself. Sometimes the students come on too strong
. . . but then again, they have to. So as a photographer I put myself in
a neutral position. If the students are throwing [rocks], I photograph
that, too." Others found they had to suppress their sentiments of soli-
darity in order to photograph effectively: "Sometimes in the middle
of a demonstration, my emotion makes me want to just hand my cam-
era over to someone else, so I can join in fully with my friends. But I

don't." Most students, however, were comfortable with their interested position. As Danu put it: "These are records of the student perspective. Surely the *aparat* [security forces] have their own."

Consuming Images

On March 11, 1998, one of the first mass demonstrations of the reformasi movement took place on the campus of Gadjah Mada University in Yogyakarta. In what was then a dangerously provocative act, students burned an effigy of Suharto—its face constructed from the official presidential portrait. Student photographers and journalists were on hand to document the scene, but no local newspaper dared publish the images. The managing editor of the Yogyakarta newspaper, *Kedaulatan Rakyat*, later recounted receiving a call from the Depart-

99. Student protest, Indonesian State Institute of Religion (IAIN), Yogyakarta, April 2, 1998. *Photo by Danu Kusworo.*

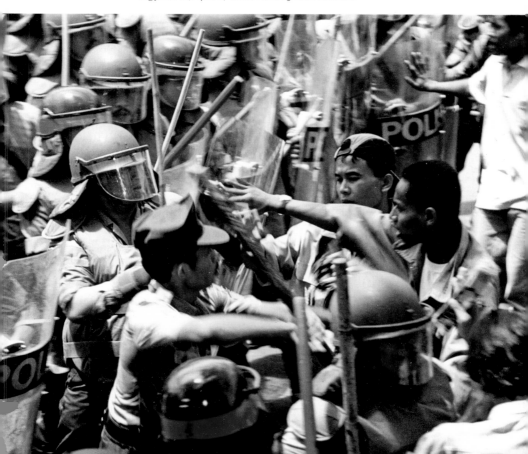

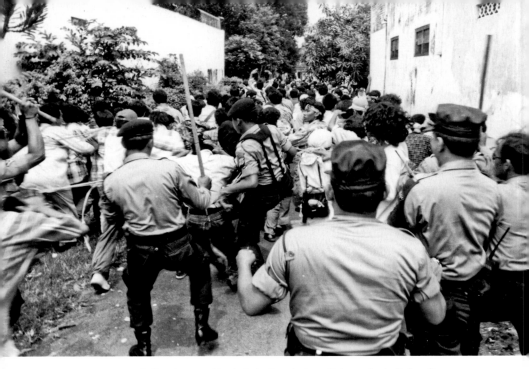

100. Police chase and beat student protestors, Cokroaminoto University, Yogyakarta, April 1998. *Photo by Patmawitana.*

ment of Information specifically warning him not to run a photograph of the burning effigy.[24] Although banned from the mainstream press, a photograph of the effigy was displayed at a campus exhibition sponsored by the student press of the Indonesian Islamic University; other images depicting the same event were published in the student press of Gadjah Mada University and other Yogyakarta schools. A faculty member at Sanata Dharma University in Yogyakarta recalled a student coming to him, fearful of repercussions because he was pictured in a photograph of the demonstration.[25] He reassured the student, "But you are part of history!"

More than a year later, in April 1999, a photograph of the burning effigy would be shown at a photo exhibition in Yogyakarta sponsored by the same newspaper that had heeded official warning and kept it out of its pages. A review of the exhibition noted that although "masses in the thousands burned an effigy and the portrait of Suharto, nevertheless, the image [of the event] became a private document that could not be published."[26] That this and other images of student protest moved out of private collections and campus circulations into public display

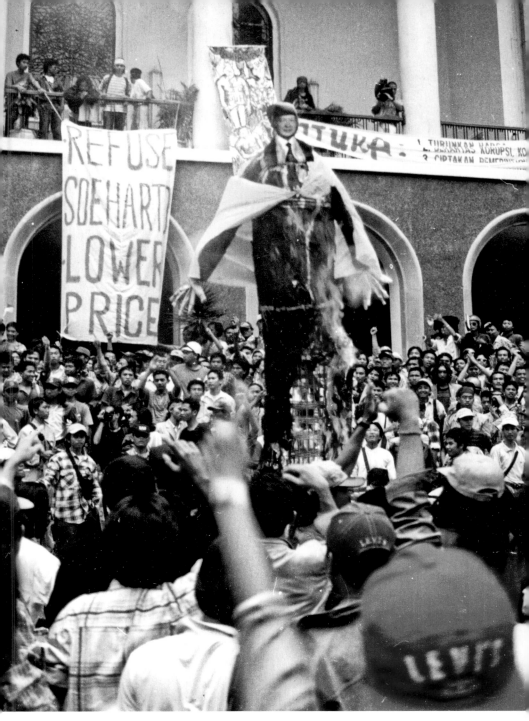

101. Students burn Suharto in effigy, Gadjah Mada University,
Yogyakarta, March 11, 1998. *Photo by Danu Kusworo.*

102. Muslim Students Action Front demonstration, Gadjah Mada University, Yogyakarta, April 17, 1998. *Photo by R. A. B. Widjanarko.*

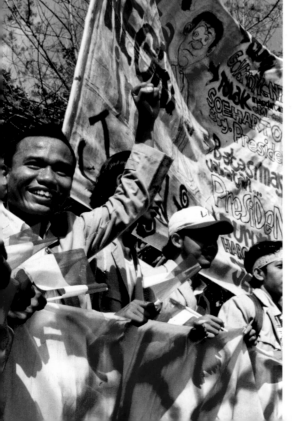

103. "Million People March," Yogyakarta, May 20, 1998. *Photo by Patmawitana.*

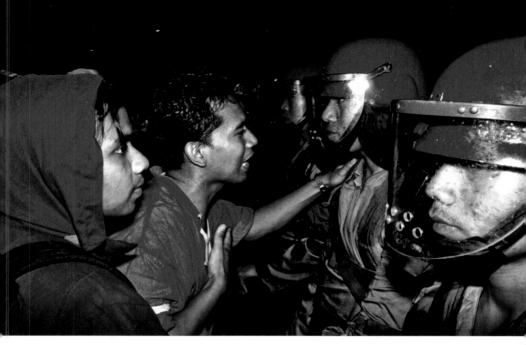

104. A student begs riot police to let marchers through to the People's Consultative Assembly building, Jakarta, November 12, 1998. *Photo by Agus Muliawan.*

105. Wounded student, Atma Jaya University campus, Jakarta, November 13, 1998. Eight students and eleven others were killed on this night, known as the Semanggi Tragedy. *Photo by Agus Muliawan.*

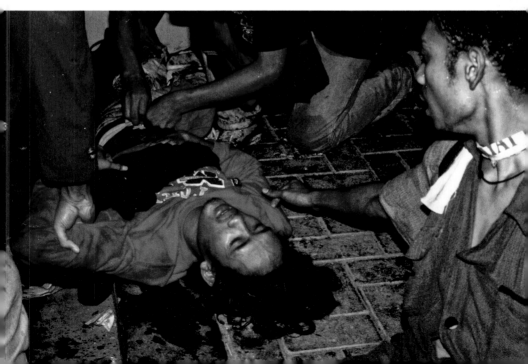

following Suharto's resignation seemed a measure of the achievement of reformasi goals.

In a gesture of his commitment to reform, one of Habibie's first acts upon assuming the presidency in May 1998 was to open up press freedoms, releasing a flood of reformasi images into the public domain via the print and electronic media. Within months, thousands of new tabloids were competing for attention, often using sensational photographs as a draw. New books, among them visual "chronicles" of the reform movement, crowded bookstore shelves.[27] At bookstores and newsmagazine stands, there were always tight circles of students avidly reading publications that few could afford to buy.

For student photographers, the glory days of their struggle seemed to come to an end at precisely the same moment that images of the student movement began to have enormous currency (and commodity value) in the public domain. The student movement was not over, of course; eruptions of student protest occurred periodically throughout 1998 and 1999, and some of the most violent repression of student protest actually took place during Habibie's rule. While students and student photographers from Yogyakarta took part in the massive protests in Jakarta during this time, student actions in Yogyakarta now tended to be smaller-scale and mostly nonviolent. Student photographers continued to document these demonstrations, but some expressed a sense of loss of purpose now that the mainstream press could print the kinds of photographs only students had dared to circulate before. Referring to the pleasing, apolitical images typical of amateur photo clubs, Kelik asked, "What do we do now? Go back to taking pretty pictures of villagers bathing in the river?"

Popular consumption of photographs of reformasi demonstrations at public exhibitions helped congeal the recent experience of reformasi into memory. Indeed, the thirst for images in the immediate aftermath of reformasi suggests the appeal of the photograph's "promise of access to a reality that was not fully apprehended in the moment of its actuality."[28] In December 1998, thousands crowded into a cultural center to see Witnesses of the 1998 Actions (*Pameran Foto Mahasiswa Indonesia: Saksi Seputar Aksi 1998*), a traveling exhibition of student photographs organized by students in Jakarta, Yogyakarta, and Surabaya, during its four-day stay in Yogyakarta. In March 1999, student photographs and video footage of the reform movement were exhibited at the University of Udayana in Den Pasar, Bali, on the occasion of a national meeting of

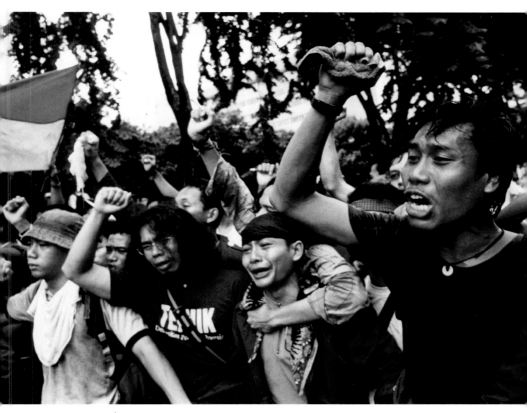

106. Students react to the news that a friend has died in a Jakarta hospital,
Jakarta, November 14, 1998. *Photo by Agus Muliawan.*

students.[29] The Association of Indonesian Photo Journalists (Pewarta Foto Indonesia, PFI, founded in 1998), also sponsored a large reformasi exhibition in Jakarta, From Stepping Down to Semanggi (*Dari Lengser Sampai Semanggi*) in December 1998; a popular calendar in 1999 made from the exhibition's images sold out in bookstores across Java.

Extracted both from private collections and the flow of news media and put on display in galleries, reformasi images became public signs of history. In February 1999, a young *Kedaulatan Rakyat* photojournalist named Eko Boediantoro exhibited eighty of his photographs in Yogyakarta (February 9–14).[30] Consistent with the "witness of history" trope, the exhibition's title, My Witnessing (*Kesaksianku*), conflated the act of witnessing with its material traces. The ending "ku" on the word for witnessing is a form of first-person possessive that connotes speech among intimates, emphasizing the personal, perspectival nature of the vision captured in these documents. An appreciative visitor, writing in a comment book, articulated the idea that the exhibition established a chain of eyewitnesses: "Thank you, because your witnessing has become our witnessing also. Success to you!"

Two months later, photojournalists from newspapers in Yogyakarta and Solo organized an exhibition called Three Orders of Yogyakarta-Solo Photojournalists (April 10–18, 1999). The exhibition, which featured student photographs as well, displayed images from the "three orders" of postcolonial Indonesian history: Sukarno's Old Order, the New Order, and Reformasi (already framed here as a defined historical period). An overwhelming proportion of the images were from the latter period, and unedited and unaired television footage of demonstrations in Yogyakarta, rioting in Solo, and protests in Jakarta in 1998 were also shown at night in an adjacent room. Consistent with the "witness of history" discourse, promotional materials for both the My Witnessing and Three Orders exhibitions emphasized that because of press censorship, many of the photographs had remained, until now, in the photographers' collections as "private documentation." As one organizer of the Three Orders exhibition told me, in displaying "these historical witnessings . . . we want to reopen the album of history."

Despite suffocating heat, crowds pressed into the small gallery of *Kedaulatan Rakyat* to see My Witnessing. Three Orders was located in a more spacious, air-conditioned gallery on the top floor of a mall, across from an arcade of video games popular with young boys. While

members of the general public, including families with small children, attended these exhibitions, most viewers were university students who thronged in, usually in small groups of two or three. A scene of collective, public consumption, the photo exhibition challenges a common assumption that the act of viewing photographs is "private" as opposed to the public and collective (mass) nature of film viewing.[31]

Indicating their enthusiasm, thousands took the time to fill out comment books left open on tables at the exits to both exhibitions. Inviting people to contribute their comments, the books reinforced a participatory sense of community forming around the images. Like the exhibitions, the books, too, were collections of "witnessings"—signs of a widespread desire to participate in history. Underscoring the collective nature of the exhibition experience, many of the comments were signed by two or more people. The comment books—a series of impressionistic, often self-referential, and emotive jottings rarely formulated in full sentences or "correct" grammar or spelling, full of slang, and often sliding fluidly in and out of Indonesian, Javanese, and occasionally English—read like an intimate, informal dialogue among peers. These books make clear that students viewed reformasi images as objects continuous with their own lives.

Historical Evidence and
Personal Memory in the Public Archive

These photographs are witnesses of what happened. They are authentic proof [bukti otentik] that cannot be denied. Changes have taken place. Reform. The era has already changed to become the era of reform. Long Live Reform. —Hamengkubuwono X, February 8, 1999

Alongside Eko Boediantoro's photographs at the My Witnessing exhibition hung this handwritten, signed message from Yogyakarta's sultan, written in the curiously stilted language of a royal pronouncement. The sultan's authority to pronounce these images "witnesses" of the new era of reformasi came not only (and rather ironically) from his power as a traditional ruler but from his popularity as a figure in the reform movement. Photographs of the sultan addressing student demonstrators and leading a massive march just one day before Suharto's resignation had become icons of Yogyakarta's peaceful reform movement.

Many comments from the comment books at both the My Witnessing and the Three Orders exhibitions echoed the sultan's sentiments: "These are truly historical witnesses," wrote one visitor; "Witness and proof of reformasi," wrote another. Another comment writer wrote: "Greetings Reform! May these photos become witnesses of the people's strength. The people are not cows but determiners of the nation's future." One viewer wrote in English—perhaps using this lingua franca to emphasize the images' universal legibility and wider international audience—to assert simply, "This is the truth." Others similarly hailed the self-evidence of the images: "Awesome! Really . . . and this is actual proof of what is and has happened in our country," wrote two young women, and "Let the facts speak for themselves," wrote another. "Photographs don't lie," commented another visitor.[32]

That so many people would respond to reformasi photographs as "visual facts" and "authentic evidence" is hardly surprising given the global currency of ideologies of photographic truth, particularly in reference to journalistic images. But the use of the language of "authentic proof" by student photographers, the sultan, and visitors to the exhibitions reflects also the growing popular perception of the New Order as a regime built on historical untruths. Many responded to the images as "material for a new history of our country," as one put it, emphasizing the importance of their display in public venues: "Photos are able to capture facts and say much—hope that events such as this will often be held"; "Great! Hold events like this often so that people 'won't forget' and can always learn from history." Another urged, "Have these exhibitions often, so that the history of the people of Indonesia will no longer be monopolized." Similarly, a writer described the images as "witnessing that can't be denied by those in power." These viewers shared student photographers' sense of urgency about generating an irrefutable and impartial documentary record of reformasi.

Yet the comment books also reveal the extent to which exhibition goers, like those who took souvenir photographs at campus actions, valued reformasi images as personal memory objects as well as historical documents. The pleasure in visiting the exhibitions seemed, for many, to lie in confirming their own place in history. Going to the exhibition was a bit like opening up a personal photo album. Over and over again, students expressed interest in seeing their own image: "Hello 'brother journalist,' thanks truly, 'cuz I was photo-ed!" wrote one; "my photo's there too," wrote another. Others were disappointed by their exclu-

sion: "Hey, our picture's not there!" wrote two young women, while a young man likewise observed, "Lots of friends. But where am I?" Although joking in tone, comments such as "Good, but . . . how come there's no picture of me?" and "What, you didn't photograph me?" indicated students' desire to be recognized as participants in reformasi through inclusion in this archive of images. Some asserted their own acts of witnessing by recording in the comment books memories triggered by the photographs: "Good, makes me remember my motorcycle that was trashed and when I fell off and was beaten up! Please show these photos to the military."

By contrast, other commentators (often not students, judging from handwriting and linguistic style) expressed gratification at the vicarious witnessing made possible through the photographs: "We get to see the event through the photo even though we didn't witness it directly," and "Now I know what I hadn't yet seen with my own eyes"; "Thank you, we didn't get to witness it for ourselves. Good luck in the struggle, heroes of the people, mother blesses you." Some expressed disappointment that they had not taken part in the demonstrations: "Too bad, I wasn't able to take part"; "Too bad, I couldn't be a history-maker."

Just as students looked for themselves in the images, so they often expressed a desire to possess them: "Wanna take home all the photos," wrote one. "My order: one picture as a souvenir," wrote another. "If possible, we want to ask for a photo as a souvenir," requested two friends. In part, such comments critiqued the sale of reformasi photos and, by extension, the commodification of their own images. In an attempt to recoup exhibition costs, the photographs at the My Witnessing and Three Orders exhibitions were available for purchase for anywhere from $100 to $500—prohibitively expensive for most Indonesians. "Heeey, lower the cost of the photos!" complained two friends, while another comment writer urged, "Hey, give out those photos for free." Striking in such comments is students' sense of entitlement to these photographs as tokens of their own past.

Others signaled the personal value of this public archive by begging photographers to be careful guardians of memories they projected into imagined family albums of the future. Echoing Ani and Tri, the college students who photographed each other at campus actions, one young man wrote that the photographs "can become memories for our grandchildren." "The photos are great, save them well for our grandkids, OK?" wrote another. Another young man commented, "Wow

. . . really cool . . . I ask that no matter what, don't let these be lost, they're all for tomorrow, for our grandkids. Cool. Thanks." And two others wrote, "Great, please store them well for our grandchildren." Some imagined themselves recounting memories stored in the photos to their grandchildren: "Every photo invites our memories about the times that later can be recounted again to our grandchildren!" wrote two young men. The idea that "these pictures will become witnesses for our grandchildren," as another visitor wrote, may be just a clichéd idiom for talking about the future. But, in imagining the images in the context of *dokumentasi keluarga*, it expressed a seamless continuity between the value of photographs as objects of family memory and their status as documents of national history.

In "Uses of Photography," an essay written in 1978 in response to Susan Sontag's bleak conclusions about the distanced approach to the past fostered by photographs, John Berger put forward a model of photographic reading that might promote an ethical engagement with history.[33] Berger contrasted public images—"dead objects," decontextualized and discontinuous with the spectator's experience—with private, personal images.[34] The engaged and connected mode of reading characteristic of personal photographs offered a model for how public images might ideally be read. Embedding spectator/present and image/past in the same social and historical field, Berger argued, would enable photography to become a genuine instrument of "social memory."[35]

This mode of reading, which combines a sense of the public import of events and one's own personal stake in them, largely characterized Indonesian students' reception of reformasi images. Just as the idea of the "witness of history" evokes the morally charged intersection of personal trajectories and national histories, the blurring of personal and journalistic genres gave reformasi photographs their distinctive value among students. Many reformasi images that followed the conventions of "journalistic" images were nevertheless read by students with the recognition, identification, and personal engagement with which one might read photographs in one's own album. In student consumption of photographs of reformasi, the ideological formations that privilege photographs as historical "proof" merged with those promoting them as ideal receptacles of personal memory.

The idea of the photograph as a witness that extends the act of witnessing suggests photography's capacity to generate an interpretive community grounded in a common visual vocabulary and a morally en-

gaged stance toward a shared history. The images gave rise to a power-
ful sense of connectedness akin to the kind of "social memory" Berger
envisioned might ideally animate otherwise "dead" public images. The
experience of rewitnessing reformasi at crowded exhibitions recreated
the thrill of group solidarity that accompanied participation in mass
actions. Students repeatedly described feeling "moved" by the images,
as did many of those who recorded their responses in the comment
books. One commented, "Makes me want to cry . . . remembering
the tragedies of the past." Another wrote, "I am moved for the second
time." As a participant in a discussion at the Three Orders exhibition
noted, "We witness this [exhibition] in order to bear witness again."

But the photographs that highlighted the peak moments of student
unity and purpose were on display at a time when the student move-
ment was faltering, with no discernible leadership and few uniting
issues. Although the wider social and political goals of the reformasi
movement were far from secured, action had shifted off campus into
a more explicitly political arena. By recycling and reliving these earlier
moments of their struggle, students were also consolidating a mem-
ory of historical agency that they increasingly located in the past. As
one student wrote, "Reminds me of when together we became makers
of history." The emotions stirred by rewitnessing reformasi through
its visual traces could potentially galvanize students for future action.
But, in more firmly consigning students' agency to the past, rewitness-
ing could also be politically disenabling. Indeed, one visitor succinctly
summed up the dominant sentiment such exhibitions aroused when he
wrote: "Nostalgia for the student struggle!"

New Order Genealogies of Witnessing and "Youth Struggle"

Alongside nostalgia, amnesia. In embracing photographs as "authentic
proof" and reveling in their own moment of heroic agency, students
were to some extent replicating the historical ideologies and mythic
narratives of the very regime they opposed. The reformasi-era cele-
brations of photographic heroism "forgot" the role that photographs
had played in the construction of the student as a privileged actor in
Indonesian history. Despite most students' sense of the novelty of their
moment, photographic witnessing had played a significant role in the
opening years of the New Order. Displays of documentary "evidence"

of communist violence cultivated shared sentiments of outrage and an atmosphere of terror, while images of student demonstrations provided apparent proof of support for the new regime.

Clearly there are significant differences between 1965–1966 and the reformasi period. The extent of state control over the production and distribution of images was far greater in the early New Order—in part because the general public had far less access to technologies for making, reproducing, and circulating images. But beyond the obvious contrasts lay less recognized similarities in the use of images and the ideologies that underpinned them.

Organized public events, including photo exhibitions and film screenings, were important propaganda tools in the aftermath of the alleged communist coup of September 30, 1965.[36] As early as November, the state sponsored screenings of footage of the burial of the generals killed in the alleged coup attempt. Announcing a showing in Yogyakarta, the newspaper urged, "This film should be witnessed by every loyal Pancasila-ist."[37] In 1967, an Independence Day exhibition sponsored by the military and the government displayed photographs alongside bloody articles of clothing as proof of traitorous violence allegedly perpetrated by communists.[38] Images of the generals' bodies being exhumed and descriptions of their supposedly mutilated bodies were important rhetorical weapons in whipping up mass hysteria and hatred of the communists. An article in *Kedaulatan Rakyat* paraphrases a military officer's speech at the exhibition's closing: "[This exhibition] gave the greatest of stimuli to every visitor by exhibiting the photos of the Revolutionary Heroes who were killed in a cruel way at Lubang Buaja and the shirt of the late General Yani soaked in blood. From the photos and the shirt it is hoped will come the awareness to always be on the watch [*waspada*] for the remnants of G30S/PKI who clearly have become our enemies."[39]

Journalists and student groups also sponsored exhibitions. An early promise of the New Order was the restoration of freedom of the press (restricted during Sukarno's increasingly dictatorial Guided Democracy, 1958–1965), which helped secure support for the new regime among many students and intellectuals. But the so-called honeymoon between the press and the government was achieved through the purging of "communists" from the ranks of the PWI (Perhimpunan Wartawan Indonesia, Indonesian Journalists Association) and the closing of leftist newspapers.[40] Nevertheless, photo exhibitions of the

early New Order, like reformasi exhibitions, were hailed as signs of a new climate of openness and political freedom. In 1967, the Yogyakarta newspaper *Kedaulatan Rakyat* sponsored a large exhibition on the press.[41] Articles about the exhibition describe crowds eagerly filling out comment books. A visitor's comment reproduced in the newspaper echoes commentaries written at reformasi exhibitions: "The KR exhibition . . . succeeds in providing to the public historical content that is pure [*murni*], so that the people will no longer be kept in the dark [*diabui*] by two-faced leaders."[42] Also quoted is a speech by Samawi, the head of *Kedaulatan Rakyat*, labeling Sukarno's Guided Democracy a "dark age for the Indonesian press" and proclaiming that "freedom of thought, freedom of speech, and freedom of writing have become the slogans of the people and the Government."[43]

In May 1966, the anticommunist student group KAMI (Kesatuan Aksi Mahasiswa Indonesia, or Indonesian University Students Action Front), together with the Yogyakarta branch of the PWI, put on an exhibition displaying photographs of their "struggle . . . to uphold justice and truth."[44] The headline for an article about the exhibition, "KAMI's Photography Exhibition Is Not a *Show* [in English]: Documentation from Their Struggle," seeks to downplay the spectacular nature of the exhibition in favor of the more sober-sounding "documentation." Another article ran the headline "Looking at the Photo Exhibit, Youth Are Spurred on by History."[45] It reported that the photo exhibition received "great attention from the public, such that the exhibition space was packed," and noted that "the photographs picture the actions of KAPPI [Kesatuan Aksi Pelajar-Pelajar Indonesia, Indonesian Students Action Front]-KAMI to defend truth and justice . . . all over Indonesia." The polemical nature of the exhibition is indicated in the article's quotation of a caption accompanying a photograph: "We can't be disbanded, because this is our moment in history."[46] The article also quotes a visitor to the exhibition, described as "riveted looking at a photograph," commenting, "For a long time I have been struck by an image . . . the jacket of Rachman Hakim soaked in blood. These photographs truly speak to us so that we know the struggle of KAPPI-KAMI."[47] This sense of historic import and of images that interpellate viewers as witnesses, generating highly personal and charged reactions, echoes the language of the photo exhibitions of 1999.

Like clothes soaked in blood, photographs were indexical objects saturated with the charge of having been there. But while photographs

of and by anticommunist students and journalists survived to bear witness to history, those by photographers on the wrong side of the political fence never made it into the public archive. Djoko Pekik, today one of Indonesia's most prominent painters, was a student photographer in the early 1960s who continued photographing student actions after he graduated from art school in Yogyakarta.[48] In 1966, when he was arrested for his affiliation with LEKRA (Lembaga Kesenian Rakyat), a communist-affiliated artists' group, and imprisoned without trial for seven years, he lost everything: "The police took it all, I was left with a pair of pants and one shirt, for seven years. Everything was taken, all my film and photos, and I had a lot of documentation. My photos of the demonstrations of that time are all lost."

Even had the police left his belongings alone, he added, his own family would probably have destroyed them once he was arrested: "Then no one was brave enough to save anything. If you had the [communist] newspaper *Harian Rakyat*, or books that smelled of the Communist Party, or photographs of Gerwani [the vilified communist women's group] they were all thrown away, burned." The eradication of photographs like Djoko Pekik's helped pave the way for the New Order regime to make use of images of "youth struggle" by erasing from the historical record the political complexity and internal divisions within the history of student activism. Images of anticommunist student demonstrations were co-opted into generalized signs of popular support for the New Order regime.

A series of photographs taken in the final months of 1965 by Moelyono, a *Kedualatan Rakyat* photojournalist (whose personal photographs we have encountered in earlier chapters), were displayed in the Three Orders exhibition. The exhibition literature described how these images had remained safe within the photographer's private collection and only now could be released into the public eye. Once again, their covert survival in private hands offered a kind of political alibi, attesting to their oppositional authenticity. Like the exposure of reformasi images formerly too explosive to show publicly, the display of once suppressed images from a more distant past affirmed that a new era of freedom had been achieved.

In fact, only one or two of the images in the exhibition from this period had not been published at the time they were made. Indeed, the exhibition materials made no reference to another history of these images: the actual conditions of their production. In several inter-

views, Moelyono explained the extent to which the military had controlled and strategically used the production and circulation of such images to generate its own circuits of witnessing.[49] He described in detail his sojourn as a reporter handpicked to document the work of the military as it searched out, captured, and killed communists in the region of Klaten (about fifteen miles from Yogyakarta), a stronghold of communist sympathy.

Moelyono was told what, when, and how to photograph, and images were selected to be published in the newspaper in collaboration with military commanders.[50] Discussing these restrictions, Moleyono told me that he was not allowed to photograph someone being killed. He could photograph a corpse, but not the corpse's face. "Their faces weren't allowed to be shown. I don't know why, I guess it was a military secret . . . The sadistic events couldn't be printed." As an example, he indicated one of the photographs displayed at the Three Orders exhibition, which showed the bodies of two members of the People's Youth (Pemuda Rakyat, the Communist Party's youth group) lying in a tangle on the ground, cords visible around their wrists. Moelyono told me that he had witnessed these two young men being shot. He claimed they had been shot separately, but their bodies were arranged together (face down) for the photograph. More common were pictures showing grim captured "communists," almost always pictured with a gun-holding soldier in clear control: "The soldier would even take on a pose!"

Moelyono's photographs, produced and consumed under carefully controlled conditions, shaped a particular vision of the eradication of communists during the first months of the New Order. But when Moelyono was invited to speak about his experiences at an exhibition discussion, obviously uninterested students talked so loudly to each other that the moderator asking Moelyono questions finally gave up. Students became interested in the discussion only when conversation came back to reformasi, to a history in which they themselves were participants.

Yet one photograph by Moelyono at the exhibition seemed to draw students' attention. It was a picture taken before the eruption of violence in 1965, showing a group of young people at a mass rally for the Indonesian Communist Party on the *alun-alun* (the large square green in front of the *Keraton*) in Yogyakarta. The orator is outside the frame; one sees only the crowds of seated listeners who appear to be casu-

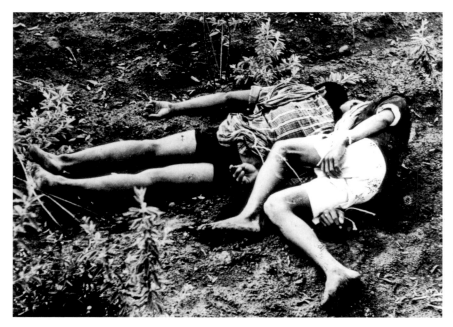

107. Two dead "Pemuda Rakyat" (People's Youth), Klaten area, 1965.
Photo by Moelyono.

108. Captured "Communists," Klaten area, 1965. *Photo by Moelyono.*

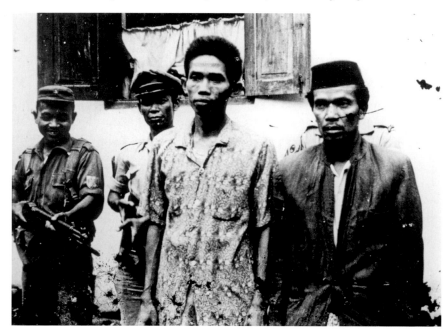

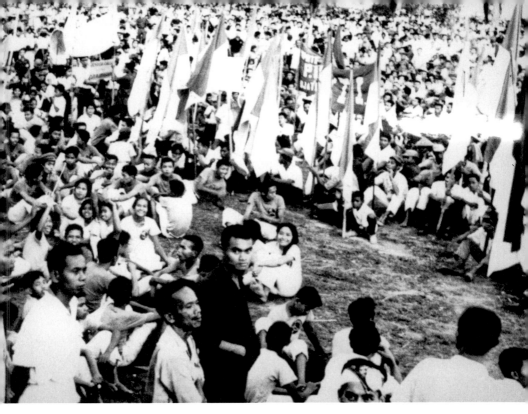

109. Moelyono's photo of a Communist Party rally, Yogyakarta, 1965, as it appeared on exhibit at the Three Orders exhibition. *Photo by the author.*

ally enjoying themselves. In the center of the photograph is a young woman who has turned her head slightly so that she happens to face the camera. She is laughing and girlishly hugging her knees to her chest. Her hair is well-combed. The punctum of the image, her lovely smile is an arresting detail that "pricks" the viewer, making one think about her "whole life external to her portrait."[51] One could not look at her face without wondering what fate had befallen her—even, perhaps, precisely because she had had the misfortune to appear in this photograph.

Throughout the exhibition, the flow of viewers always seemed to clot around this picture. People murmured to their companions, "They look so young," "They're just teenagers." Several reached up a finger as if to stroke the girl's face (the photos in the exhibition were framed, but not behind glass, so the actual surface of the photograph could be touched).[52] Yet sympathy for these innocent youth, so oblivious to their fate, was not particularly surprising. It was now a commonplace

among students that the masses of communist followers were innocent victims of elite political battles.

The strong reaction to the image suggested that it tapped into something deeper, more unexamined. Perhaps what troubled people was an unanticipated feeling of recognition. What students saw was not only a challenge to New Order demonizations of the Indonesian Communist Party, such as the disturbing images of deranged Gerwani members dancing in an orgy of torture in the state-sponsored film about the alleged 1965 coup that aired annually on national television since the mid-1980s. They saw a reflected image of themselves; they felt, perhaps, a recognition that broke through the "otherness" of the past. In the context of the Three Orders exhibition, amid images of idealistic youth from the 1990s it eerily resembled, perhaps students could not avoid reading this image, too, within a personal frame. Recontextualized in the Three Orders exhibition and within students' nostalgic memories of their own demonstrations, it ceased to be a "dead" image, divorced from its viewers' context. Like Benjamin's images serving as "political dynamite" to "destroy the mythic immediacy of the present," this image viscerally ruptured the smoothness of a history whose questioning in the reformasi moment rarely disturbed the membrane separating past from present.[53]

Archival Cooptation: Mythic Narratives of "Youth Struggle"

Moving out of private hands and into public spaces in the post-Suharto period, photographs of reformasi became material for collective memories of reformasi. Collected and displayed by state museums and agencies, they also became part of the recognized official historical record. In the process, they were subsumed within a nationalist narrative celebrating youth as the heroic vanguard of nationalist struggles.

Whereas students implored photographers to save their photographs for "our grandchildren," the state also staked its claim to the history the images recorded. In February 2000, an article in *Kedaulatan Rakyat* noted that journalists' photographs and other reformasi materials were being collected by the local branch of the national archive.[54] The article describes the archiving of this "authentic proof of history" as an act of "safekeeping." It mentions several times that the documents will be "stored neatly and safely" and "guarded" because the national archive

has a "commitment" to ensuring that no "historical *link* [in English]" will be "lost." Such insistence on "safe" storage implicitly responded to widespread public criticisms of the manipulation and destruction of state documents during the New Order.[55]

Dedicated to the history of the nationalist "struggle," Yogyakarta's Benteng Vredeberg Museum also appealed to the community to turn over any objects of "historical value" from the reformasi period. A letter from the head of the museum to his superiors at the Department of Education and Culture dated July 27, 1998, reads in part: "As one of the organizations given the task of gathering, caring for, studying, and communicating historical materials to the public, [the museum] hopes that prominent figures [*tokoh*], fighters, leaders of organizations/ agencies and the public will give documents, posters, photographs and reformasi banners that remain and that form authentic evidence of the unfolding of an event in the historical course of the Indonesian state, in order to become material in the collection of the history of the national struggle."[56]

On November 4, 1999, the museum held its annual exhibition commemorating the "Youth Oath" of 1928 (*Sumpah Pemuda*), a key event in which young nationalists from a variety of regions and groups affirmed the basic principles of the Indonesian nation: one people, one land, one language. Celebrating "the milestones of the youth struggle from the period 1908–1998," the exhibition was intended to "motivate the young generation"; heads of schools were urged to "invite their students to witness it."[57] (When I visited the exhibition on several occasions, groups of schoolchildren were the only visitors.) This exhibition consisted almost entirely of photographs, alongside artifacts like cooking utensils, clothing, swords, typewriters, and furniture that had some indexical connection to particular historical events or figures.

The captions next to the photographs depicting key events of nationalist history recited the familiar narrative of "youth struggle." But included at the end of this exhibition were three images that differentiated it from its New Order predecessors: an image of the "Malari" student demonstrations in 1974 (the first major convulsions of anti–New Order student protest);[58] an image of Sultan Hamengkubuwono X addressing the crowd during the massive reformasi march of May 20, 1998; and an image of students occupying the People's Consultative Assembly building in Jakarta on May 21, 1998. As one museum official acknowledged, such an admission of student discontent within the New Order

would never have been shown during Suharto's rule; in the delicate way of a cautious bureaucrat, he said they had had to be "very selective" about what they showed.

In the reformasi context, the Malari image helped establish continuity between the photographs of anticommunist student demonstrations of 1966 and the student demonstrations of 1998. The final two images tacked the reform movement onto the preexisting narrative of youth struggle. The image of the sultan addressing demonstrators reassured viewers that there was a proper authority in control and reinforced a local story that Yogyakarta's "peaceful" reformasi was contingent on the sultan's "traditional" authority. The student uprising was thus figured as an appeal to authorities to listen, not a seizure of power. Similarly, the final image of students triumphantly occupying the People's Consultative Assembly building implied that by gaining entry to the Assembly students had successfully gained the ear of the established political center. This climax of the student movement was also its appropriate end.

When I asked a museum staff member about the exhibition, he recounted to me (in the language and tone he might have used to speak to the groups of schoolchildren he guides through the museum) the narrative of "youth" in Indonesian history. His telling incorporated the reform movement almost seamlessly into this well-rehearsed script. He began by asserting that "the youth have a role that is very important in determining the course of the national struggle." Next he traced key moments in nationalist history, from the founding of Budi Utomo (a protonationalist Javanese organization) in 1908, to the Youth Oath of 1928, to the declaration of independence on August 17, 1945, to the revolution. He then described the New Order project of "giving substance to independence" (*mengisi kemerdekaan*) through development as the next phase of youth struggle. Finally, depicting the reformasi movement as an effort by "the youth" to "straighten out the shortcomings" of the New Order, he concluded, "So with the youth united . . . and helped by the other members of society, finally there was total reform, with demonstrations, because demonstrations are part of democracy . . . are they not? Finally it all took place smoothly."

His narrative epitomizes the containing effect of this mythic story of youth struggle. A narrative of national progress, it depicts reformasi as a correction of "shortcomings" rather than a break of any kind. Notably, his telling skips over the student demonstrations of 1966 altogether, de-

spite their visual incorporation into the exhibition, presumably because the period of transition to the New Order had become profoundly controversial. The only hint of hesitation troubling the smooth flow of this history lies in his rhetorical question: "are they not?"

A similar museum exhibition in 1995, Portrait of Indonesian Youth in History from 1908–1966, had concluded with the anticommunist student demonstrations of 1966, identifying students as the initiators of the New Order.[59] An internal report on that exhibition noted that although youth of each era face distinct challenges, they possess a "characteristic dynamic spirit" and "are always visible at the vanguard of every historical event and always emerge in front full of creativity and initiative." Although the narrative at the exhibition in 1999 had expanded to include reformasi, its structure remained the same. Historical specificity and contingency had given way to a teleological narrative and a monolithic actor: Indonesian youth.

Museum exhibitions displaying reformasi images worked to transform a moment of instability into the reassuring continuity and inevitability of mythic narrative. Signs of student protest, in line with the narrative scripts of nationalist history, came to stand in for a broader historical process that was far more messy, unpredictable, and incomplete in its resolution. The broad effects of this narrative, with its privileging of youth struggle, explain in part why the shooting of four university students on May 13, 1998, received so much public mourning in the press in comparison with the thousands of people killed and scores of Chinese Indonesian women raped during the rioting that followed. The students could be mourned because they were already national heroes; the deaths of rioters in burning malls and the suffering of the ethnic Chinese Indonesian community have no place in this narrative and thus remain senseless and publicly unmourned.[60]

Signs of Protest, Circuits of Witnessing

Reformasi photographs rendered students subjects of history in the double-edged sense of that term: they allowed students to recognize themselves as actors producing their own history and, at the same time, subjected them to a visual iconography of youth struggle that was not of their own making.[61] Photographs extended the moral power of student witnessing, expanding the reach of the student movement. But as

they traveled into public spaces and state archives, they became materials for nostalgic recollection and mythic narratives of youth struggle. Photographs of students united in protest displayed at public exhibitions and in museums acted as "screen images" eliding more disturbing fissures within the student movement and Indonesian society that were becoming particularly visible at precisely the moment that students and the general public were eagerly consuming them.[62]

But some students sought to use their photographs not as mythic screens but as triggers that might expand the circuit of witnessing and generate new kinds of historical awareness. In April 1999, students from the Indonesian Islamic University and other local campuses in Yogyakarta held what they called an Outdoor Exhibition (*Pameran Outdoor*). In the glaring midday heat, a small procession marched through the main streets of the city: a group of drummers led, followed by twenty-six students, each holding a framed student photograph, followed by another group of students holding banners painted with slogans. After a certain number of paces, the drums would roll and the students would stop in the middle of the road, turn to face the sidewalk, and hold the pictures up, silently, for about fifteen seconds, before continuing on again.

110. Outdoor Exhibition, Yogyakarta, April 1999. *Photo by the author.*

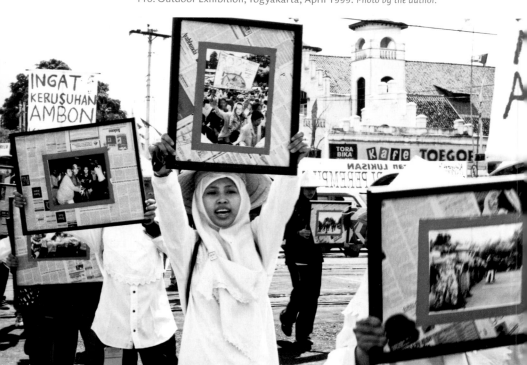

As they marched, the protesters chanted in rhythmic monotone, "Our History is Always Full of Tears" (*Sejarah Kita Selalu Ada Air Mata*), a slogan also scrawled in red paint on their white cloth banners. Other banners urged onlookers to recall violent events in the nation's past (and present): "Remember: Aceh, Ambon, Tanjung Priok, Timor." "Remember: 1965, Malari."[63] The photographs of reformasi—showing police brutality against student protesters—were thus extended as metonymic witnesses to an entire New Order history of state-sponsored violence. Using the inclusive form of the word "our" (*kita*), students invoked a broadly shared national inheritance of violence and refused the singularity of the "student" struggle.

The Outdoor Exhibition protested Indonesia's pervasive "culture of violence" (*budaya kekerasaan*) at a moment of intensifying religious conflict in Ambon and anxiety about violence leading up to the general election in June 1999. Fatchul Mu'in, one of the event's organizers, explained that the point was "to make the people closer to the events." A walking archive, the outdoor exhibition sought to create a more public space (neither the elite exhibition hall nor the state-controlled museum) where "history" could circulate and be seen, transforming passersby into witnesses.

The protestors concluded their march at the monument to the General Attack of 1949, an enshrined event of revolutionary history that had recently become a sign of New Order historical manipulation. Suharto had buttressed his credentials as a revolutionary hero by claiming to have masterminded this attack on the republic's capital, which was under Dutch occupation. After several brief statements by student activists, those who had been carrying framed photographs unfurled rolled photocopies of the images they carried and one by one pasted them to the walls of the monument gates. Left to blemish the whitewashed surfaces of monumental national history, they remained as unruly reminders of state-sponsored violence and the students who bore witness to it.

The Outdoor Exhibition seemed to offer the possibility that reformasi images might do more than isolate students within their own mythic history, serving to extend their witnessing to other witnesses, their history to other histories. Among the images carried in the exhibition and left behind as photocopied traces of witnessing were photographs by Agus Muliawan, a photographer who before and immediately after graduating from Gadjah Mada University in 1998 had

111. Students march to the People's Consultative Assembly building, Jakarta, November 12, 1998. *Photo by Agus Muliawan.*

documented student demonstrations in Yogyakarta and Jakarta. In the spring of 1999, Agus traveled to East Timor to photograph and videotape the conflict between pro-independence and pro-Indonesia groups, the referendum, and its aftermath. Having spent a semester studying in Japan, he had been offered work with a Japanese media group producing a documentary on the East Timor situation. When other journalists left the increasingly dangerous region shortly after the referendum in which East Timorese voted for their independence from Indonesia, in August 1999, Agus chose to stay and continue reporting. On September 25, 1999, he and eight others were ambushed and killed by members of an Indonesian military–trained militia. He was twenty-six years old.

Agus's murder occurred during the period that prompted Goenawan Mohamad to write the essay with which this chapter began, a moment when the loss of East Timor and international criticism of Indonesian military excesses had triggered a wave of defensive nationalist senti-ment. Had Agus been killed while documenting the student move-ment, his photograph would have been splashed across the pages of

newspapers. But although he had been active in the student movement at one of Indonesia's most prestigious public universities, his death received only brief mention in national newspapers, where he was glossed as an "Indonesian journalist working for the foreign press." Rhetorically placed outside the fold, an ally of the foreign gaze and therefore of questionable nationalist sympathies, Agus received no public mourning.[64] It did not have to be acknowledged that an Indonesian student activist had been killed by militia trained and supported by the Indonesian military.

Like many student photographers, Agus was driven by faith in the moral outrage that photographs could ignite. But his insistence on moving beyond the confines of "youth struggle"—his belief in the connection between what students fought for in 1998 and East Timorese aspirations for freedom—cost him his recognition as a witness of Indonesian history. When, several months after his death, friends in Yogyakarta tried to organize an exhibition of his photographs from Java and East Timor, his family, fearful should the exhibition be seen as a provocation to Indonesia's high-ranking military officials, decided it was best to keep his images within their private collection.

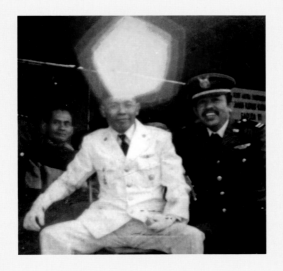

Revelatory Signs

IN THE SNAPSHOT, a pentagon-shaped area of light hovers over the head of a man dressed in a white uniform and white gloves, sitting in a wide-legged posture of authority, surrounded by military officers. For Noorman, the man touched by the light in the photograph, this glowing shape was no mere effect of light refracting within the lens of the camera.[1] The photograph was, rather, a revelatory sign that made visible that which was otherwise invisible: Noorman's divine mission to restore Indonesia to itself. Rather than a passive record, moreover, this photograph was a potent object imbued with the auratic power of its original and capable of having effects in the world.

I happened upon this photograph one morning in early 1999. I had wandered down a narrow alley near my home, intrigued by the large, faded paintings on its cement walls of revolutionary soldiers, first president Sukarno, and his daughter Megawati, then the leader of a major opposition party. Carefully lettered slogans called for a "return to the history of 1945" and proclaimed "History will repeat itself." Further ahead, I passed water-stained Megawati and Sukarno posters—commercial images of the kind sold by street vendors cashing in on nostalgia and oppositional political sentiments. These had been curiously altered. Cryptic messages had been handwritten on them—"That he who will become the Third President of the Republic of Indonesia, is he who holds the Original Manuscript of Supersemar, that is. : Bung Karno. !"[2]—and signed with the name Noorman. Attached along their borders were several faded snapshots of the man with the lens flare floating above his head.

Where the alley met another, even narrower path, there was a typical, tiny shop selling bananas, garlic, single-use packets of Sunsilk shampoo, and *kretek* (clove) cigarettes. I asked who Noorman was, and a man pointed to a house a bit further down the alley. Approaching along the side of the house he had indicated, I saw that the entire building was covered with posters, photographs, and painted slogans.

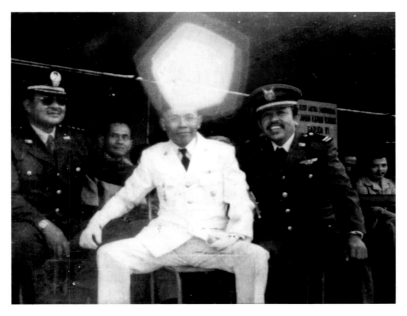

112. Noorman with the light of divine radiance, 1979 (a wallet-sized image he gives out to his followers). *Collection of the author.*

The house was on the corner, and the cement walls of the alley it faced onto were likewise blanketed with crude drawings, slogans, and faded photographic images. The house itself was a simple structure made of wood, bamboo-weave, and concrete. A young man (who turned out to be Noorman's youngest son) was seated by the open door, and when I greeted him he invited me in as if I had been expected.

Inside, images and words covered every available wall space. Hand-written slogans and arrows linked photocopied newspaper clippings, photographs, posters, and painted figures. Certain images appeared over and over: portraits of Noorman, a lithographed image of Christ to which a small identity photograph of Noorman had been affixed, photographs and posters of Sukarno and Megawati, and images of Javanese mythical figures like Semar and Ratu Kidul.[3] Mixed in among these repeated images were family photographs—stiff studio portraits from the 1950s and 1960s and enlarged identity photographs—creating a strange parody of the conventions of the Javanese front room, where family photographs are typically displayed along with various signs of political, cultural, and religious affiliation.

Noorman, a retired veteran of the revolution living in relative poverty and obscurity, had transformed the domestic space of his home into a vivid surface for rendering his alternative vision of Indonesian history. A layered and constantly changing collage of texts and images, Noorman's counterhistory is the subject of this chapter not only because of its intrinsic interest as an attempt to reenvision Indonesian history but also for the ways that it illuminates broader themes of visuality, documentary authority, and historical truth within contemporary urban Javanese life. Two different epistemologies of history, which I call documentary and revelatory history, compete and intersect within Noorman's counterhistory. Documentary history focuses on the accumulation of "authentic" documents to reconstitute the past and corresponds to the official history legitimized by state historiographical practices and disseminated in state institutions such as schools and museums. Revelatory history, by contrast, offers a messianic vision that collapses the distance between past and future, promising—through portents and miracles—return and recovery. Rooted in Javanese mystical beliefs identified with "tradition," revelatory history is nevertheless sustained and disseminated through modern print culture and technologies of mechanical reproduction. Many of the "imagetexts" Noorman produced straddled these divergent historical epistemologies, serving simultaneously as documentary traces and revelatory signs of presence.[4]

Photographs were particularly important resources in Noorman's counterhistory, serving as both documentary "proof" and efficacious, revelatory signs. On the one hand, Noorman emulated the official history he opposed, mobilizing photographs as "authentic proof" (*bukti otentik*) of history. But images such as the photograph of Noorman with the lens flare point to a different semiotic logic attending images of charismatic political and mythic figures. Rather than transparent records of a past event, these are photographs that reveal hidden truths and convey the aura of their pictured originals. The image makes visibly and tangibly present that which only appears to be absent.

Writing of the work of art, Walter Benjamin famously argued that the aura of the original—its unique presence in time and space—would inevitably wither in the age of mechanical reproduction. He noted that portraits of the dead would be the last bastion of the "cult value" of the image.[5] Yet we must question the teleology of Benjamin's statement. Instead it appears that, far from diminishing, within certain visual

regimes and semiotic ideologies the auratic "cult value" of an original can be enhanced, multiplied, and disseminated by the proliferation of copies made possible through the work of mechanical reproduction.[6] Within the messianic semiotic ideology at work in Noorman's archive, images of Sukarno, mythic figures, and Noorman himself close the gaps between past and present and between visible and invisible realms, promising recovery of a lost national authenticity.

The examination of Noorman's counterhistory pursued in this chapter also sheds light on photography's participation in a wider "culture of documentation," in which problems of authenticity and authority related to documentary regimes of truth, visible evidence, and the fraught relation between copy and original continually arise. Noorman's obsessive attention to the authority of documents, his search for other regimes of truth and authenticity, and his exploitation of photo-reproductive technologies to generate alternative documents might be called a "New Order disorder," a response to New Order historical and bureaucratic discourses that fetishize documentary regimes of truth. In questioning the validity of New Order historical narratives, Noorman borrows official history's evidentiary conventions and preoccupations while subverting, transforming, and mobilizing them to counterhistorical ends.

Photography can only be fully understood within this broader context and in relation to other technologies of mechanical reproduction such as print and photocopying. Just as officialdom's insatiable appetite for *pasfoto* helped fuel the expansion of the photography industry, so the penetration of bureaucratic documentary practices ever more deeply into everyday life in urban Java in the 1980s and 1990s fostered a growing photocopy industry. That photography and photocopying technology have developed in tandem since the mid-1980s is suggested by the fact that many newer photofinishers also offer photocopying services. Dispersed in small shops all over urban Java, photocopiers became means for the circulation of banned books and for the dissemination of knowledge under the radar of government repression.

The pervasive presence of photographic and photocopying technologies is not merely a symptom of other social transformations but a producer of effects as well.[7] Noorman exploits photocopying and photography to collect texts and images circulating in the public sphere and transform them into new kinds of documents for his alternative history. As Benjamin argued for the work of art, in detaching the original

from its moorings in time and space, mechanical reproduction allows it to move in unprecedented ways into the everyday spaces and daily lives of ordinary people.[8] A result of this mobility is a heightened citationality of texts and images and new possibilities for popular engagement with originals by way of copies—through appropriation, parody, and play. But if technologies of mechanical reproduction offered the means for Noorman's history, they also provided its conceptual framework. The fraught relationship of original to copy was the metaphor by which Noorman made sense of the history of the New Order: he depicted Suharto as a false copy of Sukarno, a false leader whose entire regime was founded on a false copy of an authentic document. By contrast, Noorman presented himself as an authentic copy—an indexical extension—of Sukarno; his appointed "task" was to recover the lost original of Supersemar, the document signed by Sukarno on March 11, 1966, that authorized Suharto's rise to the presidency.

A Writer on Walls

Noorman's career as a writer on walls began with the fervor of nationalist sentiment during the Indonesian Revolution. As a young soldier during the Dutch occupation of Yogyakarta (1948–1949), then the capital of the fledgling republic, Noorman had worked under cover of night to paint the surfaces of the city with nationalist imagery and slogans. Decades later he would return to this practice—albeit on a smaller, more domestic scale—as a means of protest against the New Order, whose regime he often referred to as a "new colonialism." As Noorman's thirty-one-year-old son, Agung, told me, Noorman had devoted himself to the task of "*meluruskan sejarah*" (straightening out history) because "the Suharto regime turned history upside down."

I would come to know Noorman through frequent discussions with him, two of his sons, and some of his admirers. Most of my visits proceeded like the first. I would sit on a woven mat in the front room of the house, talking with one of his sons and sipping tea. In the room behind, visible through the wide, open doorway but apparently paying no attention to us, Noorman himself would be perched on a stool, usually wearing shorts and no shirt, chain-smoking and leafing through clippings. Noorman could see us where we sat sipping tea but never appeared to be listening to our conversations. Occasionally he would

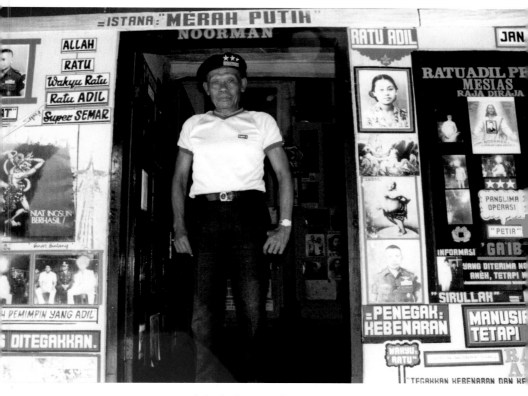

113. Noorman stands in the doorway of his home, Yogyakarta, 1999. Note the lens flare. *Photo by the author.*

burst into the front room to hand me a newly photocopied newspaper clipping or a photograph. But usually he would sit in the back until I ventured in, greeted him politely, and waited for an animated conversation to begin.

Noorman was remarkably agile for a man of seventy-one and his cropped hair, fit body, and erect posture signaled his military training. His energy and passion often seemed too great to be contained; his movements were abrupt and jerky, as if he were erupting out of his skin. Speech and laughter burst out of him in sharp punctuated gusts. Sometimes he began to preach, in long, performative orations—particularly when confronted with a tape recorder.[9]

Usually we discussed current events, which he followed avidly in the newspapers and about which he always had strong opinions. Yet

inevitably, the conversation would loop back to history, to Sukarno, Suharto's betrayal of the nation, and Noorman's privileged role as an "upholder of truth" (*penegak kebenaran*). Noorman had seen himself in this role for many years, but the situation had changed since the fall of Suharto. No longer a solitary voice in a silenced climate of fear, Noorman seemed almost drowned out amid the increasingly loud chorus echoing his anti-Suharto claims. He found affirmation, not diminishment, in the opening up of public dialogue about New Order abuses. Each time I visited, I found him surrounded by new clippings from the newspaper, some of which he would mark with underlinings and commentary, photocopy, and place on the already crowded walls, amid his handwritten slogans and explications.

While Noorman was telling me his version of national history, I was trying to piece together his personal history from his own accounts and those offered by two of his sons, who were often at the house and who provided the bulk of information about his past. A daughter sometimes served tea or bananas but never sat and talked with me; his wife had passed away a few years earlier. Noorman, it seemed, was born in 1928 in the very house in which he still lived. His father, a policeman, had been on duty for the visit of a certain Dutch general on the night of his birth; he named his son after General Noorman to commemorate the date.[10] Noorman would retroactively read his naming as a premonition of his own career as a military man. The name had other resonances as well; as one of Noorman's followers later pointed out to me, *nur* means "light" in Javanese—a classic symbol of power in Java and a prescient anticipation of the strange light that would announce Noorman's role in history. A fellow inmate when Noorman was in prison in the mid-1970s called him "*Nur Iman*," meaning "light of faith."

During one early visit, Noorman's older son Budi offered to write his father's *biodata* for me. He borrowed my notebook and, on a fresh page, carefully printed, in the style of a bureaucratic form, Noorman's name, age, religion, education, profession, and address. Budi designated Noorman's religion "Islam," supplying his official, "identity card" religion rather than his far more complex religious affiliation. Noorman himself claimed that because he communicated directly with God he no longer needed a specific religion. He referred to his religion as *gado-gado* (a mixture) or, sometimes, *gaib* (miracle or mystery). Noorman's assimilation of different religious currents reflected the sensibility typical of *Kejawen* or Javanese mystical spirituality—as

opposed to the purifying impulses of modernist Islam. It also emulated Sukarno's attempts to bring together apparently opposed ideologies in such formulations as "Nasakom" (Nationalism-Islam-Communism).

Having completed the *biodata*, Budi paused, saying, "Now, his life history [*riwayat hidup*]." Still holding my notebook, he skipped two lines and wrote:

Life History:
1: TP [*Tentara Pelajar*, Student Army]

At this point Budi was interrupted by Noorman's entrance into the room, and I never got him to finish writing his father's "life history." This narrative genre had seemed to promise more than the reductive form of *biodata*, yet that Budi chose to begin with Noorman's experience in the revolution was indicative of the limiting conventions of "life history" as well. Revolutionary soldiers (*pejuang*) have been those most entitled in Indonesia to bear the mantle of *pelaku sejarah* (historical actors) and to be the subjects of biographies and oral histories, important subgenres of Indonesian historical literature.[11] For Budi, it is at the point when his father's life intersects with national history that it becomes a story worthy of recording.

In Noorman's own account of his life, too, the revolution was the formative experience that cemented his personal investment in the nation. Noorman was sixteen when he joined the Tentara Pelajar, and it was then that his artistic talents were first put to use for the national cause. Although he had no formal art training, he was a gifted draftsman, and in the war he produced pamphlets and graffiti on walls, trains, and buildings. The revolutionary fervor of that era, along with idolization of Sukarno as nationalist hero, provided his most enduring values. Noorman often nostalgically recalled a glorious time of unity, purpose, and promise that he contrasted to other moments of Indonesian history: "There were all layers [*lapisan*], the Communist, the religious, the nationalist . . . Want to win by yourself, no way." For Noorman, Sukarno symbolized this "unity and solidarity." Noorman's sense of his own privileged role in "restoring" Indonesia to itself exaggerates sentiments shared by many men of the "Generation of 45": that they were authors of—and responsible for—the nation.

Following Indonesia's independence, Noorman pursued a military career. Despite his Sukarnoist leanings, he remained in the army after Suharto took power. But in 1968 Noorman became disillusioned with

the New Order when, through his work in the army-controlled customs office in the northern Javanese port city of Cirebon, he encountered a smuggling operation orchestrated, he claimed, by Suharto and "Bu Tien" (Suharto's wife), in collaboration with a Chinese Indonesian importer. Noorman apparently resigned from his post in protest. "After that," Budi recounted, "father retreated from worldly life. He began to be an upholder of truth."

It was in 1972, while in jail, that Noorman received the *wahyu*, a divine radiance indicating god-given power and revealing his "chosen" status as an "upholder of truth." The circumstances of this imprisonment were never clear to me; as Noorman simply put it: "As long as you were against Suharto, you'd be stamped [*dicap*]. PKI [the label of "communist"] was Suharto's weapon." (According to his son Budi, Noorman was jailed by the New Order regime three times, for several months each: "Yeah, the phrase is, 'secured' [*diamankan*]. But he was never brought to trial.") Noorman's description of the *wahyu* entering through the top of his head was highly conventional, following faithfully the contours of classic Javanese accounts of a "mysterious ball of radiance that descends on the head of the man destined to be a new king."[12]

This is a miraculous thing. A miracle befell me [*kejatuhan gaib*], that is, the *wahyu*, since 1972 . . . the month of December. If I'm not wrong, it was right on Christmas day. The miraculous light from the East like a bolt of lightning you know, it entered my head. At that time I was imprisoned by the military police in Yogyakarta. At that time I was imprisoned, the gist of it was that I had been slandered, meaning that they wanted to kill me, I had been "PKI-ed" [*di-PKI-ke*] . . .

Rather than be killed by people who didn't know the real truth, I faced God directly, in my cell. I did it at two in the morning. I hung myself, because I . . . I begged God, "If in this world there is no justice, God, better I shouldn't see this world." Then, after that, who knows but I was lifted up by two angels, angels. Even though I had done it over there, by that door, for example, suddenly I am over here, lifted up by the two angels [Laughs].

. . . [Then] I was entered by the light, by the crown of the head here it entered. The feeling was like being splashed with water. Splash . . . splash . . . splash! Cold, you know, and healthy. So that I started singing in my cell, from the happiness. And after that in my cell there was writing, even though before there had been no writing. But there

was writing on the wall, big, I read it, the writing said: Job. Job was a prophet, of course. Maybe God was trying me because my spirit was strong, and maybe I was the same as the prophet Job.

In 1976, Noorman was imprisoned again for attempting to help a community whose land had been seized in a corrupt real estate scheme involving the collusion of government officials and police. Again a miracle occurred in the prison cell. After reciting Islamic prayers deep into the night, there was rain, a flood, lightning, and a blackout. As words started coming to him directly from God, Noorman began documenting his revelations, turning inspiration into inscription: "And in the morning, inside the cell it was full of writing. It was a miracle giving me an explanation, I wrote on the wall using a piece of charcoal . . . I wrote so I wouldn't forget, God's writing. So after that, I noticed that the writing, if there was a *cicak* [a small lizard] . . . if a *cicak* brushed against the writing of Allah it would fall. The *cicak* would fall, then come back again . . . touch the writing and fall. Meaning that all those who slandered me would surely fall later, right?"

Noorman recounted how during this imprisonment a psychiatrist was called in to assess his sanity; Noorman was pressured to sign a piece of paper stating that he was insane. He refused: "If I signed, that meant I was crazy. Because I was being accused of being crazy in order to make all the facts [*fakta-fakta*] fall away [*gugur*]." The incident that led Noorman to jail in the first place had also revolved around forced signatures. Under threat of violence by police officials, villagers had signed away their land. This experience perhaps heightened Noorman's sensitivity to the power and danger of the signature, an awareness registered in his concern with the authenticity of signatures and his obsessive reproduction of them throughout his display.

Soon after he was released from prison again, in 1978, Noorman attended a ceremony for the reburial of a number of veterans in a "Hero's Cemetery." Inspired by a vision, Noorman appeared at the ceremony dressed in Sukarno's trademark white suit and *peci*. It was during this event that the first "miraculous" lens flare photographs of Noorman, photographs that revealed the *wahyu* he had received in prison years earlier, were taken. As he described it,

So, the sign was that I had to wear white, like Bung Karno. So I went like that and was noticed by many people. 'Cause everyone hated Bung Karno, they all supported 'Harto. At that time, you know. So

I emboldened myself to wear all white, to appear like that at the ceremony. As soon as I came, everyone noticed me . . . all the journalists were fighting [to take my picture]. I said, you wait, be patient, my child will take a picture first. He took it. And after I printed the photo, look! It had this sign. I truly became the center of attention, the focus. I was looked at by lots of people because of this miraculous light, the white light.

For Noorman, the photographs provided proof of his *wahyu* that had until then gone undocumented.

At that time, truly the light of God had fallen on me. It was manifested in this photo, it could be seen by many people. Because the original [*asli*] [experience of being entered by the *wahyu*], only I knew. Want to explain it, it's also difficult. Want to prove it also, you can't use words, ha! Because in an instant, lightning, you know, it entered the top of my head. So you know it's hard to explain that. After that [picture] there was the explanation: that it was miraculous, yes, it was a miracle.

Simultaneously miraculous revelations and credible documentary proof, the images explained the inexplicable and made visible that which had remained unseen. The five sides of the lens flare, Noorman told me, represented the five points of Pancasila, the state ideology authored by Sukarno. Two years later, his son took another picture of him with a different camera as he stood in the doorway of their house. Again, the same shape appeared, hovering above Noorman's head. Further convinced of his mission, Noorman devoted himself to speaking the truth of history on the walls of his home, creating an elaborate archive committed to revealing the original falsehood of the New Order, the falsification of Supersemar.

Was Noorman a revered visionary or a local eccentric? Had he been a dissident the regime found truly threatening, or merely a crackpot who ruffled the appearance of order? Most people I knew in Yogyakarta had never heard of him, yet one of Noorman's followers claimed that, several years earlier, over a thousand people had gathered to hear Noorman speak. The police stormed in, broke up the gathering and destroyed Noorman's display: "The images on the house were pulled off, ripped up. We were told to erase the writings." Occasionally Noorman's followers, mostly rural villagers convinced of Sukarno's impending return, would arrive during my visits, bringing Noorman gifts of

eggs and cigarettes. They would kneel in front of him, kiss his hand, and reverentially listen to his tirades. Profiles of Noorman had been published in local newspapers; these portrayed him as a colorful patriot loyal to the nationalist "spirit of '45" and either ignored or vaguely alluded to his career as a dissident.[13] On his walls he displayed photographs of himself with prominent visitors, among them well-known political dissidents.

Certainly Noorman was not alone in his messianic treatment of Sukarno; a significant current of "popular nationalism" in Indonesia entails mystical belief in the enduring power and presence of Sukarno.[14] Both "paranormal" tabloid papers and the mainstream news frequently report on people who announce that they have seen or communicated with Sukarno or that he is about to return.[15] Several Sukarno impersonators, like Noorman, claim a privileged mediatic relationship to the former president. Noorman, like other believers, refused to accept that Sukarno had died in 1970. When I tried to press him on this point, he would just laugh at me, or scoff, as if he could not believe how obtuse I was, " 'Course he's still alive!" (*'Kan, wong masih hidup!*). More broadly, nostalgia for Sukarno was, in the late New Order and immediate post-Suharto period, a widespread sentiment spawning a market in commercial images of Sukarno and fueling his daughter Megawati's political career.

Noorman was also not unique in his use of photocopying and photography to challenge the claims of official history. In a case in 1994 that received far more publicity than Noorman ever did, Wimanjaya Liotohe circulated a photocopied four-hundred-page manuscript, complete with appended texts and illustrations, titled "Primary Sin: Wimanjaya and the Indonesian People Accuse Suharto's Imperium" (*Primadosa: Wimanjaya dan Rakyat Indonesia Menggugat Imperium Suharto*). *Primadosa* accused Suharto of either masterminding or having foreknowledge of (and doing nothing to prevent) the alleged coup attempt of 1965. Like Noorman, Wimanjaya also claimed to be supported by Sukarno, proof of which he attributed to a mysterious light that appeared in a photograph of him taken at Sukarno's grave in Blitar.[16] If Noorman's Sukarnoist messianism and his use of photocopiers to generate alternative histories were shared by others, so too was his obsession with the lost original of Supersemar, the document that authorized Suharto's rise to power.

Supersemar: Loss and Recovery of the Original

A document that should have become historical evidence
[*bukti sejarah*], gone just like that?
—Rachmawati Sukarnoputri,
"Naskah Supersemar Dipegang Faisal Tanjung"

Noorman's mourning for lost political authenticity and his outrage at Suharto's usurpation of power found expression in an idiom of "authentic original" versus "false copy." For Noorman, the true president was still Sukarno; Suharto was a "false" president whose regime was based on a false copy of an original document. To restore the lost nation, he argued, "We must return to the source": the original, authentic Supersemar, which had mysteriously gone missing from the national archive. Supersemar marked the original betrayal, the point at which "the Republic of Indonesia was lost." Noorman's effort to debunk the legalistic claims of Supersemar and his faith in the magical implications of its recovery echoed the duality of the New Order's own fetishized treatment of Supersemar as both documentary proof and supernatural origin.

According to Noorman, "Since the loss of the original manuscript of Supersemar: Suharto does not have the right anymore to be president . . . Suharto rose to the presidency through Supersemar, Suharto will sink also from Supersemar." Recovery of the original document would not only reveal the truth of history; it would magically restore the nation to itself. This was Noorman's task: "Light of the Star: The task that came from God = to return the state of the Republic of Indonesia which has been lost."

In the early hours of October 1, 1965, six generals and one lieutenant were killed in an alleged coup attempt. Tensions had been steadily rising between the country's major power blocs, the communists and the army, as President Sukarno tried to maintain a fragile balance between the two. Yet Sukarno was generally seen to be sympathetic to the communists, and he was suspicious of right-wing generals who were, according to a document of questionable authenticity circulating at that time, working with the CIA to overthrow his government.[17] The botched "September Thirtieth Movement," which was probably led by junior military officers loyal to Sukarno and supported by some Communist Party leaders eager to preempt an anticipated military take-

over, was quickly squelched.[18] Under Suharto's command, the military rapidly consolidated control and placed blame squarely on the Communist Party. Manipulated by sensationalist reporting on the killing of the generals, protests (often army-sponsored) broke out throughout the country calling for the disbanding of the Communist Party. Sukarno refused, and this refusal (along with other factors) was represented in the military-controlled press as indication of his sympathy for the coup organizers. Although not overtly accused, the ailing and aging nationalist leader was deliberately wreathed in a cloud of suspicion.

Yet legally, Sukarno was still president for life. On March 11, 1966, as the military pursued its campaign of mass killings and imprisonment of alleged communists, Suharto presented the politically weakened Sukarno with an ultimatum. When unmarked troops (led by an officer loyal to Suharto) marched threateningly near the presidential palace in Jakarta, Sukarno left a parliamentary session for the relative safety of his palace in the nearby city of Bogor. Later that night, he signed a document that gave Suharto full authority to take all steps necessary to restore stability to the country should Sukarno himself be encumbered. Suharto would use this document to legalize the disbanding of the Communist Party and to pass a resolution in the parliament revoking Sukarno's president for life status and eventually to install himself as the president of Indonesia. Sukarno was placed under house arrest and died, much diminished, in 1970.

The circumstances under which Sukarno signed the infamous Supersemar remain unclear. What *is* known, however, is that the original document is missing. The versions held by the national archive are merely copies.[19] In 1975, when the government published a book commemorating the thirtieth year of Indonesia's independence, the book contained two slightly different versions of Supersemar printed on different pages. In the uproar that followed, the government was unable to produce the original. Moreover, the version of Supersemar identified as the authentic copy by the state department and reproduced in many school history texts indicated the place of signing as Jakarta, even though it was well known that Sukarno was at his presidential palace in Bogor. Was Sukarno given a prewritten document and forced to sign it? Was the original written on military stationery, rather than paper with the presidential letterhead, and thus intentionally destroyed rather than reveal its embarrassing provenance within military quarters,

as some have suggested?[20] Was Sukarno, as a former personal adjutant later claimed, threatened with a gun before conceding to sign?[21] Or did he dictate the letter himself, as others insisted?

In fact, the differences in the various extant versions of Supersemar are small, and all contain the provision that Suharto must submit reports on his actions subject to approval by Sukarno, an indication that the mandate was temporary and not intended to shift power fully to Suharto. Clearly, too, the process by which Suharto usurped Sukarno's authority as president was a long and complex one, involving many maneuvers, of which Supersemar was just one. That Supersemar itself became so important as the founding document of the regime had largely to do with its fetishization as "proof" of the legality of the transfer of power to Suharto. As such it not only supplied legitimacy but worked to deflect memory of the New Order's bloody origins.

New Order textbooks typically used legalistic language such as "legitimate" (*sah*), "legal" (*legal*), "proof" (*bukti*), and "law" (*hukum*) to identify the document as the legal basis for the New Order. One history textbook for high school seniors described Suharto's ascent to the presidency as a "rational-objective" "process of law."[22] Yet for all this insistence on legality and modern rationality, there was another dimension to the New Order discourse on Supersemar suggested in the document's name. The catchy term "Supersemar" (an abbreviation of *Surat Perintah Sebelas Maret*, or the Letter of Instruction of March Eleventh) combines "super" (with the same connotations as the English word) with "Semar," the name of a beloved Javanese shadow puppet figure revered as the protector of Java. Although Suharto, a lackluster, bureaucratic army man, hardly resembled the wise and irreverent *wayang* figure, he would try throughout his presidency to identify himself with Semar.

Naming this document "Supersemar" was a way to give it authority deriving not only from legalistic regimes of rule but from popular trust in mythic figures and signs. The very word came to have quasi-magical qualities, acting simultaneously to "concentrate and display" power.[23] School texts described Supersemar in religious terms, as if the document were both a divine act and an agentive object.[24] One textbook for junior high school students, for example, described Supersemar's "birth," thanks to the "greatness of God the Almighty," as "the historical milestone marking the beginning of the new life we know as the New Order, the order of renewal of the Indonesian people."[25]

This emphasis on the sacral and efficacious nature of Supersemar both

effaces the process of its production and transforms it into a *pusaka* (potent heirloom) of the New Order regime, a powerful piece of writing that, like many "traditional" Javanese texts, contains and emanates power.[26] The passing of Supersemar from Sukarno to Suharto was figured, then, not merely as a legal mandate to rule according to the formal procedures of a modern nation-state. It was also framed in "traditional" Javanese terms as the transmittal of power—embodied in an object—from an old ruler in decline to a new ruler in ascendance.

Many school texts provide illustrations of Supersemar, emphasizing its quality as a material object and lending the concrete weight of visual evidence to the textual narrative. Some strive to appear as copies of the actual text (showing a typewritten document using the pre-1972 Indonesian spelling system, for example). But others are more ambiguous: they reproduce letterhead and Sukarno's signature, but the letter itself is printed (not typed) and uses the post-1972 spelling. Reproductions like these, which pose "as if" they are copies of the original, give rise to the confusion about the authenticity of copies so significant to Noorman and others. These slippages, combined with Supersemar's fetishized status in New Order origin narratives and its mysterious disappearance from the archive, became fodder for the conspiracy theories that swirled around the events of 1965–1966.

On the walls of his home, Noorman pulled together diverse fragments of evidence to prove the false origins of the New Order regime, juxtaposing reproductions of extant "official" and "unofficial" versions of Supersemar, newspaper articles questioning Supersemar's authenticity, statements by historical witnesses, and images of Suharto and Sukarno. These materials were then overlaid with Noorman's own commentary, photographs, and signature. In 1993, Noorman began compiling a book of his collages. The photocopied "Yellow Book" allowed Noorman's counterhistory to leave the confines of his home and enter wider circulation. In 1995, Noorman sent copies to Suharto, several top government officials, sixty-one embassies, and the United Nations, along with a cassette tape of himself speaking his version of history.[27]

In the Yellow Book and on his walls, Noorman reproduced three different published versions of Supersemar so that they could be compared. He placed each "official" version of Supersemar in the center of the page, writing commentary in the margins. On one, for example, Noorman added these notations:

—The original Supersemar in Bung Karno's handwriting had two pages.

—Now the people of Indonesia have had dished up to them *as many as Three Manipulated Supersemar Documents that are Alike but Not the Same.*

—As a result of the above-mentioned Manipulated Supersemar (attached are the facts), thus . . . *The Original Supersemar Manuscript is LOST, and has been declared LOST. This is very Strange and Mysterious.*

—For the Truth of History and for future Generations, The Original Supersemar Document must be sought until it is found, and there Must Be a Person who will search for and find it. Let there be a CONTEST to find it again.

—THIS IS THE SUPERSEMAR THAT WAS INSPIRED BY AC-CURSED SATAN . . . !

Noorman at times referred to Supersemar as an *aspal* document and to Suharto as an *aspal* president. A neologism that combines the words *asli* (original, authentic) and *palsu* (false), *aspal*, as Siegel has noted, designates a falsified document that cannot be distinguished from an authentic one because it is the work of someone "on the inside."[28] *Aspal* is a more insidious form of falsehood than *palsu* because it bears the marks of genuine authenticity and authority. Supersemar is a forgery that has nevertheless achieved the authoritative status of an authentic document. Apparent signs of authenticity offer no reliable guarantee; there is corruption at the core. But Noorman's suspicion of the New Order's "paper truths" coexisted with faith in an "authentic" document whose recovery would resolve the problem of history.[29] On his wall (and in a page of his Yellow Book) he commented, "Which of these is true/authentic?" (*Mana ini yang BENAR/ASLI . . . ?*).

Noorman's obsession with the mystery surrounding Supersemar's authenticity and the whereabouts of the lost original was widely shared. Indeed, Noorman's collection of documents included numerous articles about Supersemar published in various magazines and newspapers dating back to 1991. The public conversation about Supersemar—often focused on who might possess the original document—had become less circumspect during the post-Suharto period as it became a key referent in a broader discussion about the need to "straighten out history."[30] Doubly fetishized, first by the New Order

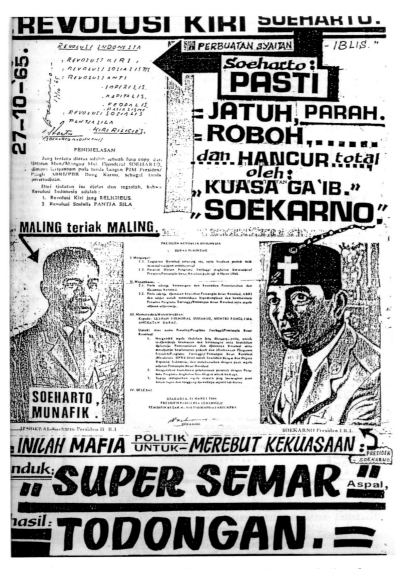

114. A page from Noorman's Yellow Book, including a reproduction of
an official version of Supersemar. The image of Sukarno is taken from a
popular commercial image, but Noorman has added the cross (equating
Sukarno with Jesus). *Collection of the author.*

state and now by its critics, Supersemar became a focal point of the post-Suharto search for historical truth.

Leaves of History: Documentation and Revelation

Just as the discourse around Supersemar portrayed it simultaneously as documentary evidence and magical object, so Noorman's counter-history drew on two competing historical epistemologies—one documentary, the other revelatory. Noorman once described the collages and pasted clippings on the walls of his home as "leaves of the course of history. The past, the present, and what will happen" (*daun-daun perjalanan sejarah. Masa lalu, sekarang, dan yang akan terjadi*). He also referred to the images and texts on his walls as "seeds I have planted; now I wait for their fruit." He recounted a parable-like story: once, not knowing quite what impulse drove him, he had gathered up discarded durian seeds from the pavement on a busy city street. He brought them home and planted them in the ground in a tiny strip of earth along the side of his house, where they were now—he pointed them out to me— growing into small saplings. Later, he realized that his actions offered a metaphor for his project: picking through the debris of history, taking its scattered remains from an infertile place, and replanting them in his home so as to bring about a new understanding of history.

On the one hand, the imagery of fallen leaves tracing the "course" of history suggests an archival, documentary history made up of artifacts of historical process collected and ordered to reconstitute the past. This documentary history, characteristic of state archives and official narratives, records a past recoverable through the accumulation of authored and authenticated records.[31] But Noorman's organic metaphors of re-planted seeds and regeneration also evoked an alternative conception of history that was equally present in his display. Revelatory history, enfolded within discourses of Javanese mysticism, is a prophetic history revealed through signs and visions, a history that seeks not only to reconstitute the past but to generate new futures. Each of these modes of history relies on different writing practices, ideas of authorship, and theories of how one comes to know the past. Each is founded on different temporalities—one linear, the other messianic. In collecting documents and images and accompanying them with analytic commentary and in his compulsive attention to dating and authorship, Noorman

mimicked—both emulated and provided a destabilizing parody of—the archival conventions of official, state historiography. Many of the "documents" Noorman produced imitated official bureaucratic forms complete with photocopied identity photographs and signatures. Using the press as a public archive, he rescued articles from the certainty of oblivion by clipping them and putting them on his wall. He amassed his own archive of documents recalling events and controversies all too easily dispersed and forgotten; his ordering of them showed how "facts" proffered in one moment were continually contradicted or called into question by a new set of "facts" or statements. On the walls of his home and in his photocopied books, relations of chronology and causality were marked, visually, by arrows linking one image to the next. As Noorman explained, his collection enabled him to scrutinize the progression of events: "Basically, I see, I [can] see the development. The problem of cause and effect." This archival accumulation of "evidence" served to challenge New Order historical claims in conformity with conventional historiographic practice.

Noorman's compulsive clipping ironically inverted a common practice of New Order historical pedagogy. During the New Order, presenting neatly glued and properly labeled newspaper clippings formed an integral part of formal education from elementary through high school.[32] Museums and state agencies even sponsored "clipping contests" on various events in national history. Students were judged on the basis of how neat (*rapi*) their presentations were and how well the articles conformed to the proper narratives learned in school. Under conditions of censorship and in a classroom environment in which there was a right answer to all questions, "clipping" tended to be a tautological exercise in confirming official narratives. But as Noorman's project indicates, the practice of clipping could also be mobilized to counterhistorical ends.

There was more to Noorman's archiving, however, than fact-finding and chronological reconstruction. An effective history that sought to bring about a new future, Noorman's project also resonated with more longstanding practices of history writing in Java in which the writing of history was not so much a project of reconstructing the past as the creation of a prophetic document to invoke new futures.[33] His rhetoric frequently drew on messianic strains of Javanese thought in which a "golden age" (*jaman emas*) is ever on the horizon, heralded by the appearance of a "Just King" (*Ratu Adil*).[34] It is in this idiom

of revelation that Noorman spoke and wrote about "the return" of Bung Karno, who would reemerge not just as "President of Indonesia" but as "Leader of the World." More cyclical than linear, this notion of history emphasizes loss and eventual return. Although associated with Javanese tradition, this mystical messianism has a very modern life in tabloid newspapers devoted to paranormal phenomena and in mainstream newspapers and television; indeed, the sloganlike dictums papering Noorman's wall often read like the headlines of paranormal tabloids.

If Noorman's clipping practice resonated with New Order pedagogy, his collages suggested a mode of authorship and a writing practice characteristic of "traditional" Javanese literature and prophetic history. Nancy Florida notes that the writer was conceived not as an "auteur/author" but rather as a "composer." The very word for writing meant to "interlace" or "bind together" words or texts in a productive manner. So, too, there was "no clear distinction between . . . writing as physical replication of prior inscription and writing as original composition."[35] Noorman worked as a gatherer (and disseminator) of other people's texts, not only in his re-presentation and combination of photocopied documents and signs of bureaucratic authority but also in his use of language and imagery drawn from diverse sources.

Visually, the "presentational" punch of Noorman's collages, with their graphic, layered presentations of text and image that hailed the reader with vivid pronouncements, had more in common with tabloid newspapers than sober historical texts.[36] His arrangements of text and image drew rhetorical power from relations of repetition, juxtaposition, and metaphor, more often than linear progression and causality. Oppositions structure the collage on the final page of Noorman's Yellow Book, which places Suharto and Sukarno in opposing corners of the page. While Sukarno is upright, Suharto's image has been turned on its side, like a sunken ship, and an X drawn across his mouth. Textual oppositions accompany visual ones, as when Noorman places the words *bangkit* (arise; a word with strong nationalist connotations) and *timbul* (emerge) near Sukarno, and *tenggelem* (sink) next to Suharto's image. Under Suharto's image, meanwhile, Noorman has printed the word *Raib*. While *raib* can be translated as "disappear," it is also etymologically a version of the word *gha'ib* (miracle or mystery), which is inscribed in a five-pointed star whose rays reach radially from the right-hand corner to touch Sukarno. Noorman thus plays on the multiple,

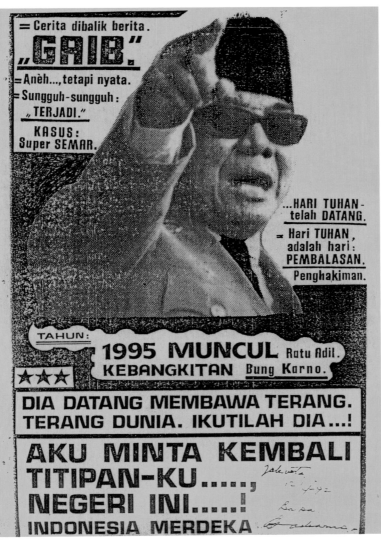

115. A photocopied collage (cover of the Yellow Book), formed from Noorman's writings and a popular image of Sukarno, which reads in the top left corner: "=Story behind the news. 'Mystery' = Strange . . . but true. = It truly: 'happened.' The case: Supersemar." To the right of Sukarno, Noorman uses messianic, evangelical language to pronounce: "THE DAY of GOD has come. The day of GOD is the day of RETRIBUTION, of Judgment." Note, in the right corner, Sukarno's signature, dated 1992, following a quote: "I ask for the return of what I left in your care . . . This country . . . !" *Collection of the author.*

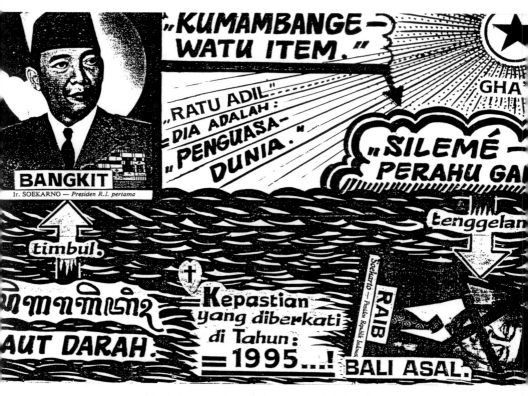

116. Final page of Noorman's Yellow Book. *Collection of the author.*

and here opposing, meanings of the same word. Through a miraculous event, Suharto will be made to vanish, Sukarno to rise again. Underneath Suharto's image, meanwhile, are the words *Bali Asal* (Jav. "Return to the Origin"). These can be read to mean that Suharto will return to the "ocean of blood" (*laut darah*, also written in Javanese script above the Indonesian) from which he rose. But they can also serve as a title for the image as a whole, that is, the fall of Suharto and the reemergence of Sukarno will bring about a return to the original and correct state of affairs. To Sukarno's right are the words "Just King = It is he: the Ruler of the World."[37] Epitomizing the blurring of revelatory and documentary regimes within his counterhistory, Noorman has inscribed this collage with a date, establishing it as a document of Noorman's inspired, prophetic vision: "Confirmation with which we are blessed in the year: = 1995 . . . !"

Noorman was caught in a dilemma inherent in the very project of a counterhistory. To counter New Order official history, Noorman needed to refute it on its own terms, making his claims according to its conventions. Noorman thus collected and produced documentary evidence to prove the falsity of a document.[38] At the same time, seeking a greater authority to back his oppositional claims, Noorman also invoked other ways of knowing the truth of history. His appeals to a higher order of knowledge rested on claims of unmediated contact with originary sources of truth: God and Sukarno. Yet even within this alternative evidentiary regime, Noorman needed to rely on copies to invoke the presences he sought to recover. He fetishized originals and questioned the authority of copies; yet it was technologies of mechanical reproduction that, by rendering documents, images, and signs of authority mobile and malleable, and by allowing contact with absent originals, made his counterhistory possible.

Noorman's effort to negotiate the tension between the authority of unmediated presence and the authority of documentation found acute expression in his use of Sukarno's signatures, which, like his photograph, were repeated throughout Noorman's display. Like a fingerprint or an identity photograph, the signature is a sanctioned proxy for the individual recognized by the state as a sign of presence. It is thus crucial to a documentary regime of truth in which documents are made credible through conventional signs of identity and authorship. But, as Derrida has pointed out, the signature is necessarily iterable and thus can never achieve the presence it proclaims.[39] The signature thus embodies the tension between presence and absence, between an original and its reproduction, so generative within Noorman's archive.

Noorman solved the problem of copies by dividing them into two types: the counterfeit and the authentic copy. The first, epitomized by Suharto and the official versions of Supersemar, stands to the original in a relationship of forgery and falsehood. The second, epitomized by Noorman himself, stands to the original in a relationship of indexical continuity.

Susan Stewart has described nostalgia as "the repetition that mourns the inauthenticity of all repetition and denies the repetition's capacity to form identity."[40] Nostalgic longing for origins and unmediated experience, she argues, is provoked by, among other things, the "inability

of the genres of mechanical reproduction to approximate the time of face-to-face communication."[41] But, motivated by a messianic nostalgia, the authentic reproduction refuses to acknowledge a complete break between copy and original, or between present and past, insisting instead on the reproduction's ultimate identity with its source. Authentic copies are copies not fully severed from their originals.

Above all, it was by rendering himself an authentic copy of Sukarno—dressing like him, adopting his poses and rhetoric—that Noorman invoked Sukarno's presence and his ultimate return. Noorman's self-presentation as a living replica of Sukarno echoed popular representations of Megawati, Sukarno's daughter. Imagery during the election campaigns of 1999 consistently pictured Megawati in front of or beside an image of Sukarno, with the daughter often mirroring her father's pose.[42]

If Megawati's genetic connection to her father allowed her to claim not only likeness but shared substance with Sukarno, Noorman also asserted a relation to Sukarno rooted in indexical connection as well as iconic resemblance. Noorman claimed he had been "designated" (*ditunjuk*, literally, "pointed to") by Sukarno to serve as his agent. Once, in conversation with me, Noorman referred to himself as "little Sukarno" (*Sukarno kecil*). Noorman also frequently described himself as the "extension of Bung Karno's tongue" (*penyambung lidah Bung Karno*), a reference to Sukarno's own self-description as the "extension of the people's tongue." A recurrent image on Noorman's wall was a commercial print of a painting of Jesus with Noorman's *pasfoto* affixed to his chest. It represented a dream in which Noorman saw himself inside the body of Jesus, looking out. Since he already identified Jesus with Sukarno (both human manifestations of God, recipients of the *wahyu* or divine light, and sacrificial saviors who would be resurrected), he interpreted this dream as meaning that he, Sukarno, and Jesus were united in a single substance, as he put it, "the Trinity."

Noorman also asserted a privileged connection to Sukarno based on face-to-face contact. In a profile of Noorman published in a weekly newspaper in 1986, he claimed that he often met with Sukarno both "in dreams and in direct dialogue."[43] In another news article he described a "meeting" with Sukarno that took place in Jakarta in 1991, during which Sukarno conferred on him the rank of lieutenant general.[44] Noorman repeated these assertions to me and quoted direct dialogue between Sukarno and Suharto, which he claimed Sukarno

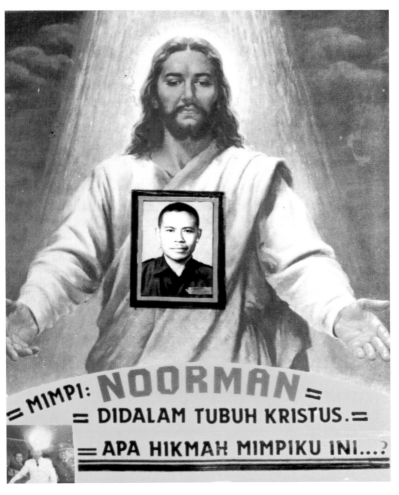

117. "=Dream: Noorman = = Inside the body of Christ = = What is the meaning of my dream?" (a wallet-sized reproduction of his collage, which he gives out to his followers). *Collection of the author.*

had recounted to him. This dialogue enacted a scene in which Sukarno warned Suharto not to use Supersemar to seize the presidency. Quoting Sukarno speaking low Javanese to Suharto, Noorman emphasized Sukarno's authority and lent a heightened sense of authenticity to his own commentary:

> The one who seized the power of President Sukarno was Suharto, via Supersemar. Supersemar was not [meant] to make him president. Harto had already been met by Bung Karno [who said]: "Look, this Supersemar is not to be used to become president." [Suharto] bows his head, feeling guilty [low Javanese: *'To, Supersemar kuwi ora dienggo dadi presiden. Ndhingkluk, merasa salah*]. And after all that emerged the false Supersemar, typed [*tik-tikan*]. The authentic [*asli*] Supersemar was two pages in Bung Karno's handwriting and signed in Bogor. Not in Jakarta. But what was disseminated in [the book] *30 Years of Indonesian Independence* was typed! So it's clear that it's false.

Noorman's insider knowledge that the original Supersemar was handwritten (and thus indexically connected to Sukarno) further undermines the authority of official, printed copies.

Noorman claimed to speak historical truth through his designation with the *wahyu* and through his direct contact, unruptured by writing and death, with Sukarno. Yet, bowing to the evidentiary standards that govern official historical knowledge, Noorman also needed to provide documentary proof of this unmediated access to Sukarno. Noorman, we recall, conceived of his writings on the wall as a way to transform inspiration into documents imbued with the "certainty" of facts. A photograph of Noorman and Sukarno, which he dates from 1987, offered visual proof of Noorman's contact with Sukarno.[45] On a popular commercial poster showing Sukarno (as if) signing the Proclamation of Independence, Noorman has written under Sukarno's pen, "Later, I will designate Noorman" and signed it with Sukarno's signature and the year, 1998.

Affixed to the wall, a "letter of instruction," supposedly written by Sukarno in 1992, announces a "contest" (*sayembara*) to find the *asli* Supersemar and names Noorman a contestant. (Since Supersemar is also a "letter of instruction," this letter is, in a sense, a "copy" of Supersemar.) Just as Noorman claimed that the authentic Supersemar was handwritten, not typed, so this letter is written (supposedly) in

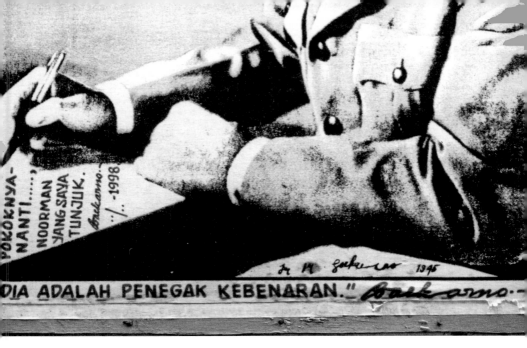

118. Altered commercial poster of Sukarno showing him writing, "Later, I will designate Noorman, [signed] Sukarno, 1998," displayed on the alley wall outside Noorman's home. Underneath, Noorman has written, "He is the Upholder of Truth," followed, again, by Sukarno's signature. *Photo by the author.*

Sukarno's hand and signed with his signature. What Noorman displayed, however, was not the original letter but its photocopy. Even as he railed against Suharto's doctoring of documents, Noorman himself relied on photocopied signatures and fabricated documents to shore up his own version of historical truth.

Photographs as Historical Proof and Effective Signs

Noorman's use of photographs reflected his counterhistory's oscillation between documentary and revelatory historical modalities. On the one hand, photographs served as "historical evidence" in a way consonant with official historical texts and displays. But they also served as revelatory and effective signs that retained the aura of their originals. In the former, the image is a transparent window that allows us to see the past "directly"; in the latter, it is a charged surface that reveals a realm of truth beyond our ordinary powers of visual perception. Both of these

photographic regimes of truth exploit the indexicality of the photographic image, the sense that "objects have reached out and touched the surface of a photograph, leaving their own trace."[46] Yet what distinguishes them are the semiotic ideologies that guide the social function and significance of "indexicality" itself. As historical evidence, photographic indexicality guarantees that what is visible in the image actually existed in the past; as revelatory sign, indexicality promises that the image bears forth into the present the power of a referent that once "touched" its surface.

Noorman's excessive repetition of a limited repertoire of images in his display seemed almost a deliberate parody of "official" uses of photographic "evidence" in New Order history museums and textbooks. New Order museums tended to show the same, limited number of blurry images of key figures and events and facsimiles of important national documents. History textbooks for all grades were also illustrated with a narrow selection of photographs. The poor quality of the image reproduction often rendered these images practically illegible; their meanings were anchored by captions that implied self-evidence while telling the viewer exactly what to see. In museums and history textbooks, photographs operated as conventional signs of historical "proof" almost independent of their powers of representation.

One of Noorman's followers once remarked to me that photographs were important in Noorman's display because the camera is an "objective machine" that tells history "without the intervention of people." His comment echoed the widespread sentiment that photographs are proof more valuable than written documents because they are divorced of intention and rooted indexically in the "real" past. According to Pak Utono, photographs were crucial in Noorman's effort to "straighten out history," because Noorman believed that history must be "proven" (*dibuktikan*). He then pointed to a blurry picture of an unrecognizable young Noorman, apparently as a guerilla fighter in the revolution, and said, "This is evidence [*bukti*], this cannot be denied." This photograph "proved" Noorman's nationalist credentials, while images of him with various officials in Cirebon buttressed the credibility of his story of New Order smuggling operations.

The repetition of Noorman's face, meanwhile, also mimicked the state's compulsive repetition of the faces of "heroes" in official texts and exhibitions.[47] Noorman's own eagerness to be photographed suggested his awareness of the performative power of photographs to establish

historical significance, as if he had internalized Berger's observation that "to go unphotographed is to be forgotten, condemned."[48] On my second visit to Noorman's house, as I was sitting talking to his son, Noorman suddenly sprang into the room holding a snapshot camera. He took a whole series of photographs of me alone, me with his son, me with his daughter, and so on. Then he had his son take pictures of us together. Noorman then went back into his room and brought out another snapshot camera and took more pictures, in case, he explained, the first camera malfunctioned. With a slightly embarrassed laugh, his son explained, "Father really likes documentation."

After this first set of images, Noorman left the room as abruptly as he had entered. About fifteen minutes later he reappeared with the two cameras, this time wearing an army uniform shirt (on top of his

119. A wall in Noorman's home. The black-and-white photos at the bottom show Noorman at his office in Cirebon in 1968. The color image at center is a photograph I took of Noorman. *Photo by the author.*

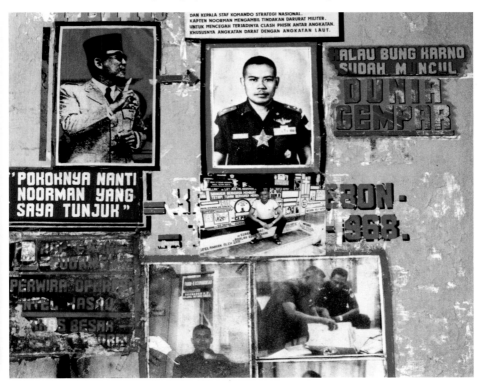

shorts) with his name embroidered on it and a military beret. Again he made his son take pictures (from the waist up), but in this series he had us pose more formally, shaking hands in a parody of dignitaries at an official meeting. Noorman explained, "This is a very important event. You've come from far away." Later, he would paste this image of us shaking hands to the wall in his home along with other images of visitors that "proved" his importance.

With his avid reading of newspapers, Noorman was savvy about the use of photographs to publicize and promote his cause. He often introduced me to others as his "journalist" and called the images I made (and gave him copies of) "useful to the campaign." He once explained my presence to a group of his followers thus: "Later all this will be made more complete with video, with a camera [*tustel*]. Later I will come forth, it will be recorded. She is my journalist." My presence as his "foreign journalist" confirmed his own role in history; perhaps he recalled that Sukarno's autobiography had been co-written with Cindy Adams, an American journalist.[49]

In the visual ideology supporting the use of photographs as historical evidence, the photograph's status as "proof" derives from the image's indexical relation to a past event and from the camera's mechanical "objectivity." But Noorman's trust in the photograph's evidentiary force extended beyond a positivist ideology of the photograph as an objective record of "what really happened." As exemplified in the *wahyu* photographs, the camera also has the power to reveal that which truly exists but cannot be seen by the ordinary eye. Albeit in a way quite opposed to that envisioned by Benjamin, these images exemplify photography's revelation of "unconscious optics" that explode the givenness of perceptual reality by opening up a whole realm of truths unavailable to the naked eye.[50]

Revelatory traces, such photographs also retain the aura of their originals through a property of indexical "contagion" or "contact."[51] Within this semiotic ideology, the indexical nature of the photographic image—its physical connection to its referent—enables it to embody and transmit the power of the photographed subject. Recalling our earlier discussion of Noorman as an authentic copy of Sukarno, we might say that he operates like a photograph—an indexical icon—that maintains contact with Sukarno and acts as a transmitter and disseminator of his power.

On one of my early visits, Noorman gave me a packet of small re-

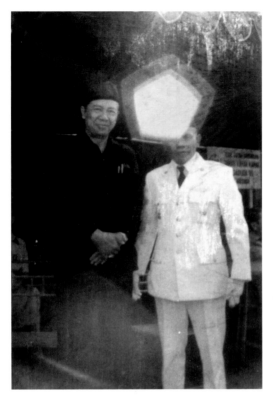

120. One of Noorman's *wahyu* photographs (a wallet-
sized image he gives out to followers).
Collection of the author.

productions of the images of himself with the *wahyu*—six altogether—
to take home with me. His son described the disseminating power of
these images: "These photos are strange . . . he who has them feels
peaceful and is rarely troubled. There's a kind of radiance [*wahyu*].
Father often gives them out, so that people can also be touched by this
light." Combining indexical connection with reproducibility and mo-
bility, the photograph enhances Noorman's own efficacy, allowing him
to extend his reach beyond face-to-face encounters through circulation
of his image.[52]

Noorman also gave me reproductions of the images of powerful
legendary figures that populated his wall. Like the wallet-sized *wahyu*
images, these were poor-quality reproductions taken with his snap-

shot camera. Each depicted a potent figure within locally significant legends: Semar, the irreverent clown and wise protector of Java; Ratu Kidul, Queen of the South Sea, the righteously vengeful consort of the sultans of Yogyakarta and Solo; and Hanuman, the monkey warrior from the Ramayana epic, also a figure of protection and loyal aid. Through display of these images, Noorman both rallied and proved their support for his cause; he insisted, for example, that Ratu Kidul was mobilizing her invisible army for the final battle to wash away vestiges of the New Order and restore Sukarno to power.[53] Affixed to Noorman's wall, such images allowed him to accumulate power; when reproduced and distributed, they extended his efficacy out into the world.

Crucial to the potency of these images was the idea that they were photographs—not paintings.[54] The "photographs" of Ratu Kidul, Semar, and Hanuman displayed on Noorman's walls were, to me, obviously commercial reproductions of paintings and drawn illustrations. Yet Noorman and his sons insisted that they were "authentic" photographs (*foto asli*). Such *asli* photographs are desirable because they contain and transmit some of the power of the "original." The queen, Hunuman, and Semar remain invisible to most people; only those to whom they grant permission can photograph them. Like Noorman's *wahyu* photographs, the images reveal, through the optical magic of the camera, that which is always present but unseen by the normal eye. Noorman claimed that he had received the images of Ratu Kidul and Semar from a spiritually powerful person who lived on Mount Lawu (mountains in Java are potent places inhabited by the spirits). As if to authenticate this account, Noorman described the exact place where each image had been taken.

Similarly auratic photographs of mythic figures could be bought from small vendors on the streets in Yogyakarta. The story was usually that these were authentic photographs taken by someone "inside" the *Keraton* (court) or an otherwise spiritually powerful person (*orang pintar*).[55] At one point an especially successful effort to sell such images made it into the newspapers. In this case, a photo of Ratu Kidul was said to have been taken with a snapshot camera by a visitor to the southern coast near the city of Cilacap. The article reported that at least ten people a day were buying copies of the photograph, until, as a follow-up article reported two days later, the police—acting as guardians of a different regime of visual truth—put a halt to its sale.[56]

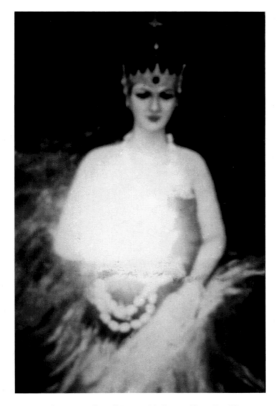

121. "Photograph" of Ratu Kidul (a wallet-sized image Noorman gives out to followers). *Collection of the author.*

Domesticating National Histories

Noorman's blending of personal and national histories on the walls of his home, and his longing for a more intimate contact with charismatic and historical figures, exemplify in exaggerated form more common ways that photographs mediate between individuals and broader national and other collectivities. A striking feature of Noorman's display was the way that his rendering of an alternative national history shared space on his walls with family portraits. By placing Sukarno, Ratu Kidul, Semar, and Hanuman amid his family photographs, Noorman literally domesticated them, entwining them with his own personal history. In many ways, his home exaggerated the conventions of the *ruang tamu* (room for receiving guests), the room that mediates be-

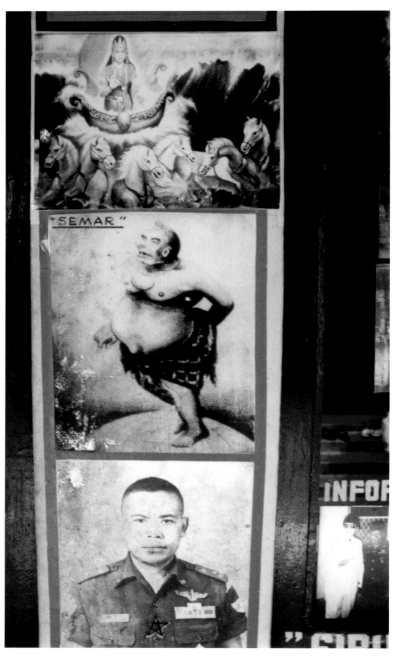

122. "Photographs" of Ratu Kidul and her invisible army, Semar, and Noorman displayed in Noorman's home. *Photo by the author.*

tween the interior familial domain and the "outside."[57] A friend of mine once joked that the "guest room" should really be called the "exhibit room" (*ruang pamer*), since it is here that the family displays itself through signs of prestige and affiliation. Images of political leaders and Javanese cultural figures like Semar frequently share wall space with symbols of religious identity, family portraits, and wedding photos. Even in tiny impoverished homes, there is usually some version of this visual display.

The messianic Sukarnoism animating Noorman's counterhistory may have been a marginal current of popular Indonesian politics, but idolization of the nationalist leader, expressed in the collection and domestic display of his portrait, was far more widespread. In 1967, as part of the state's effort to undermine Sukarno's charismatic hold on the popular imagination, the government ordered that his image be removed from public spaces and government offices, where Suharto's image now became obligatory. For many Indonesians during the New Order, displaying Sukarno's portrait at home was a way to counter his erasure from public space and discourse. Some people proudly told me that they had kept portraits of Sukarno on display in their homes throughout the New Order, even though they could be construed as signs of disloyalty to Suharto. Adapted to the smaller scale of family portraiture and incorporated into personal collections of images, their value as signs of a lost political authenticity found expression in an idiom akin to personal memory.[58]

Especially prized by collectors of Sukarno images were *foto asli* ("authentic" photos) printed from original negatives owned by journalists, which circulated via small-scale commerce and found their way into private photograph albums. These *foto asli* were not necessarily considered to be potent or miraculous objects, but like the auratic photographs of Ratu Kidul, their value lay in the heightened sense of indexical connection to their referent they appeared to provide in contrast to commercially printed photographic reproductions. This greater indexicality enhanced the sense of intimate proximity between the possessor of the image and the pictured referent.

Exemplifying the appeal of the *asli* photograph, one young man's personal photograph album included a series of *asli* photographs of Sukarno from the mid-1950s. He had acquired these images through a trade with a friend. Years before, his father had purchased a series of photographs of the sultan taken at a ritual ceremony at the *Keraton*. The palace was closed to outsiders; only official photographers and journal-

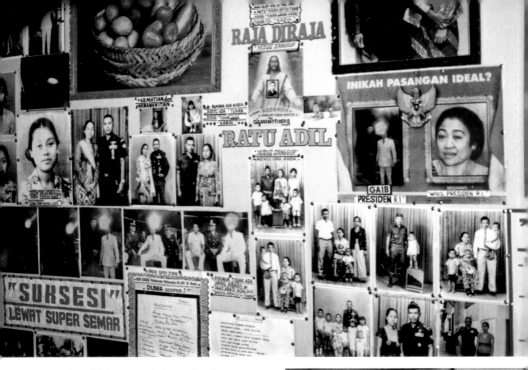

123. A wall in Noorman's home. Family portraits and enlarged identity photos of his wife share space with commercial images of Megawati, photocopied versions of Supersemar, the dream image of Jesus, Noorman's *wahyu* photographs, and a painting of a basket of vegetables by one of Noorman's sons.
Photo by the author.

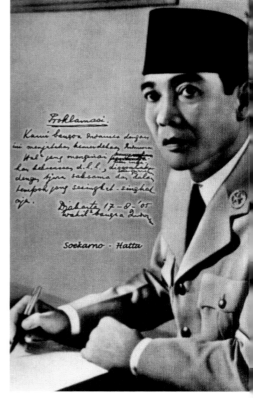

124. Popular image of Sukarno, snapshot-size, purchased from a street vendor in Yogyakarta in April 2000. The text shows a handwritten draft of the Proclamation of Independence. Noorman frequently reproduces and collages this image of Sukarno.
Collection of the author.

ists were allowed inside to document the event. The resulting images from such "closed" court ceremonies circulated informally (often sold by the photographers themselves) as *asli* images. The young man's father hoped through these images of the sultan to offer his children a view into the inaccessible world of the *Keraton*. But as a teenager flirting with oppositional politics, his son was drawn more to Sukarno than to the sultan, so he traded his father's cherished *Keraton* images for the pictures of Sukarno. Despite their different orientations, the appeal of these sets of images to both father and son lay in the intimate connection they promised to otherwise distant charismatic figures. This intimacy resulted from both their tendency to show glimpses into the private or informal world of a public figure and their heightened indexicality relative to commercially printed images.

In the reformasi period, commercial posters and massive street paintings of Sukarno reappeared in public spaces, particularly as accompaniments to Sukarno's daughter Megawati's presidential campaign. Many of these commercial images enhanced the sense of indexical contact provided by the photographic image by overlaying Sukarno's portrait with reproductions of his signature. Some, not unlike Noorman's collages, accompanied the image with quotations from the famous orator, using actual reproductions of Sukarno's manuscripts or a handwriting-like font.

Smaller scale images of Sukarno, often the size of a standard family snapshot, continued to do a brisk business among Yogyakarta's street vendors. Although most were not *foto asli*, many conveyed intimacy through their miniaturized size and their depictions of informal or familial scenes.[59] In one, Sukarno prays, flanked by his mother and wife, at the grave of his father (his handwritten text, signature, and date, meanwhile, enhance the indexicality of the image); in another he kneels before his seated elderly mother, head to her knees, in the respectful gesture of *sungkeman*. Here political authenticity appears in an idiom of familial love, and an otherwise distant political figure is transformed into an intimate relation.

In nationalist discourse in Indonesia as in many parts of the world, the nation has been conceived of along the model of a patriarchal family, yet the means by which this familial conceptualization of the nation occurs, at the level of habitual and material practice rather than official discourse, has received little attention.[60] Stored within personal albums and kept in the home, images of political figures are filtered through what Marianne Hirsch calls the "familial gaze," the nexus of familial

125. *Foto asli* of Sukarno (mid-1950s) from a young man's personal album.
Collection Endang Mulyaningsih.

ideologies and sentiments embodied in conventional representations of family life.[61] By situating Sukarno within a realm of intimate social relations and family memories, small-scale, intimate photographs of Sukarno domesticate national history, saturating it with affective charge. Miniaturized and included among other family photos, images of Sukarno and other charismatic political figures become signs of personal affiliation. Such practices of image collection and display suggest one way that national bonds come to be experienced like familial ties and political figures become intimately "familiar."

Refracted Visions

In Noorman's revisioning of Indonesian history, messianic, auratic images of political figures like Sukarno (and Noorman) collapse the gap between absence and presence and between past and present, promis-

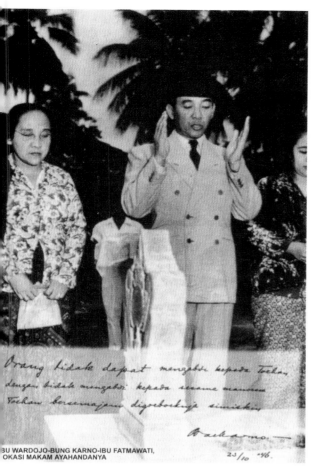

126. Image of Sukarno praying at his father's grave, purchased from a street vendor. The handwritten text quotes Sukarno: "Man does not serve God by not serving mankind. God resides in the huts of the poor," signed with Sukarno's signature and the date October 23, 1946. *Collection of the author.*

BU WARDOJO-BUNG KARNO-IBU FATMAWATI,
OKASI MAKAM AYAHANDANYA

23/10 '46.

127. Family portrait of Sukarno, sold on the street in Yogyakarta. *Collection of the author.*

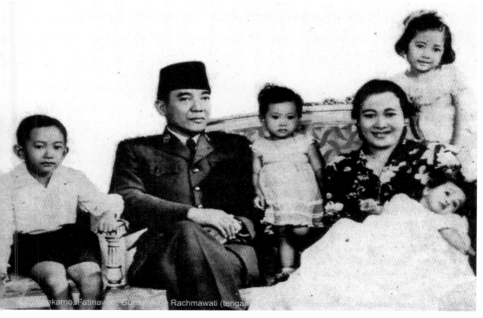

ing the recovery of a lost national authenticity. Against Anderson's argument that nationalism entailed a shift from "messianic time" to what Benjamin termed the "empty, homogenous" time of secular modernity, Noorman's counterhistory not only suggests that messianic time is alive and well within Indonesia's national modernity but that it can be mobilized as a form of popular nationalism to counter hegemonic, official renderings of national history.[62] Photography, a technology often identified with the linear, progressive historicity of the modern secular nation, here enhances rather than strips away the charismatic aura and authority of messianism through an intensified indexicality that affirms and performatively effects the presence of the apparently absent.[63] Noorman's project as a whole has to be understood in terms of two competing epistemologies of history underlying these different nationalisms, just as his auratic photographs of himself, Sukarno, Ratu Kidul, and Semar can only be understood in their opposition to the use of photographs as historical evidence in official narratives.

If the genres producing photographs as "evidence" and as "revelatory" signs are mutually defining in their opposition, images of political figures displayed in the home and in personal albums illustrate the porous blurring of generic conventions and regimes of value. Crossing the boundaries between public iconographies and personal photographs in their physical and formal proximity to family photographs, these images of political figures become incorporated into the affective domain of domestic life and personal memory. Materially interweaving Noorman's history with national history, Noorman's display on the walls of his home enacts the entanglement of individual lives and national trajectories that, I have argued, is central to the work of photographs in a variety of popular genres.

Noorman's counterhistory suggests that just as each genre takes its place within a broader visual field made up of multiple intersecting, competing, and contradictory visualities, so photography itself operates within a complex media ecology. Technologies of mechanical reproduction—not only photography but print and photocopying—provide the means for Noorman's counterhistory as well as its central metaphor of originals and authentic copies. Participating in an ambivalent Indonesian "culture of documentation," Noorman's display refracts the state's fetishization of "authentic" documents as evidence of the past, registering doubt and mobilizing alternative regimes of truth.

Noorman's counterhistory brought together texts and images culled from disparate sources so as to generate a new highly personalized version of national history. But although the principal site of Noorman's counterhistory was his own home, he continually attempted to move beyond its domestic confines. The photocopied Yellow Book— a mobile and reproducible copy of his display—extended his reach. Equipped with notebook, tape recorder, and camera, I was also to help disseminate Noorman's alternative history. When I met him, Noorman claimed he was preparing another media "campaign" of "a book, a cassette, a T-shirt, because these are what move [*bergerak*]." In using the word "move," which (as in English) is also the root word for a political or social "movement" (*gerakan*), he implied both the mobility of these copies and the idea that they may "move" people to action. In its bidirectional movements of collection and dissemination, Noorman's project epitomizes the double gesture—drawing circulating imageries inward into the realm of the personal and projecting the self outward into wider circulations—that photography makes possible and that each chapter of this book has explored in different ways.

Beyond the Paper Trace

IN 1967, WHEN SIGIT, A FRIEND OF MINE, was four years old, his father had a "stroke," was flown to Hong Kong for treatment, and was never heard from again. Throughout Sigit's childhood, no one ever spoke of his father. His mother destroyed the traces of his presence in their home: his letters, documents, clothing, books—all of his personal belongings were burned. A single wedding photograph escaped her purging, the only tangible sign for the young boy and his sister that their father had ever existed.

As Sigit and his sister grew older, they started to question the silence surrounding this photograph. They eventually learned, from an uncle they pressed for information, that their father had been an important figure in the local branch of the Communist Party. Gradually, painfully, they pieced together that he had escaped to China—as had some of the luckier communists during the purges of 1965–1967—and had never contacted them again. But their mother's fear, and the terrible stigma of communism throughout the New Order, gave silence the upper hand. They rarely spoke, even with each other, about what they were beginning to know.

In the opening days of reformasi amid newly vocal criticisms of the New Order regime, Sigit's sister began to search the Internet, where, daily, more and more information on the history of the alleged coup attempt of 1965 and its aftermath could be found. She hoped to learn something about her father's disappearance. At the time, the regular press was still censored; the Internet was a new source of knowledge about taboo and politically controversial topics. One day she brought home a stack of information that she had downloaded and printed at a local Internet cafe.

To everyone's surprise, her mother avidly read the printed sheets, one by one.

Later that night, after everyone had gone to sleep, Sigit's wife walked into the kitchen to find her mother-in-law burning the Internet papers

in the open-fire charcoal stove. "Such things . . . they shouldn't be read," she said, as she stuffed them into the flames.

The next day, she asked her daughter to bring home more documents for her to read.

A victim of political terror, a woman destroys the material traces of her husband's life. Even the most intimate and innocuous objects of memory have become dangerous. Reminders of a husband, a father, a person might be read as official evidence of a criminal, a subversive, a traitor. Perhaps she destroys them less out of fear of an external authority than out of terror that these traces might hold too much memory; they might threaten her will to move on. Or does she destroy them out of shame before her neighbors and even her own family, turning their stigmatizing gaze against herself?

Why did the wedding photograph escape her destructive impulse? Was it her most treasured memento, the one sentimental record with which she couldn't bear to part? Was it "proof" of her children's legitimacy, some last vestige of social respectability when so much had been stripped away?

More than thirty years later, on the cusp of a new era, she is confronted with a different set of documents preserved in a different kind of archive. She consumes these texts with fascination, then decides that the past had best remain silent after all. Burning the papers, she replicates her actions of thirty years before, removing the proofs that might implicate herself and her family. But unlike the irrevocable destruction of her husband's personal effects, the documents she burns now are just copies, their "originals" never definitively housed but moving in restless circulation, cut loose from location and author. Knowing that they are still out there, she is seized by desire; she wants to read them again.

I close with this story for several reasons. First, it was told to me early in my fieldwork and it haunted me throughout the time I was in Yogyakarta. As I sifted through the paper remains of people's lives, I could not help but be aware of what was missing—photographs never taken, photographs destroyed, not to mention all that remained outside the frame of any given image. An interplay of seeing and not seeing, preservation and loss, attends all photographs. In the preceding chapters, we have seen different examples of how photographic ways of seeing work to "silence the past": in the images of "authentic" Indonesia that omit

Chinese Indonesians and screen out violence; in the formal records of ritual process that edit out the spontaneous and the unscripted; in the mythic images that transform the unresolved history of reformasi into the telos of "youth struggle."[1]

Indonesia's "culture of documentation" has also walked hand in hand with a violent history of destruction: the burning of Pramoedya Ananta Toer's manuscripts and library in 1965; the burning of the Antara news agency's photo archives during the turmoil of the New Order transition;[2] the mysterious absence of hospital records that might have revealed how many people were killed in the massacre of Muslim protestors at Tanjung Priok in 1984;[3] the quiet disappearance of countless records from state archives, of which Supersemar is merely the most well known. In sleepy municipal libraries and archives like those in which I spent time in Yogyakarta, one often did not know if the gaps in collections of original newspapers and microfilm were the result of negligence, the corrosive effects of a tropical climate, or purposeful destruction.

As Sigit's story reminds us, erasure threatens not only those archives directly tied to national histories but also personal archives only obliquely or as an accident of history caught up in the fate of the nation. Carmel Budiardjo tells of prisoners stripped of their family photographs when she was held as a political prisoner in an Indonesian jail in the late 1960s.[4] An elderly Javanese woman recounted how, when the Japanese army arrived in Yogyakarta in 1942, she had burned photographs of herself with the Dutch family for whom she had worked as a servant, as well as photographs of her brother in uniform as a subaltern in the colonial army. They were the only photographs she possessed. An elderly Chinese Indonesian photographer in Semarang recalled that at the beginning of the nationalist revolution in 1945, he had burned photographs of Dutch, English, and Japanese soldiers that had been left behind in his studio, copies abruptly abandoned by their originals. The next major "change of eras," as he put it, following the alleged coup attempt in 1965, once again left him in possession of dozens of photographs of customers who had been either killed or imprisoned or had gone into hiding for being affiliated with the Communist Party. These, too, he burned. "As a matter of fact it's a shame, because these were souvenirs of history [kenang-kenangan sejarah]," but, he told me, "it wasn't safe" to keep them.

Recall Djoko Pekik: "No one was brave enough to save anything."

Indeed, it is one of the most profound cruelties of a reign of terror that people become agents of a state violence they direct against themselves. The destruction of personal archives, whether initiated directly or indirectly by the state, marks yet one more especially devastating example of how national histories refract within personal memories.

The wedding portrait saved from the fire also poignantly reminds us that the "meaning" or "value" of a photograph cannot be excavated via virtuosic readings of its mute surface alone, nor fully exhausted by historical and social analysis of its "context," however rich and subtle. There is nothing so banal, as Bourdieu would tell us, as the wedding portrait.[5] But even such highly conventionalized images made in the service of what Proust called "voluntary memory"—memories we actively choose to retain and recall—may provoke unruly, unbidden, and viscerally moving sentiments and idiosyncratic memories.[6] Clearly, Sigit's parents' wedding photograph bore an accumulated affective and mnemonic load far greater than its dully ordinary surface would imply. Only an account that acknowledges the intimate memories and particular narratives that a photograph, however formulaic, may register can begin to convey how images live and how people live with images.

Sigit's mother's encounter with the digital archive raises a final point about the technological as well as political transition occurring as I conducted the research for this book. Sigit's mother burned the Internet documents just as she had destroyed her husband's possessions thirty years earlier. Presumably, in both cases, her primary concern was to remove from her home these dangerous, implicating documents. But unlike the letters, books, and family photographs of a paper-based archival regime, these digital documents' life on paper is secondary to their primary locus within cyberspace. The power to destroy or to preserve them is no longer in her hands; she can remove them from her home, but they remain "out there."

The constraints and possibilities of celluloid negatives and paper prints profoundly shaped the photographic practices I investigated from 1998 to 2000. While eagerly anticipated by many photographers, digital cameras, effects, and circulatory networks remained marginal to the photographic practices I explored.[7] When I returned to Java in 2004, digital cameras were transforming the practice of photography much as automatic printing and color processing had dramatically changed the industry in the late 1970s. As in that earlier transforma-

tion, the shift to digital photography did not necessarily entail a radical break; many of the practices I had observed during my research were continuing apace. Indeed, it is a testament to the durability and flexibility of photographic genres that they both persist and evolve, simultaneously absorbing and being transformed by each new technological advance. Nor should we exaggerate the differences between digital and "traditional" film and paper-based photography.[8]

Yet there is little question that the paper-based "culture of documentation" within which photographic images have lived their material, ideological, and affective lives in Indonesia and elsewhere for more than a century is rapidly giving way to something profoundly different: a new digitally based "discourse network" that entails new forms of production and storage, new modes of circulation, and—perhaps most important—a fundamentally altered relationship between visual image and materiality.[9] My own fascination with the artifacts of the camera—those fragile pieces of paper onto which "histories are scored"—derived in part, I suspect, from a kind of protonostalgia.[10] This is not to say that images are becoming dematerialized—digital media have their own materialities, of course. What is changing is exactly *how* "images matter."[11]

Nor are the changes in photographic technology taking place in a vacuum. As Sigit's story suggests, the digitalization of photographic technology is part of an ongoing transformation of Indonesia's media ecology by both new technologies and a more open political regime. Decentralized, unregulated, and increasingly accessible technologies like the Internet and the cellphone are already dramatically altering Indonesian sociality and political communication, as well as becoming new means for taking, circulating, and preserving images. No doubt Indonesia's emerging media ecology will have far-reaching effects on the ways that images mediate both intimate relationships and national imaginaries, giving rise to new longings and senses of belonging, new forms of authority and authenticity, and new experiences of doubt and desire, loss and pleasure. Under these conditions, images will continue to pose in novel ways the question "What does it mean to be Indonesian?"

Preface

1 Pramoedya Ananta Toer, *This Earth of Mankind*, 17.
2 An important theme in the novel contrasts painting to photography, opposing art forged out of craft and human experience to the superficial realism of mechanical mimesis. Ultimately, Minke marries these two forms, writing carefully crafted fiction and journalism that emerges from his experience, but using technologies of mechanical reproduction to disseminate his ideas.
3 Minke is based on the historical figure of Tirto Adhi Suryo, a journalist and important early nationalist. On the newspaper as a key medium for the emergence of a national imagined community, see Anderson, *Imagined Communities*.
4 I borrow the phrase "mimic man," of course, from V.S. Naipaul's novel exploring the dilemmas of postcolonial identity, *The Mimic Men*.

Introduction: Popular Photography and Indonesian Modernity

1 See, for example, Abu-Lughod, *Dreams of Nationhood*; Mankekar, *Screening Culture, Viewing Politics*; Morley, *Television, Audiences, and Cultural Studies*; Rajagopal, *Politics after Television*. As Christopher Pinney has argued, analyses of popular visual media may offer different perspectives on "the construction of public spaces and arenas of consciousness that are intimately linked to 'nationalism'" than emerges from Anderson's focus on (elite) print capitalism (*Photos of the Gods*, 12). Because photography is more decentralized, unregulated, and associated with ostensibly personal projects, it has generally been excluded from studies of the mediation of national subjects and communities (see, for example, on mass media and the creation of "national culture" in Indonesia, Sen and Hill, *Media, Culture and Politics in Indonesia*). Yet it is precisely because of these qualities, I argue in this book,

that photography is such an important medium in the formation of political subjectivities.

2 Of course, as has long been argued by scholars of media, popular culture, and literature, consumption is never a passive activity; the "meaning" of a text is not fixed in advance but emerges from a negotiated process by which consumers make their own meanings within the constraints of the texts available to them. For classic works on this subject, see Barthes, *Image-Music-Text*; Hall, "Encoding/Decoding"; de Certeau, *Practice of Everyday Life*; Fiske, *Understanding Popular Culture*; Ang, *Watching Dallas* and *Desperately Seeking the Audience*. Popular photographic practices, which often recycle and rework images from the mass media, can be seen as a form of cultural production that is simultaneously a practice of media "reception." On the "recycling" of mass-mediated discourses in everyday speech, see Spitulnik, "The Social Circulation of Media Discourse." On popular photographic practices, see Pinney, *Camera Indica*; Pinney and Peterson, *Photography's Other Histories*; Buckley, "Self and Accessory in Gambian Studio Photography"; Behrend and Werner, "Photographies and Modernities in Africa"; Wendl, "Portraits and Scenery in Ghana"; MacDougall, "Photo Hierarchicus." Ethnographic films on popular photography include Wendl's and du Plessis's *Future Remembrance* and MacDougall's and MacDougall's *Photo Wallahs*. On personal and family photography, see Kuhn, *Family Secrets*; J. Hirsch, *Family Photographs*; M. Hirsch, *Family Frames* and *The Familial Gaze*; Spence and Holland, *Family Snaps*; Chalfen, *Snapshot Versions of Life*; Langford, *Suspended Conversations*.

3 See Foster, *Materializing the Nation*.

4 On romantic love, or *cinta*, progress, and the enlightened modernity of Indonesian nationalists, see Siegel, *Fetish, Recognition, Revolution*, chap. 6.

5 Cited in Groeneveld, *Toekang Potret*, 16.

6 On colonial-era photography in the Dutch East Indies, see Groeneveld et al., *Toekang Potret*; Wachlin, Fluitsma, and Knaap, *Woodbury and Page*; Haks and Wachlin, *Indonesia*; Theuns-de Boer, Asser, and Wachlin, *Isidore van Kinsbergen*; Knaap, *Kassian Cephas*; Reed, *Toward Independence*. Dutch photography of this period is in many ways a subset of a wider, transnational colonial photographic enterprise. On Southeast Asian photographic histories, see Morris, *Photographies East*. Among many works on colonial photography, see Edwards, *Anthropology and Photography*, "Anthropology and the Colonial Endeavor," and *Raw Histories*; Ryan, *Picturing Empire*; Pinney, *Camera Indica*; Poole, *Vision, Race, and Modernity*; Maxwell, *Colonial Photography and Exhibitions*.

7 For a recent analysis of the alleged coup attempt, see Roosa, *Pretext for Mass Murder*.

8 Several of the founding photojournalists of the Indonesian Press

Photo Service (IPPHOS, founded 1946) and Antara (1945) had been employed by Domei, the Japanese News Agency, during the Japanese occupation. Many had begun their careers as photojournalists working for the Dutch colonial press prior to the Japanese occupation. On the history of IPPHOS and Antara, see Soeryoatmodjo, "Awal Fotografi Modern Indonesia" and "The Challenge of Space"; Supartomo and Lee, "Nationalist Eye."

9 See especially Pemberton, *On the Subject of "Java."*

10 It is important to note that my research took place well before the events of September 11, 2001, and that the Bali bombings of 2002 (and others that followed) brought the resurgence of radical Islam to the forefront of both national debates and international framings of Indonesia as a locus of "terrorism."

11 The phrase is Robert Cribb's, from "A Good Idea at the Time?"

12 That many of the names of photo studios would evoke the imagery of light is not particularly surprising given that photography is, after all, "writing with light." Yet as Anderson argued, it was also with an imagery of "radiant light" that people in the Indies hailed a new, modern era of "nationalist awakening" in the first decades of the twentieth century. Many newspapers of the time contained in their titles "one or more of the following words: *matahari* (sun), *surya* (sun), *bintang* (star), *nyala* (flame), *suluh* (torch), *sinar* (ray), *cahaya* (radiance), *api* (fire), and *fadjar* (dawn). Others contained such words as *muda* (young), *baru* (new), and *gugah* (awakened)" (Anderson, "A Time of Darkness and a Time of Light," 243 n. 6). A third term links these convergent vocabularies: Chinese Indonesians owned many of the early Malay newspapers, and Anderson observes "comparable imagery in China during more or less the same period" (270 n. 118). Most photo studios in Java and elsewhere in Indonesia are owned by Chinese Indonesians.

13 On modernity as a "social fact" within people's "historical self-understanding," see Keane, *Christian Moderns*, 48.

14 Siegel, *Fetish, Recognition, Revolution*, 93. In arguments that are now well known, Benedict Anderson theorized in *Imagined Communities* that the rise of print capital and such forms as the newspaper enabled people to imagine themselves as part of a community made up of individuals unknown to each other but aware of their simultaneous movement together through what Benjamin called "homogenous, empty" time. Takashi Shiraishi's sensitive portrayal of the dawning years of nationalism in the Indies—aptly termed "an age in motion"—describes how ideas of progress and modernity seemed to be concretely manifest in new technologies of the urban landscape, such as street trams (*An Age in Motion*, 27). Rudolf Mrázek has investigated how particular technologies (cars and trains, radios and cameras) fostered experiential and imaginal renderings of the Dutch colony as a unified space that

could be "engineered" through technical and technological mastery; these technological fantasies appealed not only to colonial rulers but to indigenous elites who were forming themselves as nationalists (*Engineers of Happy Land*). In *Fetish, Recognition, Revolution*, Siegel argues that communications technologies like photography allowed colonial subjects to begin to imagine themselves in new ways, as members of "this earth of mankind," an awareness that preceded and was a necessary foundation for a specifically national consciousness. Technology has continued to play a crucial role in the postcolonial imagining of Indonesia's national modernity (see Barker, "Engineers and Political Dreams").

15 Siegel, *Fetish, Recognition, Revolution*, 93.

16 See Appaduarai, *Modernity at Large*. John Sidel has argued that "so-called nationalist struggles . . . are driven by transnational networks, movements, and horizons" ("Liberalism, Communism, Islam," 23). Alongside secular, capitalist imaginings of modernity, both Islam and communism were transnational forces that played a significant role in the formation of Indonesian nationalism.

17 Siegel, *Fetish, Recognition, Revolution*, 85.

18 The history of the ethnic Chinese in Indonesia is long and complex. The first significant Chinese settlements in Java began in the fourteenth century with immigrants from Fukien Province (mostly of Hokkien ethnicity). These immigrants (who continued to arrive through the nineteenth century) developed a distinctive mestizo, Malay-speaking culture known as *peranakan*. In the 1870s, Chinese on the island of Java numbered approximately 190,000 (1.5 percent of the population) as compared to a mere 27,000 Europeans (Rush, *Opium to Java*, 13). Toward the latter half of the nineteenth century, large numbers of Chinese, many from Canton (of Hakka and Cantonese ethnicity), began arriving in Java and the outer islands. By 1900, the number of Chinese on Java and Madura had risen to 277,265. These newer immigrants were known as *totok* (full-blooded) because they were born in China and tended to maintain a more exclusively Chinese milieu, often bringing wives from China rather than intermarrying with local women (on the distinction between *totok* and *peranakan*, see Suryadinata, *Pribumi Indonesians, the Chinese Minority, and China*). Dutch colonial policies divided those living in the Indies into distinct legal categories: "Natives" (*inlander*), "Foreign Orientals" (Chinese, Indians, Arabs), and "Europeans" (including Japanese). Foreign Orientals were placed hierarchically below the Dutch and above the native population. Over time, as a result of the growth of pan-Chinese nationalism in the early twentieth century and the uniform application of state policies toward ethnic Chinese in both the colonial and post-independence periods, the differences between the Chinese communities in Java would become less pronounced (Williams, *Overseas Chinese Nationalism*). Today

the ethnic Chinese population is approximately 3 percent of the total Indonesian population, and much higher in large cities like Jakarta, where the population is concentrated. Exact numbers are difficult to acquire because censuses between 1930 and 1999 did not categorize by ethnicity; the 2000 census reported under 1 percent of the total population as ethnic Chinese, but the numbers are believed to be severely underreported due to people's refusal to self-identify due to ongoing fears of discrimination and lingering effects of the anti-Chinese violence of 1998 (Mackie, "How Many Chinese Indonesians?" 100). For a concise, synthetic discussion of the ethnic Chinese in Indonesia, particularly their position at the vanguard of a monetized, market economy and the history of violence directed against them, see Sidel, *Riots, Pogroms, Jihad*.

19 Transnational ethnic minorities have also played a key role in the development of photography in other parts of the world, such as East Africa (Behrend, "A Short History") and the Middle East (Graham-Brown, *Images of Women*, 55).

20 On the ethnic Chinese and capitalism in Indonesia, see Twang, *The Chinese Business Elite*; Mackie, "Introduction"; McVey, *Southeast Asian Capitalists*. On the role of the ethnic Chinese in early nationalism, see Anderson, "*Sembah-Sumpah*"; Adam, *The Vernacular Press*; Salmon, *Literature in Malay by the Chinese of Indonesia* and *Le Moment "Sino-Malais" de la Litterature Indonesienne*; Suryadinata, "The Pre-World War II Peranakan Chinese Press of Java"; Reid, "Entrepreneurial Minorities, Nationalism and the State"; Oetomo, "The Chinese of Indonesia"; Cheah, *Inhuman Conditions*.

21 Despite Charles A. Coppel's appeal in 1977 for research that is "directed not only toward the Chinese as a separate group but also as a part of Indonesian society and its history" ("Studying the Chinese Minorities," 182), most scholarly treatments of ethnic Chinese continue to treat them as a discrete group. As Coppel argued then, "If we ignore the extent of interaction between Chinese and indigenous Indonesians in the past, except when it has involved hostility and violence, we are not merely denying the Chinese their rightful place as a part of Indonesian history. We are, in effect, continuing the colonial policy of attempting to segregate them from the Indonesians and, in the process, lessening our understanding of Indonesian history as a whole" (ibid). See also Strassler, "Cosmopolitan Visions."

22 See Rafael, *The Promise of the Foreign*.

23 Reid notes that, "ethnic nationalism lives uneasily with [Indonesian civic nationalism], seldom far from the surface where the Chinese are concerned" ("Entrepreneurial Minorities," 38).

24 Many formulations of Indonesian nationalism were predicated on the assumed "natural" belonging of the *asli* (original/authentic/indigenous) inhabitants of the archipelago. As Coppel argues, "In the for-

mative years of Indonesian nationalism in the early part of this century, the word *bangsa* (race) came to be used to denote the concept of nation. Most Indonesian nationalists thought of the Indonesian nation (*bangsa Indonesia*) as comprising the members of the various indigenous (*asli*) Indonesian ethnic groups (*sukubangsa* or *suku*) . . . Ethnic Chinese, who with a few exceptions were classified as 'Foreign Orientals' (*Vreemde Oosterlingen*), were perceived by the Indonesians as a separate *bangsa*, the *bangsa Tionghoa*" (Coppel, *Indonesian Chinese in Crisis*, 2–3). Many nationalist parties, including Sukarno's Partai Nasional Indonesia (PNI), did not accept Chinese Indonesians as full members.

25 See Strassler, "Documents as Material Resources of the Imagination."

26 On documentation and modernity, see Riles, *Documents*; on archival knowledge production and the Dutch colonial state, see Stoler, *Carnal Knowledge* and *Along the Archival Grain*; on authority and textual form, see Messick, *The Calligraphic State*; on archival practices and governmentality, see Feldman, *Governing Gaza* and Hull, "The File"; and on archival poetics beyond the state and the academy, see Papailias, *Genres of Recollection*.

27 On the role of technologies of inscription, including photography, in the very delineation of a boundary between "modernity" and "tradition" in a different Indonesian location, see Spyer, "The Cassowary Will (Not) Be Photographed." The opposition between an authentically "Javanese" and Indonesian national modernity has all too often been generated and reinforced by anthropologists themselves, whose assumptions of what Tom Boellstorff calls "ethnolocality" treat national culture as a modern, superficial overlay on top of a more authentic "local culture" (*The Gay Archipelago*, 18–20). In a classic article on the Indonesian language, Anderson described the project of Indonesia as a "new and thin topsoil to the cultures of Indonesia . . . only too subject to erosion once the winds begin to blow" ("The Languages of Indonesian Politics," 141). This "layer theory" treats "Indonesian" as a supplementary and impoverished identity, always figured in opposition to a prior and more authentic core rooted in localized ethnic cultures.

28 See Gupta and Ferguson, "Beyond 'Culture.'" For a classic discussion of the lack of "coevalness" assigned to the non-Western world, see Fabian, *Time and the Other*.

29 On *kesadaran* (awareness) as a key trope of early nationalist thought, see Anderson, "A Time of Darkness and a Time of Light," 262; on "national awakening" see Shiraishi, *An Age in Motion*.

30 This self-conscious approach to the project of modernity (and penchant for borrowing foreign words) was typical of the Sukarno period as well as the New Order. See, for example, Clifford Geertz's mention of Sukarno's call for "*ke-up-to-date-an*" ("The Politics of Meaning," 319).

The idea of "making culture" figures centrally in dominant imaginings of "Indonesia" as a future-oriented project of modernization. On the Indonesian language as a self-conscious project of "*cultuurscheppen*" (culture creation), see Keane, "Public Speaking."

31 My use of the term "culture" thus reclaims its origin as a "noun of process" signifying cultivation as famously discussed by Raymond Williams (*Keywords*, 77). For a critique of "culture" in the reified sense of a bounded and stable set of shared values, see Abu-Lughod, "Writing against Culture."

32 See Benjamin, "On Some Motifs in Baudelaire," 175.

33 See Berger's classic, *Ways of Seeing*. The term "visuality" draws attention to the fact that vision is not merely a physiological capacity but "a skilled cultural practice" (Jenks, *Visual Culture*, 10; see also Foster, *Vision and Visuality*; Crary, *Techniques of the Observer*). As W. J .T. Mitchell points out, the term "visuality" denotes "not just the 'social construction of vision' but the visual construction of the social" (*What Do Pictures Want?* 356). In contrast to earlier approaches to the historical and cultural training of visual dispositions, such as the "period eye" (Baxandall, *Painting and Experience in Fifteenth Century Italy*; see also Geertz, "Art as a Cultural System"), recent approaches to visuality, influenced by Foucault's attention to the centrality of technologies of vision to modern forms of rule (see *Discipline and Punish*), foreground the power relations instantiated in and through visual practices. See Jay's *Downcast Eyes* for a masterful account of Western philosophical approaches to vision and visuality.

34 By "semiotic ideology," Keane refers to underlying assumptions about what signs are and how they function in the world (see his "Semiotics and the Social Analysis of Material Things"). On Bakhtin's approach to genres as "ways of seeing," see Morson and Emerson, *Mikhail Bakhtin*, 271–305. See also John Tagg's call for analysis of "the formation and disintegration of socially structured 'ways of seeing' and the specific genres of image-making in which they are realized," in *The Burden of Representation*, 171.

35 On genres as "organs of memory," see Morson and Emerson, *Mikhail Bakhtin*, 280.

36 See Tagg, *The Burden of Representation*, 63. Examples of the "essentialist" position include Flusser, *Towards a Philosophy of Photography*; Barthes, *Camera Lucida*; Bazin, "The Ontology of the Photographic Image." For a more extensive critique of the opposing camps of "social constructivist" and what he calls "formalist" positions, see Geoffrey Batchen, *Burning with Desire*. This debate about photography is a subset of a larger debate between technological determinists and those who argue for the social construction of technology (see, for classic examples of each position, McLuhan, *Understanding Media*, and Williams, *Television*).

37 The specificity of the photographic image, for example, has long been located in its status, in Peircian semeiotic terms, as an "iconic-index," a sign that refers to its object through resemblance and physical causality or contact (Peirce, "The Logic of Semeiotic"). Yet whether its indexical properties lend the photograph a privileged status as "evidence," allow it to bear forth the auratic properties of the person it pictures, or cause it to transmit to viewers the moral charge of the photographer's act of seeing, is a function of the specific semiotic ideologies and social practices characteristic of its genre.

38 See Pinney, "Notes from the Surface of the Image," 202, and "The Indian Work of Art in the Age of Mechanical Reproduction," 356. Pinney's reference here is to Dipesh Chakrabarty's project of "provincializing Europe" through historical studies that no longer take European historical experience as normative or originary (*Provincializing Europe*).

39 See, for example, Pinney and Peterson, *Photography's Other Histories*; Klima, *The Funeral Casino*; Sprague, "Yoruba Photography." Pinney, for example, uses the term "corpothetics" to describe popular Indian sensory, corporeal engagements with photographs and other images (see Pinney, "The Indian Work of Art," and Pinney and Thomas, *Beyond Aesthetics*).

40 On photography's participation in "visual economies," see Poole, *Vision, Race, Modernity*.

41 See Bakhtin, *The Dialogic Imagination*, 4. In "The Body and the Archive," Allan Sekula argues that the various forms of photography that emerged in the late nineteenth century formed a "shadow archive," a vast, hierarchical mapping of society. Sekula's call to consider the relational nature of different photographic genres remains inspirational to this project. In "Scopic Regimes of Modernity," Martin Jay suggests that while different visualities may coexist and compete in a given society, one visuality usually dominates. (Jay borrows the phrase "scopic regime" from the film theorist Christian Metz's *The Imaginary Signifier*.) This study, however, reveals a dynamic distribution of visualities that is not ordered according to a clearly discernible hierarchy or dominant visual regime.

42 Bakhtin, *The Dialogic Imagination*, 299–300.

43 See Ferguson, *Expectations of Modernity*.

44 See Silverman, *Threshold of the Visible World*, 197.

45 Roland Barthes described the unnerving experience of posing for a portrait as the process of forming oneself "in advance into an image" (Barthes, *Camera Lucida*, 10). While Barthes meditates on the problem of misrecognition—of *not* finding oneself in one's pictured image—the work of photography, more often, is to allow what William Mazzarella calls "mediated self-understandings" to arise precisely through this process of self-othering and objectification, or "the routing of the personal through the impersonal, the near through the far, the self

through the other" ("Culture, Globalization, Mediation," 361). All mediation, he argues, "involves a double relation: a relation of simultaneous self-distancing and self-recognition" (357).

46 Like Silverman, Mitchell draws on a Lacanian approach to the visual formation of subjects to suggest that we think of visual images "as 'go-betweens' in social transactions, as a repertoire of screen images or templates that structure our encounters with other human beings . . . these images are the filters through which we recognize and of course misrecognize other people" and, I would add, ourselves (Mitchell, *What Do Pictures Want?* 351).

47 In recent years anthropologists and historians of photography have foregrounded the materiality of photographs, arguing that the efficacy of images cannot be located at the level of the visual alone (see, among others, Poole, *Vision, Race, Modernity*; Edwards, *Raw Histories*; Edwards and Hart, *Photographs, Objects, Histories*; Batchen, *Forget Me Not*). The "material turn" in the anthropology of photography has widened inquiry beyond how photographs construct views *of* the world to engagement with their participation as materially embodied representations *in* the world. As such, it has moved the field beyond the preoccupation with the politics of representation that characterized the anthropology of photography that emerged in the late 1980s and early 1990s (see, for example, Banta and Hinsley, *From Site to Sight*; Edwards, ed., *Anthropology and Photography*; Alloula, *The Colonial Harem*) and offered a corrective to narrowly semiotic approaches that treat photographs as disembodied, coded texts abstracted from the social practices in which they are embedded and the subjects they help form (see, for example, Eco, "Critique of the Image"). The heightened consideration of photographs as "agentive" objects can be traced in part to a reinvigorated material culture studies in anthropology (see Gell, *Art and Agency*; Miller, *Material Cultures*; Latour, *We Have Never Been Modern*; Myers, *The Empire of Things*; Thomas, *Entangled Objects*).

48 See Kopytoff, "The Cultural Biography of Things."

Chapter One: Amateur Visions

1 I am grateful to the historian Didi Kwartanada for sharing his knowledge of his grandfather Tan Gwat Bing's personal history and photographic practice, as well as his collection of photographs.

2 This analogy between hunting for game and shooting with the camera has long been part of the lexicon of amateurs. Indonesian amateurs use both the Indonesian word (*berburu*) and the English. On hunting with the camera, see Haraway, "Teddy Bear Patriarchy"; Ryan, *Picturing Empire*, chap. 4; Sontag, *On Photography*.

3 On the radio and other late colonial hobbies oriented around modern technology, see Mrázek, *Engineers of Happy Land*.

4 The French amateurs studied by Robert Castel and Dominique Schnapper (under Pierre Bourdieu) likewise scorned family documentation. See Bourdieu, *Photography*, 103.

5 The shifting semantics of the word *amatir* index the changing contexts within which amateurs have practiced their art for over a century. As opportunities for lucrative and prestigious careers in photography have grown in recent decades, many amateurs have parlayed their skills into professional careers; many of Indonesia's prominent photojournalists and commercial photographers received formal training under the tutelage of amateur photography clubs. As the line between sophisticated amateurs and well-paid professionals has blurred, the word *amatir* has taken on a more derogatory meaning. Today, it is often applied to those who are *amatiran*—who do things in an amateurish way—particularly quasi-professional photographers who, lacking the capital to buy a studio or fine equipment, work on a small scale with minimal profit.

6 There have always been non-Chinese members of clubs as well. Today, an increasing number of young men (and some women) of varied ethnic, religious, and class backgrounds are joining clubs. Amateur club membership remains predominantly male; during the year and a half I attended HISFA meetings and events I was always the only woman present. These young members are pushing clubs in new directions, toward both more experimental "high art" photography (including digital photography) and more documentary, journalistic photography. Despite their large numbers, because many of these young photographers are aspiring professionals and because few are committed, long-term members of amateur clubs, I do not consider them to be core figures of the amateur community. It is beyond the scope of this chapter to address their presence more fully.

7 Many Chinese converted to Christianity during the New Order when Confucianism ceased to be recognized by the state and not declaring a religion was tantamount to being labeled a communist.

8 Unlike other technologies such as radio and telephone, photography remained far too decentralized and privatized to come under state monopoly control, yet the history of amateur practice exemplifies state attempts to harness communications technologies to the promotion of national integrity (see Barker, "Telephony at the Limits of State Control").

9 See Wachlin, "Large Scale Studios and Amateur Photography," 163.

10 For a history of early pictorialist photography in England, see Harker, *The Linked Ring*; for the United States, see Greenough, "'Of Charming Glens, Graceful Glades, and Frowning Cliffs.'"

11 As cited in Newhall, *History of Photography*, 146.

12 See Greenough, "'Of Charming Glens, Graceful Glades, and Frowning Cliffs,'" 265.

13 See ibid., 271.

14 As cited in ibid., 275.

15 Wachlin, "Large Scale Studios and Amateur Photography," 163.

16 Cited ibid., 163.

17 Ibid., 164. The 1925 Salon catalogue lists a large number of international participants from Holland, Canada, the United States, England, and other countries. Of thirty-three participants from the Indies at least five were Chinese. I am grateful to Steven Wachlin for sharing this catalogue with me. The salon was announced in the British publication *Amateur Photographer and Photography* 59, no. 1888 (January 1925): 39. Reflecting amateur photography's international scope, this magazine also published images by photographers in Japan, Hong Kong, India, and other parts of Asia. It held an annual competition for "overseas" photographers in British colonies (see 59, no. 1903 [April 1925]: 440) and published articles—"An Amateur in the West Indies" (p. 437), "Photography in the Tropics" (p. 430)—gesturing to amateur activity in the colonies. In the mid-1930s, the British Royal Photographic Society included "native" members from, among other places, India, Burma, Japan, Egypt, and Singapore (see *Photographic Journal* 74 [1934]).

18 Wachlin, "Large Scale Studios and Amateur Photography." On Indies postcards, see de Graaf, *Nederlandsch-Indie in Oude Ansichten*; Hak and Wachlin, *Indonesia*; on colonial postcards more generally, see, for example, Alloula, *The Colonial Harem*; Prochaska, "Fantasia of the Phototheque"; Geary, "Impressions of the African Past"; Thompson, *An Eye for the Tropics*.

19 See Shiraishi, *An Age in Motion*.

20 Kartini, *Letters of a Javanese Princess*, 215.

21 Ibid., 188. As a Javanese, Kartini had greater access than her Dutch friends to such "peeps," but she also acknowledged some resistance: "It was most difficult to take a photograph in the kampong. A superstition says that one shortens one's own life when one allows a photograph to be taken, and that a photographer is a great sinner; all the portraits that he makes will demand their lives of him in the afterlife" (147–48).

22 A 1953 catalogue of the Semarang Camera Club lists sixty-two members, almost all Chinese.

23 According to a founding member, in its first decade HISFA had about twenty-five members, approximately half of whom were Chinese Indonesian. Members of the lesser royal palaces of Yogyakarta (Pakualaman) and Solo (Mangkunagara) were members of those cities' amateur clubs. In Yogyakarta, Sri Sultan Hamengkubuwono IX was also an avid amateur photographer, though not a club member.

24 A large Dutch and Eurasian community remained in Bandung until the late 1950s. PAF membership records from 1952 show that of 315

members, 71 were Dutch. By 1954, membership had dropped to 232, of whom 30 were Dutch. By 1955, of 216 members, 25 were Dutch (records courtesy of Tanzil Husein, April 2, 2000, Bandung); Chinese Indonesians formed a clear majority (interview R. M. Soelarko, April 1, 2000, Bandung).

25 R. M. Soelarko was a leading figure, heading both the first and second national federations of amateur clubs and translating a number of English-language photography books into Indonesian. Originally from Solo, he moved to Bandung as a student and later taught dentistry at Padjadjaran University. He died in 2005. The initials "R. M." stand for Raden Mas, an honorific title indicating aristocratic status.

26 R. Soemardi headed HISFA from 1954 to 1975. Born in 1910 in Yogyakarta and educated in Dutch schools, he began his career in the colonial bureaucracy. He began photographing in 1927 and from 1939 to 1941 he submitted photographs to the magazines *De Orient*, *Wereldnieuws*, *Star*, and *Panji Pustaka*. In 1939 and again in 1941 he won a "Night Market" (*Yaar Mark*) photography competition in Yogyakarta. Throughout the 1950s he participated in international salon contests in France, Amsterdam, Ceylon, the United States, Malaysia, and elsewhere. Inu Wicaksana, "Profil RDS Soemardi," *Buletin Khusus HISFA Berikut Katalog Salon '78* (Yogyakarta: HISFA, 1978); and interviews with HISFA members. One of the Chinese founders, Tjan Gwan Bie, worked as a propagandist for the Overseas Chinese Association under the Japanese occupation and as a journalist. In the early 1950s he was involved in the Yogyakarta branch of the Indonesian Chinese Association (Lembaga Indonesia Tionghoa Jogjakarta, Sekaten Nommer, Jogjakarta, LIT: 1950, p. 50; with thanks to Didi Kwartanada for pointing me to this source).

27 Singapore had a long history of club activity. Its earliest club, the Strait Photographic Association, was founded in 1887. By 1894 its members were participating in international competitions. The Singapore Camera Club was founded in 1924 and in March 1935 an Overseas Photographic Exhibition in Singapore included works from Singapore, Hong Kong, and British Malaya. A string of new clubs emerged in the 1950s and 1960s: Singapore Art Society (1950, renamed Photographic Society of Singapore in 1956); the Southeast Asia Photographic Society (1958); Singapore Colour Photographic Society (1967); the Photo Art Association of Singapore (1965). Photographic societies also formed in Taiwan (1954), Federation of Malaya (1952, 1958), and India (1954).

28 The 1956 Gaperfi First International Photo Salon of Indonesia catalogue features an ad for the 8th Singapore International Salon of Photography sponsored by the Photographic Society of Singapore (10).

29 R. M. Soelarko, "Pengantar Berita Gaperfi No. 1," *Kamera* 1, no. 1 (February 1956): 1. Such touting of photography as training for modernity was not limited to the postcolony. An article titled "The Most Civilized

Hobby," in the *American Annual of Photography 1946*, reads, "A man properly prepared to live under modern conditions ought to know how to see, record, file, and tinker, so that he can intelligently appreciate what is going on around him. In the kindergarten of the future, children will be taught photography because it is a necessity of everyday living" (Breuer, "The Most Civilized Hobby," 80). It was precisely such texts that Indonesian amateurs like Soelarko were reading.

30 On the history of Gaperfi, see Soedjono, Marah, and Rusli, *Tinjauan Fotografi Salonfoto Indonesia*, 16–17. See also "Wajah FPSI Kita," *Fotomedia*, August 1997, 12–15.

31 Most of the names on the organizing committee of the 1956 International Salon are either Dutch or Chinese. Of nineteen photographs published in the catalogue, fifteen are clearly by Chinese members. A list of club officers in *Kamera* shows that of four officers of Fadjar (Jakarta), three were Chinese; of four PAF officers, one was Chinese; of two Semarang Photo Club officers, both were Chinese; nine of ten officers of the Art and Camera Club of Malang were Chinese. IKAFO (Solo) is an exception: of fourteen listed officers only two appear to have been Chinese. One member of the club was Prince Mangkunagoro VIII and one was a woman.

32 *Kamera* 1, no. 1 (February 1956): 8, and "PAF News."

33 In an article in a HISFA bulletin, Agus Leonardus writes, "The salons in Hong Kong and Asia in general tend to like pictorial photography, and the salons in America like portraits and human interest." "Lomba Foto: Bukan Tujuan Utama," *Buletin HISFA* (1982): 15–16.

34 Barthes, *Mythologies*.

35 All titles are from the 1953 Semarang Photography Club exhibition catalogue.

36 In 1975, for example, Modern Photo and Fuji Film helped support the Surabaya Photography Society's Photo Salon. *Foto Indonesia* 52 (1977): 35.

37 It would continue publication until 1986. While the first edition numbered just 2,000, in its heyday it had a circulation of 16,000. Interview, Leonardi, April 1, 2000, Bandung.

38 FIAP, founded in 1950, is the authorizing body for all salons. Each country can have only one membership, so a federation of national clubs is necessary to join. The 1954 charter of the organization describes it as a kind of United Nations of photography celebrating the values of universal humanism: "The International Federation of Photographic Art, placing its activity on the universal level, has given itself the mission to raise photography to its peak by developing the photographic spirit through all countries, in the triple intention to increase the culture of citizens, to contribute to the technical, documentary and artistic enrichment of nations and to contribute, in the measure of its resources, to the strengthening of the peace in the world" (http://www

.fiap.net; accessed September 27, 2001). Once a federation is recognized as a member of FIAP, its salons are official. The salon works on a point system. Individuals receive a certain number of points depending on acceptance into salon exhibitions and winning awards. Accumulating points enables one to achieve honors that establish seniority in the salon community. The Photographic Society of America and the Royal Photographic Society work on the same principle, and many Indonesian amateurs are members of these societies on an individual basis.

39 The sixteen member clubs were from Malang, Purwokerto, Banjarmasin, Jakarta (4), Rumbai Pakan Baru, Yogyakarta, Situbondon, Surabaya (2), Bandung (2), Semarang, and Sukabumi (Soedjono, Marah, and Rusli, *Tinjauan Fotografi Salonfoto Indonesia*, 29).

40 On cultural tourism in Indonesia, see also Volkman, "Visions and Revisions"; Vickers, *Bali*; Picard, *Bali*; Rutherford, *Raiding the Land of the Foreigners*.

41 Soelarko, "Lomba Foto Pariwisata," *Foto Indonesia* 35 (1975): 6, my emphasis. The first tourism contest had four categories: flora and fauna; art and culture; festivals; and "way of life" of Indonesian peoples.

42 In 1991, the "Festival of Indonesia," a major promotion of Indonesian cultural tourism that involved a year-long set of exhibitions, performances, and concerts touring the United States, included an exhibition titled "Indonesia: Heaven for Photography," composed of winning images from a contest.

43 Adam Malik, "Introduction," Salon Foto Indonesia 1973 catalogue, December 11, 1974.

44 From PAF "Anggaran Dasar 1970," reprinted in the *Buletin PAF* no. 103 (1978).

45 Pemberton, *On the Subject of "Java."*

46 Nonprofit organizations also sponsor contests in a similar vein, most notably the annual Rana Citra Contest (since 1992) with such themes as "Traditional Markets" (1993); "The Life of Indonesian Women" (1994); "Water and Human Life" (1997).

47 The *Family of Man* exhibition traveled to thirty-seven countries. Culled from two million images submitted by amateurs and professionals from all over the world, the exhibition was "conceived as a mirror of the universal elements and emotions in the everydayness of life—as a mirror of the essential oneness of mankind throughout the world" (Steichen, cited in M. Hirsch, *Family Frames*, 49). See also Sekula, "The Traffic in Photographs," 89; Barthes, *Mythologies*, 100–102; Stimson, *The Pivot of the World*, chap. 1.

48 Source: http://www.accu.or.jp/project/3_5photocon.htm; accessed September 10, 2001.

49 "Human interest" was not in itself new to amateur photography; it had been a category alongside still life, landscape, and portraiture as early as the 1956 Salon catalogue. In describing human interest, R. M. Soelarko notably cites American magazines, including a July 1953 edition

of *Popular Photography* ("Penilaian Senifoto," Salon Foto Indonesia catalogue [13–19 July 1956]). A senior photographer recalled that the shift was in evidence as early as the International Salon of 1973, "which placed more importance on originality and human interest [and] was greatly different from what came before, which emphasized the technique of photography with content that was romantic and sentimental" ("Wajah FPSI Kita," *Fotomedia*, August 1997, 12–15).

50 These images were not necessarily more candid than pictorial images. Paying people to pose has long been a common (though not universal) practice among amateurs. Amateurs often bring props with them such as a bright-colored T-shirt to enliven a photograph of a farmer in his field.

51 See MacDougall, *Transcultural Cinema*.

52 See Lutz and Collins, *Reading National Geographic*.

53 The Indonesian Photo Salon retained a black-and-white category, alongside color prints and slides. Most international and national competitions are for color images only.

54 On *gotong royong*, see Bowen, "On the Political Construction of Tradition."

55 On travel "through originary landscapes" that are the "antithesis of the contemporary, urban everyday" as a means of rediscovering authenticity, see Ivy, *Discourses of the Vanishing*, 41.

56 A 1978 HISFA bulletin listing "Hunting Locations and Objects in Yogyakarta and Surrounding Areas," for example, described the village I had visited with Jack and Edy, Kreteg Bantul, thus: "Bamboo bridge, market women from Parangtritis cross towards Yogyakarta." A location called Jurang Jero/Srumbung was described as "misty morning, pine forest, rays of light" and another site, Plaosan, received the comment: "It's a requirement for membership in HISFA to make a portrait of the old women who guard the temple." Parangtritis Beach, an especially popular spot (where Tan Gwat Bing and his companions had gone by bicycle), received this simple description: "No comment."

57 On the refusal of the Dutch to "see" Islam, see Florida, "Writing Traditions in Colonial Java."

58 Presidential Decree No. 6, 2000, revoked Suharto's Presidential Instruction No. 14, 1967, on Chinese Religion, Belief, and Custom.

59 "Gus Dur: Ada Skenario Besar Ingin Jatuhkan Presiden," *Kompas*, February 20, 2000.

60 Ho, *The Graves of Tarim*.

Chapter Two: Landscapes of the Imagination

1 "Tak Bisa ke Cina, Cukup Foto Saja," *Kedaulatan Rakyat*, May 8, 2000.

2 Some Chinese Indonesian customers may have come to the studio to express sentiments of nostalgia and cultural identity; one elderly Chinese Indonesian man, for example, took sixteen photographs in dif-

ferent poses with his grandchildren (Ibid.). But this was clearly a minority. About 90 percent of the customers were women and 70 percent Javanese (by Kusuma's estimate).

3 "Baju Shanghai Jingga Paling Banyak Diminati: Berfoto Ala Pangeran dan Putri Cina," *Nova*, February 6, 2000, 8–9.

4 Ibid.

5 On the *jilbab* in Indonesia, see Brenner, "Reconstructing Self and Society" and "On the Public Intimacy of the New Order." I do not mean to trivialize the wearing of the jilbab, a practice of considerable political, social, and religious significance in Indonesia. Rather, I want to suggest that it can, at least for some of the women who wear it, be a fluid sign—taken on and off at appropriate times—rather than the more rigid or essential sign of identity it is often construed to be in Euro-American imaginings of "the veil."

6 A sumptuary law in 1872 made it illegal for anyone in the Indies "to appear in public attired in any manner other than that of one's ethnic group" (Rush, *Opium to Java*, 14, 91). At the turn of the century, as Chinese youth began to feel "the seductive pull of Westernization, which was then becoming synonymous with modernity and power," they expressed their "self-conscious modernity" by emulating Western dress (Rush, *Opium to Java*, 254, 245; see also van Dijk, "Sarongs, Jubbahs, and Trousers," 58). Sumptuary laws were relaxed following the 1911 revolution in China, allowing Chinese to wear Western dress and cut off their queues (Williams, *Overseas Chinese Nationalism*, 40).

7 On the importance of global media flows in providing people with imaginative resources from which to fashion possible identities, which he identifies as a defining feature of the "new global order," see Appadurai, *Modernity at Large*. Whereas Appadurai regards these global media images as always transcending or providing alternatives to the nation, I argue that being a subject in contact with global circuits was itself part of the promise of participating in the Indonesian nation.

8 In his ethnography of popular photographic practices in India, for example, Christopher Pinney found that people viewed the studio as a space "for individual exploration of that which does not yet exist in the social world" (*Camera Indica*, 178). They preferred "formalized and theatrically staged" rather than "naturalist" images (136). Pinney has argued elsewhere more generally that an aesthetic of the surface rather than an ideology of interior essences suffuses many postcolonial vernacular photographies ("Notes from the Surface of the Image"). See also Pinney and Peterson, *Photography's Other Histories*; Buckley, "Self and Accessory in Gambian Studio Photography."

9 Pinney, "'To Know a Man from His Face,'" 123.

10 Kracauer, for example, argued that when a portrait photograph becomes unmoored from the webs of memory that animate it, the per-

son becomes mere dead matter, indistinguishable from the "alien trappings" of costume, pose, and backdrop ("Photography," 430). Divorced from memory, the image "captures only the residuum that history has discharged" (429). Barthes's search for his mother's "true" portrait in *Camera Lucida* is also a paradigmatic example of this ideal of the portrait that reveals a person's transhistorical essential character, which, as in Kracauer, depends on the memory and sentimental investment of the beholder. Hence his refusal to reproduce the image, which can have no significant meaning for those who do not share his memories of and love for his mother. See also Pinney, *Camera Indica*, 200–201.

11 Pinney, *Camera Indica*, 149. That studio portraits in Java show a delight in play with appearances is perhaps of little surprise given the pervasive interest in artifice that scholars have argued lies at the heart of colonial and postcolonial Javanese cultural preoccupations (see Siegel, *Solo in the New Order*).

12 Barthes famously argued that photography's essence lay in its claim of "that-has-been" (*Camera Lucida*, 77), rooted in the photograph's status as an index, "literally an emanation of a past reality" (80).

13 On studio backdrops, see also Lippard, "Frames of Mind"; Wyman, "Introduction: From the Background to the Foreground."

14 On fashion and the appearance of modern Indonesian subjects in late colonial Indies, see Schulte Nordholt, Introduction to *Outward Appearances*; van Dijk, "Sarongs, Jubbahs, and Trousers"; Taylor, "Costume and Gender in Colonial Java"; Mrázek, "Indonesian Dandy" and *Engineers of Happy Land*; and Siegel, *Fetish, Recognition, Revolution*. For the late colonial "dandy," "a 'native' who borrowed Dutch clothes to place himself in a 'modern' society," the external signs of fashion marked a cosmopolitan, modern subjectivity (Mrázek, *Engineers of Happy Land*, 131–32). Viewed through the lens of colonial authority, the Javanese or Chinese in "Western" dress could only be a "counterfeit" (Mrázek, "Indonesian Dandy," 131). But for the young dandies who wore them, these were merely modern fashions available to anyone (Siegel, *Fetish, Recognition, Revolution*, 9). On ethnic Chinese dandies, see Kwartanada, "Visualization of the Chinese Dandies." On the importance of fashion in the elaboration of "traditional Javanese" culture, see Pemberton, *On the Subject of "Java."*

15 A daughter of the founder of Sinar, a studio that operated in Yogyakarta from 1925 until the mid-1980s, recalled of her childhood, "Every time we had a new background, members of the family would pose as models. Then [the photo] would be enlarged and hung up so that customers could see it as an example."

16 Two-thirds of these studios were connected by family ties to other studios within or outside Yogyakarta. The survey I conducted in 1999 included studios within the circumference of "Ring Road," the major artery encircling Yogyakarta. The actual metropolitan area extended

beyond this limit and included a number of studios not included in the survey. A much larger proportion of large color labs and full-scale studios were Chinese Indonesian owned; many of the *pribumi*-owned businesses were extremely small-scale and had not been open more than a decade.

17 Wachlin acknowledges the growing presence of Japanese and Chinese (as well as other non-Dutch) photographers, suggesting that the reason "these groups in particular became involved with photography was because of the contacts they had developed with the dominant European stratum . . . As 'honorary' Europeans they occupied a specific position in the ethnic and social hierarchy" ("Large Scale Studios and Amateur Photography," 123). My research suggests that by the late 1920s in Java there were more studios under Chinese than European, Japanese, or Armenian ownership, and that contacts with the "European stratum" were relatively insignificant to the spread of ethnic Chinese-owned studios. Their numbers may be significantly underestimated because smaller studios in less central locations may not have been listed in local business records or advertised in local papers.

18 Wachlin, Fluitsma, and Knaap, *Woodbury and Page*; Theuns-de Boer, Asser, and Wachlin, *Isidore van Kinsbergen*; Knaap, *Kassian Cephas*.

19 On the stratification of photo studios by class in an Indian town, see MacDougall, "Photo Hierarchicus."

20 Wachlin, "Large Scale Studios and Amateur Photography," 136.

21 Skinner notes that Cantonese tended to come to Indonesia with more capital and skills than other Chinese immigrants, including knowledge of "western machinery" gained from contacts with Europeans in Hong Kong. He observes, as did many of my informants, that Cantonese were particularly known in Indonesia as "craftspeople" (Skinner, "Golongan Minoritas Tionghoa," 8).

22 I conducted a number of in-depth oral history interviews with studio photographers and their descendents in Yogyakarta and Semarang. Interviews in other cities (Bandung, Solo, Wonosobo, Surabaya, Jakarta) and with many photographers in Yogyakarta also confirmed this typical pattern of immigration and business expansion in Java.

23 Cantonese immigrant photographers fall into the *totok* rather than the *peranakan* category of ethnic Chinese in the Indies (see Suryadinata, *Pribumi Indonesians*). They tended to be born outside Indonesia or to fully Chinese parents, to marry Chinese wives, to speak at least some Chinese at home, to live in homes attached to their storefronts, and to maintain some Chinese customs. However, most second- and third-generation photographers speak Javanese and Indonesian at home and many retain few if any overseas connections.

24 On the Lee Brothers Studio in Singapore (1910–1923) and its expansion throughout Southeast Asia, see Liu, *From the Family Album*. Berticevich notes that "many of the photographers of the Southeast Asia

region were ethnic Chinese" and many purchased their backdrops from Hong Kong in the 1950s and 1960s (*Photo Backdrops*, 17).

25 The history of Sinar Studio, founded by Tjioe Ping Bwe in 1925, follows a similar pattern, as does the history of Chung Hwa Studio (1922) in Semarang (see Strassler, "Refracted Visions" and "Cosmopolitan Visions").

26 See Kwartanada, "Kolaborasi dan Resinifikasi." Kwartanada notes that the Japanese required official identity photographs for Chinese and other "foreign" residents. Military personnel also made use of studio services for personal photographs.

27 There had been at least one pre-independence, Javanese-owned studio in Yogyakarta: Indonesische Fotograaf Trisnoro, founded 1934 (the name was changed to Saman Foto following independence). Several more opened following independence, including Studio Podjok (around 1945–1946), Panorama Studio (in Kota Gedhe, 1952), Yohannes Foto (1962), Foto Sepuluh (1963), and Surya Kaca (1968). Most of these Javanese proprietors had learned photography by working in Dutch or, less frequently, Chinese-owned studios. In the 1950s there were at least fourteen Chinese Indonesian–owned studios and only three native-owned studios in Yogyakarta.

28 Of Sinar Studio founder Tjioe Ping Bwe's twelve children to reach adulthood, ten became photographers; in 1999 there were twelve studios owned by his descendents in Yogyakarta. Tjen Hauw's children founded at least six studios in Yogyakarta and other Javanese cities. Of Y. Untung Sutanto's eight children, four opened studios of their own, three of which were located in Yogyakarta.

29 Bakhtin, *The Dialogic Imagination*, 421.

30 Backdrops that referenced a "local" setting occasionally showed Europeans enjoying the privileges of colonial rule (for example being carried in a rickshaw or waited on by a servant).

31 Taylor, "Costume and Gender in Colonial Java." When nonelite "natives" appeared in portraits with European settings, it was often clearly in the capacity of servant (see Stoler and Strassler, "Casting for the Colonial," and Appadurai, "The Colonial Backdrop").

32 Such backdrops may have gained popularity at a moment when the ties of the ethnic Chinese community in Java to mainland China were especially strong. The rise of Chinese nationalism in the first quarter of the twentieth century stimulated a surge of Chinese nationalism in the Indies as well as a movement toward "resinification" (Williams, *Overseas Chinese Nationalism*).

33 On Sokaraja paintings, see Suwardi, *Seni Lukis Sokaraja*. See Siegel, *Solo in the New Order*, for an analysis of these ubiquitous landscapes. The following section is based on interviews with three Javanese backdrop painters: Gesang (formerly A. Ngarobi), Imam, and To'at, October 12, 1999, Sokaraja, as well as interviews with studio photographers.

34 The initial founder of the local style, Ismail, was apparently a self-taught, highly talented artist who learned primarily by imitating paintings he found reproduced in books. (He received a primary school education in the Dutch *sekolah rakyat*, an elementary school for nonelites, where he may have acquired some basic training in drawing.) Over time, as Ismail's style was adopted by less gifted students and paintings were more hastily produced, the images became cruder and more stylized and brightly colored.

35 No one recalled any obvious differences of taste and style from region to region. The physical distances covered on foot by these painters and extended by distribution agents mark one of the ways that this backdrop style came to be truly "Indonesian."

36 Occasionally *ramai* has a negative connotation, suggesting a volatile or overly excited situation.

37 The idea is said to have come from the owner of Photo Studio King, a sibling of the owner of Chung Hwa in Semarang. He may have been influenced by trends occurring in China, for color backdrops also became common there and in other parts of Asia in the 1950s (see Berticevich, *Photo Backdrops*). The new innovation was not immediately accepted; Gesang recalled a *tukang potret* in Menado who said that color backdrops were fine for theater but no good for photography.

38 See Taylor, "Costume and Gender."

39 His nephew, Imam, also says with pride that he only painted Indonesian landscapes. Despite this nationalist casting, backdrops of beach scenes—local appropriations of global "tropicalization" imagery (Thompson, *An Eye for the Tropics*)—were popular during the same period in other parts of the world (see Buckley, "Self and Accessory").

40 Wachlin, "Large Scale Studios and Amateur Photography," 136, see also 145–48.

41 Samiaji Foto Studio in Wonosobo, founded in 1954, also had two other Sokaraja backdrops: one showing a volcano, a lake, and a tree; the other depicting a lake and a large house. A stamp issued in 1965 showed Sukarno posed in front of another emblematic modern hotel built by the state, the Ambarrukmo Palace Hotel in Yogyakarta (see Vickers, *A History of Modern Indonesia*, 147).

42 Cited ibid., 129.

43 One photographer recalled that as early as the 1950s he offered customers a backdrop of Prambanan Temple alongside the more standard backdrops of the time, which he enumerated as "volcano, garden, waterfall or river, and also inside a house."

44 From "Ice Boxes Sabotage Colonialism," *Variety*, no date, cited in McLuhan and Fiore, *The Medium Is the Massage*, 131. On the popular idea of "luxury" in the 1950s, see Vickers, *A History of Modern Indonesia*, 127.

45 See Caroline Steedman on the "politics of envy" and the often over-looked political significance of desire for material objects (Steedman, *Landscape for a Good Woman*).

46 Vespas and radios were common props in the portraits of the Mali photographers Seydou Keita and Malick Sidibe in the 1950s through the 1970s (Lamuniere, *You Look Beautiful Like That*). On technological icons of modernity in postcolonial portraits, see also Buckley, "Self and Accessory"; Wendl, "Portraits and Scenery in Ghana"; Pinney, *Camera Indica*.

47 Behrend, "Fragmented Visions," 318.

48 See Susan Buck-Morss's discussion in *The Dialectics of Seeing*, 81–82.

49 Pinney, *Camera Indica*, 134. For a similar Indian image from the 1890s, see p. 90.

50 An important Javanese class idiom distinguishes between those who live in brick or concrete versus bamboo structures (Mahasin, cited in Dick, "Further Reflections on the Middle Class," 67–68).

51 See the staircase backdrops in several extraordinary studio portraits of revolutionary fighters from the late 1940s in Frederick, "The Appearance of Revolution." Staircases, along with sailboats and tropical landscapes, also formed part of the iconography of Filipino studio portraits in the first decades of the twentieth century (Rafael, *White Love*, 92).

52 Even today Indonesian soap operas reveal a similar preoccupation with stairways. Key scenes are often located on or before grand stairways in wealthy mansions.

53 See also Rajagopal, *Politics after Television*, 123; Pinney, *Camera Indica*, 185.

54 Itinerant photographers, usually traveling by bicycle through poorer urban neighborhoods and city outskirts, also allowed people who did not yet possess cameras to nevertheless acquire snapshots taken at home. This type of photography has gradually declined since the late 1980s.

55 Morley, "Television," 170.

56 By the late 1960s color film could be purchased in Indonesia and processed in Singapore, but its use remained extremely limited.

57 For a parallel, if more drastic, story of the decline of studio portraiture in the Ivory Coast, see Werner, "Twilight of the Studios."

58 According to the Sokaraja painters in 1999, "abstract" backdrops made up about half of their orders. A backdrop painted by a professional painter at the time cost Rp. 350,000 (about fifty dollars). The 1980s did see a relatively short-lived trend of photographic "special effects" achieved by using masks, filters, double exposure, and other relatively simple manipulations of film exposure. Children appearing "as if" inside glass bottles, doubled portraits in which a profile image was superimposed onto a frontal portrait, and blurred "soft focus" images

heightened the technological artifice of the studio space. In contrast to the Indian studio photography discussed by Pinney in *Camera Indica*, these special effects were a minor and short-lived current of Indonesian studio photography.

59 Pinney aptly titles his chapter on postcolonial Indian studio photography, "Chambers of Dreams" (Pinney, *Camera Indica*, chap. 3).

60 The following section is based primarily on Heri Gunawan's statements at the *Dokumenku* exhibition opening (December 19, 1999), three formal interviews (February 16, 1999; April 6, 1999; February 16, 2000), observations in his studio, and frequent informal meetings and conversations.

61 The ending "ku," a first-person possessive, carries a sense of intimacy and informality. *Dokumenku*, which featured the work of four photographers, was conceived and organized by Rama Surya.

62 Heri misspeaks here, using "autobiography" when he means "biography."

63 Siegel, *Fetish, Recognition, Revolution*, 9.

64 Heri did give his children Chinese names, but they are "not written," that is, not recorded on any official document. "Only for memory, that you are Chinese, you have a Chinese name."

65 The idea of an international "style" or "culture" is often used by Chinese Indonesians to describe their tastes more generally. Chinese Indonesians typically wear "international style" wedding dresses (white gowns), for example, a practice that was common among Javanese *peranakan* as early as 1910 (see Rush, *Opium to Java*, 252).

66 Buck-Morss, *Dialectics of Seeing*, 264.

67 These phrases are from Pinney, *Camera Indica*, 149.

Chapter Three: Identifying Citizens

1 Gamal Komandoko, "Pas Foto," *Minggu Pagi*, February 20, 2000.

2 On tinted car windows and the symbolics of power, see Shiraishi, *Young Heroes*, 108–9; on colored glasses and the ability to see without being seen, as well as on colonial-era visual tropes more generally, see also Mitchell, *Colonizing Egypt*, 26.

3 Based on a survey of 125 studios in Yogyakarta in 1999. For a similar finding in an African context, see Werner, "Photography and Individualization."

4 On the modern state's controlling, simplifying, and quantifying gaze that seeks to transform complex and unruly subjects into the objects of master plans, see Scott, *Seeing Like a State*. On "optic technologies" of modern states, see also Scott, Tehranian, and Mathias, "The Production of Legal Identities." On identity documentation as a state practice, see Caplan and Torpey, *Documenting Individual Identity*.

5 Tagg, *Burden of Representation*, 63–64; Foucault, *Discipline and Punish*.

6 Anderson, *Imagined Communities*, 169. On serializing logics, see Anderson, *Spectre of Comparisons*. On the Indonesian identity card, seriality, and colonial surveillance as evoked in Pramoedya Ananta Toer's *House of Glass*, see Anderson, *Imagined Communities*, 185 n. 37. On censuses and photography as "part of the same enumerative and classificatory optic of colonial knowledge," see Rafael, *White Love*, 38.

7 Pinney, *Camera Indica*, 17. Bertillon's system of anthropometric photography for the identification of criminals, applied first in France and later transported to the colonies, was itself built in part on techniques developed in colonial anthropology (see Werner, "Photography and Individualization," 260, 267 n. 4). By the end of the nineteenth century, identification photography was firmly in place in both anthropological and criminological branches of the British colonial state apparatus (Pinney, *Camera Indica*, 45). On anthropometric techniques in colonial anthropological institutions, see Spencer, "Some Notes on the Attempt to Apply Photography to Anthropometry."

8 Barker, "The Tattoo and the Fingerprint," 136–38.

9 Mrázek, *Engineers of Happy Land*, 101–3. See also Barker, "The Tattoo and the Fingerprint," chap. 3. On the history of fingerprinting, see Pinney, *Camera Indica*, 20–21, 70; Tagg, *Burden of Representation*, 75.

10 Mrázek, *Engineers of Happy Land*. On colonial visuality, see also Mitchell, *Colonizing Egypt*.

11 Barker, "The Tattoo and the Fingerprint," 166.

12 Ibid., 161–62.

13 China considered "overseas Chinese" to be Chinese citizens. In the late nineteenth century the Chinese government cultivated greater contact with its subjects living abroad, supporting commercial societies and schools and seeking remittances. This policy, along with a rise in nationalist sentiment among overseas Chinese, caused considerable concern among Dutch authorities (Vandenbosh, *The Dutch East Indies*, 355).

14 Travel passes were valid for one year and were issued and revoked at the discretion of local officials. All but those of "good name" needed a "visa" affixed to the pass for each individual trip (see Williams, *Overseas Chinese Nationalism*, 27–30; Rush, *Opium to Java*, 106–7). An earlier system of passes and residence zoning had been in place since the mid-1830s (Rush, *Opium to Java*, 87).

15 The distinction between other "Foreign Orientals" (mostly Arabs and Indians) and the native population was less marked. By 1944, the Japanese had declared the Arab community to be Indonesian (Kwartanada, "Kolaborasi dan Resinifikasi," 130–32). This tendency to efface their non-*asli* origins (largely because of their Muslim faith) continued into the postcolonial period.

16 In Indonesia, anyone considered close to the Dutch—Chinese, Europeans and Eurasians, Ambonese, and Menadonese—was required to have an identity card with a photograph (Kwartanada, "Kolaborasi dan Resinifikasi"). Similar policies were employed in occupied Singapore (Lee, *Syonan*).

17 Coppel, *Indonesian Chinese in Crisis*, 2–3.

18 "Undang-Undang 1946 Nomor 3, Warga Negara Penduduk Negara," in Pustaka Tinta Mas, *Undang-Undang Kewarganegaraan Republik Indonesia*, 68. This included anyone of Chinese descent, even those who had lived in the Indies and intermarried with "natives" for centuries. A woman's citizenship followed her husband's.

19 "Memori Penjelasan Mengenai Undang-Undang Tentang Kewarganegaraan Republik Indonesia, Tambahan Lembaran Negara Nomor 1647, 1958," in Pustaka Tinta Mas, *Undang-Undang Kewarganegaraan*, 33. The 1945 constitution distinguished between *asli* (original/indigenous) Indonesians and those of "foreign" origins whose citizenship was based on "acquired legal status" (cited in Lindsey, "Reconstituting the Ethnic Chinese," 50). China's treatment of all overseas Chinese as citizens further confused the status of Chinese Indonesians. A treaty in 1955 between China and Indonesia required all ethnic Chinese, regardless of birthplace, to formally repudiate Chinese citizenship and apply for legal status as Indonesian citizens. (For a succinct discussion of the history of Chinese citizenship in Indonesia, see Aguilar, "Citizenship, Inheritance, and the Indigenizing.") In 1959, Presidential Decision No. 10 forbade foreign Chinese in Indonesia from engaging in trade in rural areas (Suryadinata, *Dilema Minoritas Tionghoa*, 31; Dahm, *History of Indonesia*, 198–99).

20 See, for example, "Banjak WNI Keturunan Asing: Belum Sadar Akan Kewadjibannja," *Kedaulatan Rakyat*, May 6, 1966; "Sumpah Setia WNI Tjilatjap: Siap Bela Keselamatan dan Kedjajaan Bangsa/Negara," *Kedaulatan Rakyat*, June 11, 1966; "3,500 WNI Dapat Indoktrinasi," *Kedaulatan Rakyat*, September 5, 1966. See also Coppel, *Indonesian Chinese in Crisis*.

21 See, for example, the Resolution No. III/Res/MPRS/1966 about the Cultivation of National Unity. Badan Koordinasi Masalah Cina-Bakin, *Pedoman Penyelesaian Masalah Cina*, 334–37; see also 54.

22 The Instruksi Dalam Negeri Nomor 10 Tahun 1977 tentang Petunjuk Pelaksanaan Pendaftaran Penduduk states that the number and date of the Proof of Citizenship Letter should be inscribed on the identity card (KTP) and the Family Card (*Kartu Keluarga*) of citizens of Chinese descent (Bina Dharma Pemuda Indonesia, *Peraturan Perundang-undangan Kewarganegaraan*, 121). A 1983 Keputusan Gubernur Kepala Daerah Khusus Ibukota Jakarta No. 75, Tahun 1983 states that for those of "Foreign Descent" the numeral O should be placed before the KTP number (ibid., 244).

23 Ong and Nonini, *Ungrounded Empires*, 20.

24 A photojournalist for the Yogyakarta newspaper *Kedaulatan Rakyat*, Moelyono was hired to develop and print the identity photographs of the population of this area, known as a stronghold of communism. In chapter five, I discuss Moelyono's experiences photographing the campaign to "crush" communists in this region.

25 A Ministry of the Interior regulation from 1978 states that those "involved" in G30S/PKI should have a code marked on their KTP. "Petunjuk-petunjuk lebih lanjut di bidang Pelaksanaan Pendaftaran Penduduk" issued to the governors of the regions of level one throughout Indonesia (in Bina Dharma Pemuda Indonesia, *Peraturan Perundang-undangan Kewarganegaraan*, 126). A ruling in 1983 by the governor of Jakarta also states that the letters "ET" should be added to the KTP of former political prisoners. See "Keputusan Gubernur Kepala Daerah Khusus Ibukota Jakarta No. 75, Tahun 1983" (ibid., 244). A newspaper article refers to an "Instruction of the Minister of the Interior No. 32/1981" in 1981 as the legal basis for the special codes for ex-political prisoners. "Orang Terhalang Pulang Mulai Ragu Pulang," *Kompas*, February 21, 2000.

26 Not only individuals allegedly involved in the Communist Party but their children and even grandchildren were barred from a variety of professions (including civil service, puppeteer, journalist, priest, neighborhood official [RT or RW]) through these discriminatory procedures.

27 On state concerns about imposters during the late colonial period, see Barker, "The Tattoo and the Fingerprint," 128–29, 154, 167.

28 "Aidit Pernah Menjamar sbg. 'Santri,'" *Kedaulatan Rakyat*, November 19, 1965.

29 "Algodjo Simun ditangkap Hansip PN Postel," *Kedaulatan Rakyat*, November 1, 1965; "Lari ke Djateng dari Djakarta, tetapi Tertangkap di Tjirebon" *Kedaulatan Rakyat*, November 12, 1965.

30 This ability to discern suspicious movements is today claimed by both *ronda* (neighborhood security groups) and police in their efforts to apprehend common criminals (Barker, "The Tattoo and the Fingerprint," 31).

31 "Tertangkapnya Untung Waktu Mejamar sebagai 'Tukang Buah,'" *Kedaulatan Rakyat*, October 16, 1965.

32 "Sungguh-Sungguh Terjadi," *Kedaulatan Rakyat*, November 2, 1965.

33 Sulami, *Perempuan, Kebenaran dan Penjara*, 9. She also tells of an illiterate prostitute arrested because she had no KTP who was tortured into confessing that she was a member of Gerwani and had participated in the alleged sexual torture of the generals killed in the attempted coup on September 30 (44–55). On the vilification of Gerwani, see Wieringa, *Sexual Politics in Indonesia*, 2002.

34 On the concept of *liar* in a different Indonesian context, see Lindquist, *The Anxieties of Mobility*.

35 Sulami, *Perempuan, Kebenaran dan Penjara*, 26–28.

36 "Tommy a Suspect in Judge's Murder," *Jakarta Post*, August 7, 2001.

37 It is difficult to define precisely when identity cards became a requirement for *all* citizens because many of these initiatives were undertaken initially through military command. The Registration of Residents law of 1977 states that "a. the registration of inhabitants of Indonesia has not yet been carried out well; b. in the interest of cultivating calm and national order the registration of citizens must be undertaken in an orderly manner." It calls for standardization of the family card and the identity card. "Keputusan Presiden Republik Indonesia Nomor 52 Tahun 1977 Tentang Pendaftaran Penduduk," in Biro Bina Pemerintahan Umum Setwilda Propinsi DIY, *Himpunan Peraturan Perundang-Undangan Tentang Administrasi Kependudukan*, 1–3. A regulation from 1979 about the issuance of the KTP in Jakarta refers to two 1968 regulations, one requiring the registering of all citizens in Jakarta, and another requiring that all Jakarta area residents carry KTP. See "Peraturan Daerah Daerah Khusus Ibukota Jakarta, Nomor 1 Tahun 1979 tentang Penyelenggaraan Pendaftaran Penduduk dan Kartu Tanda Penduduk dalam Wilayah Daerah Khusus Ibukota Jakarta," in Bina Dharma Pemuda Indonesia, *Peraturan Perundang-undangan Kewarganegaraan*, 145, 157.

38 The cited law is "Peraturan Pemerintah Nomor 32, Tahun 1954" (see "Keputusan Presiden Republik Indonesia Nomor 52 Tahun 1977 Tentang Pendaftaran Penduduk," in Biro Bina Pemerintahan Umum Setwilda Propinsi DIY, *Himpunan Peraturan Perundang-Undangan*, 1). A decree issued regarding implementation of the 1977 KTP law ("Pelaksanaan Keputusan Presiden Nomor 54/1977 Tentang Pendaftaran Penduduk") indicates that those of Chinese descent should have their Proof of Citizenship Letter (*Surat Bukti Kewarganegaraan*) number inscribed on their KTP in order to make it harder to "falsify" citizenship (Biro Bina Pemerintahan Umum Setwilda Propinsi DIY, *Himpunan Peraturan Perundang-Undangan* 4–10).

39 Regulations and laws concerning the registration of citizens and the KTP frequently raise the problem of falsification. See, for example, Bina Dharma Pemuda Indonesia, *Peraturan Perundang-undangan Kewarganegaraan*, 136, 167.

40 Muchtar, Rachman, and Sunoto, *Ilmu Pengetahuan Sosial*, 135–38; 35.

41 See also Shiraishi, *Young Heroes*, 119.

42 See Dewo 1994; 1993. This case was incorporated into Garin Nugroho's film about street children in Yogyakarta, *Leaf on a Pillow* (*Daun di atas Bantal*, 1998).

43 Siegel argues that in the New Order, the term *rakyat* (people) with its populist and politicized connotations of the people, was replaced by the idea of the unpoliticized, floating *massa* (masses) in need of guidance from above and vulnerable to incitement to mob violence (see Siegel's *A New Criminal Type*, "Early Thoughts," and *Naming the*

Witch). Nancy Florida notes the reemergence, during the reformasi period, of a pre–New Order progressive discourse that conjoined these two figures as the *massa-rakyat* (Florida, "A Proliferation of Pigs").

44 The trope of the "unknown corpse"—a fate awaiting those who die ignoble and dishonored deaths—has a long history in Javanese literature and art.

45 "Putra Bantul Korban GAM, Dimakamkan," *Kedaulatan Rakyat*, April 8, 2000.

46 Siegel discusses how members of the Aceh Freedom Movement (GAM) construct an alternative to Indonesian identity by creating laminated Acehnese identity cards complete with signature and *pasfoto*. This mimicry, Siegel argues, relies on the "supplement" of an apparently external, bureaucratic authority (embodied in plastic, fingerprints, identity photos, and other fetishized signs of state power) (*Rope of God*, 345–50). The term "liar" was used for guerillas in East Timor as well (Tanter, "The Totalitarian Ambition").

47 "Mobil Isuzu Panther yang hancur diterjang KA Argolawu," *Kedaulatan Rakyat*, March 6, 2000.

48 "Heboh, Mayat Bertato dalam Karung," *Jateng Pos*, August 15, 1999. On the photographic representation of "mayat bertato" in local newspapers, see Bourchier, "Crime, Law and State Authority in Indonesia," 186, 196. On pre- and post-Petrus images of corpses in bags, see Barker, "The Tattoo and the Fingerprint," 281. On Petrus, see also Barker, "State of Fear"; Siegel, *A New Criminal Type in Jakarta*; Pemberton, *On the Subject of "Java,"* 311–16.

49 During the *Petrus* operations, all petty criminals targeted by the police were required to register with the authorities and carry a special card or risk being killed (Barker, "The Tattoo and the Fingerprint," 255–56). "What was at stake for the state . . . was nothing less than its power of recognition" (259).

50 The *gali-gali* were not usually children, of course. Bourchier notes, "The origin of this term is obscure" ("Crime, Law and State Authority," 171).

51 "Mayat Tanpa Identitas di Sungai Progo," *Bernas*, March 31, 2000. See also "Kasus Wanita Hamil Tewas di Hotel: Pembunuhan Diduga Direncanakan Rapi," *Kedaulatan Rakyat*, March 23, 2000.

52 Ratna Indra Dewi, "Foto SIM Pakai Jilbab!" *Kedaulatan Rakyat*, August 30, 1999. In studios in Yogyakarta, the photographer's wife or female relatives are often on hand to take *pasfoto* for women who refuse to remove their headscarves in the presence of men.

53 Hoskins, *The Play of Time*, 274.

54 Bina Dharma Pemuda Indonesia, *Peraturan Perundang-undangan Kewarganegaraan*, 129–31.

55 On religious identification, development, and communist phobia, see also Tsing, *In the Realm of the Diamond Queen*, 273; Steedly, *Hang-*

ing without a Rope, 61–68; Keane, *Signs of Recognition*, 45 (in Sumba, *marapu* [ancestral ritualist] was still allowable on identity cards as late as the 1980s); Spyer, *The Memory of Trade*, 39–40.

56 For another example of irreverent resistance to the pinning down of religious identity via the identity card, see Steedly, *Hanging without a Rope*, 207–8.

57 For another example of vigilante-style appropriations of the state's authority to determine identity via the KTP during the "ninja" killings of 1998, see Thufail, "Ninjas in the Narrative of the Local and National Violence," 163–64.

58 Sekula, *The Body and the Archive*, 347, 345.

59 Pinney, *Camera Indica*, 113.

60 Bakhtin, *Dialogic Imagination*, 294.

61 Buckley, "Self and Accessory," 88.

62 Color identity photographs are now permitted for many official uses, but for the identity card (KTP), black and white is still required.

63 Benjamin, "A Short History of Photography," 202.

64 Wue, Waley-Cohen, and Lai, *Picturing Hong Kong*, 38–39. See also a remarkable text from 1872 by John Thomson, the Scottish photographer and traveler, satirizing the aesthetic conventions of Chinese portraiture through a fictive dialogue with a Chinese photographer (quoted ibid., 134–35).

65 In his rendering of a late 1950s Javanese funeral, Geertz makes no mention of a photograph carried in the procession, but in describing the ritual of putting food out by the bed in which the person died forty days after death, he notes that "one I saw included an ancient photograph of the deceased" (*Religion of Java*, 70–72).

66 Another photographic memorial practice associated with the ethnic Chinese also appears to be spreading to other communities. Chinese Indonesians typically include an identity photograph of the deceased in death announcements printed in the newspaper. While prior to the mid-1990s the use of photographs was limited exclusively to Chinese Indonesians, during my fieldwork I noted the inclusion of *pasfoto* in several death announcements of Christian Javanese and on rare occasions in announcements for Muslim Indonesians.

67 Such composite portraits are common; on similar portraits in Gambia, see Buckley, "Self and Accessory."

68 On the driver's license and professional distinction for chauffeurs in colonial Indies, see Mrázek, *Engineers of Happy Land*, 243 n. 205.

69 Marrying second wives is not particularly sanctioned for Javanese Muslim men, especially if they fail to support both properly.

70 A similar stamp has also appeared in Canada, Australia, Britain, Singapore, and Switzerland. "Topple the Queen! Enthrone Yourself on a Stamp," *New York Times*, June 27, 2000.

71 "Perangko Prisma Tersedia di Yogya," *Bernas*, April 4, 2000.

72 "Mulai Dipasarkan di Yogya: Prangko Dengan Identitas Diri," *Kedaulatan Rakyat*, April 11, 2000.

73 "Perangko Prisma Tersedia di Yogya," *Bernas*, April 4, 2000.

74 See Strassler, "The Face of Money."

75 "Prangko Seri Kartun 2000 Diluncurkan," *Kedaulatan Rakyat*, March 14, 2000. Also, "Perangko Prisma, Inovasi Terbaru," *Kedaulatan Rakyat*, January 31, 2000. On Indonesian postage stamps, see Leclerc, "The Political Iconology of the Indonesian Postage Stamp."

76 Tagg, *Burden of Representation*, 65.

77 See, for example, Sontag, *On Photography*, 156, 22; Anderson, *Imagined Communities*, 204–5.

Chapter Four: Family Documentation

1 *Foto Indonesia* Tahun X, no. 5, 1978 (July/August). Sakura later became Konica.

2 "Pesta Bisa Sederhana, Foto Harus Istimewa," *Kedaulatan Rakyat*, January 17, 1999.

3 She comments that people now have "awareness" (*kesadaran*) about the value of professional photography services. "Before, it was normal, you know, to ask help from a friend to photograph a wedding party. The reason was it was practical and could keep down the budget. But unfortunately there was a lot of disappointment, because the results of the photos weren't good. It wasn't even out of the question that they would fail totally."

4 *Panggilan* photographers may work freelance or be employed by studios. Although there were *panggilan* photographers in the 1950s and 1960s, it was not a widespread phenomenon. A precursor may be found in the itinerant photographer (*tukang foto keliling*), who usually made rounds of neighborhoods on a fairly regular basis but could also be commissioned to photograph particular events. While it is typical for families to lavish expense on the professional documentation of weddings, other events like birthday parties, lesser rituals, and funerals are more likely to be photographed by a family member or a neighbor with a camera. Both lay and professional photographers follow the dictates of *dokumentasi* described in this chapter.

5 Bourdieu, *Photography*, 19.

6 King, "Photoconsumerism and Mnemonic Labor," 9.

7 As Bourdieu poses the question, "How and why is the practice of photography predisposed to a diffusion so wide that there are few households, at least in towns, which do not possess a camera? Is it enough to refer to the accessibility of the instruments used in this practice, and the use of these instruments? . . . The absence of economic and technical obstacles is an adequate explanation only if one hypothetically

assumes that photographic consumption fills a need . . . But does this not amount to doing away with the sociological problem by providing as an explanation what sociology should be explaining?" (*Photography*, 13–14). For a study of the "home mode of pictorial communication" in the United States, see Chalfen, *Snapshot Versions of Life*.

8 In my survey of 125 Yogyakarta studios and photofinishers, many reported that their business was down as much as 75 percent since the crisis began in late 1997. A number had closed or were on the brink of closure. Wedding photographers reported that people were cutting back by asking them to take fewer rolls of film. Yet even the poorest people in the *kampung* in which I lived managed to photograph their weddings.

9 See M. Hirsch, *Family Frames* and *The Familial Gaze*.

10 On photography as the point of convergence between (traditional) ritual and (modern) mechanical repetition, see Pemberton, "The Specter of Coincidence."

11 On ritual, see, for example, Turner, *The Forest of Symbols*; Tambiah, *The Magical Power of Words*; Rappaport, "The Obvious Aspects of Ritual."

12 Bourdieu, *Photography*, 19.

13 Lydia Kurniawati and Herdamon, "Foto Dokumentasi," *Fotomedia* 8, no. 9 (February 2000): 6–11. The magazine *Fotomedia* was founded in 1993 and ceased publication at the end of 2003. It addressed a middle-class audience of serious amateurs, students, and aspiring young professionals. The magazine frequently underlined its own informed, elite readership's "distinction" from everyday lay practitioners of photography. On the importance of distinctions of taste to class positioning, see Bourdieu, *Distinction*.

14 Pemberton, *On the Subject of "Java,"* 229.

15 Barthes, *Camera Lucida*, 40–41.

16 Keane, *Signs of Recognition*, 95.

17 Siegel, *Solo in the New Order*, 70.

18 Ibid., 70–71.

19 Ibid., 68.

20 In this sense the *dokumentasi* series is like film, whose governing principle, according to Kittler, is the slicing of reality into fragments that are then spliced together so as to create a semblance of a seamless whole, "a second and imaginary continuity evolved from discontinuity" (*Gramophone, Film, Typewriter*, 122).

21 Brenner, *The Domestication of Desire*, 207.

22 Ibid., 209.

23 Pemberton, *On the Subject of "Java,"* 228.

24 Ibid., 197.

25 Ibid., 203, 128.

26 Geertz, *Religion of Java*, 57. At "santri" (modernist Muslim) weddings,

the bride wore a long white gown or a *kain* and *kebaya* with a *kerudung* (head shawl), while the groom wore Western clothes and the *peci*.

27 Pemberton, *On the Subject of "Java*," 202.

28 Ibid., 222–23.

29 Ibid., 198.

30 Ibid., 197.

31 On the use of printed schedules (*pranatan*) and clock time in courtly ceremonies of the colonial period, see ibid., 64; see also 179.

32 On the *protokol*'s "play by play narrative commentary," see ibid., 198, 223, 235. Even at small family gatherings people often rely on technological instruments like cameras, microphones, and tape-recorded music to structure ritual proceedings.

33 Ibid., 219.

34 According to Nancy Florida, a similar image of President Suharto bowing before his mother-in-law also circulated at one time (personal communication, June 19, 2008).

35 Like *lengkap*, *rinci* is another key word in the *dokumentasi* lexicon. The adjectival form, translated here as "detailed," also carries connotations of specified, planned, broken down into parts, elaborated. In verb form, it means to plan and schedule, especially for an official event. It also means to break something down into different sections, as well as to specify or elaborate.

36 On the figure of the *perias manten* as the guarantor of "traditional" authenticity, see Pemberton, *On the Subject of "Java."*

37 See Keane, *Signs of Recognition.*

38 Pemberton, *On the Subject of "Java*," 204.

39 Ben-Ari, "Posing, Posturing and Photographic Presences."

40 Ibid., 92.

41 "Foto Pengantin," *Fotomedia* 3, no. 2 (April 1996): 8–14, 12.

42 Most funeral albums only record the funeral ceremonies.

43 Siegel, *Solo in the New Order*, 79.

44 Ibid., 4. In Siegel's rendering, however, *ngoko* is not simply the site of the authentic and the intimate; the use of *ngoko* also entails a deferral or translation in that the speaker is not using *kromo*.

45 Although relatives will sometimes bring a snapshot camera to a funeral, usually someone outside the immediate family circle, a neighbor or a hired professional, performs the *dokumentasi*. A friend was deeply disturbed when at her mother's funeral her brother took photographs, as she put it, "like a tourist." On death photography in the United States, see Ruby, *Secure the Shadow.*

46 One young woman I knew was forbidden by her parents to attend the funeral of her boyfriend who had died in a car accident because she was unable to contain her crying. Her family attributed her distress to "shock" at the suddenness of the death.

47 Geertz, *Religion of Java*, 72–73. On the *selamatan*, a "communal feast"

that "symbolizes the mystic and social unity of those participating in it," as Java's "core ritual," see p. 11.

48 Geertz, "Ritual and Social Change, a Javanese Example."

49 Siegel, *Solo in the New Order*, 260.

50 Ibid., 276.

51 Geertz, *Religion of Java*, 74; Siegel, *Solo in the New Order*, 265.

52 Siegel, *Solo in the New Order*, 266.

53 Geertz, *Religion of Java*.

54 The mask was also a colonial trope. For a critique of Geertz's uncritical reliance on elite Javanese sources and Dutch colonial scholarship concerned with locating the "true" Javanese behind an inscrutable social surface, see Sears, *Shadows of Empire*; on colonial genealogies of the mask in relation to the "veneer" of Islam masking an authentic Javanese core, see Florida, "Writing Traditions in Colonial Java," 188.

55 Anderson, "The Languages of Indonesian Politics," 131–32.

56 Ibid., 130.

57 Siegel's approach to high Javanese should be seen in contrast to the Dutch colonial branding of *kromo* as an artificial and degenerate form, a superficial affectation masking the essential "healthy" core of *ngoko* (Siegel, *Solo in the New Order*, 3). Anderson treats high Javanese as a product of the rarefied atmosphere of the Javanese courts under colonial conditions, an affectation that buttressed hierarchy and masked the loss of real power (Anderson, "*Sembah-Sumpah*," 205; "The Languages of Indonesian Politics," 131; Siegel, *Solo in the New Order*, 22).

58 Florida, *Writing the Past, Inscribing the Future*, 275.

59 Barthes, *Camera Lucida*, 50.

60 Simanjuntak, *Berkenalan dengan Antropologi*, 120.

61 *Muhammadiyah* is the largest modernist Islamic organization in Indonesia.

62 The children's behavior echoes the *rebutan* that forms part of some Javanese rituals. *Rebutan* involve a form of dissemination that contrasts with the formal procedural nature of Javanese rituals so enshrined in the New Order (see Pemberton, *On the Subject of "Java*," 208–9).

63 On the discursive appearance, around the turn of the century, of a generic "Javanese" person as "an identity projected through life-cycle rituals," see ibid., 216.

64 On photograph albums and "the historicity that springs from [the] intersection of the cyclical and the unique," see Pinney, *Camera Indica*, 153.

65 Geertz, *Religion of Java*, 39.

66 Sponsored by the magazine *Ibu and Anak*, March 2–8, 2000.

67 Their music is also heard on the radio and available on cassette and CD. They endorse products in advertisements, get profiled in magazines, and appear at special promotional events (where fans can sometimes have a souvenir photograph taken with them). Several of the

most popular *artis cilik* during the time of my research were Chinese Indonesian.

68 Nugroho, Sigit Wahyu, Aan Kurniawati, and Renny Yaniar, *Album Artis Cilik*.

69 Hasantoso, *Namaku Joshua*.

70 Bourdieu, *Photography*, 19.

71 I have preserved the peculiarity of language in this rather awkward translation to stress the sense of an imperative: one is "not allowed" (*tidak boleh*) to forget. "Kencana Photo Studio: Mengabadikan Kenangan Indah dalam Karya Foto Terbaik," *Bernas*, December 6, 1999.

72 Sutherland, *The Making of a Bureaucratic Elite*, 5; Anderson, "Sembah-Sumpah," 223.

73 Although in dictionary definitions, *kenangan* means memory and *kenang-kenangan* means souvenir, there is considerable slippage between these two words in everyday usage.

74 Anderson, "A Time of Darkness and a Time of Light," 245–49 n. 33.

75 Perhaps the most exemplary of memory objects passed down within Javanese families are *pusaka*, powerful heirlooms that not only serve as reminders of genealogical relation but, if properly cared for, contain and transmit the power of ancestors (see Florida, *Writing the Past*, 255–56). While *dokumentasi* and photograph albums establish temporal distance between past and present, *pusaka* and other such memory objects work to collapse time. To possess a *pusaka* is ideally to lay hold of the very power possessed by one's own ancestors.

76 On the belief that a mother's clothing will keep her child safe, see Geertz, *Religion of Java*, 44.

77 On "regimes of value," see Myers, *The Empire of Things*.

Chapter Five: Witnessing History

1 Goenawan Mohamad, "Nasionalisme," *Tempo*, October 10, 1999, 94.

2 Soeharto, *Saksi Sejarah*, n. p.

3 Ibid.

4 "IPPHOS, Saksi Sejarah Yang Nyaris Tersisih," *Fotomedia*, April 1996. The Indonesian Press Photo Service (IPPHOS) was founded in 1946. On the history of IPPHOS, see Soeryoatmodjo, "The Challenge of Space" and "Awal Fotografi Modern Indonesia"; Supartomo and Lee, "Nationalist Eye."

5 An internal report at Yogyakarta's Benteng Vredeberg Museum, for example, equates photographs with artifacts, noting that these allow students to encounter history "in a direct way." Without such forms of "authentic historical evidence, the value of a history will be diminished in terms of its credibility." The exhibition consisted of sixty-three photographs and thirty-seven historical objects. *Laporan Pameran:*

Dokumentasi Lintasan Sejarah Pergerakan Nasional sampai dengan Orde Baru, October 14–18, 1996.

6 For different takes on the self-authenticating status of photographs, see Barthes, *Camera Lucida*, 87; Kittler, *Gramophone, Film, Typewriter*, 11–12; Tagg, *The Burden of Representation*.

7 McGuire, *Visions of Modernity*, 133.

8 Barthes, *Camera Lucida*, 93.

9 In 1999, the national newspaper *Kompas* included a photography rubric within a special weekly supplement for youth. Articles offered basic information about how to use cameras, how to choose lenses and film, how to maximize snapshot cameras, and how to take journalistic photographs. For example, "Memotret itu Sungguh Mudah," *Info Aktual Muda, Kompas*, June 5, 1999, and "Mendayagunakan Kamera Saku," *Info Aktual Muda, Kompas*, July 17, 1999.

10 Yogyakarta's largest university, Gadjah Mada University, has had a Unit Fotografi since 1991. In 1999, the club listed over 300 students as members.

11 Modeled on amateur clubs, campus clubs emphasized mastery of technical knowledge and collective activities such as hunting excursions and group exhibitions. In informal surveys I conducted in 2000, students reported a preference for "human interest" and "art" photography, photographic genres that also reflect the influence of amateur clubs. Student clubs, like amateur clubs, tend to be male dominated. While one campus club reported a 50–50 ratio, most reported an 80–20 percent male to female ratio. Also according to these surveys, only 30–40 percent of students in photography clubs actually own cameras.

12 Kuhn, *Family Secrets*, 68.

13 In the etiquette of personal photography in Java, the photograph is the rightful property of the photographed as much as, or more than, the photographer. People will even ask for the negatives (perhaps because photo studios provide customers with negatives as well as positives).

14 There is a close relationship between campus photography clubs and the outdoor hiking clubs described by Tsing in *Friction*.

15 On the documentary impulse, the presumed "natural" relationship between seeing and compassion, and modern subjectivity, see Chakrabarty, "Witness to Suffering."

16 In his classic discussion of photographic indexicality Barthes described the photograph as a "laminated" object in that the referent "adheres" to the image (*Camera Lucida*, 5–6).

17 Aspinall, "Students and the Military," 33, 40. On students in the reformasi movement, see Siegel, "Early Thoughts on the Violence." On the *pemuda* of the revolution, see Anderson, *Java in a Time of Revolution*. Frederick notes the association of *pemuda* with schooling, modernist nationalism, and the expectation of future leadership, as well as their self-mythologizing, in part through photography (Frederick, "The Appearance of Revolution"; see also his *Visions and Heat*).

18 Interview with a former photojournalist, March 21, 2000, Yogyakarta. This is not, however, to diminish the bravery and political commitment of many Indonesian journalists and photojournalists.

19 *D&R*, December 19, 1998, 26.

20 At least one photo studio in Yogyakarta gave students discounts on developing, and others sold students just-expired film at a significant discount. Photojournalists faced similar constraints of poor equipment and pay. Photographers working for Yogyakarta's newspapers, for example, had to buy their own film and received payment only for photographs actually printed in the paper.

21 On May 1, 1998, for example, a photojournalist with the news agency Antara was beaten by plainclothes "preman" (hired thugs), his press badge ripped up, his film taken, and his camera destroyed. "Kartu PWI Dirobek-robek: Wartawan 'Antara' Dipukuli Aparat," *Kedaulatan Rakyat*, May 1, 1998.

22 A group of student photographers formed an independent freelance photojournalist association to pool resources and gain better access to publication. They also hoped that carrying an association identity card might lessen police abuse should they be apprehended. In May 1998, the Yogyakarta branch of the Indonesian Journalists Association (PWI) issued new press badges for their members to more effectively distinguish them. "Bagi Wartawan Peliput Unjukrasa: PWI Yogya Keluarkan Pengenal Khusus," *Kedaulatan Rakyat*, May 16, 1998.

23 "Mahasiswa Tewas Bertambah Seorang," *Republika*, October 4, 1999; see also "Persma Berkabung Korban Lampung," *Jateng Pos*, October 5, 1999.

24 Octo Lampito, April 27, 1999, Seminar on Journalistic Photography, Indonesian Islamic University, Yogyakarta.

25 An intelligence agent who was captured and interrogated by students reportedly had in his wallet the name of the student who had made the Suharto effigy, as well as the names of students who had burned Suharto's photograph ("Menguak Jaringan Inteligen di Kampus Biru," *Balairung* XV [1999], 57). Two students who were mysteriously shot at on separate occasions in the spring of 1998 were believed to have been targeted because of their involvement in burning Suharto's image (63–64).

26 "Dipamerkan, Foto yang Pernah Dilarang," *Kedaulatan Rakyat*, April 10, 1999.

27 For example, *Kedaulatan Rakyat* published the *Book of Reform Documents*. A review calls it "a factual portrait of the historical journey of reform . . . a source of authentic data [*data otentik*] for today's generation and the future." "Memotret Fakta Sejarah Bangsa," *Kedaulatan Rakyat*, December 20, 1998. A Solo newspaper published *The May 1998 Incident in Solo: The Lens's Recording*. Newspapers even sponsored reformasi photo contests. "Lomba Foto Reformasi di DPD AMPI," *Bernas*, April 21, 1999.

28 Morris, "Surviving Pleasure at the Periphery," 350.

29 "Foto Gerakan Reformasi Dipamerkan di Denpasar," *Bernas*, March 29, 1999.

30 See "Pameran Foto 'Kesaksianku' Eko Boediantoro: Media Refleksi Mengakhiri Kekerasan," *Kedualatan Rakyat*, February 5, 1999; "Pameran Foto 'Kesaksianku' Eko Boediantoro, Meski Pahit Realitas Perlu Ditampilkan," *Kedaulatan Rakyat*, February 11, 1999; "Fotografi Jurnalistik Diuntungkan Situasi," *Kedaulatan Rakyat*, February 14, 1999.

31 One finds this dichotomy, for example, in Metz's influential *The Imaginary Signifier*.

32 This is a sampling of hundreds of similar comments from both exhibitions. Although difficult to convey in translation, I have attempted to preserve the informal, "spoken" quality of the comments. Only very rarely did writers question photographic truths, as in this comment: "Photos indeed don't play tricks, but who knows the intention of the photographer? Photos are only dead images that don't clarify the reality that takes place."

33 Berger's essay appears in the collection *About Looking*; see Sontag, *On Photography*.

34 Berger, *About Looking*, 60.

35 Ibid., 65.

36 An American anthropologist visiting Yogyakarta in 1967 recalls attending a photo exhibition of violent images (Margot Lyon, personal communication, April 11, 2000, Yogyakarta). News reports frequently mention the "Commando Team for Mental Operations," whose "information" sessions targeted those considered "at risk" for sympathy with communists. See, for example, "Djapen Klaten Mulai Bergerak: Memberi Penerangan Didaerah Konsolidasi," *Kedaulatan Rakyat*, November 5, 1965; "Team Penerangan Pantja Tunggal di Kemantren-Kemantren," *Kedaulatan Rakyat*, December 11, 1965; "Pendjelasan tentang Perang Urat Saraf," *Kedaulatan Rakyat*, December 14, 1965. For a detailed discussion of anticommunist media and propaganda campaigns in Bali and nationwide, see Robinson, *The Dark Side of Paradise*.

37 Pancasila is the official state ideology. "Film Indonesia Membangun dan Pemakaman Djenazah Pahlawan Revolusi Diputar di Jogja," *Kedaulatan Rakyat*, November 27, 1965. Such obligatory witnessing would become incorporated into the structure of historical pedagogy, reaching its ultimate expression in 1982 in the docudrama film *Penghianatan G30S/PKI* (The Treason of the September 30th Movement: The Indonesian Communist Party). Civil servants and schoolchildren were forced to watch this violent "obligatory film" (*filem wajib*), and it was shown annually on television on the anniversary of the alleged coup until 1998. On a state-produced fake documentary film made by forcing women prisoners to enact the alleged orgy at Lubang Buaya, see Sulami, *Perempuan, Kebenaran dan Penjara*, 61.

38 "Pameran ABRI dan Pembangunan Dibuka: Dipamerkan Badju Djenderal Yani jang Berlumuran Darah," *Kedaulatan Rakyat*, August 18, 1967.

39 "Pameran ABRI dan Pembangunan Ditutup," *Kedaulatan Rakyat*, August 22, 1967. Lubang Buaya was the well into which the bodies of the generals were thrown following their alleged torture. General Yani was one of the murdered generals.

40 See, for example, "PWI Petjat Anggauta-anggautanja yang Korannja Dilarang Terbit," *Kedualatan Rakyat*, October 16, 1965; "'Gestapu' Gagal Kup LKBN 'Antara,'" *Kedaulatan Rakyat*, November 11, 1965; "PWI Jogja Lagi Memetjat Sementara 4 Anggautanja," *Kedaulatan Rakyat*, December 11, 1965.

41 "Pameran Pers Kedaulatan Rakyat Dibuka Besok Djam 17:00," *Kedaulatan Rakyat*, August 14, 1967, and "Pameran Pers Terbesar Jang Pertama Diselenggarakan oleh Kedaulatan Rakyat," *Kedaulatan Rakyat*, August 16, 1967.

42 "Petikan Kesan2 Pameran Pers," *Kedaulatan Rakyat* August 16, 1967.

43 "1958–1965 Masa Suram bagi Pers Indonesia," *Kedaulatan Rakyat*, August 16, 1967. A speech given by Sri Paku Alam (ruler of Yogyakarta's lesser royal palace) appeared under the headline "Press: Don't Cover Up Facts that Harm the People." His call on the press to "serve the people" was tempered by his admonition that it also "form an instrument of information that channels the desires of the government to its people." "Pers Djangan Tutupi Fakta2 jang Rugikan Rakjat," *Kedaulatan Rakyat*, August 17, 1967.

44 "Pameran Photo KAMI Bukan Show: Dokumentasi dari Perdjuangannja," *Kedaulatan Rakyat*, May 27, 1966. Photo exhibitions sponsored by student groups took place throughout this period. KAPPI sponsored an exhibition of photographs of "Lobang Buaja" in Medan, Sumatra, "to increase the awareness [*mental*] of the people of Medan in particular towards the cruelty of G30S" ("Pameran Foto2 Lobang Buaja," *Kedaulatan Rakyat*, September 30, 1966). An exhibition in Yogyakarta in June 1967 featured two hundred photographs by "members of KAMI," including photographs of the "first action of KAMI in Yogyakarta on March 7, 1966." Both student leaders and a military officer spoke at the exhibition opening ("Pameran Foto dan Karikatur Laskar Arma," *Kedaulatan Rakyat*, June 26, 1967). A similar exhibition took place in May 1968 ("Pahlawan2 Ampera di Sonobudojo," *Kedaulatan Rakyat*, May 24, 1968).

45 "Melihat Pameran Foto: Pemuda-2 Berpatju dengan Sedjarah," *Kedaulatan Rakyat*, May 30, 1966.

46 This statement may be a reference to Sukarno's attempt to disband KAMI in February 1966.

47 Rachman Hakim was a student killed in demonstrations against Sukarno on February 24, 1966.

48 Interview with Djoko Pekik, Bantul, February 21, 2000. In an interview with Nancy Florida, Djoko Pekik dated his arrest to 1965 (see Florida, "A Proliferation of Pigs").

49 I came to know Moelyono over a period of more than a year. The following account is drawn primarily from two taped interviews conducted at his home in Yogyakarta, May 5, 1999, and March 15, 2000.

50 Only "invited" journalists could report from within military-controlled areas. According to our interviews, Moelyono lived with the army in Klaten for three months, returning to Yogyakarta weekly in order to print his photographs (at his darkroom at home) and submit those to be published to the editorial office at *Kedaulatan Rakyat*. He was driven back and forth to Yogyakarta accompanied by a member of the military police, who would wait at his home while he printed his photographs and review them when they were done. The military command in Yogyakarta often printed their own copies of his photographs for their archives. Usually, but not always, they returned the negatives to him.

51 Barthes, *Camera Lucida*, 47, 57.

52 At the same exhibition, a close-up photograph of Suharto praying on Idul Fitri in 1998 was marked with the pens of visitors who wrote derogatory epithets across his face.

53 Buck-Morss, *The Dialectics of Seeing*, x.

54 "Foto Reformasi Yang Dimuat KR Melengkapi Koleksi Arsip Nasional," *Kedaulatan Rakyat*, February 15, 2000.

55 "Citra Arsip Masih Rendah," *Kedaulatan Rakyat*, January 30, 2000. See Strassler, "Documents as Material Resources of the Imagination."

56 "Laporan Survai Pangadaan Koleksi Tahun Anggaran 1998/9." Founded in 1987 as a project of the Department of Education and Culture, it became a full museum in 1992. The museum building was originally a Dutch fort and later served as a New Order prison where the artist Djoko Pekik was held for seven years. Ironically, his first solo painting exhibition was held in the museum that had once served as his prison.

57 "Pameran Dokumentasi Perjuangan Muda," *Kedaulatan Rakyat*, November 4, 1999.

58 The Malari (an abbreviation of "Malapateka Januari" or January Disaster) demonstrations greeted an official Japanese visit to Indonesia in 1974. Students protested the New Order's foreign investment–oriented policies.

59 Exhibition report for the exhibition held October 31 to November 4, 1995, Benteng Vredeberg Museum, Yogyakarta.

60 On the rapes of Chinese Indonesian women during the 1998 riots, see Strassler, "Gendered Visibilities."

61 In "The Subject and Power," Michel Foucault notes, "There are two meanings of the word *subject*: subject to someone else by control

and dependence, and tied to his own identity by a conscience or self-knowledge. Both meanings suggest a form of power which subjugates and makes subject to" (212).

62 My use of the term "screen images" draws on Marita Sturken's reformulation of Freud's concept of a "screen memory," which she uses to describe the processes by which representations of national pasts serve as "screens, actively blocking out" more disturbing and unresolved memories (Sturken, *Tangled Memories*, 8). See Freud, "Screen Memories."

63 "Aceh" refers to the military occupation and ongoing violence in that province; "Ambon" refers to the religious violence that erupted in early 1999 and was also ongoing; "Tanjung Priok" refers to the massacre of Islamic protesters in Jakarta in 1984.

64 A further poignancy to this exclusion is that Agus Muliawan was of Chinese descent. In December 2001, the Special Panel for Serious Crimes of the District Court in Dili, East Timor, convicted seven men for "crimes against humanity" in the case of Agus Muliawan and his companions ("East Timor: Killers of Indonesian Journalist Convicted of Crimes against Humanity," CPJ 2001 news alert, http://www.cpj .org/news, visited October 30, 2003).

Chapter Six: Revelatory Signs

1 A lens flare is a common phenomenon that occurs when a camera is pointed into the sun. Light refracts within the camera lens, often assuming a geometric shape.

2 Literally meaning "Brother Sukarno," "Bung Karno" is an affectionate and intimate term for the first president.

3 Semar is a beloved shadow puppet figure, a clown said to be the protector of Java. Ratu Kidul is the legendary Queen of the South Sea, beautiful consort and vengeful protector of the Central Javanese sultans.

4 In *Picture Theory*, W. J. T. Mitchell uses the term *imagetext* to designate "composite, synthetic works (or concepts) that combine image and text" (89 n. 9).

5 Benjamin, "The Work of Art in the Age of Mechanical Reproduction," 225–26.

6 For similar arguments, see Pinney, "The Indian Work of Art in the Age of Mechanical Reproduction" and *Photos of the Gods*; Roberts and Roberts, *A Saint in the City*, 27.

7 See Schwartz, *The Culture of the Copy*.

8 Benjamin, "The Work of Art in the Age of Mechanical Reproduction," 221.

9 I taped Noorman only once, preferring the more dialogic discussions that happened when we talked informally. During the taped interview,

Noorman spoke almost nonstop and later requested a copy for himself.

10 Choosing names that commemorate the date or circumstances of birth is a common practice in Java.

11 See Stoler and Strassler, "Castings for the Colonial." On state-sponsored biographies of "heroes," see Schreiner, "The Making of National Heroes," 273–75.

12 See Anderson, "*Sembah-Sumpah*," 221, and "The Idea of Power in Javanese Culture," 31; Florida, *Writing the Past, Inscribing the Future*, 39.

13 "1945 to 1991 Non-Stop War!" *Minggu Pagi*, week 4, August 1991; "Bung Karno Memberi Letjen," *Minggu Pagi*, week 4, August 1992. A newspaper profile from 1986 describes Noorman as "known to the people of Yogyakarta as a upholder of truth and justice" and notes that he is facing an unspecified court case. "Pesan Bung Karno Untuk Noorman: 'Jangan Grogi,'" *Asas*, April 12, 1986.

14 On popular versus official nationalism, see Anderson, *Imagined Communities*.

15 On believers in Sukarno's return, see, for example, "Ratusan Warga ke Banyuwangi: Yakin 1 Suro Bung Karno Muncul," *Kedaulatan Rakyat*, April 3, 2000, and "Bung Karno Pidato dan Bertapa," *Posmo*, November 6–12, 1999. The latter reports that according to believers, "Bung Karno truly has not yet died. Bung Karno still gives out tasks and orders to face the problems of the nation that is being afflicted with suffering." This article also mentions the popular belief that Sukarno is being helped in his effort to save Indonesia by Ratu Kidul, the legendary spirit-queen who also figured prominently in Noorman's display. Noorman was featured in an article on the phenomenon of Sukarno-revivalists and impersonators in Indonesia's English-language daily. See "Believers Claim Sukarno Is Alive and Well," *Jakarta Post*, April 11, 1999.

16 Putut Trihudoso, Linda Djali, and Rihad Wiranto, "Buku Primadosa: Dulu Sawito, Kini Wimanjaya," *Tempo*, February 5, 1994. The title of the book echoes Sukarno's famous defense speech ("Indonesia Accuses") of 1930. It was Suharto himself who most effectively generated publicity about the book when he mentioned it (and denied its accusations) in a speech; after circulating widely in photocopied form, the book was banned (even though it had never been formally published). In a previous case in 1976, Sawito Kertowibowo secretly circulated anti-Suharto manuscripts; he was imprisoned for his activities.

17 The Gilchrist document, leaked from the British embassy, referred to "our local army friends," who, it implied, were working to oust Sukarno (see Brooks, "The Rustle of Ghosts").

18 The most recent and thorough account of the alleged coup attempt is Roosa, *Pretext for Mass Murder*. For earlier analyses, see (among others) Anderson, McVey, and Bunnell, *A Preliminary Analysis of the*

October 1, 1965, Coup in Indonesia; Crouch, *The Army and Politics in Indonesia*; Cribb, *The Indonesian Killings*.

19 "Naskah Asli Supersemar Diburu," *Bernas*, July 9, 1999. According to another article, the archive holds four copies of the manuscript. One was published by the Pusat Penerangan Angkatan Darat (Center of Intelligence for the Armed Services) while another, from the State Department, was published in the book *30 Years of Indonesian Independence*. Between just those two manuscripts there are twenty-five differences in content, typing, commas, the kind of letters, and the signature. "Berburu Supersemar Yang Misterius," *Kompas*, March 17, 2000.

20 See, for example, "Supersemar: Rekayasa Politik," *Kedualatan Rakyat*, March 2, 2000; Asvi Warman Adam, "Mengakhiri Kontroversi Supersemar," *Kompas*, March 8, 2000.

21 In 1998, a former adjutant of Sukarno, present at the signing of Supersemar, claimed that Sukarno had been forced to sign at gunpoint. Wilardjito was promptly sued by the police for "spreading lies" and his case was taken up by the Yogyakarta Legal Aid Society. See, for example, "LBH Desak Tuntaskan Kasus Wilardjito," *Kedaulatan Rakyat*, June 3, 1999; "Hari Ini atau Besok ke Pengadilan," *Bernas*, July 26, 1999; "Wilardjito, Pembela dan Saksi Siap," *Bernas*, July 28, 1999; "Kasus Wilardjito Masih Belum Jelas: LBH Harapkan tak ada Diskriminasi," *Kedaulatan Rakyat*, August 25, 1999; "Kasus Wilardjito 'Digantung,'" *Bernas*, September 6, 1999; "Kontroversi Supersemar: Wilardjito Tetap Yakin Soekarno Ditodong," *Bernas*, March 12, 2000; "Ingin Luruskan Sejarah, Jadi Tersangka," *Kedaulatan Rakyat*, March 13, 2000.

22 Badrika, *Sejarah Nasional Indonesia dan Umum*, 45.

23 Anderson, "The Idea of Power in Javanese Culture," 26.

24 See also Shiraishi, *Young Heroes*, 121.

25 Lubis et al., *Pendidikan Sejarah Perjuangan Bangsa*, 122–23.

26 According to Florida, "A *pusaka* is a manifest thing endowed with supernatural powers, which powers may become available to persons, especially its owners or custodians, who come into contact with it" (*Writing the Past*, 255–56).

27 In 1996, he sent his son to a photocopier to make thirty copies of the book. When his son went to pick up the copies, intelligence agents intercepted him and questioned him for six hours. When they tried to accuse him of spreading lies and "discrediting the government," he suggested that they call in his father. But they did not. He told me, "If someone else wrote a book like this, maybe he'd be finished. But nothing happened to father!" A young follower of Noorman told me that he spent much of 1996 circulating Noorman's book and cassette all over Java and beyond. He too was taken in and interrogated "all night" but then released. Again, the police confiscated his copies, but not Noorman's original.

28 Siegel, *A New Criminal Type in Jakarta*.

29 On the state's "paper truths," see Tarlo, *Unsettling Memories*, 10.

30 See Strassler, "Documents as Material Resources of the Imagination."

31 "Documentary" history, in the sense I mean here, could also be called "positivist" history. Ginzburg writes that the role of the historian in positivist history is to assess the authenticity and reliability of documents, with the assumption that true documents will yield a truthful picture of the past ("Checking the Evidence").

32 On clipping and historical practice in Indonesia, see Strassler, "Documents as Material Resources"; Mrázek, *Engineers of Happy Land*, 211.

33 On this prophetic, effective historicity, see Florida, *Writing the Past*.

34 Anderson, "The Idea of Power," 34–35.

35 Florida, *Writing the Past*, 19.

36 On the opposition between presentational and discursive forms, see Langer, *Philosophy in a New Key*.

37 Above these words is a cloudlike shape with the text *Kumambange—Watu item* (Jav. "black stone that floats") and then an arrow to a rain cloud on the horizon in the far right, under the star, which says *Sileme Perahu Gabus* (Jav. "sponge that sinks")—two opposed miraculous impossibilities.

38 Emma Tarlo writes, "The state's demand for paper proofs generates the popular production of paper truths as people mimic the very writing technologies that ensnare them. Such acts of mimesis bear witness to the reach of the state in the everyday lives of ordinary citizens, but they also point to the limitations of that reach, for ultimately the state risks drowning in the artifice of its own creation" (*Unsettling Memories*, 9–10). For a similar argument, see also Das, "The Signature of the State."

39 Derrida, *Limited Inc.*

40 Stewart, *On Longing*, 33.

41 Ibid., 23–24.

42 See Strassler, "The Face of Money."

43 "Pesan Bung Karno Untuk Noorman: 'Jangan Grogi,'" *Asas*, April 12, 1986.

44 "Bung Karno Memberi Letjen," *Minggu Pagi*, fourth week of August, 1992.

45 This is probably a photograph of Noorman with a well-known Sukarno impersonator, Romo Kusno.

46 Batchen, *Each Wild Idea*, 139.

47 An *Album of Heroes of the Nation*, for example, provides a portrait of each "hero" accompanied by a one-page biographical narrative (Bakry, *Album Pahlawan Bangsa*).

48 Berger, *About Looking*, 58–59.

49 Sukarno, *Sukarno*.

50 Benjamin, "The Work of Art," 237.

51 See Taussig, *Mimesis and Alterity*.

52 The photographs Noorman took of me were also, apparently, effective objects. He told me that he had reproduced them and given them to others, promising that my image would protect them from illness and hunger. On "proximal empowerment" through contact with and within photographs of deities, see Pinney, *Camera Indica*, 171.

53 Noorman's collection of these images echoes the practice in Javanese courts of gathering around the ruler "any objects or persons held to have or contain unusual Power" (Anderson, "The Idea of Power," 27).

54 In his study of Indian popular images, Pinney, by contrast, found no marked semiotic difference between photographs and chromolithographs (which are also often referred to as photos); "photography . . . is not lexically or semiotically marked in local discourse as indexical" (*Camera Indica*, 131).

55 Nor were such ideas restricted to mystics, con artists, and technological novices. A serious amateur photographer with technical knowledge of photography told me of a strange gray, smoky form that had appeared next to the sultan in photographs he had taken of his coronation ceremony. Surprised, he took the photographs to the *Keraton*, where the sultan himself confirmed that the smoky figure was Ratu Kidul. Photographers' stories of strange figures appearing in their images and of the camera's ability to record *makhluk halus* (spiritual beings) were also fairly common. Some photographers told stories of encounters with the dead while on the job photographing funerals. On the use of photography to reveal the presence of spirits and other occult phenomena in Europe and America, see Cheroux et al., *The Perfect Medium*.

56 The article reported that some doubted the authenticity of the photograph, claiming it was merely a copy of a painting by the famous painter Basuki Abdullah. See "Foto 'Nyi Roro Kidul' yang Menghebohkan," *Kedaulatan Rakyat*, May 18, 1998; and "Penjualan Foto 'Roro Kidul' Dihentikan Kepolisian Wangon," *Kedaulatan Rakyat*, May 20, 1998.

57 For a perceptive discussion of this room, see Shiraishi, *Young Heroes*.

58 For an excellent discussion of the privatized version of the cult of Ataturk in Turkey, see Özyürek, "Miniaturizing Ataturk."

59 Commercial photographs of the Sultan of Yogyakarta, Hamengkubuwono X, similarly include informal-familial representations. A set of nine photographs on sale at the Yogyakarta *Keraton* in 1999, for example, combined images of court ceremony, family portraits, and informal snapshots of family life.

60 On the patriarchal model of the nation in Indonesia, see Shiraishi, *Young Heroes*; Sears, *Fantasizing the Feminine*.

61 M. Hirsch, *Family Frames*.

62 Anderson, *Imagined Communities*, 24. For a similar critique, see also Pinney, *Photos of the Gods*.

63 On the link between photography and linear historicity, see Anderson, *Imagined Communities*, 204.

1 Trouillot, *Silencing the Past*.
2 Yudhi Soerjoatmodjo, "The Challenge of Space."
3 "Sebagaian Dokumen Kasus Priok Dimusnahkan," *Kompas*, May 8, 2000.
4 Budiardjo, *Surviving Indonesia's Gulag*, 162.
5 Bourdieu, *Photography*, 16–17.
6 Proust, *Remembrance of Things Past*, 47. On photography's alignment with voluntary memory, see also Benjamin's discussion of Proust (Benjamin, "On Some Motifs in Baudelaire," 186–88).
7 Young members of amateur clubs were already experimenting with digital effects then, and a handful of the most high-end studios were also using digital technology to enable people to pose next to their favorite celebrity or sports star. Although none of the student photographers I knew possessed a digital camera, some had used scanning and the Internet to circulate their photographs.
8 Many of those who proclaim the end of photography as a medium do so on the basis that digitalization undermines photographic truth claims. Yet manipulation and artifice have always been part of photography (see Batchen, "Ectoplasm," 18). The status of the photograph as "evidence" has always depended on the ideological and institutional apparatuses that support these claims as much (or more) than on the inherent properties of the image itself (Tagg, *The Burden of Representation*, 160).
9 See Kittler, *Discourse Networks 1800/1900*.
10 The phrase is Tagg's, from *The Burden of Representation*, 65. Certainly the new attention to the materiality of the photographic image-object in studies of photography can be seen in part as a response to the digital transformation of the medium.
11 See Mitchell, *What Do Pictures Want?* 108.

BIBLIOGRAPHY

Abu-Lughod, Lila. 1991. "Writing against Culture." *Recapturing Anthropology: Working in the Present*, ed. Richard Fox, 137–62. Santa Fe, N.M.: School of Social Research.

———. 2005. *Dreams of Nationhood: The Politics of Television in Egypt*. Chicago: University of Chicago Press.

Adam, Ahmat B. 1995. *The Vernacular Press and the Emergence of Modern Indonesian Consciousness (1855–1913)*. Ithaca, N.Y.: Cornell University Press.

Aguilar, Filomeno V. Jr. 2001. "Citizenship, Inheritance, and the Indigenizing of 'Orang Chinese' in Indonesia." *Positions* 9, no. 3: 501–33.

Alloula, Malek. 1987. *The Colonial Harem*. Manchester: Manchester University Press.

Anderson, Benedict. 1966 [1990]. "The Languages of Indonesian Politics." *Language and Power: Exploring Political Cultures in Indonesia*, 123–51. Ithaca, N.Y.: Cornell University Press.

———. 1972a [1990]. "The Idea of Power in Javanese Culture." In Anderson, *Language and Power*, 17–77.

———. 1972b. *Java in a Time of Revolution: Occupation and Resistance, 1944–1946*. Ithaca, N.Y.: Cornell University Press.

———. 1979 [1990]. "A Time of Darkness and a Time of Light: Transposition in Early Indonesian Nationalist Thought." In Anderson, *Language and Power*, 241–70.

———. 1984 [1990]. "*Sembah-Sumpah*: The Politics of Language and Javanese Culture." In Anderson, *Language and Power*, 194–237.

———. 1991. *Imagined Communities: Reflections on the Origin and Spread of Nationalism*. 2nd edition. London: Verso.

———. 1998. *The Spectre of Comparisons: Nationalism, Southeast Asia and the World*. London: Verso.

Anderson, Benedict, Ruth McVey, and Frederick Bunnel. 1971. *A Preliminary Analysis of the October 1, 1965, Coup in Indonesia*. Ithaca, N.Y.: Cornell Modern Indonesia Project, Interim Report Series.

Ang, Ien. 1985. *Watching Dallas: Soap Opera and the Melodramatic Imagination*. London: Methuen.

―――. 1991. *Desperately Seeking the Audience*. New York: Routledge.

Appadurai, Arjun, ed. 1986. *The Social Life of Things*. Cambridge: Cambridge University Press.

―――. 1996. *Modernity at Large: Cultural Dimensions of Globalization*. Minneapolis: University of Minnesota Press.

―――. 1997. "The Colonial Backdrop." *Afterimage* 24, no. 5: 4–7.

Appadurai, Arjun, and Carol Breckenridge. 1992. "Museums Are Good to Think: Heritage on View in India." *Museums and Communities: The Politics of Public Culture*, ed. Ivan Karp, Christine Mullen Kreamer, and Steven D. Lavine, 34–55. Washington, D.C.: Smithsonian Institute Press.

Aspinall, Edward. 1995. "Students and the Military: Regime Friction and Civilian Dissent in the Late Suharto Period." *Indonesia* 59 (April): 21–44.

Badan Koordinasi Masalah Cina. 1979. *Pedoman Penyelesaian Masalah Cina di Indonesia*. Jakarta: Bakin.

Badrika, Wayan. 1997. *Sejarah Nasional Indonesia dan Umum*, vol. 3. Jakarta: Penerbit Erlangga.

Bakhtin, Mikhail. 1981. *The Dialogic Imagination: Four Essays*. Edited by Michael Holquist. Austin: University of Texas Press.

Bakry, H. Oemar, ed. 1977 [1998]. *Album Pahlawan Bangsa*. Jakarta: Mutiara Sumber Widya.

Banta, Melissa, and Curtis M. Hinsley. 1986. *From Site to Sight: Anthropology, Photography, and the Power of Imagery*. Cambridge, Mass.: Peabody Museum Press.

Barker, Joshua. 1998. "State of Fear: Controlling the Criminal Contagion in Suharto's New Order." *Indonesia* 66 (October): 7–42.

―――. 1999. "The Tattoo and the Fingerprint: Crime and Security in an Indonesian City." Ph.D. dissertation, Cornell University.

―――. 2002. "Telephony at the Limits of State Control: 'Discourse Networks' in Indonesia." *Local Cultures and the "New Asia": The State, Culture and Capitalism in Southeast Asia*, ed. C. J. W. L. Wee, 158–83. Singapore: Institute of Southeast Asian Studies.

―――. 2005. "Engineers and Political Dreams: Indonesia in the Satellite Age." *Current Anthropology* 46, no. 5: 703–27.

Barthes, Roland. 1957 [1972]. *Mythologies*. Translated by Jonathan Cape. New York: Hill and Wang.

―――. 1977. *Image-Music-Text*. Translated by Stephen Heath. New York: Hill and Wang.

―――. 1980 [1981]. *Camera Lucida*. Translated by Richard Howard. New York: Hill and Wang.

Batchen, Geoffrey. 1997. *Burning with Desire: The Conception of Photography*. Cambridge, Mass.: MIT Press.

―――. 1999. "Ectoplasm: Photography in the Digital Age." *Over Exposed: Essays on Contemporary Photography*, ed. Carol Squiers, 9–23. New York: New Press.

————. 2002. *Each Wild Idea: Writing, Photography, History*. Cambridge, Mass.: MIT Press.

————. 2004. *Forget Me Not: Photography and Remembrance*. Princeton, N.J.: Princeton Architectural Press.

Baxandall, Michael. 1972. *Painting and Experience in Fifteenth Century Italy: A Primer in the Social History of Pictorial Style*. Oxford: Clarendon Press.

Bazin, André. 1960. "The Ontology of the Photographic Image." Translated by Hugh Gray. *Film Quarterly* 13, no. 4: 4–9.

Behrend, Heike. 1999. "A Short History of Photography in Kenya." *Anthology of African and Indian Ocean Photography*, 161–65. Paris: Revue Noire.

————. 2001. "Fragmented Visions: Photo Collages by Two Ugandan Photographers." *Visual Anthropology* 14, no. 3: 301–20.

Behrend, Heike, and Jean-Francois Werner. 2001. "Photographies and Modernities in Africa." Special issue, *Visual Anthropology* 14, no. 3: 241–42.

Ben-Ari, Eyal. 1991. "Posing, Posturing and Photographic Presences: A Rite of Passage in a Japanese Commuter Village." *Man* new series 26, no. 1: 87–104.

Benjamin, Walter. 1934 [1980]. "A Short History of Photography." *Classic Essays on Photography*, ed. Alan Trachtenberg, 199–216. New Haven, Conn.: Leete's Island Books.

————. 1936 [1968a]. "The Work of Art in the Age of Mechanical Reproduction." *Illuminations*, ed. Hannah Arendt, trans. Harry Zohn, 217–51. New York: Schocken Books.

————. 1939 [1968b]. "On Some Motifs in Baudelaire." *Illuminations*, 155–200.

Berger, John. 1972. *Ways of Seeing*. London: British Broadcasting Corporation and Penguin Books.

————. 1991. *About Looking*. New York: Vintage International Edition.

Berticevich, George C. 1998. *Photo Backdrops: The George C. Berticevich Collection*. Exhibition catalogue. San Francisco: Yerba Buena Center for the Arts.

Bina Dharma Pemuda Indonesia. 1989. *Peraturan Perundang-undangan Kewarganegaraan Republik Indonesia dan Kependudukan beserta Peraturan Pelaksanaanya*. Jakarta: Bina Dharma Pemuda Indonesia.

Biro Bina Pemerintahan Umum Setwilda Propinsi DIY. 1987/88. *Himpunan Peraturan Perundang-undangan Tentang Administrasi Kependudukan*. Yogyakarta: Biro Bina Pemerintahan Umum Setwilda Propinsi DIY.

Boellstorff, Tom. 2005. *The Gay Archipelago: Sexuality and Nation in Indonesia*. Princeton, N.J.: Princeton University Press.

Bourchier, David. 1990. "Crime, Law and State Authority in Indonesia." *State and Civil Society in Indonesia*, ed. Arief Budiman, 177–214. Monash Papers on Southeast Asia no. 22. Clayton, Victoria: Monash Asia Institute.

Bourdieu, Pierre. 1965 [1990]. *Photography: A Middle-brow Art*. Translated by Shaun Whiteside. Stanford, Calif.: Stanford University Press.

———. 1984. *Distinction: A Social Critique of the Judgment of Taste*. Translated by Richard Nice. Cambridge, Mass.: Harvard University Press.

Bowen, John B. 1986. "On the Political Construction of Tradition: Gotong Royang in Indonesia." *Journal of Asian Studies* 45, no. 3: 545–61.

Brenner, Suzanne. 1996. "Reconstructing Self and Society: Javanese Muslim Women and 'The Veil.'" *American Ethnologist* 23, no. 4: 673–97.

———. 1998. *The Domestication of Desire: Women, Wealth and Modernity in Java*. Princeton, N.J.: Princeton University Press.

———. 1999. "On the Public Intimacy of the New Order: Images of Women in the Popular Indonesian Print Media." *Indonesia* 67 (April): 13–37.

Breuer, Miles J. 1945. "The Most Civilized Hobby." *American Annual of Photography, 1946*, vol. 60, 77–80. Boston: Chapman and Hall.

Brooks, Karen. 1995. "The Rustle of Ghosts: Bung Karno in the New Order." *Indonesia* 60 (October): 61–99.

Buckley, Liam. 2001. "Self and Accessory in Gambian Studio Photography." *Visual Anthropology Review* 16, no. 2: 71–91.

Buck-Morss, Susan. 1991. *The Dialectics of Seeing: Walter Benjamin and the Arcades Project*. Cambridge, Mass.: MIT Press.

Budiardjo, Carmel. 1996. *Surviving Indonesia's Gulag: A Western Woman Tells Her Story*. London: Cassell.

Burgin, Victor. 1982. *Thinking Photography*. London: Macmillan.

Caplan, Jane, and John Torpey, eds. 2001. *Documenting Individual Identity: The Development of State Practices in the Modern World*. Princeton, N.J.: Princeton University Press.

Castel, Robert, and Dominique Schnapper. 1990. "Aesthetic Ambitions and Social Aspirations: The Camera Club as a Secondary Group." *Photography: A Middle-brow Art*, ed. Pierre Bourdieu, trans. Shaun Whiteside, 103–28. Stanford, Calif.: Stanford University Press.

Certeau, Michel de. 1984. *The Practice of Everyday Life*. Translated by Steven Rendall. Berkeley: University of California Press.

Chakrabarty, Dipesh. 2000a. "Witness to Suffering: Domestic Cruelty and the Birth of the Modern Subject in Bengal." *Questions of Modernity*, ed. Timothy Mitchell, 49–86. Minneapolis: University of Minnesota Press.

———. 2000b. *Provincializing Europe: Postcolonial Thought and Historical Difference*. Princeton, N.J.: Princeton University Press.

Chalfen, Richard. 1987. *Snapshot Versions of Life*. Bowling Green, Ohio: Bowling Green State University Popular Press.

Cheah, Pheng. 2007. *Inhuman Conditions: On Cosmopolitanism and Human Rights*. Cambridge, Mass.: Harvard University Press.

Chéroux, Clément, Andreas Fischer, Pierre Aprazine, Denis Canguilhem, and Sophie Schmit. 2004. *The Perfect Medium: Photography and the Occult*. New Haven, Conn.: Yale University Press.

Coppel, Charles A. 1977. "Studying the Chinese Minorities: A Review." *Indonesia* 24 (October): 175–83.

———. 1983. *Indonesian Chinese in Crisis*. Kuala Lumpur: Oxford University Press.

Crary, Jonathan. 1992. *Techniques of the Observer: On Vision and Modernity in the Nineteenth Century*. Cambridge, Mass.: MIT Press.

Cribb, Robert. 2002. "A Good Idea at the Time?" Paper presented at the "What Is Indonesia?" Reading Roundtable, Association of Asian Studies Meetings, Washington, D.C., April 5.

———, ed. 1990. *The Indonesian Killings, 1965–1966: Studies from Java and Bali*. Monash Papers on Southeast Asia no. 2. Clayton, Victoria: Monash University.

Crouch, Harold. 1978. *The Army and Politics in Indonesia*. Ithaca, N.Y.: Cornell University Press.

Dahm, Bernard. 1970. *History of Indonesia in the Twentieth Century*. London: Praeger.

Das, Veena. 2004. "The Signature of the State: The Paradox of Illegibility." *Anthropology in the Margins of the State*, ed. Veena Das and Deborah Poole, 225–52. Oxford: James Curry Ltd.

Derrida, Jacques. 1988. *Limited Inc*. Edited by Gerald Graff, translated by Jeffrey Mehlman and Samuel Weber. Chicago: Northwestern University Press.

Dewo, B. Ertanto Cahyo. 1993. "Kere Ki Ra Sah Mati. Yen Mati Ngrepoti: Studi Mengenai Anak Jalanan dan Perubahan Sosial." Unpublished paper.

———. 1994. "Penertiban Penduduk dan Lahirnya Wong Gelap." Unpublished paper.

Dick, Howard W. 1985. "The Rise of a Middle Class and the Changing Concept of Equity in Indonesia: An Interpretation." *Indonesia* 39 (April): 71–92.

———. 1990. "Further Reflections on the Middle Class." *The Politics of Middle Class Indonesia*, ed. Richard Tanter and Keith Young, 63–70. Monash Papers on Southeast Asia no. 19. Clayton, Victoria: Monash University Press.

Dijk, Kees van. 1997. "Sarongs, Jubbahs, and Trousers: Appearance as a Means of Distinction and Discrimination." *Outward Appearances: Dressing State and Society in Indonesia*, ed. Henk Schulte Nordholt, 39–83. Leiden: KITLV Press.

Eco, Umberto. 1970 [1982]. "Critique of the Image." *Thinking Photography*, ed. Victor Burgin, 32–38. London: Macmillan.

Edwards, Elizabeth, ed. 1992. *Anthropology and Photography, 1860–1920*. New Haven, Conn.: Yale University Press.

———, ed. 1997. "Anthropology and the Colonial Endeavor." Special issue, *History of Photography* 21, no. 1.

———. 2001. *Raw Histories: Photographs, Anthropology and Museums*. Oxford: Berg.

Edwards, Elizabeth, and Janice Hart, eds. 2004. *Photographs, Objects, Histories: On the Materiality of Images*. London: Routledge.

Fabian, Johannes. 1983. *Time and the Other: How Anthropology Makes Its Object*. New York: Columbia University Press.

Feldman, Ilana. 2008. *Governing Gaza: Bureaucracy, Authority, and the Work of Rule, 1917–1967*. Durham, N.C.: Duke University Press.

Ferguson, James. 1999. *Expectations of Modernity: Myths and Meanings of Urban Life on the Zambian Copperbelt*. Berkeley: University of California Press.

Fiske, John. 1989. *Understanding Popular Culture*. London: Routledge.

Florida, Nancy K. 1995. *Writing the Past, Inscribing the Future: History as Prophecy in Colonial Java*. Durham, N.C.: Duke University Press.

———. 1997. "Writing Traditions in Colonial Java: The Question of Islam." *Cultures of Scholarship*, ed. S. C. Humphreys, 187–217. Ann Arbor: University of Michigan Press.

———. 2008. "A Proliferation of Pigs: Spectres of Monstrosity in Reformation Indonesia." *Public Culture* 20, no. 3: 497–530.

Flusser, Vilém. 2000. *Towards a Philosophy of Photography*. London: Reaktion.

Fontein, Jan. 1991. "Kassian Cephas: A Pioneer of Indonesian Photography." *Toward Independence: A Century of Indonesia Photographed*, ed. Jane Levy Reed, 45–47. San Francisco: Friends of Photography.

Foster, Hal, ed. 1988. *Vision and Visuality*. Dia Art Foundation Discussions in Contemporary Culture no. 2. Seattle: Bay Press.

Foster, Robert. 2002. *Materializing the Nation: Commodities, Consumption and Media in Papua New Guinea*. Bloomington: Indiana University Press.

Foucault, Michel. 1979. *Discipline and Punish*. Translated by Alan Sheridan. New York: Vintage Books.

———. 1982. "The Subject and Power." *Michel Foucault: Beyond Structuralism and Hermeneutics*. Herbert L. Dryfus and Paul Rabinow, 208–26. Chicago: University of Chicago Press.

Foulcher, Keith. 1990. "The Construction of an Indonesian National Culture: Patterns of Hegemony and Resistance." *State and Civil Society in Indonesia*, ed. Arief Budiman, 301–20. Monash Papers on Southeast Asia no. 22. Clayton, Victoria: Monash Asia Institute.

Frederick, William H. 1989. *Visions and Heat: The Making of the Indonesian Revolution*. Athens: Ohio University Press.

———. 1997. "The Appearance of Revolution: Cloth, Uniform, and the Pemuda Style in East Java, 1945–1949." *Outward Appearances: Dressing State and Society in Indonesia*, ed. Henk Schulte Nordholt, 199–248. Leiden: KITLV Press.

Freud, Sigmund. 1899 [1962]. "Screen Memories." Translated by James Strachey. *The Standard Edition of the Complete Works of Sigmund Freud*, 3:301–2. London: Hogarth Press.

Geary, Christaud. 1990. "Impressions of the African Past: Interpreting Ethnographic Photographs from Cameroon." *Visual Anthropology* 3, nos. 2–3: 289–315.

Geertz, Clifford. 1960. *The Religion of Java*. Chicago: University of Chicago Press.

———. 1973a. "Ritual and Social Change, a Javanese Example." *The Interpretation of Cultures*, 142–69. New York: Basic Books.

———. 1973b. "The Politics of Meaning." *The Interpretation of Cultures*, 311–26. New York: Basic Books.

———. 1983. "Art as a Cultural System." *Local Knowledge*, 94–120. New York: Basic Books.

Gell, Alfred. 1998. *Art and Agency: An Anthropological Theory*. Oxford: Clarendon Press.

Ginzburg, Carlo. 1991. "Checking the Evidence: The Judge and the Historian." *Critical Inquiry* 18, no. 1: 79–92.

Graaf, H. J. de. 1974. *Nederlandsch-Indie in Oude Ansichten*. Zaltbommel: Europese Bibliothek.

Graham-Brown, Sarah. 1988. *Images of Women: The Portrayal of Women in Photography of the Middle East, 1860–1950*. London: Quartet Books.

Greenough, Sarah. 1991. "'Of Charming Glens, Graceful Glades, and Frowning Cliffs': The Economic Incentives, Social Inducements, and Aesthetic Issues of American Pictorial Photography, 1880–1902." *Photography in Nineteenth-Century America*, ed. Martha A. Sandweiss, 259–81. New York: Harry N. Abrams.

Groeneveld, Aneke. 1989. "Photography in the Aid of Science: Making an Inventory of the Country and its Population." In Groeneveld et al., *Toekang Potret*, 15–47.

Groeneveld, Aneke, Liane van der Linden, Steven Wachlin, and Ineke Zweers, eds. 1989. *Toekang Potret: 100 Years of Photography in the Dutch Indies, 1839–1939*. Amsterdam: Fragment Uitgeverij and Museum voor Volkenkunde.

Gupta, Akhil, and James Ferguson. 1992. "Beyond 'Culture': Space, Identity, and the Politics of Difference." *Cultural Anthropology* 7, no. 1: 6–23.

Haks, Leo, and Steven Wachlin. 2005. *Indonesia: 500 Early Postcards*. Singapore: Archipelago Press.

Hall, Stuart. 1973 [1980]. "Encoding/Decoding." *Culture, Media, Language: Working Papers in Cultural Studies, 1972–79*, ed. Stuart Hall, Dorothy Hobson, Andrew Lowe, and Paul Willis, 128–38. London: Hutchinson.

Haraway, Donna. 1994. "Teddy Bear Patriarchy: Taxidermy in the Garden of Eden, New York City, 1908–1936." *Culture/Power/History*, ed. Nicholas Dirks, Geoff Eley, and Sherry B. Ortner, 49–95. Princeton, N.J.: Princeton University Press.

Harker, Margaret. 1979. *The Linked Ring: The Secession Movement in Photography in Britain, 1892–1910*. London: Heinemann.

Hasantoso, Abi. 1999. *Namaku Joshua: Sebuah Biografi Artis Cilik Joshua Suherman*. Jakarta: Jel and Friends Advertising.

Hirsch, Julia. 1981. *Family Photographs: Content, Meaning, Effect*. New York: Oxford University Press.

Hirsch, Marianne. 1997. *Family Frames: Photography, Narrative, and Postmemory*. Cambridge, Mass.: Harvard University Press.

———, ed. 1999. *The Familial Gaze*. Hanover, N.H.: University Press of New England.

Ho, Engseng. 2006. *The Graves of Tarim: Genealogy and Mobility across the Indian Ocean*. Berkeley: University of California Press.

Hoskins, Janet. 1994. *The Play of Time: Kodi Perspectives on Calendars, History, and Exchange*. Berkeley: University of California Press.

Hull, Matthew. 2003. "The File: Agency, Authority, and Autography in a Islamabad Bureaucracy." *Language and Communication* 23, nos. 3–4: 287–314.

Iit Rasita, Bambang Sumbogo, Hasanuddin T. 1991. *Cintaku Negeriku: Buku Pelengkap PSPB Untuk Kelas 3 SMP*. Klaten: PT Intan Pariwara.

Ivy, Marilyn. 1995. *Discourses of the Vanishing*. Chicago: University of Chicago Press.

Jay, Martin. 1988. "Scopic Regimes of Modernity." *Vision and Visuality*, ed. Hal Foster, 3–28. Dia Art Foundation Discussions in Contemporary Culture no. 2. Seattle: Bay Press.

———. 1993. *Downcast Eyes: The Denigration of Vision in Twentieth Century French Thought*. Berkeley: University of California Press.

Jenks, Chris, ed. 1995. *Visual Culture*. London: Routledge.

Kartini, Raden Adjeng. 1964. *Letters of a Javanese Princess*. Translated by Agnes Louise Symmers. New York: W. W. Norton.

Keane, Webb. 1997. *Signs of Recognition*. Berkeley: University of California Press.

———. 2003a. "Public Speaking: On Indonesian as the Language of the Nation." *Public Culture* 15, no. 3: 503–30.

———. 2003b. "Semiotics and the Social Analysis of Material Things." *Language and Communication* 23, nos. 3–4: 409–25.

———. 2007. *Christian Moderns: Freedom and Fetish in the Mission Encounter*. Berkeley: University of California Press.

Keenan, Catherine. 1998. "On the Relationship between Personal Photographs and Individual Memory." *History of Photography* 22, no. 2: 60–64.

King, Barry. 1993. "Photoconsumerism and Mnemonic Labor: Capturing the 'Kodak Moment.'" *Afterimage* 21, no. 2: 9–13.

Kittler, Friedrich. 1999. *Gramophone, Film, Typewriter*. Translated by Geoffrey Winthrop-Young and Michael Wutz. Stanford, Calif.: Stanford University Press.

———. 1990. *Discourse Networks, 1800/1900*. Translated by Michael Metteer. Stanford, Calif.: Stanford University Press.

Klima, Alan. 2002. *The Funeral Casino: Mediation, Massacre, and Exchange with the Dead in Thailand*. Princeton, N.J.: Princeton University Press.

Knaap, Gerrit. 1999. *Kassian Cephas: Photography in the Service of the Sultan*. Leiden: KITLV Press.

Kopytoff, Igor. 1986. "The Cultural Biography of Things: Commoditization as Process." *The Social Life of Things*, ed. Arjun Appadurai, 110–38. Cambridge: Cambridge University Press.

Kracauer, Siegfried. 1993. "Photography." Translated by Thomas Y. Levin. *Critical Inquiry* 19, no. 3: 421–34.

Kuhn, Annette. 1995. *Family Secrets*. London: Verso.

Kwartanada, Didi. 1997. "Kolaborasi dan Resinifikasi Komunitas Cina Kota Yogyakarta Pada Jaman Jepang, 1942–45." University of Gadjah Mada thesis, Yogyakarta.

———. 2007. "Visualization of the Chinese Dandies, 1900–2002." Paper presented at the "Public Eyes, Private Lenses: Visualizing the Chinese in Indonesia and North America" conference. University of British Columbia, Vancouver, March 1–2.

Lamuniere, Michelle. 2001. *You Look Beautiful Like That: The Portrait Photographs of Seydou Keita and Malick Sidibe*. New Haven, Conn.: Yale University Press.

Langer, Susanne. 1957. *Philosophy in a New Key: A Study in the Symbolism of Reason, Rite, and Art*, 3rd edition. Cambridge, Mass.: Harvard University Press.

Langford, Martha. 2001. *Suspended Conversations: The Afterlife of Memory in Photographic Albums*. Montreal: McGill-Queen's University Press.

Latour, Bruno. 1993. *We Have Never Been Modern*. Translated by Catharine Porter. Cambridge, Mass.: Harvard University Press.

Leclerc, Jacques. 1994. "The Political Iconology of the Indonesian Postage Stamp (1950–1970)." Translated by Nora Scott. *Indonesia* 57 (April): 15–48.

Lee, Geok Boi. 1992. *Syonan: Singapore under the Japanese, 1943–1945*. Singapore: Singapore Heritage Society.

Lindquist, Johan. 2008. *The Anxieties of Mobility: Emotional Economies at the Edge of the Global City*. Honolulu: University of Hawaii Press.

Lindsey, Tim. 2005. "Reconstituting the Ethnic Chinese." *Chinese Indonesians: Remembering, Distorting, Forgetting*, ed. Tim Lindsey and Helen Pausacker, 41–76. Singapore: Institute of Southeast Asian Studies.

Lippard, Lucy R. 1997. "Frames of Mind." *Afterimage* 24, no. 5: 8–11.

Liu, Gretchen. 1995. *From the Family Album: Portraits from the Lee Brothers Studio, Singapore, 1910–1925*. Singapore: Landmark Books.

Lubis, Husin, Gatot Suraji, S. Harijadi Judha, Sudarmadji, Jacobus Rinussa, St. Negoro. 1984. *Pendidikan Sejarah Perjuangan Bangsa*. Jakarta: Yudhistira.

Lutz, Catherine, and Jane Collins. 1993. *Reading National Geographic*. Chicago: University of Chicago Press.

MacDougall, David. 1992. "Photo Hierarchicus: Signs and Mirrors in Indian Photography." *Visual Anthropology* 5, no. 2: 103–29.

———. 1998. *Transcultural Cinema*. Princeton, N.J.: Princeton University Press.

Mackie, James. 1966 [2001]. Introduction to *Sojourners and Settlers: Histories of Southeast Asia and the Chinese*, ed. Anthony Reid, xii–xxx. Honolulu: University of Hawaii Press.

———. 2005. "How Many Chinese Indonesians?" *Bulletin of Indonesian Economic Studies* 41, no. 1: 97–101.

Mankekar, Purnima. 1999. *Screening Culture, Viewing Politics: An Ethnography of Television, Womanhood and Nation in Postcolonial India*. Durham, N.C.: Duke University Press.

Maxwell, Anne. 1999. *Colonial Photography and Exhibitions*. London: Leicester University Press.

Mazzarella, William. 2004. "Culture, Globalization, Mediation." *Annual Review of Anthropology* 33:345–67.

McGregor, Kate. 2007. *History in Uniform: Military Ideology and the Construction of Indonesia's Past*. Singapore: Singapore University Press.

McLuhan, Marshall. 1964. *Understanding Media: The Extensions of Man*. New York: McGraw-Hill.

McLuhan, Marshall, and Quentin Fiore. 1967. *The Medium Is the Massage: An Inventory of Effects*. New York: Bantam Books.

McQuire, Scott. 1998. *Visions of Modernity: Representation, Memory, Time and Space in the Age of the Camera*. London: Sage Press.

McVey, Ruth, ed. 1992. *Southeast Asian Capitalists*. Ithaca, N.Y.: Cornell University Southeast Asia Program.

Messick, Brinkley. 1993. *The Calligraphic State: Textual Domination and History in a Muslim Society*. Berkeley: University of California Press.

Metz, Christian. 1982. *The Imaginary Signifier: Psychoanalysis and the Cinema*. Translated by Celia Britton, Annwyl Williams, Ben Brewster, and Alfred Guzzetti. Bloomington: Indiana University Press.

Miller, Daniel, ed. 1998. *Material Cultures: Why Some Things Matter*. Chicago: University of Chicago Press.

Mitchell, Timothy. 1991. *Colonizing Egypt*. New York: Cambridge University Press.

Mitchell, W. J. T. 1994. *Picture Theory: Essays on Verbal and Visual Representation*. Chicago: University of Chicago Press.

———. 2005. *What Do Pictures Want? The Lives and Loves of Images*. Chicago: University of Chicago Press.

Morley, David. 1992. *Television, Audiences, and Cultural Studies*. London: Routledge.

———. 1995. "Television: Not So Much a Visual Medium, More a Visible Object." *Visual Culture*, ed. Chris Jenks, 170–89. London: Routledge.

Morris, Rosalind. 1998. "Surviving Pleasure at the Periphery: Chiang Mai and the Photographies of Political Trauma in Thailand, 1976–1992." *Public Culture* 10, no. 2: 341–70.

————, ed. 2009. *Photographies East: The Camera and Its Histories in East and Southeast Asia*. Durham, N.C.: Duke University Press.

Morson, Gary, and Caryl Emerson. 1990. *Mikhail Bakhtin: Creation of a Prosaics*. Stanford, Calif.: Stanford University Press.

Mrázek, Rudolf. 1997. "Indonesian Dandy: The Politics of Clothes in the Late Colonial Period, 1893–1942," In Schulte Nordholt, *Outward Appearances*, 117–50.

————. 2002. *Engineers of Happy Land: Technology and Nationalism in a Colony*. Princeton, N.J.: Princeton University Press.

Muchtar, S. P. Rachman, and H. R. Sunoto. 1994. *Ilmu Pengetahuan Sosial 1b, Untuk Kelas 3 SD Caturwulan II*. Jakarta: Yudhistira.

Myers, Fred, ed. 2001. *The Empire of Things: Regimes of Value and Material Culture*. 2001. Santa Fe: SAR Press.

————. 2004. "Ontologies of the Image and Economies of Exchange." *American Ethnologist* 31, no. 1: 1–14.

Naipaul, V. S. 2001. *The Mimic Men*. New York: Vintage International.

Newhall, Beaumont. 1982. *History of Photography: From 1839 to the Present*. New York: Museum of Modern Art.

Nijs, E. Breton de. 1973. *Tempo Doeloe*. Amsterdam: Querida.

Nugroho, Sigit Wahyu, Aan Kurniawati, and Renny Yaniar. 1999. *Album Artis Cilik*. Jakarta: Penerbitan Sarana Bobo.

Oetomo, Dédé. 1991. "The Chinese of Indonesia and the Development of the Indonesian Language." *Indonesia* 51 (April): 53–66.

Ong, Aiwa, and Donald Nonini, eds. 1997. *Ungrounded Empires: The Cultural Politics of Modern Chinese Nationalism*. New York: Routledge.

Özyürek, Esra. 2005. "Miniaturizing Ataturk: Privatization of the State Imagery and Ideology in Turkey." *American Ethnologist* 31, no. 3: 374–91.

Papailias, Penelope. 2005. *Genres of Recollection: Archival Poetics and Modern Greece*. New York: Palgrave.

Peirce, Charles. 1955. "Logic as Semiotic: The Theory of Signs." *Philosophical Writings of Peirce*, ed. Justus Buchler, 98–119. New York: Dover.

Pemberton, John. 1994. *On the Subject of "Java."* Ithaca, N.Y.: Cornell University Press.

————. 2003. "The Specter of Coincidence." *Southeast Asia over Three Generations: Essays Presented to Benedict R. O'G. Anderson*, ed. James T. Siegel and Audrey R. Kahin, 75–89. Ithaca, N. Y.: Cornell Southeast Asia Program Publication.

Peters, J. D. 1997. "Seeing Bifocally: Media, Place, Culture." *Culture, Power, Place: Explorations in Critical Anthropology*, ed. A. Gupta and J. Ferguson, 75–92. Durham, N.C.: Duke University Press.

Picard, Michel. 1996. *Bali: Cultural Tourism and Touristic Culture*. Paris: Didier Millet.

Pinney, Christopher. 1993. "'To Know a Man from His Face': Photo Wallahs and the Uses of Visual Anthropology." *Visual Anthropology Review* 9, no. 3: 118–25.

————. 1997. *Camera Indica: The Social Life of Indian Photographs*. Chicago: University of Chicago Press.

————. 2002. "The Indian Work of Art in the Age of Mechanical Reproduction: Or, What Happens When Peasants 'Get Hold' of Images." *Media Worlds: Anthropology on New Terrain*, ed. Faye Ginsburg, Lila Abu-Lughod, and Brain Larkin, 355–69. Berkeley: University of California Press.

————. 2003. "Notes from the Surface of the Image: Photography, Postcolonialism, and Vernacular Modernism." In Pinney and Peterson, *Photography's Other Histories*, 202–20.

————. 2004. *Photos of the Gods: The Printed Image and Political Struggle in India*. London: Reaktion Books.

Pinney, Christopher, and Nicholas Peterson, eds. 2003. *Photography's Other Histories*. Durham, N.C.: Duke University Press.

Pinney, Christopher, and Nicholas Thomas, eds. 2001. *Beyond Aesthetics: Art and the Technologies of Enchantment*. London: Berg.

Poole, Deborah. 1997. *Vision, Race, and Modernity*. Princeton, N.J.: Princeton University Press.

Pramoedya Ananta Toer. 1975 [1990]. *This Earth of Mankind*. Translated by Max Lane. New York: Willam Morrow.

Prochaska, David. 1991. "Fantasia of the Phototheque: French Postcard Views of Colonial Senegal." *African Arts* 24 (October): 40–47.

Proust, Marcel. 1913 [1982]. *Remembrance of Things Past*. Vol. 1, *Swann's Way: Within a Budding Grove*. Edited and translated by C. K. Scott Moncrieff and Terence Kilmartin. New York: Vintage Books.

Pustaka Tinta Mas. 1986. *Undang-Undang Kewarganegaraan Republik Indonesia*. Surabaya: Pustaka Tinta Mas.

Rafael, Vicente L. 2000. *White Love and Other Events in Filipino History*. Durham, N.C.: Duke University Press.

————. 2005. *The Promise of the Foreign: Nationalism and the Technics of Translation in the Spanish Philippines*. Durham, N.C.: Duke University Press.

Rajagopal, Arvind. 2001. *Politics after Television: Hindu Nationalism and the Reshaping of the Indian Public*. Cambridge: Cambridge University Press.

Rappaport, Roy. 1979. "The Obvious Aspects of Ritual." *Ecology, Meaning and Religion*, 173–221. Richmond, Calif.: North Atlantic Books.

Reed, Jane Levy, ed. 1991. *Toward Independence: A Century of Indonesia Photographed*. San Francisco: Friends of Photography.

Reid, Anthony. 1997. "Entrepreneurial Minorities, Nationalism and the State." *Essential Outsiders: Chinese and Jews in the Modern Transformation of Southeast Asia and Central Europe*, ed. Daniel Chirot and Anthony Reid, 33–71. Seattle: University of Washington Press.

Ricklefs, M. C. 1981. *A History of Modern Indonesia*. Bloomington: Indiana University Press.

Riles, Annelies, ed. 2006. *Documents: Artifacts of Modern Knowledge*. Ann Arbor: University of Michigan Press.

Roberts, Allen F., and Mary Nooter Roberts. 2003. *A Saint in the City: Sufi Arts of Urban Senegal*. Los Angeles: UCLA Fowler Museum of Cultural History.

Robinson, Geoffrey. 1995. *The Dark Side of Paradise: Political Violence in Bali*. Ithaca, N.Y.: Cornell University Press.

Roosa, John. 2006. *Pretext for Mass Murder: The September 30th Movement and Suharto's Coup d'Etat in Indonesia*. Madison: University of Wisconsin Press.

Ruby, Jay. 1995. *Secure the Shadow: Death and Photography in America*. Cambridge, Mass.: MIT Press.

Rush, James. 1990. *Opium to Java*. Ithaca, N.Y.: Cornell University Press.

Rutherford, Danilyn. 2003. *Raiding the Land of the Foreigners: The Limits of the Nation on an Indonesian Frontier*. Princeton, N.J.: Princeton University Press.

Ryan, James. 1997. *Picturing Empire: Photography and the Visualization of the British Empire*. Chicago: University of Chicago Press.

Salmon, Claudine. 1981. *Literature in Malay by the Chinese of Indonesia: A Provisional Annotated Bibliography*. Paris: de la Maison des Sciences de l'Homme.

———, ed. 1992. *Le Moment "Sino-Malais" de la Litterature Indonesienne*. Paris: Cahier d'Archipel.

Schriener, Klaus. 1997. "The Making of National Heroes: Guided Democracy to New Order, 1959–1992." In Schulte Nordholt, *Outward Appearances*, 259–90.

Schulte Nordholt, Henk, ed. 1997. *Outward Appearances: Dressing State and Society in Indonesia*. Leiden: KITLV Press.

———. Introduction to Schulte Nordholt, *Outward Appearances*, 1–37.

Schwartz, Hillel. 1998. *The Culture of the Copy*. New York: Zone Books.

Scott, James C. 1998. *Seeing Like a State: How Certain Schemes to Improve the Human Condition Have Failed*. New Haven, Conn.: Yale University Press.

Scott, James C., John Tehranian, and Jeremy Mathias. 2002. "The Production of Legal Identities Proper to States: The Case of the Permanent Family Surname." *Comparative Studies in Society and History* 44, no. 1: 4–44.

Sears, Laurie J. 1996a. *Shadows of Empire: Colonial Discourse and Javanese Tales*. Durham, N.C.: Duke University Press.

———, ed. 1996b. *Fantasizing the Feminine*. Durham, N.C.: Duke University Press.

Sekula, Allan. 1984. "The Traffic in Photographs." *Photography against the Grain: Essays and Photo Works, 1973–1983*. Halifax: Press of Nova Scotia College of Art and Design.

———. 1989 [1992]. "The Body and the Archive." *The Contest of Meaning*, ed. Richard Bolton, 343–88. Cambridge, Mass.: MIT Press.

Sen, Krishna, and David T. Hill. 2000 [2007]. *Media, Culture and Politics in Indonesia*. Jakarta: Equinox Publishing.

Shiraishi, Saya. 1997. *Young Heroes: The Indonesian Family in Politics*. Ithaca, N.Y.: Cornell Southeast Asia Program Publication.

Shiraishi, Takashi. 1990. *An Age in Motion: Popular Radicalism in Java, 1912–1926*. Ithaca, N.Y.: Cornell University Press.

Sidel, John T. 2003. "Liberalism, Communism, Islam: Transnational Motors of 'Nationalist' Struggles in Southeast Asia." *International Institute of Asian Studies Newsletter* 32:23.

———. 2006. *Riots, Pogroms, Jihad: Religious Violence in Indonesia*. Ithaca, N.Y.: Cornell University Press.

Siegel, James T. 2000. *The Rope of God*. Ann Arbor: University of Michigan Press.

———. 1986. *Solo in the New Order: Language and Hierarchy in an Indonesian City*. Princeton, N.J.: Princeton University Press.

———. 1997. *Fetish, Recognition, Revolution*. Princeton, N.J.: Princeton University Press.

———. 1998a. "Early Thoughts on the Violence of May 13 and 14, 1998 in Jakarta." *Indonesia* 66 (October): 75–108.

———. 1998b. *A New Criminal Type in Jakarta: Counter-Revolution Today*. Durham, N.C.: Duke University Press.

———. 2005. *Naming the Witch*. Stanford, Calif.: Stanford University Press.

Silverman, Kaja. 1996. *Threshold of the Visible World*. New York: Routledge.

Simanjuntak, Posman. 1998. *Berkenalan dengan Antropologi, Untuk SMU Kelas 3*. Jakarta: Penerbit Erlangga.

Skinner, William. 1981. "Golongan Minoritas Tionghoa." *Golongan Etnis Tionghoa di Indonesia*, ed. Mely G. Tan. Jakarta: Leknas-LIPI and Yayasan Obor Indonesia.

Soedjono, Soeprapto, Risman Marah, and Edial Rusli. 1999. *Tinjauan Fotografi Salonfoto Indonesia dalam Konteks Pengembangan Seni Budaya Nasional*. Yogyakarta: Lembaga Penelitian Institut Seni Indonesia Yogyakarta.

Soeharto, R. 1984. *Saksi Sejarah*. Jakarta: CV Purnawisata.

Soeryoatmodjo, Yudhi. 1999. "Awal Fotografi Modern Indonesia." *Tempo* (December): 172–75.

———. 2000. "The Challenge of Space: Photography in Indonesia, 1841–1999." *Serendipity: Photography, Video, Experimental Film and Multimedia Installation from Asia*, ed. Furuichi Yasuko, 143–48. Tokyo: Japan Foundation Asian Center.

Sontag, Susan. 1977. *On Photography*. New York: Anchor Books.

Spence, Jo, and Patricia Holland, eds. 1991. *Family Snaps: The Meanings of Domestic Photography*. London: Virago.

Spencer, Frank. 1992. "Some Notes on the Attempt to Apply Photography

to Anthropometry during the Second Half of the Nineteenth Century." In Edwards, *Anthropology and Photography*, 99–107.

Spitulnik, Deborah. 1996. "The Social Circulation of Media Discourse and the Mediation of Communities." *Journal of Linguistic Anthropology* 62, no. 2: 161–87.

Sprague, Stephen. 1978. "Yoruba Photography: How the Yoruba See Themselves." *African Arts* 11, no. 1: 52–59.

Spyer, Patricia. 2000. *The Memory of Trade: Modernity's Entanglements on an Eastern Indonesian Island*. Durham, N.C.: Duke University Press.

———. 2001. "The Cassowary Will (Not) Be Photographed: The 'Primitive,' the 'Japanese,' and the Elusive 'Sacred' (Aru, Southeast Moluccas)." *Religion and Media*, ed. Hent de Vries and Samuel Weber, 304–19. Stanford, Calif.: Stanford University Press.

Steedly, Mary Margaret. 1993. *Hanging without a Rope*. Princeton N.J.: Princeton University Press.

Steedman, Carolyn. 1987. *Landscape for a Good Woman*. New Brunswick, N.J.: Rutgers University Press.

Stewart, Susan. 1993. *On Longing: Narratives of the Miniature, the Gigantic, the Souvenir, the Collection*. Durham, N.C.: Duke University Press.

Stimson, Blake. 2006. *The Pivot of the World: Photography and Its Nation*. Cambridge, Mass.: MIT Press.

Stoler, Ann Laura. 2002. *Carnal Knowledge and Imperial Power: Race and the Intimate in Colonial Rule*. Berkeley: University of California Press.

———. 2008. *Along the Archival Grain: Epistemic Anxieties and Colonial Common Sense*. Princeton, N.Y.: Princeton University Press.

Stoler, Ann Laura, and Karen Strassler. 2000. "Castings for the Colonial: Memory Work in 'New Order' Java." *Comparative Studies in Society and History* 42, no. 1: 4–48.

Strassler, Karen. 2003. "Refracted Visions: Popular Photography and the Indonesian Culture of Documentation in Postcolonial Java." Ph.D. dissertation, University of Michigan.

———. 2004. "Gendered Visibilities and the Dream of Transparency: The Chinese Indonesian Rape Debate in Post-Suharto Indonesia." *Gender and History* 16, no. 4: 689–725.

———. 2008a. "Cosmopolitan Visions: Ethnic Chinese and the Photographic Envisioning of Indonesia in the 1950s." *Journal of Asian Studies* 67, no. 2: 395–432.

———. 2008b. "Documents as Material Resources of the Imagination in Post-Suharto Indonesia." *Timely Assets: Resources and Their Temporalities*, ed. Elizabeth Ferry and Mandana Limbert, 215–42. Santa Fe: SAR Press.

———. 2009. "The Face of Money: Crisis, Currency and Remediation in Post-Suharto Indonesia." *Cultural Anthropology* 24, no. 1: 68–103.

Sturken, Marita. 1997. *Tangled Memories: The Vietnam War, the Aids Epidemic, and the Politics of Remembering*. Berkeley: University of California Press.

Sukarno, with Cindy Adams. 1965. *Sukarno: An Autobiography*. Indianapolis: Bobbs-Merrill.

Sulami. 1999. *Perempuan, Kebenaran dan Penjara*. Jakarta: Cipta Lestari.

Supartomo, Alex, and Doreen Lee. 2007. "Nationalist Eye." *Van Indië tot Indonesië*, ed. Els Bogaerts and Remco Raben, 133–51. Amsterdam: Netherlands Institute for War Documentation, Boom Press.

Suryadinata, Leo. 1971. "The Pre–World War II Peranakan Chinese Press of Java: A Preliminary Survey." Athens: Ohio University Center for International Studies, Southeast Asia Paper no. 18.

———. 1978 [1992]. *Pribumi Indonesians, the Chinese Minority, and China*. Singapore: Heinemann Asia and Institute of Southeast Asian Studies in Singapore.

———. 1984. *Dilema Minoritas Tionghoa*. Translated by Ny. Wilandari Supenda. Jakarta: Grafiti Pers.

Sutherland, Heather. 1979. *The Making of a Bureaucratic Elite*. Singapore: Heinemann.

Suwardi. 1985. *Seni Lukis Sokaraja Ditinjau Dari Obyek Pelukisnya*. Yogyakarta: Institut Seni Indonesia Yogyakarta, Proyek Peringkatan Pengembangan Pendidikan Tinggi, Fakultas Seni Rupa dan Desain.

Tagg, John. 1988. *The Burden of Representation: Essays on Photographies and Histories*. Amherst: University of Massachusetts Press.

Tambiah, Stanley. 1968. "The Magical Power of Words," *Man* new series 3, no. 2: 175–208.

Tanter, Richard. 1990. "The Totalitarian Ambition: Intelligence Organisations in the Indonesian State." *State and Civil Society in Indonesia*, ed. Arief Budiman, 213–88. Monash Papers on Southeast Asia no. 22. Clayton, Victoria: Monash Asia Institute.

Tarlo, Emma. 2003. *Unsettling Memories: Narratives of India's "Emergency."* Berkeley: University of California Press.

Taussig, Michael. 1993. *Mimesis and Alterity: A Particular History of the Senses*. London: Routledge.

Taylor, Jean Gelman. 1997. "Costume and Gender in Colonial Java, 1800–1940." In Schulte Nordholt, *Outward Appearances*, 85–116.

Theuns-de Boer, Gerda, Saskia Asser, and Steven Wachlin. 2006. *Isidore van Kinsbergen, 1821–1905: Photo Pioneer and Theatre Maker in the Dutch East Indies*. Leiden: KITLV Press.

Thomas, Nicholas. 1991. *Entangled Objects: Exchange, Material Culture, and Colonialism in the Pacific*. Cambridge, Mass.: Harvard University Press.

Thompson, Krista. 2006. *An Eye for the Tropics: Tourism, Photography, and Framing the Caribbean Picturesque*. Durham, N.C.: Duke University Press.

Thufail, Fadjar. 2005. "Ninjas in the Narrative of the Local and National Violence in Post-Suharto Indonesia." *Beginning to Remember: The Past in Indonesia's Present*, ed. Mary Zurbuchen, 150–67. Seattle: University of Washington Press.

Tim Penulis Buku Prestasi. 1989. *Pendidikan Sejarah Perjuangan Bangsa, Kelas 3 SD*. Semarang: Aneka Ilmu.

Tim Penyusun Sejarah. 1995. *Ilmu Pengetahuan Sosial Sejarah Nasional dan Umum untuk Kelas 3 SMP*. Jakarta: PT Tiga Pustaka Mandiri.

Trouillot, Michel-Rolph. 1995. *Silencing the Past: Power and the Production of History*. Boston: Beacon Press.

Tsing, Anna Lowenhaupt. 1993. *In the Realm of the Diamond Queen*. Princeton, N.J.: Princeton University Press.

———. 2005. *Friction: An Ethnography of Global Connection*. Princeton, N.J.: Princeton University Press.

Turner, Victor. 1967. *The Forest of Symbols*. Ithaca, N.Y.: Cornell University Press.

Twang, Peck-yang. 1998. *The Chinese Business Elite in Indonesia and the Transition to Independence, 1940–1950*. Kuala Lumpur: Oxford University Press.

Vandenbosch, Amry. 1942. *The Dutch East Indies: Its Government, Problems, and Politics*. Berkeley: University of California Press.

Vickers, Adrian. 1989. *Bali: A Paradise Created*. Berkeley: Periplus Editions.

———. 2005. *A History of Modern Indonesia*. Cambridge: Cambridge University Press.

Volkman, Toby Alice. 1990. "Visions and Revisions: Toraja Culture and the Tourist Gaze." *American Ethnologist* 17, no. 1: 91–110.

Wachlin, Steven. 1989. "Large Scale Studios and Amateur Photography." In Groeneveld et al., *Toekang Potret*, 121–64.

Wachlin, Steven, Marianne Fluitsma, and G. J. Knaap. 1994. *Woodbury and Page: Photographers Java*. Leiden: KITLV Press.

Wendl, Tobias. 1999. "Portraits and Scenery in Ghana." *Anthology of African and Indian Ocean Photography*, 142–55. Paris: Revue Noire.

Werner, Jean-Francois. 1999. "Twilight of the Studios." *Anthology of African and Indian Ocean Photography*, 92–97. Paris: Revue Noire.

———. 2001. "Photography and Individualization in Contemporary Africa: An Ivoirian Case Study." *Visual Anthropology* 14, no. 3: 251–68.

Wieringa, Saskia. 2002. *Sexual Politics in Indonesia*. New York: Palgrave.

Williams, Lea. 1960. *Overseas Chinese Nationalism: The Genesis of the Pan-Chinese Movement in Indonesia, 1900–1916*. Glencoe, Ill.: Free Press.

Williams, Raymond. 1974. *Television: Technology and Cultural Form*. New York: Schocken.

———. 1976. *Keywords: A Vocabulary of Culture and Society*. New York: Oxford University Press.

Wue, Roberta, Joana Waley-Cohen, and Edwin K. Lai. 1997. *Picturing Hong Kong: Photography, 1855–1910*. New York: George Braziller and Asia Society Galleries.

Wyman, James B. 1997. "From the Background to the Foreground: The Photo Backdrop and Cultural Expression." *Afterimage* 24, no. 5: 2–3.

MacDougall, David, and Judith MacDougall. 1991. *Photo Wallahs*. Canberra: Fieldwork Films/Australia Film Commission/Australian Broadcasting Corporation.

Noer, Arifin C. 1982. *Penghianatan G30S/PKI*. Jakarta: Pusat Produksi Film Negara.

Nugroho, Garin. 1998. *Daun di atas Bantal*. Jakarta: Christine Hakim Film.

Wendl, Tobias, and Nancy du Plessis. 1998. *Future Remembrance: Photography and Image Arts in Ghana*. Gottingen: Institut fur den Wissenschaftlichen Film.

Indonesian Newspapers and Magazines

Asas

Balairung

Bernas

D&R

Fotomedia

Foto Indonesia

Ibu & Anak

Jakarta Post

Jateng Pos

Kedaulatan Rakyat

Kompas

Media Indonesia

Minggu Pagi

Posmo

Republika

SoloPos

Tempo

atheism, 143–44

Atma Jaya University, 227

authenticity (*asli*), 15, 20, 305nn23–24; conventional understandings of, 60–64, 315n56; countervisions of, 254–56, 270–79, 292–93, 343n55; exclusion of ethnic Chinese community from, 64–69, 114–15, 131–34; in human interest photography, 55–57, 63, 67, 314n49, 315n50, 315n56; New Order's preoccupation with, 17–18, 21–22, 37–38, 54, 280, 293, 342n47; of original photographs, 254–56, 282–84, 292; role of ritual and tradition in, 54, 171, 175–77, 184–85; of student demonstration photographers, 219–23, 333n4, 334n17; as subject of amateur photography, 32–36, 49–51, 60–63, 69–71; tourism's promotion of, 37–38, 49–59

backdrops and props, 74–122, 317n10, 317n14; of classical Chinese scenes, 85–87, 319n31; of domestic scenes, 102–9; of European landscapes, 77–79, 85–87, 319n30; idioms of national spaces and modernity in, 80, 92–102, 321n45; of mosques, 93–96; neutral backdrops, 111, 321n57; role of fashion in, 79–80, 317n13; Sokaraja style of, 87–93, 95–97, 319n32, 320nn33–36, 320n38, 320n40; special effects in, 321n57; transcendence of time, space, and social location in, 98–102, 316n7, 316n9; virtual travel through, 93–96, 320n42; for weddings, 177. *See also* iconography; studio portraiture

Bakhtin, Mikhail, 23, 85, 307n34

Bali bombings of 2002, 303n10

Bandung Art Club, 39, 311n17

Baperki, 65

Barker, Joshua, 130

Barongsai dance, 67–69, 74–76

Barthes, Roland, 308n45; on photographic indexicality, 49, 334n16; on photography as witness to history, 211; on portraiture, 316n9, 317n11; on the punctum, 193, 241; on unary images, 173

batik cloth, 204–5

Behrend, Heike, 98

Ben-Ari, Eyal, 184–85

Benjamin, Walter: on the aura of the original, 254–56, 282; on commodity-on-display, 98; on complex training of the senses, 18; on homogenous, empty time, 292, 303n14; on images as political dynamite, 242; on mimetic improvisation, 116; on the spark of accident, 150; on unconscious optics, 282

Benteng Vredeberg Museum, 243–45, 333n4, 338n55

Berger, John, 234–35, 281, 307n33

Bertillon, Alphonse, 130, 323n7

biographical documentation, 158–61, 194, 200–203, 333n71

birthday photography, 194–203, 332n62, 333n71

black-and-white photography, 57, 88, 150, 315n53, 328n57

Boediantoro, Eko, 230

Boellstorff, Tom, 306n27

Book of Reform Documents, 335n27

Bourdieu, Pierre, 167–68, 170, 299, 329n7

Brenner, Suzanne, 175, 192

Buckley, Liam, 147

Buddhist celebrations, 67

Budiardjo, Carmel, 298

Budi Utomo, 244

Bung Karno. *See* Sukarno (Soekarno)

Canon, 57
Cantonese immigrants. *See* Chinese minority community
Cephas, Kassian, 81
Chakrabarty, Dipesh, 308n38
charismatic political leader photography, 18, 22, 292–93; counterhistories in, 252–56, 270–74, 285–93; Hamengkubuwono X and, 343n59; Sukarno and, 252–79; value of authenticity in, 254–56, 282–84. *See also* Noorman
Che Lan Studio, 99–100
children: biographical documentation of, 158–61, 194, 200–203, 333n71; child stars, 201–2, 204, 332n67; homeless children, 140; identity photos of, 156–58; political status of, 325n26
Chinese minority community, 7, 11–16, 36–38, 298, 304n18, 304nn19–24; amateur photography in, 20, 30–33, 41–45, 63–69; ancestor worship portraits in, 150–52, 328nn64–66; birthday parties in, 195; Christianity of, 36, 64, 310n7; citizenship status of, 131–34, 323nn13–14, 324nn18–19, 326n38; colonial-era mandates on, 42, 77, 131; cosmopolitanism of, 41–42, 65, 69, 114–15, 322n64; exclusion from *asli* of, 64–69, 114–15, 131–34; funeral rituals of, 193–94; identity photographs of, 131–34; Imlek celebrations of, 67, 74; immigration to Indonesia of, 82, 319n20; international associations among, 44–45, 65–66; nationalist movement of, 14–15, 36–38, 42, 319n31; New Order restrictions on, 67, 74–75, 113–15, 120, 133–34; *peranakan* community of, 41–42, 318n22; photographic construction of tradition in, 54, 177; photo studios of,

11–12, 74–77, 303n12; racism and violence against, 8, 14–15, 36–37, 46, 63–64, 114, 122, 133; reformasi period openness to, 67–69, 74–75; studio portraiture of, 20, 81–84, 315n1, 317n15, 318n16, 318nn22–23, 319n27; *totok* community of, 110, 304, 318n22; transnational networks of, 134. *See also* photography clubs; studio portraiture
Christianity, 36, 64, 310n7
Chung Hwa Studio, 85–86, 319n24
citizenship: of ethnic Chinese, 131–34, 323nn13–14, 324nn18–19, 326n38; KTP (identity cards) as documentation of, 135–43, 324n22, 326nn37–39; *warga* and *liar* designations of, 138, 140–43, 326n43, 327n46. *See also* authenticity (*asli*)
City Photo Studio, 92, 100, 110
clubs. *See* photography clubs
Cokroaminoto University, 224
collage, 25, 158, 270, 272–74
colonial Indonesia: amateur photography of, 38–43; collapse of, 6–7; creation of *asli* in, 131–34; early photography in, 6–8, 302n6, 302n8; education in, xiii–xiv; ethnic minorities in, 131–34, 323nn13–15, 324nn16–22; European backdrops of, 77–79, 85, 319n30; identity photography of, 129–34; Islam in, 64; modernity of photography in, 13; photographic expeditions in, 81; studio portraiture of, 82–84, 318n16, 318nn22–23
color photography, 51, 57, 109, 166, 315n53, 321n55
coming-of-age rituals, 184–85
Commando Team for Mental Operations, 336n35
commercial photography, 39, 310n5

22, 308n37, 343n54; Barthes on, 49, 211, 334n16; of charismatic leaders, 256, 275–84, 289, 292–93; of demonstration photographs, 237; of family *dokumentasi* series, 174–75, 200, 205; of identity photographs, 156; of studio portraiture, 77, 79

Indonesian Communist Party, 238–42, 264–65. *See also* communism/communists

Indonesian Democratic Party of Struggle, 67–69

Indonesian Institute of Art, 213

Indonesian Islamic University, 246–47

Indonesian Journalists Association (PWI), 236, 335n22

Indonesian language, 13

Indonesian Photography Society (FPSI), 51

Indonesian Press Photo Service (IPPHOS), 219, 302n8

Indonesian State Institute of Religion (IAIN), 223

Indonesian Students Action Front (KAMI), 237, 337n43

Indonesische Fotograaf Trisnoro, 319n26

Ingalls, Laura, 113–14

Internet, 218, 296–97, 300

Ircham, 48, 50

Islam/Muslims, 7; backdrop depictions of mosques for, 93, 96; funeral rituals of, 193; headscarves as identity marker for, 76–77, 143, 196, 316n4, 327n52; Hong Kong mania among, 76–77; KTP raids of, 144–45; modernist symbols of, 196; paucity of amateur photography of, 63–64; rise of radicalism in, 9, 36; transnational identification of, 95

itinerant photographers, 321n53, 329n4

Japanese studios, 319n25

Javanese language levels, 174, 188, 272, 331n34, 332n57

Jawa Studio, 85

Jay, Martin, 308n41

Jesus, 276–77

jilbab (headscarves), 76–77, 143, 196, 316n4, 327n52

kain (batik cloth), 204–5

Kamera magazine, 46, 47

KAMI, 237, 337n43

KAPPI-KAMI, 237, 337n43

Kartini, Raden Adjeng, 41, 311n21

Kauman mosque, 95

Keane, Webb, 307n34

kenangan, 204–5, 333n73, 333n75

Kenang-Kenangan (Soetomo), 204

Kencana Studio, 166, 175, 203, 333n71

Keraton (sultan's palace), 10

King, Barry, 168

Kodak, 51

Konica Film, 58

Kracauer, Siegfried, 316n9

kromo (high Javanese), 174, 188, 193, 331n34, 332n57

KTP identity cards, 135–45, 150, 324n22, 325nn25–26, 326nn37–38, 328n57; religious affiliations on, 143–45, 327n52; *warga* and *liar* designations of, 138, 140–43, 326n43, 327n46

Kuhn, Annette, 214

Kusuma, Hendra, 74–75

Kusworo, Danu, 212, 223

leaders. *See* charismatic political leader photography

Lebaran, 93

Lembaga Fotografi Candra Naya, 44

lens flares, 339n1

Leonardus, Agus, 68, 85, 98, 313n33

liar, 138, 140–43, 327n46

Liek Kong Studio, 83, 97, 111

Linked Ring salons, 38

official records of, 16–17, 242–45, 338n55; openness to Chinese culture of, 67–69, 74–75; photo exhibitions of, 229–31; press freedoms of, 229, 238, 338n51; prisma stamps of, 161–62; resignation of Suharto, 2, 8, 162, 212, 229. *See also* demonstration photography

refraction, 23–28; as appropriation and personalization of public images, 24–26, 79, 161, 293, 308n45, 309n46; in domesticated histories, 285–90; as movement across and blurring of photographic genres, 26–27, 145–48, 171–72, 184–85, 214–16, 231–34; of national history within personal memories, 28, 122, 299

reproduction, 255–56, 275–76, 292

revelatory history, 254, 270–74, 279–84, 292–93

revolution. *See* independence era

ritual baths, 181–84

ritual photography. *See* family ritual photography

Rona Studio: Hello Hong Kong Mania, 74–77

Sacred Monkey, 76

Sadar Wisata program, 52

Sakura, 51, 166, 168

Salon Foto Indonesia, 53–54

salon photography, 38–43, 47–49, 59, 311n17; commercial sponsorship of, 51, 313n36; international salons, 46, 313n31, 313n33, 313n38; national salons, 51, 313n39; state and organizational sponsorship of, 54–55, 314nn46–47; tourism contests of, 51–53, 313nn41–42

Saman Foto, 319n26

Samawi, 237

Samiaji Photo Studio, 320n40

Sanjaya, Dom, 172

screen images, 246, 338n61

Sekula, Allan, 145, 308n41

Semanggi Tragedy, 227, 229

Semar, 253, 284–87, 292, 339n3

Semarang Camera Club, 44, 52

semiotic ideology, 18, 307n34, 308nn37–38

Setiawan, S., 56, 61

Shiraishi, Takashi, 303n14

Sidel, John, 304n16

Siegel, James T., 5–6, 13, 174, 303n14, 327n46; on funeral photography, 189–90; on masks of formality, 193, 332n57

signatures, 275–79

Silverman, Kaja, 26

Sinar Studio, 84, 319n24

Singapore, 44–45, 312nn27–28

Sin Ming Hui club, 44

siraman rituals, 181–84

Skinner, William, 318n20

snapshot photography, 109–11

social constructionism, 19

social memory, 234–35

Society of World Ethnic Chinese Photographers (SWECP), 45, 65–66

Soekilah, Ibu, 2–4, 28; family identity photographs of, 26–27, 127, 151, 154–55; first photographs of, 5–6, 14; photo collection of, 16, 26–28, 97; portraiture goals of, 23–25

Soelarko, R. M., 44–46, 52, 312n25, 314n49

Soemardi, R., 44, 312n26

Soetomo, R. M., 204

Sokaraja backdrops, 87–93, 95–97, 319n32, 320nn33–36, 320n38, 320n40, 320n42

Sontag, Susan, 234

souvenirs. *See* memories/souvenirs

spatial orientations, xv; in funeral portraiture, 150; in photography of tradition, 36; transcendence through backdrops and props of, 77–80, 93–96, 98–102, 320n42

Srihadi Sudarsono, 208–9, 212

staircases, 101–2, 321n50–51
Steichen, Edward, 55
Stewart, Susan, 275–76
stringer work, 218
students. *See* youth
studio portraiture, 18, 74–122; altered identities offered by, 77–80, 115–16, 316n7, 316n9; Chinese minority practices of, 20, 81–84, 315n1, 317n15, 318n16, 318nn22–23, 319n27; colonial era origins of, 82–84, 318n16; domestic scenes in, 102–9; early equipment of, 84; Heri Gunawan's photographs of Laura, 112–22, 322nn59–61, 322n63; of independence era, 85–93; in Japanese studios, 319n25; modernity and national spaces in, 80, 92–109, 115, 321n45, 321nn50–51; New Order transformations of, 109–11; snapshot photography and automatic processing in, 109–11; use of backdrops in, 87–93. *See also* identity photography
study of photography, 213
Sturken, Marita, 338n61
Sudirman, Ibu: on birthday photography, 199; family portraits of, 153–54; funeral albums of, 187–88, 193–94; pregnancy ritual photographs of, 181–83; wedding albums of, 205
Suharto, 7–9, 16–18; anti-communist campaign of, 136; burnt effigies of, 223–25, 335n25; economic liberalism of, 166; General Attack of 1949, 247; Noorman's countervision of, 256, 258, 264, 272–74, 276–78; ouster of Sukarno by, 265–67, 340n16; photographs of, 287, 331n34, 338n51; resignation of, 2, 8, 162, 212, 229. *See also* New Order regime

Suharto, Hutomo "Tommy" Mandala Putra, 137, 143
Suherman, Joshua, 201–2
Sukarno (Soekarno), 6–7, 93, 306n30, 339n2; autobiography of, 282; *foto asli* of, 287–89, 290; Guided Democracy period of, 7, 236–37; Noorman's visions of, 252–70, 272–79, 342n45; ouster by Suharto of, 265–67; Pancasila of, 236, 263, 336n36; paranormal reports of, 263, 340n15; photographs of, 22, 181, 219, 252, 287–92; reaction to anti-communist campaign of, 337nn45–46; signature of, 275–79; on significance of modernity, 97–98; Supersemar document of, 252, 256, 263–70, 273, 278, 288, 298, 341n19, 341n21
Sulami, 136–37, 143, 325n33
Supersemar document, 252, 256, 263–70, 273, 278, 288, 298, 341n19, 341n21
Surya, Rama, 112
SWECP. *See* Society of World Ethnic Chinese Photographers
Syuhada Mosque, 95

Tagg, John, 19, 129
Taman Mini Theme Park, 95
Tanah Lot Temple, 95
Tan Gwat Bing, 30–31, 40–43, 77–78, 87, 103
Tanjung Priok, 247, 298, 339n62
Tarlo, Emma, 342n38
tattoos, 142
technological essentialism, 19, 307n36
technology of photography, xiii–xv, 6; associations with Chinese minority of, 13–16; automatic cameras, 109–11; automatic processing, 166; color, 51, 57, 109, 166, 315n53, 321n55; digital photography, 299–300, 344nn7–8; as emblematic of nation and moder-

nity, 13–14; mass access to, 8, 109–10; reproduction and photo-copying, 255–56, 263, 275–76, 292

temporal orientations, xv; in family ritual (*dokumentasi*) photography, 21, 205–6; of funeral portraiture, 150; of Javanese calendars, 200; in nostalgia for the past, 5, 36–37, 57, 60–63, 95, 235, 263, 275, 300, 315n1; in photography of ahistorical authenticity, 36–37, 60–63; of self-conscious modernity, xiv, 306n30; transcendence through backdrops of, 98–102

Tentara Pelajar, 259

terrorist bombings of 2002, 303n10

Thirtieth of September Movement. *See* G30S

This Earth of Mankind (Pramoedya), xiii–xiv, 301nn1–3

Three Orders of Yogyakarta-Solo Photojournalists exhibition, 230–35, 238–42

Tik Sun Studio, 83

Tirto Adhi Suryo, 301n3

Tjan Gwan Bie, 312n26

Tjen Hauw, 83, 111, 319n27

Tjio Ping Bwe, 319n24, 319n27

tourism: contribution of amateur photography to, 37–38, 49–59, 71; photography contests promoting, 51–53, 313nn41–42; virtual travel through props and backdrops, 77–80, 93–96, 320n42

tradition. *See* authenticity (*asli*)

Tugu Studio, 106–8

UNESCO, 32, 51, 54–55

Untung, Lieutenant, 136

"Uses of Photography" (Berger), 234–35

visual economies, 19–20

visualities, 18–19, 307n33; in identity photography, 129–31, 138, 145–47; indexicality of, 279–84, 292–93

voluntary memory, 299

Wachlin, Steven, 318n16

Wahid, Abdurrahman, 9, 67, 69, 74

Waisak celebration, 67

warga, 138–41, 326n43. *See also* citizenship

Ways of Seeing (Berger), 307n33

wedding photography, 167, 175–87, 299

West Papua independence movement, 9

White Snake Legend, 76

Widjanarko, R. A. B., 213, 226

Widyawati, 166

Williams, Raymond, 307n31

Wimanjaya Liotohe, 263, 340n16

witnessing history, 8–10, 18, 21–22, 209–12, 230–35, 334n9, 335n20; authenticity of photography in, 211, 219–23, 232, 333n4; obligatory witnessing, 236, 336nn35–36; public exhibitions of, 229–45, 335n27, 336nn30–31, 336n35. *See also* demonstration photography

Witness of the 1998 Actions exhibition, 229

WNI. *See* citizenship

Yani, General, 236

Yogyakarta, 8–14, 303n12

Your Own Identity Stamp (prisma stamps), 161–62

youth: authenticity (*asli*) of photography of, 219–23, 334n17; national narrative of, 243–46, 339n61; New Order role of, 219–20, 235–42, 245. *See also* demonstration photography

Youth Oath of 1928, 244

Yulianto, Kirana, 166, 329n3

Yulianto, Tun, 111

Y. Untung Sutanto, 83, 319n27

Karen Strassler

is an assistant professor of

anthropology at Queens College of

the City University of New York.

Library of Congress Cataloging-in-Publication Data

Strassler, Karen, 1969–
Refracted visions : popular photography
and national modernity in Java / Karen Strassler.
p. cm.
(Objects/histories : critical perspectives on
art, material culture, and representation)
Includes bibliographical references and index.
ISBN 978-0-8223-4593-0 (cloth : alk. paper)
ISBN 978-0-8223-4611-1 (pbk. : alk. paper)
1. Photography—Social aspects—Indonesia—Java.
2. Portrait photography—Indonesia—Java.
3. Group identity—Indonesia—Java.
4. Memory.
I. Title. II. Series: Objects/histories.
TR183.S77 2010
770.9598′2—dc22 2009041452